Modern Theories of Art, 1

Moshe Barasch

MODERN THEORIES OF ART, 1

From Winckelmann to Baudelaire

NEW YORK UNIVERSITY PRESS

NEW YORK AND LONDON

1990

Library of Congress Cataloging-in-Publication Data
Barasch, Moshe.
Modern theories of art, 1: from Winckelmann to Baudelaire/
Moshe Barasch
p. cm.
Bibliography: p.
Includes indexes.
ISBN 0–8147–1133–2 (alk. paper)
1. Art—Philosophy. 2. Aesthetics, Modern—18th century.
3. Aesthetics, Modern—19th century. I. Title
N70.B2 1989 89–34682
701—dc20 CIP

Book design by Ken Venezio

Contents

All illustrations appear as a group following p. 184.

Preface

The themes and doctrines presented in this volume have held my attention for many years. In the course of time I have been helped, or forced, to clarify and develope some of the ideas—mainly by students, whose persistent questions I remember with gratitude. In pursuing the studies that led to this history of art theory I leaned heavily on the help of librarians. Wherever I came, they have offered me help and friendship. With particular gratitude I should record the assistance offered by the staff of the University Library in Jerusalem, and by the librarians at Yale University. It is a pleasure to acknowledge gratefully the lively and stimulating interest Mr. Colin Jones, director of New York University Press, has taken in this book. I was encouraged by him in all the stages of writing. In the process of publication the book has benefited from the care and devoted attention of Mrs. Despina P. Gimbel, managing editor of the press. Mrs. Mira Reich helped me in many ways, and not for the first time. I enjoyed the continuing help of Dr. Luba Freedman, colleague and former student. And, as with all the books I have written, I thank my wife once again for her particular blend of encouragement, criticism, and forbearance.

I

The Early Eighteenth Century

I. INTRODUCTION

Students of letters are apt to balk at drawing sharply demarcated lines between periods. Such students, particularly when they have historical leanings, know better than most that, as a rule, the past persists in the present, and that what now seems the typical expression of the present has often been anticipated in the past. History is a constantly moving stream, and in this dynamic complexity the attempt to find, or establish, watertight compartments is almost a desperate one. This banal truth is valid, of course, also for the history of reflection on the figurative arts, that is, the theory of painting and sculpture. Particularly when we come closer to modern times, where the clarifying effect of historical distance offers us less support than in the case of the more remote past, the difficulties of periodization become more manifest. No wonder, then, that few will venture to suggest a precise date at which modern art theory begins. And yet students of our subject cannot help feeling that around the middle of the eighteenth century some events occurred that, small as they may seem, indicate a dramatic turning point in the tradition of aesthetic reflection on the visual arts, and thus can be taken to announce a new age. I should like to mention a few of these events. To most of the developments mentioned we shall have to come back in

different contexts for more detailed discussions. Here I shall list them only in concise form. The crowding of these dates within the short span of fifteen years may indicate the profound transformation that becomes manifest at the middle of the century.

Precisely at mid-century, in 1750, Alexander Gottlieb Baumgarten, a student and teacher of Latin rhetoric and poetry, published a voluminous book bearing the word *Aesthetica* on its title page (after he had already used that term in the dissertation he had composed fifteen years earlier). Aesthetics, he said, denotes a special domain of cognition, namely the domain of sensual cognition. To be sure, in the hierarchy of cognitional modes sensual cognition occupies a lower rank than cognitions based on pure ideas of logical derivation, but it is recognized as a domain in its own right, with a distinct character. In Baumgarten's presentation the domain of aesthetics is not clearly and firmly outlined, but it was only a short time before the term he coined came to denote what we now understand by it. Though originally not intended primarily for use in the discussion of the arts, it soon proved an excellent conceptual framework for such a discussion, and, as one knows, it has remained so till this very day.

Shortly after the publication of Baumgarten's *Aesthetica* the attentive reader must have felt that he was witnessing a kind of eruption. The year 1755 proved particularly abundant in expressions of aesthetic thought. In that year Moses Mendelssohn published his *Briefe über die Empfindungen,* trying to define the philosophical status of aesthetics. Since beauty is an "indistinct image of a perfection," he believed, God can have no perception of beauty; this is a particularly human experience. In the same year a young and hitherto unknown schoolmaster and librarian, Johann Joachim Winckelmann, published a slim pamphlet, *Thoughts on the Imitation of the Greek Works of Painting and Sculpture.* The little treatise achieved a surprising success; the rich echo it found clearly shows that the ideas suggested in it were "in the air," the generation waiting for them to be expressed. When only eleven years later Gotthold Ephraim Lessing, who in literary history is perceived in the role of Moses who led his people out of French servitude toward the promised land of *Deutsche Klassik,* published his *Laocoön* (1766), he argued energetically against some of Winckelmann's assertions, but he clearly treated

the ideas expressed in *Thoughts on the Imitation* as generally known and authoritative. Two years before that date, in 1764, Winckelmann, who in the meantime had moved to Rome, published his *History of Ancient Art*. It was the first work to use the term "history of art" as a description of a field of study, and the first to employ it in the title of the work. One can say that, in an important sense, the year 1764 is the year in which the history of art was born as an academic discipline.

The year 1755 proved crucial in still another respect. In that year began the more or less systematic archaeological excavations of Pompeii and Herculaneum. The impact on arts and letters of what these excavations brought to light was not uniform, but it was vivid and almost instantaneous. Already, a year before the beginning of the systematic excavations, Charles Cochin fils and J. Bellicard published their *Observations sur les antiquités de la ville d'Herculaneum* (1754). In this work they tried to come to terms with the little that was as yet known about the city, and they actually rejected the testimony of what had been found, considering it a marginal phenomenon. In our next chapter we shall have occasion to describe how this attitude changed. The great folio edition of *Le Antichità di Ercolano* began to appear in 1757 (the seventh volume was published in 1779), and its impact was immediate. It is now generally accepted that, beginning about 1760, developments in the visual arts, especially the "classicist" trend, were accelerated by the new archaeological publications, particularly by engravings after the paintings in Pompeii and Herculaneum. Both artists and patrons (among them successive ministers of Louis XV and Louis XVI) were imbued with a new spirit and found authoritative legitimization in what could be learned from the ancient paintings revealed. But it was not only on painting that the great new discoveries imposed themselves. Theoretical reflection on the arts could not neglect the revelations mediated by what was discovered. The themes of art theory were enlarged by the results of the excavations. In the Renaissance and Baroque periods the impact of the classical tradition was largely determined by the sculptural remains so generously present in Rome. Now, with the treasures of Pompeii becoming known, it is increasingly painting, color, and vivid illusion that form the image of Antiquity.

The crucial decade between 1750 and 1760 saw still another major

departure in the annals of theoretical reflection on the arts. In 1759 Denis Diderot began to publish his critical reviews of the Salons, the biennial exhibitions of contemporary French painting. Art criticism was not invented by Diderot—he had forerunners; but it was only with him that this branch of art literature became institutionalized, and attained the significance we now assign to it. As one follows Diderot's successive reviews one can actually observe how art criticism emerges and takes shape. The movement was rapid, and the leaps were wide. The review of 1759 is still modest in size and conservative in taste; the critic here follows the publisher Grimm and his personal attitudes quite closely. The exhibition of 1761 is reviewed at greater length, with an analysis of details and considerable background to the discussion of the individual paintings. Diderot at this point hesitates much less in pronouncing his personal judgment. With the next review (discussing the exhibition of 1763), it has been said, began the great period of Diderot's art criticism. Now he was on familiar terms with the artists; he had visited them in their ateliers. Perhaps the most striking sign that art criticism had come of age was that Diderot spoke not only of the paintings and the artists who produced them, but also reflected on the virtues and limitations of criticism itself. With the review of 1765 the transformation of art criticism into art theory is completed: in addition to the criticism of that year's exhibits, and intimately interwoven with his critical judgments, Diderot presented his "Essay on Painting," a theoretical consideration of the basic elements of that art. As the history of art had come of age with Winckelmann's *History of Ancient Art* of 1764, so did art criticism with Diderot's review of the Salons of 1763 and 1765.

What was achieved in the roughly fifteen years between Baumgarten's *Aesthetica* and Winckelmann's *History of Ancient Art* or Diderot's "Essay on Painting" was not only the establishment of aesthetics, the history of art, and art criticism as important disciplines for which the future held great developments in store. More than this, one may safely say, the whole approach to the visual arts was altered, its very foundations radically transformed. No wonder, then, that there was a change in the scope and character of theoretical art literature, both with regard to the audience addressed and the aims the authors set out to achieve.

It is only logical also that a shift took place in the actual themes discussed in art theory. These transformations were so radical and comprehensive that one can well understand historians who, notwithstanding their natural hesitation, chose 1750 as the date symbolically marking the beginning of a new age.

Yet it is equally clear, I hope, that this momentous transformation that burst into the open within the narrow confines of a decade and a half, could not have taken place had it not been evolving—hidden from sight, as it were—over a longer period of time. What, one feels compelled to ask, brought this change about? What made it possible? How are we to understand that some formulations, suggesting rather than fully expressing ideas that were revolutionary for their time, had such a profound and instantaneous impact? Not much effort need be expended to convince the student that an analysis of the generation or two preceding the crucial dates I have just listed may yield interesting results. It is our present task to undertake such an analysis. We shall try to discuss (as far as possible within the limits of a single chapter) pertinent developments in the first half of the eighteenth century. It is of course not our intention to provide an exhaustive picture of intellectual life in this half-century, even if limited to reflection on the arts. Whatever we shall talk about, we shall do so with one question in mind: what prepared the revolution of the mid-century?

In the course of the chapter we shall look at three groups of authors who approached the problem of the visual arts from quite different points of departure. Though one cannot hermetically isolate one group from the other (an individual author may well belong to two groups at the same time, or at different periods of his life), one can safely claim that these groups differed in both background and aims. Yet one will see, I hope, that in spite of their disparateness they have some constituent elements or orientations in common, and thus fit into an overall picture both of the age as a whole and of the specific problems (and formulations) of reflection on the visual arts.

The first group to be considered are the philosophers. In the early eighteenth century the term "philosopher" is not as clear—or so at least it seems to the modern student—as it was in the age of Plato and Aristotle, or even in that of Descartes. Not only are there no towering

figures in the thought of the first half of the eighteenth century; the very scope and nature of a philosopher's subject matter is obscured. Frequently therefore we shall have to ask whether a certain figure is a philosopher or whether he should rather be classified with the critics, the historians, or some other group. In the present chapter, then, the term "philosopher" should be taken with even more caution than is usually necessary. In speaking of philosophers I have in mind those thinkers who dealt mainly with general problems and whose contribution to the study of the arts is usually detached from the consideration of specific works of art or particular techniques.

Another type, altogether different from the philosophers both in the kind of material they studied and in the frame of mind they brought to that study, are the antiquarians. In the first half of the eighteenth century they attained notoriety, and became an important and characteristic feature of the intellectual life of the time. Usually avoiding high abstraction, and often afraid of any kind of generalization, they did not contribute directly to the study and interpretation of art as such or to the theories about it. Yet their variegated activity and ample legacy had an important, if often roundabout, effect on the various attempts to reflect theoretically on what the painter and sculptor do. A careful study of *how* the antiquarians looked at their objects, and of what they tried to find in them, can help us better understand how that seemingly sudden revolution that burst forth in the middle of the century was being prepared for behind the scenes.

The artists themselves are the last, though obviously not the least important, group whose testimony is to be considered in this chapter. There is no dearth of sources. Some of the painters who lived in the first half of the eighteenth century actually spoke at great length about their art. But the analysis of their literary legacy poses, as we shall see, particularly difficult problems of interpretation. If one accepts the readings here suggested, then artists' testimony may be found to shed a particularly interesting light on what was going on—perhaps hidden from most of the authors themselves—in that transitory period, the first half of the eighteenth century, preparing the coming of a new age.

II. THE PHILOSOPHERS

1. VICO

To begin an attempt at drawing a map of eighteenth-century theories of painting and sculpture with a discussion of Giambattista Vico may call for a word of explanation. At first blush, not much seems to recommend the evoking of Vico's spirit in this particular context. He did not have an appreciable influence in his own period; he was "discovered" only in the nineteenth century. Most important, he was not concerned with art; his work is perhaps best described as a philosophy of culture; he has also been called "the father of sociology." Though he devoted great attention to what he calls "poetics," he did not cover the whole range of the arts, and what he has to say about the visual arts is next to nothing. Why then does a student of modern art theory feel impelled to invite his readers to immerse themselves in the teachings of this strange author, who seems to be marginal to our domain? In the following pages it will emerge, I hope, that Vico articulated the basis of one of the great trends in modern thought on art, including thought on the figurative arts of painting and sculpture. Some of the encompassing problems that have remained central issues in the theory of art were first projected by Vico onto the horizon of European reflection. If Vico, then, is not a productive "source" for the understanding of what his own generation believed and said, he allows us to glance into what was hidden in the depths of eighteenth-century thought.

The obscure conditions of Vico's life have provided an attractive theme for modern historians. Born in Naples in 1668, the son of a modest bookseller, he spent most of his life in his native city, and died there in 1744. He held an inferior professorship in "rhetoric," complementing his modest salary with all kinds of occasional jobs, among them the composition of other people's inaugural lectures (some of which contain his most original ideas). A cripple all his life as a result of a fall in childhood, he lived in ill-fated family conditions and embittered poverty, his genius not recognized for several generations. This biography, some scholars suggest,[1] is romantically exaggerated. We know that

Montesquieu bought a copy of Vico's book and that Goethe, during his trip to Italy in 1787, spoke of him with great admiration.[2] But though his *vita* obviously needs correction in some respects, it remains essentially accurate. A philosopher out of place and born before his time—this rather stereotyped traditional verdict has more than a kernel of truth. Vico published several studies, but his central work, the *Scienza nuova,* exerted a magic spell on his life. After it was printed in a first edition (1725), he practically rewrote it for the second one (1730); he kept on adding to it, and when it was reprinted in the year of his death, it was again considerably enlarged and changed. Yet in spite of this continual struggle to shape his work, Vico's style remained baroque, undisciplined, and often obscure. The eighteenth century, which so much admired clarity, punished him for his faults by forgetting him. Eventually, however, the abundance and originality of his ideas prevailed.

We are of course not concerned with Vico's system as a whole, and shall look only at what may be of significance—even if not directly—for an understanding of modern theories of art. Among the great themes of Vico's thought is a version of what we would today call aesthetics. Benedetto Croce, the Italian philosopher who did so much to revive Vico, believes that aesthetics should actually be considered a discovery of Vico,[3] though, as one knows, Alexander Gottlieb Baumgarten coined the term only ten years after the first edition of the *Scienza nuova* was published. But Vico's approach to the aesthetic domain is not the usual one, and it never became the accepted academic pattern. He conceived of aesthetics, which he called "poetics," as being concerned with a basic human activity, seeking not to give pleasure or embellish truths but to articulate a vision of the world.

Vico's main approach to "poetics" is the analysis of language. In language, he believed, we make a basic distinction between two modes, the literal and the metaphorical. To be literal is to call things by their appropriate names and to describe them in plain, simple terms; to use metaphor is a poetical way of creating vivid, imaginative effects.[4] The significance for our subject of what Vico has to say about this distinction derives from the fact that metaphor, a descriptive mode of expression,

has a natural affinity to images. The discussion of metaphors is, by implication, a discussion of the nature and validity of images.

The origin of metaphor is one of Vico's important themes. Metaphor and simile, even allegory, are not deliberate artifices, calculated, thought-out forms. They are natural ways of expressing a vision of life and reality. Vico sharply rejects the views of those "philologians" who conceive of language as a product of convention. "On the contrary," he says, because the meanings of words have a natural origin, "they must have had natural significations" (444).[5] Language has many features and tropes, but "the most luminous and therefore the most necessary and frequent is metaphor" (402). It is by metaphor that we try to animate nature and give "sense and passion to insensate things" (404). "It is noteworthy," he continues, "that in all languages the greater part of the expressions relating to inanimate things are formed by metaphor from the human body and its parts and from human senses and passions" (405). In metaphor then (and, by implication, in imagery) we come to terms with the world surrounding us, and make it part of ourselves.

To grasp the full revolutionary significance of these views one has to see them against their proper historical background. The late seventeenth century was a time in which the very use of metaphor was widely suspect, its theoretical justification hardly imaginable. Metaphor was considered directly opposed to any scientific frame of mind. Professor M. H. Abrams, in his well-known work *The Mirror and the Lamp,* has adduced an impressive amount of material to show how in the seventeenth century metaphor came to be connected with "the false world of ancient superstitions, dreams, myths, terrors with which the lurid, barbarous imaginations peopled the world, causing error and irrationalism and persecution.[6] As against metaphor, the arbitrary linguistic sign was held up as an ideal of clarity, while to assure the status of the arbitrarily chosen linguistic sign it was essential to deny any innate layers of speech in man. There is no innate language, many of the progressive thinkers claimed. Nature created man without any language, so George Sibscota, one of the earliest students of the speech of the dumb and deaf, maintained, and nature's purpose in doing so was "that he may learn them all . . ."[7] In this context, Isaiah Berlin quotes Thomas

Sprat, one of the founders of the Royal Society, to the effect that the Royal Society "should avoid 'mists and uncertainties,' and return to 'a close, naked, natural way of speaking . . . as near the Mathematical Plainness as they can.' " [8]

Vico was obviously aware of this attitude (though not necessarily of the individuals who articulated it), as we can see from his polemical remarks against the "philologians" who defended the arbitrariness of the linguistic sign (444) Vico, by contrast, believed that metaphor is a fundamental category of viewing the world. How fundamental and irrevocable metaphor is can be seen from the fact that it is man's innate language, or at least essential for man's early stage of development. Men once thought in images rather than in concepts, and "attributed senses and passions to bodies as vast as sky, sea and earth" (402). Thinking in images is what Vico calls "poetic logic." This was the pattern of imaging, speaking, and thought in the Age of Heroes. The early stage of mankind is similar to the early stage of individual man. The most sublime labor of poetry is to give sense and passion to insensate things; and it is characteristic of children to take inanimate things in their hands and talk to them in plays as if they were living persons. This philologico-philosophical axiom proves to us that in the "world's child-hood men were by nature sublime poets" (186–187).

In Vico's view, a discussion of the metaphor's origin and its nature cannot be kept apart. Metaphors, and therefore also images, are docu-ments of the early history of man; they must not be read as skillfully contrived expressions of ideas essentially in contrast with, or alien to, the structure of the expressive media. This may be the case with arbitrary signs. In metaphor and image, so Vico keeps stressing, there is no intrinsic tension between the content that is being conveyed and the shape in which it is expressed, between the idea and the form. The image is not the passive reflection of an alien form imposed by the senses; the passive moment of "pure sensation"—which is the presup-position of a dualistic conception of the image—is wholly lacking in the life of the human spirit, as Vico conceives it. The image is rather the imposition by the mind or spirit of its own form. The image is therefore an image not of an alien object, of an external world, but of the spirit itself. Primitive men "gave the things they wondered at

substantial being after their own ideas" (375). The first men "created things according to their own ideas," and they did so "by virtue of a wholly corporeal imagination" (376). In all these passages the notion of "image" is not sufficiently distinct: while it always means the image we see in our mind, it often may also mean the image carved in some kind of material substance. How close, indeed, Vico's concept of "image" is to a work of art we can see in what he says about the origin of idolatry. In the course of discussing "poetics" he says, basing himself on a passage of the Church Father Lactance,[9] that the first men "invented the gods" (382). Invention, which is practically synonymous with imaging, with "poetic" creation, is thus valid both for what the mind sees and for the material object that can be adored.

Vico takes myths and fables seriously. They are the creations of early human consciousness, and even if they are now dead and fossilized, they are for us the richest source of knowing and understanding the collective imagination of mankind. "Fables are true histories of customs" (7), and hence "mythology is the first science to be learnt" (51). Vico is aware of the difficulties of such a study. It may be "beyond our power to enter into the vast imagination of these first men, whose minds were not in the least abstract, refined, or spiritualized, because they were entirely immersed in the senses, buffeted by the passions, buried in the body" (378).

Nothing tells us so much about man as his imagery of the gods. Vico is of course concerned with the motives that caused people to create their gods. These motives, he believes, are mainly "terror and fear" (382). For our purpose, however, the motives are less important than the ways in which the gods were created. What was the process by which men imagined and shaped the gods? A great deal of the *Scienza nuova* is devoted to unriddling and describing this process. "This is the way in which the theological poets apprehended Jove, Cybele or Berecynthia . . . at first mutely pointing, [they] explained them as substances of the sky, the earth and the sea, which they imagined to be animate divinities and were therefore true to their senses in believing them to be gods." But can we give to these beings a specific form? The casting of the gods in a concrete shape Vico sees as a process of personification, a process achieved primarily by means of the imagination. This process

is actually the painter's domain. "For when we wish to give utterance to our understanding of spiritual things," we read in the *Scienza nuova,* "we must seek aid from our imagination to explain them and, like painters, form human images of them" (402).

It is characteristic of primitive men as well as of children to grasp the abstract by projecting it in a concrete form. Or, as Vico explains it, "the first men, the children, as it were, of the human race, not being able to form intelligible class concepts of things, had a natural need to create poetic characters; that is, imaginative class concepts or universals, to which, as to certain models or ideal portraits, to reduce all the particular species which resembled them" (209). He complains of those scholars who consider the origin of letters as a separate question from that of the origin of language, "whereas the two were by nature conjoined." All nations, Vico believes, "began to speak by writing," that is, to use modern parlance, by forming concrete, visually perceptible shapes. " 'Character' . . . means idea, form, model; and certainly poetic characters came before those of articulate sounds" (429). The intuitive visual configuration precedes the conventionally contrived alphabet.

Considering his views on the nature and origin of letters, it seems natural that Vico should devote serious attention to hieroglyphs. In the *Scienza nuova,* hieroglyphs are frequently mentioned, and this should not surprise a student of early eighteenth-century culture. It was precisely in the early eighteenth century that a significant split in the traditional interpretation of hieroglyphs was becoming manifest. On the one hand, the traditional Neoplatonic explanation of Egyptian sacred writing was further elaborated (especially by the followers of the great seventeenth-century scholar Athanasius Kircher), but, on the other, these inherited, almost sacrosanct readings were being violently attacked by the forerunners of modern scientific Egyptology. Renaissance humanism, as we know, regarded hieroglyphs as a type of secret writing, employed by the sages of a mythical past. By using this secret script the illuminati ensured that the divine knowledge would be transmitted to the chosen few who, in future ages, would be worthy, and able, to decipher the signs, and at the same time they safeguarded the message against profanation by the undeserving.[10] By Vico's time this view was beginning to be undermined. I shall here only mention Bernard de Montfau-

con who, in the fifteen volumes of his *L'Antiquité expliquée* (1719–1724), not only included an enormous amount of material but also broke with the Neoplatonic scholars of the Renaissance in his refusal to admire Egyptian wisdom. Egyptian religion he regarded as monstrous, and Egyptian art as horrible.[11] He refused to try to interpret hieroglyphs and even maintained that they could not be interpreted with any accuracy. Montfaucon gave voice to a new spirit, a spirit that would be identified with eighteenth-century rationalism. In the attitude he represents, archaeological erudition went hand in hand with sober criticism and emotional disenchantment.

Vico seems practically untouched by the new critical spirit. He was aware of the new approach to hieroglyphs, and in his first, juvenile essay, *De antiquissima Italorum sapientia* (1710), he referred at least once to Montfaucon, though he did not assimilate Montfaucon's exact scholarship.[12] Yet intellectually he is much closer to the traditional type; his affinity to such thinkers and scholars as Ficino, Pierio Valeriano, and Kircher is manifest. But his view of the nature and function of hieroglyphs dramatically contradicts what Renaissance humanists believed and held as undoubted truth. He vigorously attacked their central idea about sacred and secret writing by denying that hieroglyphs were the formulation of esoteric knowledge and wisdom. "The matchless wisdom of the ancients, so ardently sought after from Plato to Bacon's *De sapientia veterum*" was no esoteric wisdom at all. "Whence it will be found . . . that all the mystic meanings of lofty philosophy attributed by the learned to the Greek fables and the Egyptian hieroglyphs are as impertinent as the historical meanings they both must have had are natural" (384).

Students blindly following the principles and assumptions of rationalistic interpretation (and only such can Vico have meant when, in this context, he spoke of "scholars") themselves create the difficulty they encounter in their search for the origin of letters. Their fault is analysis; they separate spoken language from writing. By so doing, Vico is convinced, they show that they understand neither the nature of man nor the character of his early history. "Thus, in their hopeless ignorance of the way in which languages and letters began, scholars have failed to understand how the first nations thought in poetic characters, spoke in

fables, and wrote in hieroglyphs" (429). The writing in hieroglyphs is not the result of long deliberation aimed at preventing secret wisdom from reaching the unworthy; it is rather a form of direct expression, intuitively grasped by men who are able to contemplate ideas. So natural is the contemplation of ideas that the language "hieroglyphic, sacred or divine" was the first language of the Egyptians, the one dominating the first age in history. Only after that came the language that Vico calls "symbolic," that is, the expression whose shape does not fuse with the contents. Symbolic language is secondary, derived, whereas hieroglyphic is primordial. It is endowed with universal validity, and we find it also outside Egypt. "The divine fables of the Greeks and Latins must have been the true first hieroglyphs, or sacred or divine characters, corresponding to those of the Egyptians" (437).

If we disentangle what Vico says about hieroglyphs from the language and modes of expression of his time, and translate it into modern parlance, some conclusions would seem to impose themselves. First, the hieroglyph is conceived as a concrete shape (or physical object) that makes an idea manifest. Our mode of experiencing the hieroglyph is probably best described as direct contemplation of ideas; in other words, it is a sensuous experience of an abstract universal. That experience is not aided by any contrived symbolism. The ability to contemplate ideas, Vico was convinced, is innate in man. Both the creation and the reading of the hieroglyph occurs naturally. But what is such an object, the modern reader wonders, other than a work of art? What is the mode of experiencing the hieroglyph, as described by Vico, but a kind of aesthetic experience in front of a work of art? In fact, in Vico's doctrine the hieroglyph, though not fully identical with a picture or a statue, comes very close to being a work of art.

A second conclusion reaches still further. Vico conceived of visual experience (such as the contemplation of ideas as a physical act) and creative activity in the fields of visually perceptible forms (such as hieroglyphs) as the ways of perception and expression typical of mankind's earliest stage. (The awareness of this intrinsic relationship is reinforced by the claim that images are the natural means of expression employed by children.) Now, visual experience and visual shapes would also seem to include the visual arts. By firmly situating the visual arts in

that first stage of mankind (and man), Vico anticipates an important trend in philosophical aesthetics that came to the fore two generations later, around the turn of the century. Philosophers of the Romantic period who continued in the same vein (though not necessarily basing themselves upon, or even acquainted with, Vico's writings) made painting and sculpture the primeval arts. In their attempts to combine the arts into a comprehensive, structured system, they made the visual arts the most typical representatives of the earliest stages of mankind, and considered them also the most primitive—because the most bodily and material—of the arts.

Vico's significance for modern thought on the arts has still another focus. Here too he only anticipated, in broad general lines, what was brought into the open by later generations, but he seems to have foreshadowed certain central ideas. He was implicitly concerned not only with the artist's creative activity, but also with the problem of the spectator who experiences a work of art. Once more I should emphasize that he does not speak explicitly of experiencing a painting or a piece of sculpture. What he has in mind is how we understand the whole world that humans have shaped, yet obviously this also includes the understanding of works of art. A great part of the modern attempt to analyze and explain our experiencing of works of art seems to be predicted in the thought of this strange Neapolitan professor of rhetoric in the early eighteenth century.

Vico, is has recently been said,[13] "virtually invented the concept of understanding—of what Dilthey and others call 'Verstehen.' Others before him, philologists or historians or jurists, may have had inklings of it; Vico brings it to light." The concept of understanding the manmade world has many aspects altogether beyond the scope of the present study (as, for instance, the difference between understanding objects made by nature and those made by man); here I shall only briefly note such features as may bear on the understanding of art.

Vico's theory of understanding is derived from his concept of primeval creation. Early gentile people, we know, "were poets who spoke in poetic characters." Vico himself declared this insight to be "the master key to this Science," that is, the *Scienza nuova* (34). Now, it is these "poetic characters" that we discover and interpret when we read

poetry or experience any other art form. We do so by virtue of a vivid capacity for imaginative reconstruction, for conceiving the *modificazioni* of the human mind, a capacity that is innate in us. We understand what human imagination has shaped in the past by activating our own imagination, which is as human as was that of the creators. We are sentient beings, and we therefore have this basic understanding of creatures who were similar to ourselves, and of what they produced. Creative imagination plays a dominant role in human consciousness; it is active both in the creator of a work of art and in the spectator, reader, or listener who experiences and understands it. Obviously this is also valid in grasping modes of feeling and expressing them.

Though little is here said explicitly about the arts, it is obvious that Vico anticipated certain central features of the theories that attempt to explain aesthetic experience as a process of empathy, of making the spectator identify with what he perceives.

2. DUBOS: THE SUBLIMATION OF THE PASSIONS

The vast and complicated landscape that aesthetic thought of the early eighteenth century offers to the modern student is extremely varied in feature. Some of the figures (such as Vico and Shaftesbury) are rather unusual, hard to fit into a general pattern, whether of a period or a traditional school. But if one wishes to get a panoramic view of what the philosophers of the time thought about our arts, it will not do to concentrate our attention on such individual thinkers. They were out-standing, but—at least, to some degree—they were also isolated. Ahead of their time, they may reveal to the historian (who has the advantage of hindsight) what their period held in store for the future, but their impact was experienced only later: Shaftesbury's influence is largely felt only in the latter half of the eighteenth century, partly through its stimulation of German philosophy; Vico's impact becomes discernible only in the nineteenth and even the twentieth centuries. When we ask what was the aesthetic thought dominating the first half of the eighteenth century, how that age saw itself, we have to turn to different authors. They may make for less fascinating (though sometimes easier) reading than the isolated geniuses, but they reflect more clearly

what was thought at the time itself. Authors who express a commonly held opinion, it may be worth adding, are not necessarily devoid of originality; in fact, I shall try to show that what they say can be new and of great import. It is only that their originality is less that of an individual than that of a society or culture as a whole. For reflection on painting in the early eighteenth century, the Abbé Dubos will be a good witness.

Is it permissible to count Dubos among the philosophers? The answer is far from obvious. Measured by the yardstick of Descartes or Spinoza, Dubos cannot be considered a philosopher at all. He did not try his hand at any of the philosopher's traditional tasks: he did not deal with metaphysics, the theory of knowledge, or ethics. When he senses a philosophical difficulty, it has recently been said,[14] he is inclined to shrug, or to change the subject. And yet he has been called, not altogether without justification, "an initiator of modern thought." Jean-Baptiste Dubos (1670–1742), a priest (though he became Abbé only late in life), was also a diplomatic envoy, a scholar, a writer, and a man of letters. A prolific author, he published extensive studies in many fields of scholarly endeavor. He was a literary critic, a theoretician of politics and the state, and a historian of the emergence of the French monarchy. He himself may well have seen his historical researches as the most important part of his work. We should add here that, whatever else he was, Dubos had no concrete experience whatsoever of art; he moved among many people, but these were mainly scholars; his connections with artists seem to have been nonexistent.

In the midst of his hectic diplomatic activity Dubos found time to write a long work on aesthetics and art theory, the *Réflexions critiques sur la poésie et la peinture,* appearing anonymously (as the custom was) in 1719. This book must be one of the largest works on the subject published in the entire eighteenth century. The two volumes of the original edition hold some 1,200 pages. Dubos's *Réflexions critiques* is certainly one of the most prominent productions in the history of eighteenth-century art theory. Its impact may be guessed by reviewing the many editions of the work as well as by recalling its more distinguished readers. During the author's lifetime the work was reprinted twice, and before the end of the eighteenth century it had been

reprinted not less than sixteen times—no mean achievement even for much later periods. Among the readers of the *Réflexions critiques* was Voltaire, who considered it "the most useful book ever written on this matter in any nation." In England the book was discussed by Edmund Burke, the statesman and author, and by David Hume, the philosopher. In Germany a large part of the work (the last third) was translated into German by none other than Gotthold Ephraim Lessing, who also referred to it in both his *Hamburgische Dramaturgie* and his *Laocoön*.[15] Clearly we are entitled to see in Dubos' *Réflexions critiques* an important representative of a central trend in early eighteenth-century thought on the arts.

A careful reader of the *Réflexions critiques* cannot escape sensing a strong contradiction pervading the work. On the one hand, Dubos's style of thought and manner of presentation are altogether traditional. There are the references to Pliny and Quintilian (sometimes without quoting the names), unavoidable in art literature for many centuries before our author wrote his book; there are the equally unavoidable references to the authority of Plato, Aristotle, and other ancient authors (particularly Plutarch); and there are, of course, the inevitable comparisons of literature and painting that form part of the great Horatian tradition in European letters. For Dubos these features are more than just a matter of external form; they indicate his sources as well as his commitment to the humanistic tradition that had dominated European thought since the Renaissance. These features also show the modern historian what in fact was Dubos's frame of reference in matters of aesthetic concepts and doctrines. When one gets behind this curtain, however, one encounters themes, opinions, and ideas that do not belong to the humanistic tradition, and sometimes clash with its fundamental beliefs and its spirit. Dubos himself may well have felt this contradiction. Several times he seems to make the attempt to harmonize the component parts of his doctrine. That he does not succeed can hardly surprise the historian; the conflict of various elements in his theory may be seen as a hallmark of an author who is the spokesman of a transitional period. Dubos was such a one.

In attempting to discuss these conflicts we should remember, first, that in the *Réflexions critiques* Dubos does not deal with comprehensive

ideas of aesthetics; on the contrary, he is altogether committed to the analysis of two individual, specific arts, poetry and painting. As we shall presently see, he is not primarily concerned with what the two arts have in common (that is, with the major theme of the Horatian *ut pictura poesis*) but rather with what makes each of them different from the other and thus unique. No wonder, then, that he devotes a great deal of attention to what we would now call the "medium" of each art, to its particular structures and effects, and had in fact more to say about this subject than most of his predecessors. In concentrating on the particular arts—rather than on the general aesthetics that was in the air—Dubos followed the traditional type of art theory. In spite of all this, however, his point of departure differs from that of traditional art theory. It is not the performance of the artist's job that occupies his mind; the workshop experience, and the practical tasks emerging from it, are not part of his background. His basic theme is the audience. For our purpose, it is the spectator who looks at a painting. The question underlying Dubos's whole doctrine is how the spectator experiences the work of art.

The spectator—and in a broader sense, the audience in general—did not invade art theory all of a sudden. That artists were always aware, though in different ways and to varying degrees, of the spectator and reflected on him is a truism that need not be belabored here. At least since the teachers of ancient rhetoric had urged the orator always to have his audience in mind, the public was, implicitly or more overtly, present in the theories of the various arts. We have seen that in the Renaissance, with the full evolution of art literature, the spectator became a factor openly determining theories of painting. In the sixteenth century, "art theory," instead of being exclusively a theory for the artist with the aim of instructing him in his work, became a branch of literature that explained the work of art, and possibly also its production, to nonartists, to the general public.[16] But all this was undertaken from the artist's point of view. Even when the general public was addressed, the authors of art theoretical treatises always had the artist's task in mind. The question behind all their efforts can be stated as follows: what do I, the creative artist, do, what do I have to know, and what means must I employ to represent nature (or any other

subject) appropriately and to reach my audience and evoke its proper response?

In Dubos's work this is radically changed. The artist's needs have receded; they seem to have disappeared as the principal subject matter, or as the leading question, of art theory. What is now asked is: how and why does the spectator enjoy the work of art he is looking at (or the poem he is reading)? By placing the spectator at the center of his analysis Dubos is anticipating a large part of the modern discussion of what is now called "aesthetic experience" as an independent and important subject matter in philosophical thought. The spectator as the point of departure for all reflections determines the structure of Dubos's doctrine in the same way that the spectator dominates a great deal of modern thought on the arts.

Dubos actually begins his *Réflexions critiques* with an analysis of the spectator. In a brief introduction—a text that bears the clear imprint of a somewhat simplistic Enlightenment philosophy—he explains the function and significance of the arts as derived from a general concept of man's nature. Man, he claims, experiences pleasure only when he is satisfying a need. One human need is to keep our minds busy. Boredom, resulting from not occupying our minds, may lead to difficult and dangerous situations. "Boredom is so painful that a man will frequently undertake the most exhausting labors to spare himself this torment." The need, or desire, to keep our minds and souls occupied is the reason for our being so profoundly attracted by spectacles of all kinds, particularly by those evoking powerful emotions. "In all countries," says Dubos, "people will go to watch the most horrible spectacles," such as the condemned being led to the gallows. This leaning of human nature is also the reason why the Romans invented the fight between gladiators and turned it into a spectacle. Nor do such cruel "performances" belong to the past only. A bullfight may seem less perturbing or inflammatory than a fight between gladiators, but it is also dangerous; many a bullfighter has lost his life while combating the furious beast. And yet "Spaniards of all walks of life watch these dangerous displays."[17] In these words, Dubos echoes—possibly without being aware of it—the Church Fathers' strong rejection of the arena. It is enough to think of

Tertullian's passionate invective against the circus,[18] or of St. Augustine's fascinating description of a huge audience in the arena held in the grip of mass hysteria. But Dubos knows that the danger of being carried away by passions is universal. "The allure of the emotions makes the most good-hearted of nations forget the first principles of humanity."

It is here that art comes in. From the human condition just described, from that danger caused by emotions, Dubos derives the function of art. "Could not art," he asks, "find a way to forestall the evil consequences which most pleasant passions bear with them? Could it not produce objects which would arouse artificial passions capable of occupying us for the moment, but not involving any real suffering or emotion?" And he answers: "Poetry and painting have achieved this objective."[19] How does art achieve this end? I should like, first, to present Dubos' views on the subject, and, second, to make some brief observations on the historical significance of his views and on the meaning of some of the terms he employs.

To successfully forestall the evil consequences of the passions—this is the cornerstone of Dubos' psychology of the beholder—we would have to have "a means of separating the evil consequences of most of the passions from those [effects] that are agreeable." There *is* such a means, Dubos believes, and it is what he calls the "artificial passions." The lord and master of "artificial passions" is the artist. "The painter and poet excite in us these artificial passions by presenting to us imitations of the objects that are capable of exciting our real passions."[20]

So far Dubos seems to follow the traditional pattern. That we understand a work of art by empathy, and that the artist's task is to evoke our emotions, were ideas accepted since Alberti's *On Painting* of 1435. But in the whole tradition from the early Renaissance to the seventeenth century it was also accepted that the emotions the painting evoked were the very same that the object depicted would have evoked. This was the power and the danger inherent in images. Here Dubos introduces an important transformation. The "artificial passion" is not only artificially evoked (by a representation instead of by the figure or object itself), it is a weakened, paler passion, manageable precisely

because it lacks the vigor and power of the passion in its full strength. "Artificial passions" are passions of a different degree, and maybe of a different sort, than real ones.

Let us mention a single example, one that Dubos himself adduces. To show that "artificial passions" differ from real ones, our author describes a famous painting by Charles Lebrun, the president of the Academy of Art in Paris who played such an important part in formulating the academic ideology that art aimed at moving the beholder.[21] The painting is *The Massacre of the Innocents,* and Dubos, at the beginning of his *Réflexions critiques,* discusses its impact on the beholder. In that great canvas, we see terrible scenes, such as "the frantic soldiers cutting the throats of the children in the laps of their bleeding mothers." Yet Le Brun's painting, where we see the rendering of this tragic event, so Dubos continues, "disturbs us and moves us, but it leaves no troublesome idea in our soul: this painting excites our compassion without really afflicting us." A few lines later, Dubos uses this vivid metaphor: "The affliction is, as it were, only on the surface of our heart."[22]

We shall presently come back to the question of why the emotions evoked by a work of art are mild and weakened—harmless, if I may say so—, and shall now ask: what kind of emotion *does* the spectator feel when looking at a work of art? The answer would seem to be as clear as it is new: the emotion prevailing when we look at a work of art is simply pleasure. To put it crudely, Dubos comes close to describing art as entertainment. Let us listen to his somewhat elevated language: "The pleasure one feels in looking at the imitations that painters and poets know how to make of objects that are apt to evoke in us passions had they been presented to us in reality is a pure pleasure."[23]

One can hardly exaggerate the revolutionary nature of Dubos's notion. To appreciate how new his ideas were and how profoundly they upset an old and firmly established traditional view, one should keep in mind that throughout European history there were constantly recurring attempts to provide a comprehensive "justification" of the arts, and particularly a vindication of painting and sculpture. Such conceptual vindications naturally also determined views on the specific functions of the arts and on the kind of job the artist should perform. An exhaustive

presentation of these attempts would fill another volume. Here it will suffice to recall a truism, namely, that the great world views at different periods tried to justify art, and to determine its function, according to their own needs and beliefs. As an example, we may recall the attempts made in the Middle Ages to make art serve religious ends by leading the spectator's mind "upwards." Another fully articulate medieval attempt to justify the art of painting was, as we know, to consider images as a "script of the illiterate," that is, to make the didactic function the basis of art. To be sure, modern scholars, particularly Meyer Schapiro, have shown that in medieval testimonies we also encounter the expression of sheer joy experienced in looking at precious and beautiful artifacts. But even where such experiences are recorded, the explicit *aim* of art is not seen as one of giving pleasure.

In the Renaissance and Baroque periods, the urge to justify art by relating it to some central value it supposedly served (and which differed from art itself) was even intensified. In the fifteenth century, the belief prevailed that one of the main values art served was discovering the truth and understanding the world of nature; the work of art contains, or leads us to, a scientific cognition of the world. In the sixteenth century, particularly in the Counter-Reformation, painting was often justified on the ground that it provided a powerful stimulus to the emotions, and could thus be employed to intensify religious experiences and beliefs. Art could also be considered as containing the formulation of some ancient wisdom or as reflecting a primary layer in our nature. How strong this view was we can infer from Vico who, as we have seen, held and even further developed it. Even when in the seventeenth century Nicolas Poussin declared *delectation* to be the "aim" of painting, this term still carried, as we have tried to show, some metaphysical or even mystical connotation.[24]

What all the justifications listed—and the many others that might be mentioned—have in common is the belief that art is a means of achieving some noble, elevated aim, that it is often employed to come closer to some redemptive end. There is a heroic air about art that does not derive purely from the art itself. In most periods there would have been agreement that a picture, a statue, or some other kind of precious

artifact could also delight the spectator, but before the eighteenth century the pleasure derived from looking at such a work would have been considered only a by-product of a striving towards a nobler aim.

After having reviewed this awe-inspiring background of two millennia of continuing reflection associating art with the highest of values, one reads Dubos' definition of the aim of painting and poetry with disappointment. What the work of art gives us, he claims, is nothing but pleasure, or "pure pleasure," as he puts it. The dignity with which art was endowed by making it a road to great aims seems to be dwarfed here. If the secular is conceived as being of a lower status than the sacred, then Dubos may be said to introduce a secularization in our seeing of art.

It may be worthwhile here to pause for a moment, to direct our glance ahead instead of backwards, and to ask what "pure pleasure" may actually mean. Let me put it in the simplest and crudest way: of what has the pleasure we experience in looking at a beautiful picture been purified? Unfortunately we cannot learn much from Dubos's text. He speaks of "pure pleasure" only at the beginning of the *Réflexions critiques;* he never defines that notion, perhaps because he thought it self-evident. Keeping in mind how new the concept was, one can well understand that he had difficulties in defining it, or that he may even not have been aware of what it implied. But for us, aided by what the centuries have in the meantime made clear, it is possible to reconstruct its original meaning, perhaps even beyond what Dubos himself was aware of. Now, the only answer to the question that offers itself is that the "pleasure" we are speaking of has been purified of anything that transcends the experience of looking at the picture. In looking at the painting and enjoying it we are not concerned with the redemption of our soul, or with the cognition of the world, or with the intensification and orientation of our emotions. Our experience in front of the work of art is free from any aim or consideration outside the aesthetic experience itself. One cannot help feeling that we have here an early formulation of the idea that, eighty years later, Kant was to call "disinterested pleasure" *(interesseloses Wohlgefallen),* making it the cornerstone of any modern theory of aesthetic experience.

In addition to causing "pure pleasure," for Dubos painting and poetry fulfil yet another function. As we just saw, art removes the danger from emotions. How can art achieve this end? What is there in their very nature that makes it possible for painting and poetry to perform this task? The passions, we remember, are made harmless by draining the intensity out of them. Dubos does not doubt that in the process the nature of the particular emotion remains manifest; we know that it is pity or terror or joy that we are experiencing before the picture evoking these passions, but their intensity is so reduced that we are not in danger of being carried away by them. They are quasi-passions. In Dubos's psychology, the "artificial passion" is a quasi-passion, an "as if" passion.

Now, it is one of our author's most original ideas that he links the illusionary reality created by art with the unreal nature of the "artificial passion." The semipassions we experience when we are looking at a work of art or reading a poem have something in common with the semireality of artistic portrayal. The pictorial representation of a natural object is a "copy" of that object, and copies obey a law of their own: they are always less powerful than the object they are imitating. Dubos quotes Quintilian to the effect that "everything that is the resemblance of something else must necessarily be inferior to that of which it is a copy."[25] Dubos quoted only the first half of Quintilian's sentence. The other half reads: "as the shadow is to the substance, the portrait to the natural face, and the acting of the player to the real feeling." But although Dubos did not quote the latter half of the sentence, the idea expressed in it is incorporated in his thought. Art is a shadow of reality. "Even the most perfect imitation," Dubos explains at the beginning of the *Réflexions critiques,* "is nothing but an artificial being, it has but a borrowed life, while the power and activity of nature dwell in the object that is imitated."[26]

But as the "copy" of a real object made by the artist is a quasi-object, so the emotion evoked by it, that is, the "artificial passion," is a copy of the real passion, a quasi-passion. It is precisely as quasi-passions that the emotions are less dangerous than the actual passions, those encountered in real life. The particular nature of the artistic world—

that world of semi-reality—transmits itself to the passions, purges them of the dangerous drives normally inherent in them, and makes them manageable.

In speaking of "quasi-reality" or "illusionary reality," we should be careful not to confound what Dubos has in mind when he uses these terms with what they have now come to mean. The creation of an illusion has, of course, for centuries been considered the aim of painting, success in creating such an illusion being one of the highest forms of praise for a work of art. A perfect illusion, it has been said in various formulations, is achieved when the spectator is deceived into taking the artistic representation of reality for reality itself. So deeply rooted and long-lived was this view that literary *topoi* developed to illustrate it. In antiquity and since the early Renaissance, art literature has told and retold the stories of the sparrows picking at painted grapes, and of the ancient painter who lost a contest because he tried to pull a curtain that his competitor painted on the wall. Whether or not the art of the different periods supported this theory, one believed or at least paid lip service to the dogma that deceiving the senses, creating the perfect illusion, was the summit of the painter's art. The question that was asked, explicitly or implicitly, was how to achieve the mastery of means that would make it possible for the artist to delude the spectator's eye.

Here, too, Dubos turned away from established traditions. He did not go on asking, as had been done for centuries, how to achieve such deception; rather he made it questionable whether it was desirable to create a perfect illusion of reality in a work of art. He deals directly with the problem quite briefly, devoting only a single, rather short chapter to it. However, it is not difficult to infer from his general system that he would consider a perfect illusion undesirable. He knows the critical tradition, and he rejects it. Intelligent people have believed, he tells his readers, "that illusion is the first cause of the pleasure that spectacles and paintings give us."[27] This opinion he altogether rejects. The function of art, as we remember, is the purgation of the emotions, and this end is achieved by presenting images (or spectacles) that are clearly recognizable, yet devoid of full immediacy. Were the picture so to deceive the spectator that he mistook the artist's representation for the figure or subject represented, he would react as if to the real scene.

26

What would then be the value of art? The achieving of total illusion would negate everything art stands for.

Interestingly enough, Dubos discusses illusion not in the context of the two arts to which his book is dedicated, poetry and painting, but rather in conjunction with the theater. Here he suggests a crucial distinction, that between being moved by what we watch and being misled by an illusion into believing we are witnessing reality itself. The distinction is not explicitly stated, but it emerges with sufficient clarity from the context. "It is true that all we see in the theater converges towards us," Dubos says, "but nothing produces an illusion to our mind, because everything reveals itself as an imitation."[28] We are moved by what we are watching on stage, but we do not believe that we are watching a tragedy in real life. We look around in the theater, we know that what we are seeing is only a play, and yet we continue to derive pleasure from the experience.

What is true for the theater is also valid for painting. Dubos reminds his readers of Raphael's famous fresco in the Stanza d'Eliodoro, the *Expulsion of Attila:*

The picture of Attila painted by Raphael does not derive its merits from its imposing itself upon us in order to seduce us, and make us believe that we truly see St. Peter and St. Paul hovering in the air, and, sword in hand, threatening that barbarian king who is surrounded by troops urging him to sack Rome. But in the painting of which I speak Attila ingenuously represents a frightened Scyth; Pope Leo who explains the vision to him displays a noble confidence, and a demeanor appropriate to his dignity; all the participants (the other figures) look like people whom we would meet under the circumstances Raphael assigned to the different figures, even the horses contribute to the principal action. The imitation is so likely that, to a large extent, it makes the impression the actual event would have made on them.[29]

That the spectator's senses are not deluded does not mean that the picture lacks expression. We know quite well that what we are looking at is only a picture, an artistic rendering, yet the emotions expressed in the figures affect us, we are moved by them. The expressive effect of a work of art, then, does not depend on the rather primitive belief that we are witnessing the actual event.

The rejection of the *trompe l'oeil* should by no means be taken to

imply a disregard for the specific nature of each individual art. On the contrary, in the *Réflexions critiques* Dubos is not concerned with general notions of aesthetics, nor does "art" in general attract his thought; he is concerned with the specific, unique character and conditions of painting and poetry, and he shows a real ability to discriminate what is and is not possible in one or the other of these arts. Dubos's presentation and his thought are far from consistent; in the analysis of each art there are many digressions and even contradictions. Yet the major lines of his reasoning emerge quite clearly. In the following brief survey, I shall disregard the inconsistencies in an attempt to present Dubos' views as simply as possible.

Dubos constantly compares painting and poetry; even where he discusses each art separately, he does so in comparative terms. As I have already suggested earlier in this section, his leaning is to separate one art from the other, to actively oppose them, and thus to bring out what is unique and unparalleled in each rather than what they have in common.

The difference between poetry and painting is not merely a technical one, based on material. The two arts are rooted in two different dimensions of human experience: the art of poetry (and literature in general) materializes in a temporal sequence, painting (and the visual arts in general) in a timeless presence. Considering these basic data, one understands the limitations of each art as well as the power residing in each separately. The painter and the poet should be aware of these limitations, and they should choose their subjects according to what they can achieve within limits they cannot change.

That painting depicts only a single moment, one stage of an action that is detached from what has gone before and from what will come afterwards, whereas poetry describes a succession of events taking place in time—this, of course, is not a new idea. Even if one considers only Dubos's immediate predecessors in the theory of the visual arts, like testimonies abound. André Félibien, in his *Entretiens sur la vie et sur les ouvrages des plus excellents peintres* (1685), expressed this idea, and, a few years after the publication of Dubos's work, it attained a classic formulation in Lessing's *Laocoön* (1766).[30] Dubos's formulation, even though not fully consistent, is clear enough. "As the painting that represents an

action does not show more than an instance of its (the action's) duration"—so he begins the discussion of whether the painter is able to appropriately portray the sublime. It is in the nature of the sublime, we understand from what Dubos says, that events that happened in the past may shed important light on the present, that they may endow regular objects, figures, or situations with a particular significance and make them into what they now are. This complex but essential relationship between the past and the present the painter is unable to make visible. He can only show what is present, not what was in the past. Poetry, on the other hand, describes all the stages and events that are significant for the action or theme the poet relates. Poussin, in the *Death of Germanicus,* could represent the different kinds of suffering and affliction that beset the relatives and friends of the dying hero, but he was unable to show the hero's last feelings, the thoughts that crossed his dying mind.[31] A poet can do precisely this, and what he does will affect the spectator. A tragedy, Dubos says, includes fifty pictures. The playwright presents us, successively as it were, with fifty pictures, and they lead us, step by step, to that extreme emotion that makes us shed tears.[32]

Dubos mentions still another limitation of painting, one that scholars do not seem to have noticed. To put it in modern parlance: the amount of new information the painter is able to supply to the spectator is limited. To be intelligible, the painter must employ figures his spectators already know; he has no means of providing them with fresh information, of telling them what is so far unknown to them. In Poussin's *Death of Germanicus,* a female figure, placed next to the dying hero, covers her face with her hands, an expression of grief that surpasses the sorrow expressed by all the other figures. "Those who know," Dubos draws the conclusion from what he has said before, "that Germanicus had a wife uniquely attached to him, and who received his last breath, as surely recognize her as Agrippina as the antiquarians identify her by her hairdo." But what about those spectators who do not know the story? Will they be able to read the picture appropriately? Even if Dubos did not mention those spectators who are ignorant of the stories and meanings the artist suggests in his work, the modern student cannot forget them. What emerges from Dubos's theory is that painting cannot

teach the spectator what he does not know already. "To move us, he (the painter) is confined to availing himself of figures we already know." Painters themselves have felt their inferiority to the poets in this respect. This is shown by their use of inscriptions in paintings. Whether they used inscribed banderols, as did the Gothic painters, or found other forms, as have certain artists, they had to rely on the written word, even in pictures.[33]

But painting has also its strengths. Even in the field of providing information, though generally inferior to the spoken or written word, the visual arts have some advantages over literature. The painter can provide a great deal of information at one and the same time, without being subject to the tedious succession by which the individual bits of information are transmitted in literature. "Nothing is easier to the intelligent painter," Dubos points out, "than to make us grasp the age, the temperament, the sex, the profession, and even the homeland of his figures, by using the dress, the color of flesh, of the beard and hair, their length and thickness as well as their natural movement, the habit of the body, of the face, the shape of the head, the physiognomy, the movements, the color of the eyes, and several other things that make the character of a figure recognizable."[34] All this the painter gives at once, in one cluster, as it were, while the poet must break up the data into individual pieces of information, not without "annoying detail," as Dubos has it. Music altogether lacks the ability to provide information.[35]

Another feature of painting is more important than its ability to provide information. Here one would wish Dubos to be more consistent, and more articulate on certain issues, but one cannot deny that what he has to say leads us, stumblingly perhaps, into the future. In comparing the two arts, Dubos emphasizes that painting is closer to nature than poetry is. "I believe that the power of painting over men is greater than that of poetry, and I support my feeling by two reasons. The first is that painting acts upon us by the sense of vision. The second is that painting does not employ artificial signs, as does poetry, but uses natural signs."[36] The concept of "sign" in the context of the arts has a definitely modern ring, even though it is doubtful whether what Dubos meant by this term exactly corresponds to its meaning in modern thought. What Dubos surely meant by it is that in poetry there is an

unbridgeable gap between the object described and the means employed to describe it. Whatever poetry relates or expresses — heroic deeds or tender love, profound melancholy or exuberant joy — the words by which the acts or sentiments are described are altogether alien to these contents. In relation to what it describes, we can say, the word is an "artificial" or an "arbitrary sign." [37]

Painting, on the other hand, does not address the beholder by artificial means or arbitrary signs. "The signs that painting employs in order to speak to us are not arbitrary or prescribed signs, as are the signs poetry employs. Painting employs natural signs." But Dubos quickly corrects himself. "I may express myself badly," he admits, "when I say that painting employs signs: it is Nature herself that Painting is placing before our eyes." This is the power of painting. "Painting has the advantage that it can place before our eyes the very incidents of the actions of which it treats." [38] Painting, then, does not employ signs at all. But what can this mean but that the gap between the reality represented and the means employed in representing it, the gap Dubos found so characteristic of poetry, is here eliminated? In other words, that in painting reality and representation in some exceptional way merge with one another?

The skeptical critic may ask how this assertion, so central to Dubos's characterization of the individual arts, accords with another statement, not less crucial for his doctrine of art in general, namely, that art should not be confounded with nature itself, that it achieves its end — to create "artificial passions" — precisely because there always remains a distance that cannot be bridged between raw nature and its artistic portrayal. But it is not our task to criticize or to find fault with Dubos's reasoning; we want to understand what he is saying and what attitude he is expressing. If that attitude contains contradictions, they are not less a part of his doctrine than those parts that seem to us consistent.

Perhaps because what we see is so much closer to reality than what we hear in a description (when it is transformed into the arbitrary signs of words), the sense of sight is more powerful than the sense of hearing. "One can say, metaphorically speaking, that the eye is closer to our soul than the ear." [39] It was not the story of Caesar's assassination that filled the people of Rome with terror and indignation, but "the sight of

the bloody robe that was displayed."[40] Dubos quotes Quintilian to testify to the power of the eye upon the soul. Images, that venerated teacher of rhetoric believed, when "so distinctly represented to the mind that we seem to see them with our eyes, and to have them before us," are powerful in the stirring of the emotions. Therefore, "whoever shall best conceive such images, will have the greatest power in moving the feelings."[41] But once more, the modern critic remembers that the emotions Quintilian has in mind are not "purified emotions," they are not "artificial passions," to use Dubos's terms; rather they are the real passions, not mitigated by an aesthetic distance. If an author of the sixteenth or seventeenth century had quoted these passages by Quintilian, he would not have doubted that the orator wished to stir the real passions. That Dubos should quote precisely these sentences shows yet again how the old and the new, the traditional and the revolutionary, coexist in his thought. Though he quotes the advice on how to stir real passion, what he ultimately aims at is the experience of aesthetic pleasure.

Dubos's historical position becomes even more manifest in yet another aspect, the characterization of the two arts and the analysis of their relationship. Let us for a moment leave our author and the early eighteenth century, and remember that in European thought there were two different yet articulate traditions of comparing the arts. One of these found its fullest expression in what is known as the *paragone* literature; the other became famous under the Horatian dictum *ut pictura poesis*. Both traditions originated in Antiquity, were revitalized in the Renaissance, and have remained a living force ever since. The debates known under the title of *paragone* developed largely in the workshops; it is characteristic of them that they compare all the arts, with the intention of defining what is unique in each and thus distinguishing it from all the others. If we are to judge by the best-known representative of the *paragone* literature in the Italian Renaissance, Leonardo da Vinci, the arts most frequently compared and juxtaposed to each other are painting and sculpture; music comes next, and poetry plays only a minor part. The Horatian tradition is to emphasize what the two arts have in common; the differences between them are often treated as if they were of only marginal significance. Painting, Plutarch's

saying is endlessly echoed, is mute poetry, poetry is loquacious painting. It is *one* art, realized in different media.[42]

For Dubos, a literary scholar raised in the tradition of classical learning, it was natural to adopt the Horatian model, and this is indeed the conceptual framework of his comparisons of the arts. His great work, the *Réflexions critiques sur la poésie et sur la peinture,* already betrays in its title the author's allegiance to the Horatian tradition: it singles out painting and poetry, the two arts that Horace compares. In the text itself Dubos keeps referring to the authorities of humanism: he quotes Cicero and Quintilian, and he refers to Pliny, Vergil, and Horace. The views he expresses, however, often plainly contradict the credo of the Horatian tradition. Dubos shows, as we have seen, that painting and poetry essentially differ from each other, that they are rooted in different dimensions of the human experience, and that their respective structures are subject to altogether different laws. Dubos's main emphasis is on what we would today call the awareness of the medium. It is worth our attention that this happens not in the workshop of the practicing artist, but in the writings of an educated literary man.

Perhaps nowhere do Dubos's new and revolutionary ideas manifest themselves more clearly than in his discussion of allegory in painting. At least since the Renaissance, allegory (in literal translation: saying something else) has occupied an important place in theoretical reflections on the arts. Not only were countless allegorical paintings and sculptures produced and displayed, but there emerged a considerable literature meant to assist the artist in the shaping of allegories, and the audience in correctly reading them.[43] Allegorical paintings and sculptures were most highly regarded, and allegory was considered a noble and learned art form. Seen against this background, it is highly remarkable that Dubos should have directly attacked allegory in painting. The chapter in the *Réflexions critiques* devoted to this subject is an important document of a changing mentality, and it deserves more careful attention than it has received so far.

An allegory, so Dubos defines the time-honored concept from his own point of view, is an action that has never taken place or a figure that has never existed.[44] The painter who produces an allegorical composition knows quite well that he is depicting something that is not

and has never been part of reality. Dubos discusses individual allegorical figures and whole allegorical scenes separately. Individual allegorical figures consist of two types: those invented a long time ago, and those the artist invents as he goes along in order to express his personal ideas. The first type—those figures that form part of the inherited culture, as we would say today—has "acquired citizenship, as it were, among human beings."[45] France represented as a woman, the crown firmly on her head, the scepter in her hand, her figure covered in a blue mantle with golden fleurs-de-lis, or the "Tiber" rendered as a recumbent, half propped-up male figure, with a she-wolf at his feet: these are allegorical figures everybody knows and easily recognizes in artistic imagery. Because they are known, the artist is permitted to place Harpocrates, the god of silence, or Minerva, the goddess of wisdom, next to the portrait of a prince, thus suggesting his circumspection and his prudence.

The other type of allegorical figure consists of images that are not inherited, and therefore are not common knowledge; the artist invents them as he works. How can the spectator grasp these personal symbols? Indeed, they remain unintelligible. They are, says Dubos, like "ciphers to which nobody has the key, not even those who search for it."[46]

Complete allegorical compositions are also of two kinds, those that are wholly invented, and historical scenes to which some allegorical parts are added. We shall comment briefly only on those that are wholly invented. "It is rare that painters succeed in purely allegorical compositions," Dubos assures his readers.[47] Why should this be so? The answer, according to our author, is simple. Purely allegorical scenes are obscure and opaque; the spectator, confused by unintelligible figures and attributes, cannot make out the meaning of what he sees. "In compositions of this kind it is almost impossible to make their subject matter distinctly recognizable, and to make their ideas available even to the most intelligent spectators." Being unintelligible, they will not move the beholder,[48] and will thus fail in what is the painter's central task and the justification of any work of art. The painting of allegories is a trap endangering the artist in his work. "I dare say," the learned abbé says, "that nothing more often prevents painters from achieving the true aim of their art ... than their desire to be applauded for the subtlety of their imagination, that is, of their mind." The subtlety of

imagination, as reflected in intricate allegories, is not the artist's true calling nor is it the true value of the work of art. It is the expression of emotions that remains the painter's end. "Instead of sticking to the imitation of the passions, they [the painters of allegories] surrender to the efforts of a capricious imagination, and to the forging of idle fancies, amongst which mysterious allegory is an enigma more obscure than ever were those of the Sphinx."[49] The painter's task, he says a little later, is not to exercise our imagination by confronting us with entangled subjects we are called upon to unravel; the artist's task is to move us. Therefore Dubos condemns the artists who, "instead of speaking to us in the language of passions, common to all men, speak in a language they have invented themselves."

Dubos was not alone in his age in rejecting allegory. Eighteenth-century thought was largely dominated by a lasting, sustained endeavor to properly understand, and to pass judgment on, allegory, its use and impact on different fields of creative activity. The modern student of that century is therefore forced to return frequently to this subject. In his attitude toward allegory Dubos may well have been inspired by Pierre Bayle, the great philosopher of the French Enlightenment. Our author was an admirer of Bayle's work; he studied it, and was influenced by Bayle in different ways (including the exchange of letters).[50] Pierre Bayle severely criticized allegorical explanations of religion, a type of explanation that was largely inherited from Renaissance humanism. He was determined to destroy the last vestiges of Renaissance allegorism and to that end condemned the religions of Greece and Rome by the ugly accusation of their barbaric worship of cats, dogs, serpents, and other disgusting objects.[51]

In the first half of the eighteenth century, however, the criticism of allegory did not apply to the visual arts. Here Dubos opens up a discussion that, in various and ever changing forms, was to last till our own days. For the present purpose, it is of particular significance to us to recognize not only the fact that Dubos rejected allegory in painting but his reasons for doing so. In effect, he adduces one basic reason: the uninitiated spectator will not be able to understand the allegorical painting, and will therefore not be moved by what he sees. It is the spectator who remains the ultimate judge of the work of art, and, as

has been said at the beginning of this section, he is the central axis of Dubos' theory of art. What he says about allegory in painting, as about several other specific questions, only reveals additional aspects of that central belief.

3. SHAFTESBURY

The modern mentality, destined to overturn so much of what for centuries had seemed firm and solid truth in matters of taste and the arts, was originally so deeply embedded in inherited traditions that, even with the advantage of hindsight, we can hardly distinguish it from what was still a remnant of the past. At the turn of the seventeenth and eighteenth centuries, that major wellspring of Western tradition, Neoplatonism, once more inspired a new approach to the arts and infused aesthetic reflection with new life. This version of Platonism, to be sure, was quite far removed from Plato's original doctrine and even from the idea of his latter-day followers in late Antiquity and the Renaissance. Within the framework of this loose Platonism we can observe how, around 1700, some specifically modern notions and attitudes took shape. The Platonism of that period is best represented by Shaftesbury.

Anthony Ashley Cooper, the third Earl of Shaftesbury (1671–1715), like so many of the great minds of his time, was not a systematic thinker. His important contribution to theoretical reflection on the arts consists less in well-formulated doctrines than in the very fact that he raised, and invigorated, certain lines of thought, often without carrying them to final formulation. Shaftesbury was personally linked with some of the major trends in European thought. Educated in the English deistic tradition, to which he remained true in a special way, he was associated with the early Enlightenment, particularly with Pierre Bayle, whom he frequently met when they were both in Amsterdam. He was a citizen of the early eighteenth-century republic of letters, but always a very unusual and original one. In both capacities, as a representative of early Enlightenment thinking and as a highly individual man of letters, he exercised a major influence on the thought of his time.[52]

Shaftesbury's contributions to the theory of art and artists, particularly his ideas about creativity (human and divine), are obscured by

appearing in a context of moral speculation. This was so in his time, and remains so even today. In the eighteenth century the impact of what he had to say about aesthetic matters was not felt among living artists. His influence on the philosophy of the century was profound; Kant's doctrine of the aesthetic experience, it has been said, was stimulated by his ideas, but in the workshops and academies of art nobody knew his name. This is perhaps less surprising than it may seem at first. It is doubtful whether Shaftesbury had an actual theory of painting and sculpture; what he occasionally has to say about a picture or about a painter's or sculptor's subject sounds rather conventional, and hardly suggests any original departure from accepted generalities. His invigorating influence on the thought of art flows from a different source. What he says about nature in general, and about landscapes in particular, sometimes displays a surprising affinity to art and an understanding of artistic processes. Whoever tries to understand Shaftesbury's view of art and his formative impact on modern aesthetics must grasp the character of his thought as a whole rather than focus on specific details in his doctrine.

An insight into the aesthetic aspect of Shaftesbury's combination of Platonic idealism and psychological intuitionism affords us his vision of the world as a work of art created by God. A perfect relationship between the parts and the whole is characteristic of the world, and it has an artistic character. Shaftesbury uses many terms to designate this relationship, such as "the whole," "the One," and "unity of design," but the most important one is "harmony." Harmony, the highest value, is achieved in the universe as a whole. In a sentence that could have been written by St. Augustine, he says: "In the real Cosmos the whole is harmony, the numbers entire, the music perfect." That cosmic harmony is both static (as the perfect balance fully achieved) and dynamic (as the inborn striving to achieve that perfect balance). Shaftesbury emphasizes the dynamic quality of the cosmic harmony. The universe is not a machine but an animated organism of forms; it is, in his words, a "conspiring beauty."[53]

Similar ideas, it need hardly be stressed, are commonplace in the Platonic tradition. As a rule, harmony was seen as static; often it was considered the very basis of stability. A dynamic view of harmony,

though never altogether absent in the Platonic tradition, became more prominent only in the late Renaissance. As always, then too dynamism entailed a certain intrinisic tension, as has been shown with much learning by Leo Spitzer in his *Classical and Christian Ideas of World Harmony*.[54] The interpenetration of cosmological and aesthetic ideas characterized the late-Renaissance notion of dynamic harmony. Giordano Bruno, taking the orbit of the sun as a symbol, made a diagram with two circles, one within, one outside, the orbit, intending to make visible the principle that motion and rest, temporal and eternal, coincide. An inborn desire to achieve complete harmony animates the universe so outlined. It was this concept of dynamic harmony, associated with intrinsic contrast and tension, to which Shaftesbury was heir. The infinite process of harmonization requires, he believes, a "divine artificer," a "sovereign genius." The age-old image of God as a craftsman fashioning the world is revived here in the modern garb of "genius."

Among Shaftesbury's prominent contributions to our subject are his views of the creative artist, or, as he called him, the "genius." A present-day reader, reviewing what Shaftesbury had to say about the creative artist, cannot help feeling that his opinions are commonplace, even trite. This impression shows, perhaps more than anything else, how far-reaching was his contribution, how profoundly he has shaped the modern notions of the artist. We find it difficult to envisage the views of the artist that were current before the early eighteenth century, and we today follow—to a larger extent than we realize— Shaftesbury's guidance. He figures eminently among the philosophers and poets who created one of the great myths of the modern age, the myth of the creative artist. Shaftesbury's epigrammatic, pithy, pointed formulations, some critics maintain, are often quoted out of context, and thus may sound more radical than they actually are. Be this as it may, one cannot be in doubt so far as the general orientation of his thought is concerned.

Two features are essential in the creative artist, Shaftesbury believed: originality and creative power. The notions themselves are not new, but the earlier stages of our study did not accustom us to any emphasis on originality or novelty. Shaftesbury, however, declares time and again that the artist is an original master. "All is invention," he says, "crea-

tion, divining." As if to explain what he means, he adds: "Things that were never seen, nor that ever were; yet feigned." It is this spirit of invention that assures the artist's independence. " 'Tis on themselves that all depends." Over and over again he emphasizes the artist's freedom.[55]

What did he have in mind when he spoke of this liberty? He could hardly have meant a lack of social restriction. The time when artists had to struggle for their liberation from the bondage of restrictive medieval practices, as when Lorenzo Ghiberti had to go to jail for refusing to belong to a guild, had long since passed. By 1700, painters, at least those who were successful, were considered gentlemen. Nor could Shaftesbury have meant only the freedom from rules that Federigo Zuccari and Giordano Bruno had referred to precisely a century before.[56] The rejection of restrictive and rigid rules plays a certain part in Shaftesbury's thought, but this does not seem to be a central issue or one endowed with immediate urgency. What "freedom" means here, I believe, is that the artist draws from his individual self, that he is the ultimate origin of his work.

If this interpretation is correct, Shaftesbury, by shifting the emphasis from one part of a traditional pattern to another, departs from tradition. That "invention" is a major component in the creative process was a belief held in many ages. *Invenzione,* as is well known, is the first part in the "system of painting" that the Renaissance bequeathed to modern Europe, and in art literature since the fifteenth century the artist's inventive power was often praised. But "invention" was not contrasted with tradition, nor was it allowed to endanger the commitment to the cultural and artistic heritage. It is characteristic that the founder of the Renaissance theory of art, Leone Battista Alberti, advises painters to associate with poets and orators, the exponents of literary tradition, precisely where he speaks of *invenzione*. The poets and orators "could be very useful in beautifully composing the *istoria* whose greatest praise consists in the invention," he says (*Alberti on Painting* [New Haven, 1956], pp. 76 ff.). This is how invention was understood for centuries. "The novelty in painting," said Poussin in the mid-seventeenth century, more than two centuries after Alberti and only one generation before Shaftesbury, "does not consist principally in a new subject, but in good

and new disposition and expression, and thus the subject from being common and old becomes singular and new " (*Lettres de Poussin,* ed. P. du Colombier [Paris, 1929], pp. 243 ff.).

The artist's inventiveness and originality, as Shaftesbury saw them, differ from that traditional view. Pictures and statues are real and literal creations, images the artist draws from himself, rather than more or less slight modifications of a tradition handed down through the centuries. Shaftesbury did not touch upon the age-old problem of *creatio ex nihilo,* the "creation out of nothing," but it seems obvious that he believed the individual artist, and not accumulated cultural patterns, to be the real originator of the work. A comparison of Shaftesbury's beliefs concerning artistic and moral freedom may be useful here. As ultimately man, and not the moral law, is responsible for his deeds, so ultimately the individual artist, not the tradition he inherits, shapes his work. It is as an original, creative spirit that the artist has an inherent affinity to God. Not fortuitously, Shaftesbury's preferred mythological hero is Prometheus, the independent creator, whom, as Oskar Walzel has beautifully shown, the age between Shaftesbury and Romanticism metamorphosed into the rebellious artist. One of our author's most frequently quoted utterances claims that the artist is "a Prometheus sub Jove, a second maker." [57]

To what degree Shaftesbury believed the creative gift to be an altogether personal, individual endowment, one can infer from his advice that the artist seek the solitude of nature, the true place of inspiration. Withdrawing from the social racket, retreating into the silence of seclusion: this is the best way to discover one's own, true character. Shaftesbury even offers technical advice for educative behavior: in solitude the artist should talk to himself in a loud voice. Soliloquy in retreat leads to self-knowledge, and self-knowledge is an essential condition in forming and articulating one's character. The ancients did this (Shaftesbury may have had Marcus Aurelius in mind, an author much read in seventeenth- and eighteenth-century England), and thus they became "self-examiners." An artist should be a self-examiner. Whoever undertakes to represent the character of others should first know his own. [58]

To a twentieth-century reader, Shaftesbury's high regard for the

artist's solitude may sound trite. If that is so, however, the reader forgets how alien such a view was in the periods that preceded our author, especially the Renaissance and Baroque. Anchorites and men of letters, philosophers and mystics were reported to have sought solitude; they were admired, their life stories were told, and there were some intermittent attempts to imitate them. But the notion of the painter and sculptor was little affected by all this. To be sure, occasionally an artist's bent for seclusion was noted (Michelangelo is the most famous example), but on the whole this was considered as still another expression of that individual artist's strange character and unsocial behavior. Art as such was conceived as part of social life (when the term is taken in its widest sense), and the production of a work of art was seen as an act intimately interwoven in the social and cultural fabric of the community. It would be very difficult to find Renaissance and Baroque art literature advising the painter to retire into solitude in order to discover, and articulate, his own character. In some ages, we should not forget, the very showing of the artist's character was seen as a danger rather than an advantage. Leonardo da Vinci and the Venetian painter and critic Paolo Pino, for instance, alerted the artist to the danger of inadvertently depicting his own face in multifigure compositions. But even where self-knowledge was accepted as valuable, its articulation and expression were still considered to take place within a social matrix. The young artist should get acquainted with his own nature, that is, the star under which he was born—so Lomazzo requires—so that he could find a teacher born under the same star who would help him to shape his character. It was taken for granted that one's personality and style were shaped in continuing contact with society and by absorbing the collective cultural heritage.[59] For the Renaissance and Baroque periods, the artist's individuality outside any participation in his social and cultural context was simply unthinkable. When Shaftesbury praises seclusion as a way of knowing one's character, he is breaking with a long tradition and announcing the coming of the modern age.

In considering Shaftesbury as a thinker endowed with a subtle sensitivity for processes that were unfolding beneath the surface, as it were, we cannot fail to mention his particular version of the Sublime and his new conception of the aesthetic experience. Shaftesbury did not

explicitly discuss the Sublime, certainly not in painting. In fact, his taste in painting was rather conventional for his time. Raphael and the Carracci he saw as models of perfection. He tells his readers how he could believe a picture by Raphael to be done by angels. Michelangelo, significantly, "erred," but "on the side of Greatness." Yet while he did not outspokenly present any views on the Sublime, he foreshadowed the notions and helped prepare the emotional climate for the fascination with the Sublime that became such a distinct feature in the course of the eighteenth century. Enthusiasm, to which he devoted a lengthy discussion, is not only a form of religious fanaticism and a disorder of the imagination—all this was in full agreement with opinions held in his time; it also provides a psychological basis for the Sublime.[60]

Here we need not attempt a discussion of the Sublime, for we shall have to return to that subject several times. I should like only to mention briefly the specific direction of Shaftesbury's influence respecting this important issue. Shaftesbury was among the thinkers who linked the Sublime with the external world, with what we visually perceive of the world around us. As Marjorie Nicolson has shown, while at a time in France when the idea of the Sublime remained mainly rhetorical, in England a concept of the "Natural Sublime" was developing that found literary expression in books ranging from Thomas Burnet's *A Scared Theory of the Earth* (1681, 1684) to Joseph Addison's *Pleasures of the Imagination* (1712). Shaftesbury played an important part in this development.[61] In a well-known chapter of *The Moralists,* published in 1709 but written earlier, he describes his emotional response to walking in a mountainous wilderness. The travelers "are seized with giddy horror, mistrusting the ground they walk on, led by new experience with vast and wild Nature to meditate upon the ruins of a world." Here he distinguishes, though hesitantly and in his rhapsodic manner, between the Beautiful and the Sublime. In face of the latter, "we cannot help being transported with the thought of it. It inspires us with something more than ordinary, and raises us above ourselves." This feeling for the indescribable, the "Aesthetics of the Infinite," to use Marjorie Nicolson's felicitous phrase,[62] anticipates much of the latter half of the eighteenth century's thought on art, its potentials and

limitations. It also anticipates, and possibly sets the pattern for, some considerations in the narrower field of art theory.

The other idea in which Shaftesbury anticipates a great deal of modern aesthetic thought is altogether different. This is the notion of aesthetic experience as being, to use the formulation Kant gave it by the end of the century, a "disinterested pleasure" *(interesseloses Wohlgefallen)*. The idea, if not the term, is clearly present in Shaftesbury's writing. We experience beauty, our author claims in *The Moralists,* only if our response to what we perceive is unselfish and without bias, that is, if it is a disinterested perception. The experience of beauty, he insists, must be completely separate from the desire to possess or the urge to manipulate. In *The Moralists,* one of the interlocutors addresses the other: "Imagine, then, good Philocles, if being taken to the beauty of the ocean, which you see yonder at a distance, it should come into your head to seek how to command it, and, like some mighty admiral, ride master of the sea, would not the fancy be a little absurd? . . . Let who will call it theirs . . . you will own the enjoyment of this kind to be very different from that which some naturally follow from the contemplation of the ocean's beauty."[63]

A critical reader may ask whether there is not a strain—though no outright contradiction—between being transported into the unseen and indescribable, on the one hand, and the altogether disinterested contemplation of the sight one is faced with, on the other. But, as I have said earlier, Shaftesbury is not a consistent systematic thinker. His significance lies in anticipating the great problems of modern aesthetics, and, at least partly, in indicating the direction of the intellectual development of thought on art.

III. ANTIQUARIANS AND CONNOISSEURS

Modern reflection on the visual arts drew from many sources. Along with philosophers and artists there were other groups that determined the course of aesthetic thought, and among those groups the antiquarians and connoisseurs loom prominently. "In the eighteenth century,"

writes Arnaldo Momigliano, himself a connoisseur of antiquarians, "a new humanism competed with the traditional one." The exponents of that new humanism "preferred travel to the emendation of texts, and altogether subordinated literary texts to coins, statues, vases and inscriptions."[64] The history of the archaeologically minded humanism is, at a first glance, less enthralling than that of other groups. In the story of antiquarianism, whether the objects unearthed belong to a distant or to a more recent past, there are few sudden breaks and dramatic turns, and the spirit of the ages they deal with can scarely be measured in terms of years or decades. That story, then, has a slower pace than that governing artistic creation or philosophic reflection. In the first decades of the eighteenth century, however, the cumulative effect of the devoted and meticulous scholarship that often goes under the name of antiquarianism on the broad intellectual orientation of the age must have become quite considerable. As with so many other processes that were taking place in the dark, as it were, it suddenly came to light in the great intellectual upheaval of the middle of the century. Some of the most important figures that founded the modern view of art were either antiquarians or people with deep roots in connoisseurship. Winckelmann was not only officially in charge of the ancient monuments of Rome but became, as one knows, the founder of modern archaeology; Herder was a connoisseur of both medieval literature and lore and of ancient sculpture; Lessing not only revived the ancient vision of death; he also retrieved from libraries the precious texts of medieval works on connoisseurship (among them, Theophilus's *On Diverse Arts*) and wrote on ancient scarabs and amulets as well as on ancient perspective. A review of what antiquarianism and the connoisseurship attitude may have contributed to the theory of painting and sculpture seems therefore desirable.

Antiquarians and connoisseurs, normally not concerned with the "great," comprehensive problems of artistic creation, may seem to be far removed from the issues and aims of art theory. What could these scholars, so totally immersed in figuring out the value of a Roman coin or identifying the emperor represented on it, so profoundly concerned with sorting out and classifying different objects, man-made or found in nature, what could they contribute to the theory of painting? One

cannot help wondering. Yet a closer look convinces the student that connoisseurship and art theory, different as they may seem at a first sight, are not altogether separated from each other. Antiquarian studies help to determine the course of modern art theory less in terms of the specific notions or concrete tasks they formulate than in the intellectual environment they create. It was in the crystallization of mental attitudes, of points of departure for further investigation, that the major contributions of antiquarian studies to the living, growing art theory, totally directed to the present, became significant. Though it is in the nature of things that these contributions cannot be singled out easily, they are not beyond the reach of rational analysis. I shall attempt to present some of the central factors in the antiquarian contribution to thought on art.

Nothing, it seems, could be further removed from the intellectual world of antiquarians and connoisseurs than universal beliefs that, in a precise sense of the word, go beyond what can be seen and proved. Antiquarians, we have been educated to think, were completely devoted to the individual object, the concrete, the material, and the tangible. Yet they entertained theoretical convictions, among them the belief that the visual is a truer and more reliable witness than the verbal record. The notion that the image holds more truth than the word seems to underlie a great deal of antiquarian study, and it may well turn out to have been one of the major ideas that antiquarianism bequeathed to late eighteenth-century philosophy of art.

As early as 1671, Ezechiel Spanheim, the founder of modern numismatics, reminded his readers of Quintilian's observations on the contradictions in what historians say, often concerning basic historic facts, and of the consequent unreliability of historical research that is the necessary result of these observations. The remedy for such uncertainty seemed to lie only in the "ancient marbles."[65] The testimony of the material object is more secure than the literary evidence. A few years later, in 1679, Jacques Spon, a physician who became a celebrated numismatist, proclaimed the superiority of material, archaeological evidence over all other forms of testimony.[66] Once more we hear that marble and bronzes are truer to what happened in the past than the words of historians or of any other witnesses of remote events. In the

same sense, the early eighteenth-century writer Joseph Addison asserted that "It is much safer to quote a medal than an author for in this case you do not appeal to Suetonius or to Lamprodicus, but to the emperor himself or to the whole body of a Roman senate."[67] At about the same time, an Italian scholar started a work entitled *La Istoria Universale provata con monumenti e figurata con simboli degli antichi,* also based on the underlying conviction that *simboli* (that is, monuments largely pertaining to what we call the visual arts) provide a firmer basis for historical inquiry than does literary evidence.[68]

The value of visual material as historical evidence is not here our concern. The art historian is fully aware that visual testimony cannot always be taken at face value, that it requires interpretation, and is thus liable to error and false reading. What interests us here is that beliefs were entertained, though not fully articulated, that the object perceived in visual experience belongs somehow to a more elementary level of being, is somehow closer to the origin of all things, than the more subtle, but also more artificial, works belonging to the arts of the word. When German Idealist philosophers, as we shall see in the next chapter, started constructing hierarchic systems of the arts, they made the visual arts the basis of the whole structure. Did they continue, and explicitly formulate, what numismatists and connoisseurs intuitively believed?

The many students here lumped together under the collective heading of "antiquarians," though in fact they applied themselves to rather heterogeneous branches of learning, made another important, and more explicit, contribution to the foundation of a modern art theory: they created the notion of connoisseurship and shaped the type of investigation that goes under that name. It was a contribution that was to make a lasting impression on the mind of the modern world. So far, the history of connoisseurship has not received the attention it deserves as a unique way of studying art. Its life story has not been told as a continuous narrative; only individual stages or facets of its development have been more carefully explored. In some rudimentary form, it strikes one as obvious, connoisseurship must always have existed; in all ages people have surely tried to group pictures, statues, and objets d'art according to what they believed to be their origin and function, or according to some other criteria. And yet we shall probably not go

wrong in believing that it was only in the seventeenth century that connoisseurship came into its own; only then was it regarded as an activity *sui generis,* its practitioners having particular ends in mind and gradually developing the conceptual apparatus necessary to meet those ends. When in the late seventeenth century the Abate Filippo Baldinucci (who died in 1696) classified the many drawings in Florentine collections, distinguishing "hands" and trying to detect in them individual masters, and then carefully catalogued these works of art, he produced one of the first feats of connoisseurship in the modern sense of the term.[69] Yet even though Baldinucci applied his approach to works of art of a different nature as well (he bought paintings for Cosimo III, and he wrote the first history of engraving), he did not have a *theory* of connoisseurship. Such a theory appeared only shortly after his death.

The theory came from Paris. In 1699 Roger de Piles, surrounded as he was by a certain revolutionary aura, was finally admitted into the very conservative Academy of Art, and in the same year he published his *Idea of the Perfect Painter.*[70] In that slim volume he presented what must be the earliest doctrine of connoisseurship. The full title of Roger's work reads *The Idea of the Perfect Painter: or, Rules for Forming a Right Judgment on the Works of the Painters.* The tension between the two parts of the title is immediately obvious. The first (major) part of the title is concerned with the artist, even with his most general image, his "Idea"; the second part (the subtitle) is concerned with the artist's work, and is so from the point of view of forming a judgment. In the present context, we are of course concerned with what is indicated by the subtitle, the painter's work.

Carefully reading de Piles' text one senses both how large the connoisseur's problems loomed in the aesthetic reflection of the time and also how dim and obscure the outlines of what precisely these problems included still were. "There are three several sorts of knowledge relating to Pictures," Roger declares in Chapter 28 of his *Idea of the Perfect Painter;* it is a chapter titled "Of the knowledge of pictures." The first sort is "to know what is Good and what is Bad in a picture."[71] What he here has in mind, then, is actually art criticism rather than connoisseurship. By the end of the eighteenth century, the two prov-

inces, art criticism and connoisseurship, were neatly separated from each other, and the process of division took place mainly in France. When in the second half of the century Denis Diderot, in his reviews of the Salons, wrote art criticism proper, the question of the pictures' authorship or related problems of connoisseurship didn't come up. And when Lessing published his *Laocoön* in 1766, his introduction clearly distinguished between the critic's concerns and those of the connoisseur. Two generations earlier, however, in 1699, when Roger de Piles published his *Idea of the Perfect Painter,* the line between criticism and connoisseurship had not yet been sharply drawn. The notions were still indefinite, their outlines somewhat blurred.

The other two "sorts of knowledge" that Roger adduces actually belong to the realm of connoisseurship. One of them is "to know who is the Author of the Picture." For centuries, one need hardly say, this remained the key connoisseur question and it seems already perfectly evident to Roger de Piles. It is one that, in principle, makes a clear-cut answer possible, for the notion of authorship needs no qualification, and our author therefore concentrates on how to give definite answers. Now, what is the solution? What should a connoisseur, asking who is the author of an as yet unknown picture, actually do? He should look and compare, says Roger quite sensibly, "The Knowledge of the Names of the Authors in got by long Practice, and the sight of a great many Pictures of all Schools. . . ." He also knows how the connoisseur should proceed in detail. "And, after having by much Application acquir'd a distinct Idea of each of these Schools, if we could find out to which of them a Picture belongs, we must compare it with that to which we think it has the nearest affinity, and when we have found out the School, we must apply the Picture to that Painter, whose Manner agrees most with that Work. . . ." [72]

Roger, then, is aware of the problem; he also knows that comparison is the only way to approach its solution. But just *what,* which features, should be compared is a question that is still completely beyond his horizon. The same is also true for the third sort of knowledge pertaining to our question, "If a Picture be an Original or a Copy," in Roger's words. To answer this question he knows that you have to have a fine sense of discrimination for the intangible, indefinable qualities that

characterize a master, and this sense of discrimination is cultivated by continuous observation and comparison. In the third sort of knowledge, the observation and comparison (or whatever notions our author may apply) remain intuitive, and therefore ineffable, as in the second sort. An analysis of observation and comparison still belongs to a distant future. Looking and comparing for Roger de Piles are essentially non-analytical; he does not discriminate between the various parts, elements, and features we take in while we look at a painting. In the second half of the nineteenth century, in the heyday of scientific connoisseurship, Giovanni Morelli, trained as a physician, became known beyond the limited groups of connoisseurs for his method of ascertaining the authorship of a painting. Every true artist, he claimed, is committed to the repetition of certain characteristic forms. To determine who painted a certain picture, we should identify its *Grundformen,* its fundamental forms, and then find out which artist used these forms.[73] The very singling out of such fundamental forms is the beginning of an analysis of observation and comparison, a removal of these processes from the realm of the merely intuitive experience. But even more important is the notion that the *Grundformen* that are characteristic of each individual artist are not evenly distributed across the whole of the painting. Certain parts (for example, composition, face) will be more strongly determined by general, nonpersonal conventions than others, such as the shape of the thumb or the lobe of the ear. What Morelli, then, looks for are not the central part of the painting (such as the composition of the major figures or the facial expressions of the central heroes), but rather what seem to be marginal features that did not attract much attention. How deeply interwoven with modern ideas these thoughts are has been shown in an interesting study by Richard Wollheim.[74] If we now look to Roger de Piles, it instantly becomes manifest how different intuitive connoisseurship is from analytical, and on what different themes it concentrates.

It is interesting to notice that though Roger de Piles asks who is the author of the picture, his categories are not those of individual artists but of collective entities, of schools. The connoisseur's first and essential task is to attribute the picture in front of him to a school, to an artistic tradition. Roger even knows how many schools there are in the history

of painting, namely six. He is of course aware that there remains the task of placing the picture more precisely within the school. "There are Pictures made by Disciples, who have Copy'd their Masters very exactly in their Judgment and their Manner. . . . Nevertheless this Inconvenience is not without Remedy for such, as not satisfying themselves in knowing a Master's Hand, have Penetration enough to discover the Character of his Mind." [75]

The gradual building up of a theory of connoisseurship was a process that involved the major European countries. Jonathan Richardson, the British painter, collector, and writer to whom we shall revert at the end of this chapter, was not only a connoisseur himself; he also gives a clear picture of connoisseurship in his day and, what is more important, emphasizes a certain aspect of connoisseurship that was to become a central and characteristic feature of this activity. A good connoisseur, Richardson claims, must avoid prejudice. [76] What he probably intends to say is that the connoisseur cannot be a critic, nor can he be an advocate of a certain style or manner. In this respect, Richardson sets off clearly (though he does not say so) connoisseurship from art theory, as it was practiced during the Renaissance. In the fifteenth and sixteenth centuries, writers on art were usually convinced that there was only one "true" or "correct" way of painting, and they naturally tried to influence painters to follow this way. Richardson believes that the connoisseur should refrain from preaching a gospel. While it would be vastly exaggerated to claim for Jonathan Richardson the modern idea of a "value-free" approach to art, it remains true that he thought that the connoisseur should not be concerned with a comparison of values at all.

As the connoisseur is not a critic who can discriminate the better from the worse because he has a reliable yardstick by which to measure values, so he is not an educator who intends to shape the art of the present and future. Here again, one sees how connoisseurship gradually removes itself from Renaissance and Baroque art theory. In those periods, authors of art theory had their own generation in mind, or claimed — not always convincingly — that they wished to shape the art of the present and future. This was so even when, to a large extent, their studies and writings actually dealt with antiquities or with the history of painting and sculpture. It is sufficient in this connection to

remember the writings of Vasari and of Bellori. In the writings on connoisseurship composed around 1700 or shortly thereafter, the perspective changes appreciably. Richardson speaking of connoisseurship disregards the creating artist of his day. Claims of educating the next generation of artists and of improving their work become thinner and lose significance.

If waiving the claim to judge and to educate implies inevitable losses, it also affords certain gains. The most important among the latter is a catholicity of taste that must have struck early eighteenth-century audiences as truly universal. Let me mention as an example that curious aristocrat and professor at Leipzig, J. F. Christ, who in 1726 published a monographic study of the German Renaissance painter Lucas Cranach.[77] Because the author had little literary material to rely on, he had to draw his knowledge from the pictures themselves, and so it is natural that his ideas on connoisseurship play an important part. The careful observer, he claims, should not trust too much in signatures or monograms. (It is worth recording in this context that in 1747 Christ published the first book on monograms.) He should recognize the works of the masters by discerning their spirit, character, and manner. To be able to do this, he ought to acquaint himself with the works of all periods and all schools. The idea of art history—he actually employs the term "history of art" a generation before Winckelmann, though not as a title—serves as a framework for a truly comprehensive connoisseurship. Modern art historians may find it entertaining that for J. F. Christ an ample collection of engravings—the reproductions of that time—served as the material basis for acquiring the intimate knowledge of the art of different periods and schools.

Let me conclude this brief sketch of connoisseurship in the first half of the eighteenth century with an example from France. A. J. Dezaillier d'Argensville published another *Abrégé des vies des peintres* (1745) that was much read, reprinted, and translated. Questions of connoisseurship come up frequently, and great attention is devoted to the classification of art into "schools." Like some of the other writers of that period, Dezaillier d'Argensville asks how one goes about attributing a picture to a school or a master, and, as with the other authors, he sees in comparison the key to the solution. But unlike most other writers, he

makes comparison a little more specific. Painters often have some peculiarities, and noticing them may aid in identifying their works. The works of some masters show particular facial expressions, they do the hair and beards in a special manner, they prefer a particular fall of garments, sharp or soft contours, accurately or carelessly painted hands and feet, short or long fingers, small soft folds, and even a certain direction of the brush strokes in shading. He gives some eye-opening examples. Thus he singles out Parmigianino for the long, delicate fingers of his figures. In shading, for example, Giulio Romano proceeds from right to left, and where the shadows are heaviest the lines of the brushstrokes cross each other. His heads have fine features, but the contours of his figures tend to be vague, sometimes becoming altogether indistinct. As opposed to the Italian master (who is here characterized in an unusual manner), Rembrandt's shading is irregular, and the attitude of his figures is given by frequent retouching. The details of his pictures remain inaccurate and unfinished; it is only the total impression of a work that shows Rembrandt's intention.[78]

Here we watch connoisseurship slowly emerging from the somewhat indistinct shape that resulted from the intuitive approach. New foci of observation gradually crystallize as looking at a picture and comparing it with other paintings becomes a more structured process. The contribution of these observations, originally regarded as rather modest, was profound and lasting. It rescued the theoretical approaches of art from vagueness and a strict following of abstract norms that is always in danger of becoming anemic. Antiquarians and connoisseurs, in their love for minute and meticulous learning, discovered a whole new dimension of looking at painting and sculpture.

IV. THE ARTISTS

1. INTRODUCTION

The artists of the early eighteenth century, perhaps even more than the philosophers of the age, testify in their written legacy to the character of the period as an age of transition. The treatises composed by painters

in the first generation of the century offered the reader a curious blend of traditional thoughts and patterns of composition, inherited from Renaissance and Baroque art literature, and themes, emphases, and points of view that were often new and that sometimes proved even revolutionary. This curious blend may be taken as an indication of the momentous transformation that was taking place at the time. Even though in the early decades of the century the process was subterranous, as it were—breaking into the open, as we know, only in the middle of the century—some of the artists were obviously sensitive enough to perceive these as yet invisible transformations. In their writings, as often also in their paintings, the artists of the early eighteenth century lack the profundity, the liveliness, and the originality that we experienced in the literary legacies of an Alberti or a Leonardo, a Dürer or a Zuccari, a Poussin or even some academicians. Yet for a better understanding of the further development of art theory, from the mid-eighteenth century to our own day, it is worthwhile to analyze what the artists of the first half of the eighteenth century said as carefully as we can within the limits of the present study.

A few preliminary remarks concerning the conditions—intellectual, social, and otherwise—from which these treatises emerged may help us to focus on what is characteristic and new in them. The feature that instantly catches one's eye is that the most important documents of art theory composed by artists of this period originated in northern Europe, England, and the Netherlands. Italy, the classical country of art theory, was at the time the captive of its own glorious past, and even France, still under the powerful impact of what was going on in the Academy, had little new to say. It is not for us here to ask what might have motivated this shift from the South to the North, from one civilization to another. It is of some interest, however, and may be worth noting, that in this very generation, in the early eighteenth century, the significance of natural environment on the development of intellectual life, and particularly of art, was carefully considered, and a variety of natural conditions explored. It was none other than the Abbé Dubos who investigated what natural conditions, and particularly what climate, might contribute to explaining the phenomenon of genius and to an understanding of the cyclical development of cultural history. Dubos

anticipated much that, more than a century later, became the famous doctrine of Hippolyte Taine.[79]

But whatever the explanation, the map of art theory, and with it the cultural traditions and actual artistic models, gradually changed. It was particularly England that, as one knows, began early in the century to exert a profound influence on the aesthetic thought of the European continent. Shaftesbury gave a new turn and urgency to the ancient problem of creativity, to the problem of the artist and his inspiration, stirring philosophical thought mainly in Germany. A short while later emerged the great tradition of English art theory that will reappear frequently in the pages of this book. Dutch painters emerged as important contributors to art theory at the beginning of the eighteenth century, and only one generation later German philosophers and painters began to make their mark. It goes without saying that these changes in territorial distribution introduced a great variety of artistic traditions and almost necessarily led to the manifestation of new problems.

In the whole of western and central Europe, but possibly with particular significance in the "new" countries, social conditions were undergoing dramatic changes. Most important for our purpose is the training of the artist. Italy and France, countries with established academies of art, were possibly less affected by this process in the early eighteenth century, though they too must have felt the differences. In the first half of the century the workshop education of the artist reached the final stage of its disintegration. In his well-known book on the academies of art, Nicolas Pevsner has adduced some interesting statistical information that sheds light, even though indirectly, on what must have been going on in the workshops. Around 1720, only three or four institutions bearing the name of Academy of Art could be regarded as real academies, functioning regularly and actually educating the next generation of artists. Between 1720 and 1740, only six more such institutions were opened, and even these few were of a rather dubious value. By 1790, however, well over a hundred academies of art or public art schools were flourishing.[80] Between 1740 and 1790, a veritable outburst of academic activity affecting the education of the artist took place, fully and definitively transforming the way an artist was trained.

It is surely not too much to conjecture that in the generation preceding that unprecedented increase, that is, in the first generation of the eighteenth century, theories of art and the thought of artists were in a state of profound crisis. One imagines that in the thought of the artists something similar to what we have seen in the philosophers' thought was happening: an invisible, subterranean revolution that, in the next generation, was to break into the open. Vico and Dubos have shown us that though the major transformation remained invisible for the moment, some indications of the great process were revealed. Is the same true for what the painters and sculptors thought? What do the artists themselves tell us?

The views prevailing among the artists of the first eighteenth-century generation—and particularly among those of them who could be described as "progressive"—can be learned mainly from two works, *Het Groot Schilderboek* by the Dutch painter Gérard de Lairesse, and *An Essay on the Theory of Painting* by the British painter Jonathan Richardson. These books enjoyed great popularity at the time, and their wide diffusion testifies that they said what people wished to hear. The treatise by Gérard de Lairesse appeared originally in Amsterdam in 1707, and was reprinted, in the original Dutch, in 1712 and 1740. A French translation appeared in 1719 and was reprinted in 1787, while a German translation was published in 1728 and reprinted in 1780. Richardson's work also met with obvious success. His *Essay on the Theory of Painting* was originally published in 1715, and only a few years later, in 1719, it was reprinted in an enlarged version, which, in turn, was reprinted in 1725. A French translation appeared in 1728.

The commercial success and wide distribution of these two works—no small achievement when measured by early eighteenth-century standards—raises the important question of the audience that actually bought, and presumably also read, these large volumes of not always gripping prose. That question leads us to another, though closely related, query: what audience did the authors of these bulky works originally have in mind? All this ultimately boils down to this question: what was the purpose of art theory in the minds of the artists composing it? Did Gérard de Lairesse and Jonathan Richardson wish to help,

and thereby also direct, the painter in the workshop while he was standing in front of his canvas, or was it rather their wish to explain the problem of painting to the general educated public?

So far as I know, there are no specific studies on the early eighteenth-century readers of these particular treatises. A sociological investigation of art theory (and of the visual arts in general) remains an important and urgent desideratum; so far, no real attempt has been made to fill the gap, and I cannot consider myself competent to venture a detailed hypothesis. Since the external evidence that might be used to answer our questions is scant and unexplored, we must attempt to form an opinion on the basis of the texts themselves and of their broad historical context. In reading and discussing the treatises by Richardson and de Lairesse, we will have to keep our questions in mind, and it may then be possible for us to suggest, I hope in some detail, who constituted the audience for these Northerners' works on art theory. We shall then see that, under the cover of a rather traditional presentation, the two authors raised new and original problems, and addressed a reader who was neither a craftsman who, like medieval artists, was being provided with a "do-it-yourself" manual, nor a Renaissance humanist who approached art from the point of view of a rich literary tradition, and frequently seems to have believed that an abundance of classical quotations would suffice him in unriddling the secrets of painting. The audience that both Gérard de Lairesse and Richardson wished to address was no longer profoundly impressed with the display of sheer technical skill and mastery of the medium; in what these artists say, the virtuoso seems to be dethroned. Neither do sheer literary erudition, the subtlety of allegorical reference, and the evoking of historical memories continue to constitute the unquestioned peak of artistic achievement. The painter of *istoria,* although not openly disparaged as in the later nineteenth century, seems to be losing that almost sacred ground he had held at least since the days of Alberti. To be sure, craft was appreciated and the literary allusion highly regarded. But the emphasis seems to have lain somewhere else, both for the audience and the artists.

With the advantage of hindsight we can say that the themes that were slowly emerging in the first half of the century were the reality of

the work of art and the particular modes of existence of the different types of pictures. Originally these themes were obscure, as are the words we are using here, but in the course of the first decades of the eighteenth century they gradually become clearer. At first, the artists reflecting in writing on their work done in paint did not possess the concepts and categories necessary to deal appropriately with the problems that emerged in their thought. Gérard de Lairesse's extensive discussion of the "genres" in painting is a serious attempt to come to grips with what we have called modes of existence. Richardson's exploration of the Sublime may be another contribution to the same problem. We shall now turn to them.

2. GÉRARD DE LAIRESSE

A modern reader (or spectator) may find it difficult to understand what made Gérard de Lairesse so popular in his own day, but there can be no doubt that he was greatly appreciated both as a painter and as a writer on art. Jean Baptiste Descamps, a painter who between 1753 and 1763 published a monumental history of the art of his own time, *La vie des peintres flammands, allemands et hollandais,* described Gérard as a "Dutch Poussin;" the only detailed description of a painting that we have by Johann Joachim Winckelmann is of a work by Gérard de Lairesse; and no lesser mind than Goethe read his writing carefully.[81] Gérard himself, although a successful painter, obviously felt the need to reflect upon his craft and calling. After an earlier, and rather brief, *Principes du dessin* (1701), he published his great theoretical work, *Le grand livre des peintres ou l'art de la peinture* (1707), in two heavy volumes.

In the Preface to the *Grand livre* Gérard explains his motivation for writing the treatise and how it was composed. Referring to his blindness at the time of writing (a misfortune he had in common with another great figure in the theory of art, Giovanni Paolo Lomazzo), he mentions two central impulses for composing the treatise: love of his art, and the desire to be helpful to the young painter. So far, he remarks, the writers who have treated of painting have indulged themselves in "pompous praises" of that art rather than endeavored to trace its "sure principles."[82] This, then, is what he wishes to do: to give the young painter

the "sure principles" of his work. In itself, this aim is not new. Precisely during the Italian Renaissance there were innumerable proclamations of it. However, abstract theory ("pompous praises") does not attract him. What he envisages comes as close as possible to a "practical" book. This book, he further notes, he has "composed in fragments," a characterization clearly borne out by the not very systematic order of the text itself.

It would be futile to look in the *Grand livre* for an overall compositional principle. In the Italian Renaissance, when the independent art theoretical treatise was born, authors and probably also their audiences insisted on a transparently rational structure. "To make clear my exposition in writing this brief commentary of painting," so reads the very first sentence of Leone Battista Alberti's treatise *On Painting*, "I will take first from the mathematicians those things with which my subject is concerned. When they are understood, I will enlarge on the art of painting from its first principles in nature in so far as I am able."[83] Alberti's work, written as early as 1435, set the tone for the art theory of the Renaissance. A treatise, everyone at that time seems to have taken for granted, first had to lay out basic and general principles; only after having done this should the author set out to derive from these tenets, proceeding systematically, his more specific and detailed observations and even the practical rules addressed to the practicing artist.

About three centuries later, when Gérard de Lairesse set out to compose his *Grand livre,* the intellectual climate had changed and so, it seems, had the aims of art theory. Just listen to the opening sentence of Gérard's *Livre:* "There are two different handlings of brushes: one suave, mellow and smoothly finished, the other bold, intrepid and vigorous."[84] However interesting this distinction may be in itself, and whatever the sensitivity it may reveal toward the artist's craft and the pictorial values of a painting, one cannot but wonder what made Gérard open his work with such a sentence. The *Grand livre* is a very long work (of well over 1,000 pages) and deals with a wide range of the problems that may be raised by the study of art. To open such a monumental work on painting with some acute observations on types of brushstroke may lead the reader to expect a modern homage to the artist's individuality as expressed in his "handwriting." The reader who entertains such expec-

tations will be disappointed. Gérard de Lairesse is too close to the academic age and spirit to hold such views or aims. Though he has a keen eye for distinguishing between different ways of using the brush, he does not overesteem the brushstroke in general. Brushstrokes don't have a value of their own. A picture is completed, he instructs his readers, when all traces of work have been blotted out; at the end, "one does not leave on the work any trace of the brush."[85] That a painter could allow himself to be identified by his brushstrokes—his "hand-writing," as we would say today—would probably have appeared to him a serious deviation from a good norm, a danger the artist should foresee and overcome. This disregard for the individualistic personal manner often shows in his work. In his discussion of portrait painting, to give but one example, we read: "Above all the painter should beware not to adopt a particular manner, as some masters have done; so that it is easier to identify the brush than the person of whom the portrait is made."[86]

This criticism increases our bewilderment at Gérard's opening his comprehensive treatise with an observation on types of brushstroke. The solution to this riddle can be gathered from the first chapter of the *Grand livre,* from which we have quoted the opening sentence. "Art," we here learn, "is a theory or a production of the *mind (esprit);* whereas *manner (manière)* is nothing but a *practice (pratique)* or manual execution that depends on a certain skill in appropriately employing the brush and laying out the colors in a suitable way." Of the "mind," let us say in advance, we do not hear much in the rest of this bulky work. To be sure, there is a considerable amount of codified cultural symbolism in the *Grand livre,* particularly in the detailed and specific discussions of the "meanings" the individual colors carry. Speculations on the Mind or the Spirit, however, are not in keeping with Gerard's personality. His heart lies elsewhere, with the "manners" and what hangs together with them. There he time and again stresses the need for "suitability."

Nowhere in this long book does Gérard de Lairesse tell us just what a manner is. He obviously took it for granted that every reader of his work would know what he had in mind. Yet if the reader indeed wishes to understand this notion with some precision he is left with the task of reconstructing it from various hints dispersed throughout the book.

Nor is his task made easier by Gérard's using the term in a loose way and in a great variety of contexts. It is therefore difficult to propose a formal definition. The core of the notion, one that is preserved in all the various formulations, consists of a congruous relationship between two poles, a relationship our author frequently calls "suitability." What these poles are is suggested in the first chapter of the work.

"Everything can be reduced to two manners of operating," as we remember, the two types of brushstrokes. In addition, however, our author says that "every kind of painting has its own, different manner of operation." Gérard de Lairesse lists them in detail. "The landscape painter has his [manner] for painting the foliage of trees; the painter of animals has another [manner] for hide and wool; the still-life painter employs another [manner] for the velvetness and variegation of flowers."[87]

This short list of different types of painters, given within the narrow confines of a single sentence, corresponds largely to the division into "books" of the major part of Gérard's *Grand livre*. The kinds of painting, *genres,* as they are called in the French edition, are Gerard's central problem. To understand and properly appreciate his contribution one has to analyze the problem of "kinds of painting," and see what exactly are the individual kinds he adduces. Before we set out to present what Gérard has to say about the individual classes of painting, we should perhaps pause for a moment and define the general notion of "kind" a little more specifically.

Gérard de Lairesse, it need hardly be stressed, did not invent the division of the "art of painting" into large, comprehensive units. The idea that the bewildering mass of pictures—extant and possible—should be arranged in a few basic classes has a long and rich history. Within that traditional matrix, however, Gérard's division is worth attention, and should be studied both for the insights it may afford into actual art and for the testimony it bears to the intellectual climate in which art was contemplated in the early eighteenth century. We shall begin by comparing Gérard's "kinds of painting" with the older attempts at such structuring.

The most significant of the older notions that comes to mind in the present context is that of "mode" *(modus)*. Underlying a great deal of

Renaissance speculation on art, this notion was fully articulated in the Baroque period. Nicolas Poussin's letter of 1647 to Paul Fréart Chantelou is now probably the best-known document of this development in Baroque art theory. Borrowing his terminology from the theory of ancient and Renaissance music, Poussin spoke of "modes" *(modi)* of painting. What he had in mind in using this term were fundamental emotional characters. The Dorian mode, he says, is "stable, grave and serene;" the Phrygian mode fits "pleasant and joyous things;" the "Hypolidian mode contains a certain suavity and sweetness which fills the soul of the spectators with joy; it lends itself to subjects of divine glory, and paradise."[88]

We should keep in mind two characteristics of the concept of *modus* as it was understood in the seventeenth century. The first one is obvious: emotional qualities are the fundamental principle determining the artistic modes. These emotional qualities do not necessarily correspond to types of paintings. Pictures belonging to all the modes mentioned above would in fact form a single category in both Gérard's and even the Renaissance views: they would all be multifigure compositions in which human figures act under the impact of emotions. But other kinds of painting could also easily be made to manifest the different modes. We can well imagine a "stable, grave and serene" landscape as opposed to a "pleasant and joyous" one or one filled with a "certain suavity and sweetness." Though it would be more difficult to apply these modes to portrait painting (though even this is not impossible), it is again easy to think of still lifes exhibiting these emotional traits. The system of modes is one that altogether disregards the system of pictorial genres. Gérard de Lairesse's list of "kinds of painting" thus cannot be derived from the theory of modes.

The other characteristic of *modus* is the explicit assumption of a congruity between the emotional character and the form in which the picture is shaped. In other words, a "mode" is not just a mood, the emotional nature of a certain subject matter, but rather the way in which this mood or subject matter is pictorially represented. Therefore the "mode" could be conceived as a specifically artistic category. Academic doctrine took over the notion in this particular sense. Henri Testelin, the late seventeenth-century secretary and theoretician of the

Paris Academy of Art, insistently repeats the traditional request that all parts of a painting partake of the character of the subject represented, so that the emotions the work seeks to evoke can be brought to life immediately.[89] Here, in this general demand of the mode, Gérard follows the model, and repeats the traditional requests.

Other developments, both in the arts themselves and in aesthetic reflection, should also be mentioned; they loom large in the background of Gérard de Lairesse's doctrine of the "kinds" of painting. Conspicuous among these developments is the emergence and crystallization of pictorial genres as art forms in their own right. The establishment of the genres was a central process in the artistic and intellectual world of the seventeenth and eighteenth centuries. Around 1600, still life, genre painting, and self-contained landscapes began to evolve as more or less autonomous species. The portrait, as we know, had for centuries been accepted as a self-sufficient, articulate art form in painting and sculpture. It is a matter of common knowledge that in this process northern Europe played a crucial part, and even in Italy the emergence of the pictorial genres did not take place without the active participation of northern, mainly Flemish and Dutch, artists. Gérard de Lairesse thus knew the crystallization of genres at first hand.

We are not concerned with the history of art itself, and in the present context we shall therefore only briefly observe whether, and how far, art theory around 1700 was aware of the development that the generation witnessed. On the whole, art theory was slow in coming to terms with the variety and independence of pictorial genres. The noble art of history painting held pride of place, almost to the exclusion of all other forms (except the portrait). Ever since Leone Battista Alberti had written in 1435 that "The greatest work of the painter is the *istoria*" and *"Istoria* gives greater renown to the intellect than any colossus,"[90] this view remained dominant for almost three centuries. It governed not only theoretical opinion but was reflected in specific judgments and in many other ways. How dogmatic the belief in the superiority of history painting was, and how widely ramified was its influence, we can see — to adduce only one, somewhat farfetched illustration — from the way exhibitions of paintings were arranged in eighteenth-century Paris. The great canvases depicting historical scenes were placed on the top;

below them came smaller paintings, often representing less noble or elevated themes. Jean Seznec, who has called attention to this feature, has correctly noticed that history paintings were "not on top in the physical sense only."[91] But while the supposed superiority of the history painting is well known, we are less well informed about the relationship between the other pictorial genres. Were they conceived as one mass, juxtaposed as such to noble history painting, or were they seen as part of a structured system, each capable of being arranged on a scale?

The question, perhaps not fully articulated, was obviously in the air. In 1667 André Félibien, who can be considered the spokesman of Poussin's doctrine, delivered a lecture to the Academy of Fine Arts in Paris in which he made a contribution to our problem. He started by reminding his listeners that painting is an intellectual pursuit; mixing colors and drawing lines do not qualify one as an artist but rather as a craftsman. He then went on to show how and in what way painting concerns the mind. Insofar as artists concern themselves with more difficult and more noble objects they emerge from the lower regions of their art and rise to a more dignified status. For instance, the most excellent are the artists who represent a group of dramatic figures in a subject borrowed either from history or mythology. Next comes the portrait painter; though he represents the human figure, he has not yet reached the summit of painting. The painter who depicts portraits, however, ranks higher than his fellow artist who renders only fruit, flowers, or shells. The painter who represents living animals deserves more esteem than the one who depicts only lifeless things. Still life, then, seems to be the lowest degree in this system.[92]

Félibien delivered his lecture only one generation before Gérard de Lairesse wrote his *Grand livre,* summarizing his ideas that surely reflect, to a large extent, accepted, conventional wisdom. It is worth emphasizing some elements in Félibien's concepts; in comparison with them the novelty, as well as the links with tradition, of Gérard's system may become manifest. Let us stress, first, that Félibien lists all major pictorial genres, some of them clearly with Dutch art in mind, such as the depiction of animals. Second, these pictorial genres are arranged in a hierarchic system, each art graded and assigned its place on the scale.

Now let us come back to Gérard de Lairesse. What distinguishes his

approach to the "kinds of painting," when compared to the *modi* of Poussin or the "species" mentioned by Félibien, becomes almost tangible. Gérard's "kinds of painting" are neutral in expressive character, they have no emotional character of their own, and therefore they are indifferent to the moods. The universal maxim, "Variety is the soul of pleasure,"[93] is also valid for the genres of painting. Therefore, our author claims, you can have different emotional characters within a single "kind of painting." Let us look at a single example, at what he says about landscape painting. Gérard de Lairesse, perhaps against his own will, was still deeply rooted in the mythographic tradition; it is not surprising, therefore, that he lists some mythological motifs that could appropriately be depicted in landscape settings. One of them is the story of Venus and Adonis, a story that in the seventeenth century provided an excuse for quite a few almost pure landscapes. From the narrative Gérard picks three moments: (1) Venus lavishing caresses on Adonis; (2) Adonis, preparing for the hunt, bids farewell to Venus; (3) Venus finds the dead body of her beloved Adonis. These three stages are, in fact, the embodiment of three emotional states and can thus be considered as demanding representation in three different modes. The natural setting in each of the scenes—that is, the landscape—is described as fully reflecting the mood characteristic of the action taking place. In the first picture, showing Venus caressing Adonis, "the site is a delicious field, where one finds everything that can soothe the sight;" it is "a beautiful spring day," the "light is one of a radiant sun."[94] The scene represented in the second picture is one of conflict. The painter's way of showing the natural setting partaking in the moral nature of the event is to place dramatic elements on either side of the picture. To the right, Gerard suggests, "an elevation" (a mountain) should be seen; it is apparently high, as it can be climbed only in several stages. To the left, between the center of the painting and the frame, are seen "three or four beautiful trees, beginning from the groundline and reaching above a hill;" in the background, behind the trees, "there rises a big rock of savage mien."[95] In the third picture, the dead Adonis is seen lying at the foot of a mighty oak, leaning his head against its trunk. Behind the oak one sees a cloudy sky. "The season is rainy and cloudy, a winter day. . . . The trees have only a few leaves."[96]

Two lessons, it seems, can be learned from this single example. On the one hand, the landscape is decidedly a medium of manifesting emotions, the natural features—the field, the trees, the hills and rocks—participate in the feelings pervading the actions represented. On the other hand, we also see that landscape as such, as an articulate art form, is devoid of any emotional leanings or character of its own. Landscape, like the other genres of painting, is capable of expressing different emotions because it has none of its own. With regard to expression, then, Gérard's "kinds of painting" are altogether opposed to the modes in sixteenth- and seventeenth-century art theory.

Félibien's "species" of painting differ from Gérard's "kinds" in an altogether different way. In listing the individual genres, Félibien and Gérard largely overlap, though there are significant divergences. Yet they are altogether divided with regard to the principle dominating the grouping of the individual genres and establishing an order between them. Félibien, it will be recalled, built a hierarchic structure, a ladder of pictorial "species." Gérard de Lairesse sees no hierarchy of pictorial classes and therefore does not rank one "kind" higher than the other. This is not to suggest that Gérard treated all elements or motifs in painting as of the same value or as if there were no need to prefer one to the other. Within each "kind of painting," Gérard does not doubt, various objects have different values. Again, a single example will clearly show his intention. In the Eleventh Book of the *Grand livre,* that dealing with still life, he refers to the variety of objects that can be represented. "Now I will leave it to the judgment of connoisseurs and sensitive people," he continues, to decide "which are the nature-objects that merit preference over others."[97] While he does not hesitate, then, to accept the principle of discriminating between the more or less meritorious within each class of picture, he refuses to apply this principle to the "kinds" as such. The modern student is forced to conclude that for Gérard de Lairesse all pictorial genres were, in principle, of equal value.

The equivalence of pictorial genres is testimony to a historical shift of far-reaching consequence; it should be reckoned among the most telling signs of the arrival of modernity. What it suggests is that the value of a work of art is no longer dependent on its subject matter. This is a secularization of painting. Instead of the dignity of subject

matter, of the idea expressed, another value emerges, indifferent to the theme depicted. It was none other than the great German philosopher G. W. F. Hegel who, a century after Gérard de Lairesse published his *Grand livre,* articulated the essence of this transformation. He argued that the "Dutch replaced the interest in significant subject matter with an interest in the means of representation as an end in itself."[98]

Having considered Gérard's general notion of pictorial genres, let us now turn to the "kinds of painting" he actually gives. I shall start with a brief comment on the list as a whole and shall then discuss some of the individual "kinds." Since Gérard's "kinds of painting" do not form a rational system, where one part follows from the other by logical necessity, their nature and scope must be explained by the historical reality from which they emerged.

The art historian does not have to be told that artistic production in seventeenth-century Holland was dominated by a hitherto unknown specialization in the history of painting. Painting was practically split into various types, or "kinds," of secular subject matter, each type tending to acquire a definite shape of its own. The categories of landscape, still life, scenes from everyday life, and so forth originated in the latter half of the sixteenth century, but it was only during the seventeenth that they became fully defined as pictorial types. As church commissions became steadily scarcer, the need to cater to popular taste became an increasingly powerful motivating force in giving definite form to these types. Moreover, subtypes crystallized in the process. Landscape, for instance, became either the depiction of a regular piece of nature, or an image of a city (cityscape), or of the sea (seascape), with a variety of further subtypes. When this process had reached its apogee, painting in the Netherlands presented a gallery of fully formed "kinds."

The composition of Gérard's list, the presence or absence of certain categories, also indicates the origin of his thought in contemporary historical reality. The notions and categories he employs reflect what we know from Dutch art of the seventeenth century. Thus, in the *Grand livre,* religious subject matter does not form a "kind" of painting, and in general it is very little mentioned. Protestant iconoclastic zeal, it is well known, was particularly widespread in the Netherlands. In actual paint-

ing, the representation of sacred themes was severely reduced, and art forms serving religious ritual (such as the altarpiece) almost disappeared. Gérard's categories, or rather the conspicuous absence of some of them, reflect this state of affairs. The subject matter of "history" painting proper—that is, glorious historical events, and mainly mythological stories—is more frequently adduced. It often serves to enliven some types of painting which belong to one of the accepted "kinds." A good example, which we have already mentioned, is that of the stages of the story of Venus and Adonis, used to accentuate different moods of landscape. However, while the themes of "history" painting are frequently mentioned, they do not form a "kind" in their own right; they are not accepted as one of the major parts of painting.

To appreciate how far removed Gérard de Lairesse was from the traditional system of pictorial "kinds," it will be enough to compare his list of genres with that of Giovannni Paolo Lomazzo, the last great Renaissance theoretician of art. Gérard is much more concentrated than Lomazzo. In the last part of the *Trattato della pittura,* a part devoted to "practice," Lomazzo adduces tens of categories, thus leaving the reader with the feeling of some rather blurred diffusiveness. In comparison, Gérard's seven "kinds" give the impression of being firmly structured. Yet the difference in the nature of the categories is much more profound. Lomazzo, heir to humanistic learning and writing under the powerful impact of the Counter-Reformation, extensively discusses religious themes, as the painter should know and see them. He also explores in great detail the subject matter of *istoria,* devoting much attention to both mythology and allegories. Religious and mythological themes are categories, or genres, in their own right. But Lomazzo does not know of any classes or types of pictures devoted to landscape or still life. Between Italy in 1584, when Lomazzo wrote his *Trattato,* and the Netherlands in 1707, when the *Grand livre* was published, an almost complete reversal took place, both in actual art and in the theory reflecting on the problems it raises.

At first, the individual genres discussed by Gérard de Lairesse seem a rather odd mixture. Landscape (Book VI), portrait (Book VII), still life (Book XI), and flowers (Book XII) do not surprise us; they are art forms to which we have become accustomed. But "ceiling painting" also gets

a book of its own (IX), because "among all the kinds of painting there is none more difficult." [99] That in a treatise on painting architecture should also get a long discussion (Book VIII) may seem even more surprising, but the author explains at the opening of the book that he will not deal with architecture as such but only insofar as an acquaintance with "that fine art" is useful for the painter. In the book on architecture he includes a short but very interesting chapter on ruins, a highly topical theme in eighteenth-century painting. [100] The book on sculpture is rather isolated in the *Grand livre*. The emphasis the author places on relief (a theme rarely touched by Italian writers on sculpture in the seventeenth century) again indicates that the tridimensional art is actually seen from a painter's point of view. The last book (XIII), devoted to engravings and the uses that can be made of them, is an afterthought. Reviewing the books on the different genres, one may still find some oddities and unexpected combinations, yet the dominant concern is clear: everything is seen with a painter's eye.

What an individual "kind of painting" is and what it involves, I shall try to show by analyzing one example. Nowhere perhaps are Gérard's originality as well as his limitations so manifest as in his treatment of still life (Book XI) to which the discussion of flowers (Book XII) should be appended. Even a brief analysis of what he has to say about still life will show, I hope, that Gérard stands midway between two great ages. Past and future clearly meet in his work, and this meeting is often a transformation of the old into the new, but sometimes also a clash between them. Perhaps for this reason Gérard's treatment of still life is, as Georg Kauffmann noticed in a useful article, [101] diffuse and "brittle."

That Gérard's treatment of still life is hesitant should surprise no one. Though painters produced many still lifes — in seventeenth-century Holland, but also in France and in other countries, still life painting became a veritable industry — contemporary critics and philosophers of art were slow in coming to terms with this flourishing art form. Even in the most comprehensive treatises of art theory composed in the late eighteenth century, still life is often omitted or only marginally mentioned. It was only in the nineteenth century that critics, looking at art and its history from an altogether modern point of view, discovered still life as an artistic genre in its own right, with its own distinct

problems. In his time Gérard de Lairesse was isolated in his theoretical concern with still life, and his pioneering efforts in this particular domain have not yet received the attention they deserve.

Gérard does not, as a rule, give a formal definition of the "kind of painting" he is discussing. In the books on portrait and landscape, for example, we shall look in vain for a rigid statement of what precisely the subject matter or portrait or landscape is. This may be because the "aim" of each given genre seemed to him so obvious that no explanation was called for. In the case of still life, however, he deviates from his normal procedure. The aim of still life, Gerard explains, "is to render all the inanimate [the Dutch editions has: all the still] objects, such as flowers, fruits, vases, utensils, and musical instruments of all metals, as well as marble, stones, wood. . . ."[102] Here an attempt is made to outline the scope of still life, perhaps also to emphasize what is essential in that genre, namely the material nature of the objects routinely encountered in everyday experience. Histories are represented, we have heard since the Renaissance, for their noble subject matter or for the religious message they convey; portraits are painted to keep alive the memory of the deceased, or to honor rulers or poets. But why depict a fruit, a utensil, or a piece of wood?

Gérard de Lairesse does not spell out the question. But the reader, attentive to tone and context, will not find it too difficult to extract an answer from Gérard's prose. There are, in fact, two different answers, placed side by side and often even interpenetrating. Still life as a theme in painting, to follow Meyer Schapiro, corresponds to a field of interest outside art. We sense this, without having to refer to a particular cause, when we note the gradual separation of still life as an independent subject in the sixteenth century, or the fascination with it in seventeenth-century painting. The objects chosen for still-life representation —flowers, fruits, vases, implements, and manipulated materials (such as stones or wood)—belong to the specific domains of the private, the domestic, the gustatory. "Simply to note these qualities is to suggest a world view."[103]

It is not for us to decide what were the motivations that prompted this world view. Was it the appetite for sensual experience, or was it rather the surrender to the tangible reality of material objects? Gérard's

text can be read in support of both explanations. He obviously enjoys the color and texture of objects, and stresses that the painter should choose such objects that "flatter the eye." But he also indicates his complete absorption in the tangible, material reality of objects. It is a sin against the rules, Gérard says, to introduce into a still life elements of other "kinds of painting," such as landscape, architecture, or human beings. "That would absolutely destroy the idea of still life." Nevertheless, in his treatment of other kinds of painting—portrait, landscape, and so on—he does not make similar demands. The puzzle may be solved when we remember that this "idea" denotes the world of objects that are nothing but material objects, the domain of sheer tangible things. Probably to preserve the object character of these things, Gérard makes still another request: it is a "matter of principle" that the objects of a still life should not be represented smaller than they are in nature.[104]

Sensual delight in beautiful objects or the impact of sheer materiality are not the only motives for reproducing in art the images of everyday objects; frequently one paints, and enjoys, such pictures because still life can be made into a carrier of symbolic messages. "It is not impossible," says Gérard, "to give to still life painting an allegorical meaning, as is applicable particularly to certain figures."[105] Examples of still lifes carrying allegorical meanings can be found, he goes on, in the pictures of Willem Kalf, whose works the young artist wishing to devote himself to this field of painting would do well to study. This Dutch painter, as one knows, used to represent elaborate gold, silver, and glass vessels, glittering objects of great value, endowing them with symbolic messages of death and the fragility and vanity of human life and material possessions. He is a good example of the well-known genre of Vanitas still life, a type of painting particularly common in seventeenth-century Holland. In such paintings, if we are to follow the interpretation offered in the *Grand livre* (it was an interpretation broadly accepted at the time), the shining, tangible object loses it sheer opaque materiality and becomes a medium that lets symbolic ideas shine through.

How does symbolic thought work in still life? How do material objects become the transparent carriers of abstract ideas? Gérard de Lairesse, though he does not put the question in these words, is

profoundly concerned with it. He wants to discover the permanent patterns by which meanings are transmitted in still-life painting. Symbolic objects, all of them inherited from classical antiquity, are one of the established channels of investing the domestic object with an invisible, yet clearly perceptible meaning. These classical objects, we know, evoked certain specific connotations, the audience reacted to them in specific ways, and they came to be accepted as the carriers of these specific meanings. However these objects came to be invested with symbolic power, one cannot help wondering about their place within the category of still-life painting. To be sure, they were inanimate, yet they were hardly household possessions. Roman cuirasses and crowns were rarely found even in better Dutch homes. If still-life painting purposes to depict more or less ordinary objects, it is difficult to make these ancient symbolic artifacts fit into the conceptual frame of the genre. Gérard evidently devotes such a large part of his discourse on still life to these object-symbols because of his desire to institutionalize the role of still life as a carrier of ideas. In the actual contents of his discussion he is close to the heraldic reading of ancient remains and imagery that was so widespread in his time. Just listen to what some of these objects are: a steel cuirass, a beautiful helmet, a golden chain, a sword, a scepter topped by an eye, triumphal crowns, Roman military costume as well as that of other peoples (Persians, Carthaginians, and so on). A full list would probably hold several dozen historical and symbolic items. Obviously we are here witnessing the imposition of the antiquarians' work on the theory of even such a "modern" branch of art as still life. At the same time, we also see how confused and ambiguous were views as to what still life as a category of painting really was.

Another way of establishing symbolic meanings in still life is associated with the relationship between the individual picture and the patron, or limited audience, for whom it is painted. The still life is made to adjust to the function and social role of the patron. Gérard describes four ideal still lifes done for, respectively, a victorious warrior, a judge, a jurist, and a clergyman. The pictures differ from each other in the selection of the symbolic objects represented. Being adjusted to the patron's function, they help define his role in society. In none of

the other pictorial genres, it should be recalled, is such an adjustment of the picture to the patron even considered. The general, one infers, does not get a different landscape or architectural piece than the judge or clergyman; not even in the portrait is the social differentiation so clearly manifested as in the still life. Still life is the single genre conveying meanings that is required to adjust itself to the client. In this Gérard de Lairesse is clearly following the emblematic tradition that was powerful and popular in the northern Europe of his time. This can be seen both in the selection of the objects appropriate to each type and in the explanation of these objects that the author provides. The eleventh book of the *Grand livre,* that dealing with still life, affords a rare opportunity to watch the secularization of emblematics and its transformation into still life.

Symbolic meanings need not always be conspicuously displayed; they can also follow more subtle routes. Certain flowers, for example, are connected with certain gods and goddesses; they can symbolically represent these gods and perhaps also what these gods stand for. Nature provides a variety of flowers, and each of them, Gérard emphasizes, has different qualities that make it appropriate for depiction. "The white lily is dedicated to Juno; the sunflower to Apollo; the rose to Venus; the poppy to Diana and Morpheus; the corn flower to Ceres."[106] Fruits, too, have affinities with the gods. "The pomegranate is granted to Juno; vine branches as well as figs belong to Bacchus; peaches and wheat to Ceres and Isis; apples to Venus and Apollo." The same is also true for that other favorite feature of still lifes, musical instruments: "the lyre is consecrated to Apollo, the Muses, and to Mercury; the flute to Pan and Venus; the trumpet to Mars. . . ."[107] The whole world of "inanimate" objects, it turns out, is covered by a fine network of symbolic meanings and relations. You cannot approach a simple object, you cannot step into this domain of everyday things without getting enmeshed in this symbolic fabric. Every seemingly innocent flower piece or still life combining some vine branches or apples in front of a casually placed flute may thus carry an encoded emblematic message. The spectator enjoying the picture in front of him may have no inkling of the symbolic depth of what he sees. The colors themselves, even when they are the colors of a flower or a fruit, are carriers of meaning. The yellow

sunflower, the red rose, the white lilly: they are all permeated with meanings.[108] Choosing one or the other is a handling of symbols.

Let us not forget, however, that in Gérard's treatment of still life there is still another trend, along with the emblematic attitude, and this one is strikingly modern. The very objects — the flowers, the fruits, the musical instruments — whose symbolic dimensions are stressed, are described in a manner that makes us altogether forget any emblematic attitude. Let us look at a single example. In the treatment of flowers, only a few pages after the passages just quoted, we read: "My intention is to form a large mass of beautiful flowers in bright colors, placing in the middle the thickest and most vigorous one, such as the white ones, the yellows, those of a lively red. The tallest ... will be a sunflower; and at the sides I will place others of less beautiful colors, mixing them here and there with a beautiful blue." [109] The reader is amazed. Is this the same writer who attributes flowers and fruits to gods known only from books, and who simultaneously describes a flower piece with such vividness of perception and enjoyment of color sensation that one cannot even think of a possibly symbolic aspect of his subject matter?

Gérard's views of still life — among his most original contributions — are typical of his notions of the other "kinds of painting" and of his doctrine as a whole. The clash between attitudes, between the traditional and the modern, within the teaching of the same writer, marks, perhaps more than anything else, the specific position he holds between the ages. It perhaps also specifically characterizes the first half of the eighteenth century as an age of rapid transition, preparing the great changes that were about to take place in the middle of the century.

3. RICHARDSON: THE RISE OF THE SUBLIME

The process of transformation that introduced the modern age compels the student of art theory constantly to redraw his map. For many centuries the great schools of art theory were to be found in Italy, and to Italy scholars all over Europe turned whenever matters of painting and sculpture were discussed. Only in the seventeenth century did France and the Netherlands (and, to a lesser degree, other countries, such as Spain) acquire in this field a status that could be regarded as

independent. Since the Middle Ages, England had played a rather marginal role in articulating thoughts on painting and sculpture, but in the eighteenth century it emerged strongly in this field, bursting forth with a surprising creativity. A wide range of intellectual types now entered this domain, and new, original problems were raised. The English contribution to art theory made an immediate impact on aesthetic thought in Europe, and thus became a part of a comprehensive process.

In the periodization of English aesthetic thought in the eighteenth century we usually follow the pattern generally accepted for other countries, namely, that the chief contributions are clustered in the middle and second half of the century. A glance at the dates of the outstanding works would seem to confirm this impression. Thus, to give but a few examples, Edmund Burke's *A Philosophical Enquiry into the Origins of Our Ideas of the Sublime and the Beautiful* appeared in 1757, William Hogarth's *The Analysis of Beauty* in 1753, and Joshua Reynolds's *Fifteen Discourses on Art* were delivered to the Royal Academy, of which Reynolds was a member, on ceremonial occasions from 1769 to 1790 and were published individually. Yet in spite of what these dates seem to imply, the first half of the century in England was one of productive growth. The trends that were to come into the open by mid-century were quietly but powerfully ripening in the earlier decades. Moreover, at the beginning of the century some important contributions were actually made, and they evoked a lively response on the European continent. Earlier in this chapter I mentioned Shaftesbury; now I shall turn to a less philosophical treatise, composed and published in the early eighteenth century. It is the literary work of Jonathan Richardson (1665–1745), who was assisted by his son, Jonathan the Younger (1694–1771). The Richardsons, father and son, were painters, critics, and collectors. Their reflections on painting are significant both as a testimony to the thought current among British painters in the first decades of the century and as an adumbration of some of the great problems and trends that dominated late eighteenth-century thought and, particularly, Romanticism.

Jonathan Richardson the father in his time was a well-known portrait painter. From his teacher, John Riley, he inherited a stiff and solemn

manner, which he further propagated in the school he founded (called St. Martin's Lane Academy). His major impact, however, was made through his books. The first, *An Essay on the Theory of Painting,* appeared in 1715, and in an enlarged version in 1725 (to which another brief treatise, *Two Discourses,* originally published in 1719, was added). With his son he also wrote a guide book (*An Account of the Statues, Bas Reliefs, Drawings and Pictures in Italy, France, etc.,* London 1722) that enjoyed a great reputation; the noble and educated who went on the Grand Tour employed it widely and took it with them, and Winckelmann still thought that, in some respects, it was the best book written on the visual arts.[110] In the present context, it is of course the first work, *An Essay on the Theory of Painting,* with which we are concerned.

Most parts of the *Essay* do not offer any new message. The student of art theory feels he is treading familiar ground. The conservative character of Richardson's thought is not surprising; of an author of his artistic orientation and social position one does not expect the preaching of a new gospel or the proclaiming of something that might undermine the norms accepted in his time and world. Only with respect to one, though admittedly rather central, issue does the author of the *Essay* contrive the seemingly impossible: to closely follow some widely known and accepted ideas and, at the same time, to make an original contribution to art theory. Here the interaction of the different cultural traditions was so complex that one doubts whether, in fact, our author was altogether aware of how original he was. The issue I have in mind is his discussion of the Sublime in painting.

The Sublime, it need hardly be said, is an age-old problem. Inherited from Antiquity, it was to some extent revived in Renaissance aesthetic thought, and certain aspects of it were extensively examined in the critical literature of the seventeenth century. Yet throughout that eventful history, the Sublime with a capital S, that is, as a conceptual category, remained firmly enclosed in literary criticism and theory. It was not systematically expanded to include the other arts. To be sure, ever since the sixteenth century, philosophers, critics, and artists reflecting on painting or sculpture did occasionally touch on the Sublime, but they never conceived of it as a category in their own deliberations. It is symptomatic that in the vast Renaissance literature on painting and

sculpture, a literature that abounds in crystallizing a new and comprehensive terminology for the visual arts, no term was coined, or used, for the sublime. Even in the seventeenth century, when interest in the sublime was pronounced in all fields of literature, it hardly appeared on the horizon of the writer on the visual arts. Roger de Piles only once mentions *le Sublime et le Merveilleux* in his *Traité de peinture parfait,* a work that appeared in 1699, and even here it is included in a short chapter of less than a page stressing that the Grand Gusto, the Sublime and the Marvellous are the same.[111] A few years later, in 1715, Richardson included in his *Essay* a lengthy and detailed discussion, extending over thirty-three pages, of the sublime in painting.[112] He is also the first to expressly adduce pictorial examples for this category. It is no exaggeration to claim that his chapter constitutes the first real discussion of the sublime in painting, and that we here witness the introduction of this notion into the theory of the visual arts. In the following observations, I shall concentrate on this one contribution of Richardson's.

All discussions of the sublime in European history, we need hardly remind ourselves, go back to one ancient document, the *Peri Hupsos* (On the Sublime) attributed to Longinus, a Greek rhetorician of the third century A.D. It is not for us to discuss this famous text, to which many fine studies have been devoted, but in order to better understand eighteenth-century art theory I shall emphasize some of its specific points. The effect of the sublime, so Longinus suggests, is to take the spectator "out of himself." When man encounters the sublime—in nature, in human life, or in the arts—it "lifts him up." This is also true for the effect of art. Referring to literature, Longinus said: "A lofty passage does convince the reason of the reader whether he will or not." Being carried away, taken out of oneself, swayed whether one wills it or not—these reactions would seem to stand in marked contrast to the values for which works of visual arts have been traditionally praised, such as a harmony of the parts that imparts calmness, precision, and a conviction of the natural character of the representation. Can one infer that the sublime is more appropriate to the narrative than to the visually evident, to literature than to painting and sculpture? Now, interestingly enough, Longinus can in fact be read to that effect. The sublime is found in nature and also in literature, but not in the visual arts. "It has

been argued by one writer," he says, "that we should not prefer the huge disproportioned Colossus to the Doryphorus of Polycletus. But (to give one out of many possible answers) in art we admire exactness, in the works of nature magnificence; and it is from nature that man derives the faculty of speech. Whereas, then, in statuary we look for close resemblance to humanity, in literature we require something which transcends humanity."[113]

When, in the sixteenth and seventeenth century, concern with the Sublime revived, there was little change in this respect. The whole problem obviously was not considered as an important one, but so far as Longinus was studied, people accepted what he said without much questioning. This is also the impression one gets from Boileau's famous, though not always precise, translation of Longinus' work and from the great French tradition of interpreting *On the Sublime*. Seen against this background, Jonathan Richardson's long chapter devoted to the Sublime in painting stands out as very unusual. How are we to account for this novel departure? Richardson may have drawn from two different sources. The great French academic school of art theory may well have been one of them. Roger de Piles could have provided the legitimation of introducing the notion of the sublime into a discussion of painting. As I have already said, his *Art of Painting* (the original edition of which was published in 1699, and the English translation in 1706, only nine years before Richardson published his *Essay*) mentions the sublime in a short chapter speaking of the Grand Gusto. "In painting," he says there, "the grand Gusto, the Sublime and the Marvellous are one and the same thing."[114] Yet though Roger de Piles's authority was important, the content of that brief chapter is rather meager.

Another source of inspiration, though less direct, may prove to have been more decisive. The Longinian tradition in England, traced with much understanding by Samuel Monk,[115] made visual experience the major stimulus of the feeling of sublimity. The emphasis on the visual in evoking the sublime was articulated during the very years Jonathan Richardson conceived and wrote his *Essay on the Theory of Painting*. I shall illustrate this process by one example, the writings of Joseph Addison (1672–1719). Although writers like Shaftesbury and others had been discussing the Sublime, so Walter John Hipple, Jr., writes in his inter-

esting and instructive study, "it was Addison's *Essay on the Pleasures of the Imagination* which formulated the problem of aesthetics in such a fashion as to initiate that long discussion of beauty and sublimity."[116] Addison did not use the term "sublime," perhaps, as Samuel Monk believes, because it had a definitely rhetorical ring; instead, like Roger de Piles, he employed the term "great." He distinguished between the great, the uncommon, and the beautiful. In the discussion of the first, he repeatedly stresses both the transcending of boundaries (the essence of the sublime) and the visual origin of this process. "By greatness," he explains, "I do not only mean the bulk of any single object, but the largeness of a whole view considered as one entire piece." Such pleasures of the imagination, by which "we are flung into a pleasing astonishment at such unbounded views, and feel a delightful stillness and amazement in the soul at the apprehension of them," arise "originally from sights." Among the examples of such grandeur he mentions "a troubled ocean, a heaven adorned with stars and meteors, or a spacious landscape cut out into rivers, woods, rocks, and meadows."[117]

But do these visual affinities of the sublime also affect man-made objects, or are they restricted to untouched nature? The object that immediately offers itself for inspection is the garden. Around 1700, that well-known discussion began concerning the character and shape of the garden, a discussion in the course of which the "formal," tailored garden that reached its apogee in seventeenth-century France was juxtaposed with the seemingly "wild" type known all over Europe as the "English Garden."[118] As Panofsky has reminded us in a delightful study, Shaftesbury had already taken part in that discussion, speaking out in favor of "all the horrid Graces of the Wilderness itself, as representing Nature more." Addison, criticizing artificial regularity, cites the Chinese who "choose rather to show a genius in works of this nature. . . ." Echoing the tradition of revolting against mathematical rules, he says that he "would rather look upon a tree in all its luxuriancy and diffusion of boughs and branches, than when it is thus cut and trimmed into a mathematical figure." He, too, distinguishes between nature and art. "If we consider the works of nature and art, as they are qualified to entertain the imagination," he writes, "we shall find the last very defective in comparison with the former; for though they may

appear sometimes beautiful or strange, they can have nothing in them of the vastness and immensity." But even he makes an attempt to bridge the gap, at least in some respect, between nature and art. In speaking of the pleasures of imagination, or fancy, he says, "I here mean such as arise from visible objects, either when we have them actually in our view, or when we call up their ideas into our minds by paintings, statues, descriptions, or any the like occasion."[119] The work of art, it would seem to follow from what Addison says, may be inferior to nature itself, yet it is capable of stimulating the rapture of the sublime.

When we look into the specific character of the Longinian tradition in England, Richardson's introduction of the Sublime into the theory of painting appears less out of context. The difference between the visual experience of nature and of the picture that represents a piece of nature is after all not an abysmal gap that cannot be bridged. But dealing with the sublime in the context of painting would seem to compel the author to be more specific about the practical meaning of the notions he is using. What indeed, in Richardson's view, is the Sublime in painting? Were we to take his theoretical formulations at face value, it would be difficult to find a clear answer to this question. His philosophical "definitions," as far as one may call them so, suggest that he was not too clear in his mind about what the sublime may actually signify in a painter's workshop. Were we to follow his abstract definitions only, we would have to understand the sublime simply as the excellent or outstanding, a degree of excellence rather than a distinct character or quality. In the preface to the second, enlarged edition of the *Essay,* Richardson declares, in a context that would suggest the sublime, the superiority of "a fine Thought, Grace, and Dignity" to "the Lesser, to the more Mechanical Parts of the Picture." The sublime is rather generally defined as "the most Excellent of what is Excellent, as the Excellent is the Best of what is Good." In other words, the sublime is just another rung in the ladder of achievement, it is some kind of a "superexcellent." In discussing the sublime in literature, Richardson seems to be a little more specific, suggesting some social and psychological characteristics that have an intrinisic orientation. Here he claims that the sublime is "the Greatest, and most Noble thought, Images, or Sentiments, Convey'd to us in the Best chosen Words." Nobility and

greatness are not just excellence; they have a specific character. But where Richardson provides abstract definitions of the sublime in painting, such character is lacking.

In coming closer to actual painting, Richardson's text gets more specific; it bears ample testimony to the various facets of that great transformation to modern thought that dominated the period. This becomes particularly evident in a small, seemingly technical detail. The reader is struck by Richardson's renunciation of the careful finish of the picture, a hallowed value in the workshop tradition. The sublime can be expressed, so it follows from what our author says, in a sketch, a drawing, or a finished picture. No preference is given to the completed work over the other forms, which for centuries were considered only as records of the creative process, not as its result. The craftman's pride in the fine polish characteristic of the finished picture was particularly strong in northern Europe. To see that this was still true in Richardson's generation, it is enough to recall what Gérard de Lairesse had to say about brushstrokes: the finished painting, ready to be taken out of the workshop and presented to the public, is that where no trace of brushstroke can be seen, where no vestiges remain of the process whereby the work was shaped.[120] Gérard was not being polemical in stressing this point, he was simply repeating what was an article of faith in the workshop mentality. When Richardson places—at least with regard to the sublime—the finished work on the same level as the sketch and the drawing, he undermines this mentality. In fact, earlier in the *Essay* the problem of the brushstroke and the final polish had already appeared. There Richardson treated it as a merely mechanical part of the painter's job; he has to adjust the brushstroke to the conditions under which the work will be seen.[121] In small pictures, meant to be seen from close by, brushstrokes should be delicate and carefully worked into each other, making for a surface that will be fine and smooth. In large-scale pictures, intended to be seen from a greater distance, the brushstrokes can be rougher, the workmanship more sketchy. These views, even if not always orthodox in their time, are still in accordance with the craftman's ethos. But what he says about the finish with regard to the sublime goes beyond that mentality, which had so stubbornly

persisted over many centuries. The present-day reader cannot help recognizing a specifically modern attitude.

Richardson's notion of the sublime in art is not easily derived from his definitions or general concepts; it is best grasped by looking at the pictorial examples he selects for review. He took his examples seriously, much thought going into selecting them. "I might have given examples to my Purpose from the Works of several other Masters," he writes at the end of a lengthy passage dealing with Rembrandt's *Hundred Guilder Print,* "but I made choice of This, not only as being at least Equally remarkable with the Best I could have found, but to do Justice. . . ." The example, then, represents a great deal of meditation. Its significance also follows from the fact that painting defies description. Who can describe with words, Richardson rhetorically asks, what Raphael, Guido Reni, or Van Dyck did with their brushes? To explain the sublime in painting, he also relies on works of art.

His first example is a drawing by Rembrandt, now in the Municipal museum in Bayonne, and identified as *St. Peter's Prayer before the Raising of Tabitha.* Richardson then owned the drawing, and from his description one can guess how often and carefully he contemplated it. (That he didn't get the iconography right is obvious). The artist, our author says, "has given such an Idea of a Death-Bed in one Quarter of a Sheet of Paper in two figures with few Accompagnements, and in Clair-Obscure only, that the most Eloquent Preacher cannot paint it so strongly by the most Elaborate Discourse; I do not pretend to Describe it, it must be Seen." Nevertheless he goes on to describe the major features of the composition. "An Old Man is lying on his Bed, just ready to Expire. . . . the Son of this Dying Old Man is at Prayers . . . (there is) such a Touching Solemnity, and Repose that these Equal anything in the Arts. . . ." The praying figure thinks: "Oh God! What is this World! Life passes away like a Tale that is Old." [122]

The other example Richardson adduces to illustrate the sublime in painting is Federico Zuccari's *Annunciation.* Neither the angel nor the Virgin is particularly remarkable, the author admits; but an indication of the sublime is found in the open space, in the vast sky in which God the Father and an infinite number of angels appear. It is obvious from

his description that it is not these heavenly figures that attract his attention, but the open vastness itself. Now, vastness has always been conceived as one of the constitutive elements of the sublime. In English literature, as Marjorie Nicolson reminds us in her stimulating discussion of the "Aesthetics of the Infinite,"[123] it is attributed to God. "Those distances belong to Thee," said the poet George Herbert in the early seventeenth century. "Magnificence, vastness, ruin," to follow Miss Nicholson's quotations, is particularly characteristic of the sublime. In the mid-eighteenth century, as we need hardly remark, Edmund Burke made vastness a definite category of the sublime. Richardson's focusing on the vast sky rather than on the participating figures in Zuccari's *Annunciation* has, then, a venerable ancestry.

On what does Richardson concentrate in his description of pictures, such as Rembrandt's drawing and Zuccari's painting? The question is not as odd as it may appear at first glance. We still do not have a systematic investigation of the structure and literary forms of the descriptions of paintings, and therefore any observation of changes occurring in that field is necessarily based on impressions. We shall however be not too far off the mark when we say that the major type of painting description (or *ekphrasis,* as it was called in Antiquity) relates the painting as an action performed or as an event taking place. This narrative structure of the description may to some extent go back to the Aristotelian formula that the objects of imitation are the actions of men; it was surely further promoted by the rhetorical tradition. Ever since the Renaissance it had been the central way of reading a picture. When we compare this pattern of description with Richardson's way of giving an account of a work, we cannot help feeling a certain shift of emphasis. What he describes is less a specific action than the general air pervading the painting, an intangible quality. Moreover, that general air is one that admittedly transcends the describable, such as the terror of death or the unlimited vastness of the open spaces. To be sure, Richardson was not the first author to use, or suggest, such qualities in descriptions of paintings. Even in the most typical Renaissance descriptions, such as those given by Vasari, one finds adumbrations of the ineffable. But a careful reading of Richardson leaves us with the impression that for him the hinting at the ineffable, the suggestion of what

cannot be fully portrayed, is the core both of paintings and of their descriptions.

NOTES

1. See, for example, Frank Manuel, *The Eighteenth Century Confronts the Gods* (New York, 1967), pp. 149 ff.
2. In the entry dated March 5, 1787, of his "Journey to Italy" Goethe writes about the *Scienza Nuova:* "In [his] fathomless depths the newer Italian legists greatly refresh themselves. Upon a cursory perusal of the book [Vico's *Scienza nuova*] which they communicated to me as a holy work, it seemed to contain sibylline presages of the good and the true . . ."
3. See B. Croce, *Aesthetic: As Science of Expression and General Linguistics,* trans. D. Ainslie (New York, n.d.), pp. 220 ff. (Chapter V). See also Croce's *Die Philosophie Giambattista Vicos* (Tübingen, 1927), p. 40. Somewhat similar views have also been expressed in British philosophy. See R. G. Collingwood, *The Principles of Art* (New York, 1958; original edition 1938), p. 138.
4. I am here following the distinctions proposed by Isaiah Berlin in *Vico and Herder: Two Studies in the History of Ideas* (New York, 1977), pp. 45 ff. See also R. Caponigri, *Time and Idea: The Theory of History in Giambattista Vico* (Notre Dame, Ind., 1953), esp. pp. 167, 173 ff. Discussions that are of value if our context may be found in the two volumes of *Vico and Contemporary Thought,* ed. G. Tagliacozzo, M. Mooney, and D. P. Verene (Atlantic Highlands, N. J., 1979).
5. The figures in parentheses, after quotations from Vico, refer to the number of the paragraph (not of the page), a system introduced by Fausto Niccolini in his 1953 edition of the *Scienza nuova.* This numeration has been taken over in the English edition. See *The New Science of Giambattista Vico,* translated by Thomas Bergin and M. Fisch (Ithaca, N. Y., 1968), from which all our quotations are taken.
6. M. H. Abrams, *The Mirror and the Lamp: Romantic Theory and the Critical Tradition* (Oxford, 1971; originally published in 1953), pp. 285 ff.
7. Quoted in L. Formigari, "Linguistic Theories in British Seventeenth Century Philosophy," *Dictionary of the History of Ideas,* ed. P. Wiener (New York, 1973), III, p. 75.
8. See Berlin, *Vico and Herder,* p. 104; Abrams, *The Mirror and the Lamp,* p. 285.
9. In *Scienza nuova,* 188, which corresponds to the passage just quoted, Vico speaks of a "golden Passage" in Lactance. And cf. Lactance, *The Divine Institutes* I, Chapter 15 (in *The Works of Lactantius,* translated by W. Fletcher [Edinburgh, 1871], pp. 40 ff.
10. Cf. my *Theories of Art: From Plato to Winckelmann* (New York, 1985), pp. 263 ff., for context and further literature.

11. For Montfaucon and other antiquarians, see below, pp. 43 ff.
12. See A. Momigliano, *Studies in Historiography* (New York, 1966), p. 19.
13. By Berlin, in *Vico and Herder,* p. 106.
14. By Francis Coleman, *The Aesthetic Attitude of the French Enlightenment* (Pittsburgh, 1971), p. 15. See also the brief characterization of Dubos in André Fontaine, *Les doctrines d'art en France: Peintres, amateurs, critiques de Poussin à Diderot* (Geneva, 1970; original edition, Paris, 1909), pp. 197–203.
15. A. Lombard, *L'Abbé Du Bos: Un initiateur de la pensée moderne* (Geneva, 1969; originally Paris, 1913), pp. 313 ff., carefully surveys the impact made by the *Réflexions critiques* on contemporary Europe.
16. *Theories of Art,* pp. 203 ff., 270 ff.
17. For reference purposes, I shall use the reprint Du Bos, *Réflexions critiques sur la poésie et sur la peinture* (Geneva, 1967). In quoting, I shall first give the page number of the reprint and then, in parentheses, the volume and page number of the original edition. The sentence just quoted may be found on p. 13 (I, 22).
18. Cf. Tertullian's "The Shows, or *De spectaculis,*" translated into English by S. Thelwall, *The Ante-Nicene Fathers,* IV (Ann Arbor, Mich., 1976), pp. 79–91.
19. *Réflexions critiques,* p. 14 (I, 26 ff.).
20. *Réflexions critiques,* pp. 13 ff. (I, 25 ff.). It is Section III of the first volume that is devoted to this problem and that lays out the fundamentals of Dubos's psychology of the spectator.
21. For a brief survey of Le Brun's theory, cf. *Theories of Art,* pp. 330 ff.
22. *Réflexions critiques,* p. 15 (I, 30 ff.). Dubos applies the words quoted to a tragedy by Racine, but since he speaks of Le Brun's painting in the very same paragraph, the statement obviously refers also to him. The precise formulation is worth quoting: "C'est, sans nous attrister réellement, que la piece de Racine fait couler des larmes de nos yeux: l'affliction n'est, pour ainsi dire, que sur la superficie de notre coeur."
23. *Réflexions critiques,* p. 14 (I, 29).
24. For Poussin's theory of *délectation,* see *Theories of Art,* pp. 324 ff.
25. The passage occurs in Quintilian, *Institutio oratoria* X,ii,11, and is quoted by Dubos in *Réflexions critiques,* p. 14 (I, 28 f.).
26. *Réflexions critiques,* p. 14 (I, 28).
27. Ibid., p. 120 (I, 451 ff.). This is Section XLIII, which bears the title "Que la plaisir que nous avons au Théâtre n'est point produit par illusion."
28. *Réflexions critiques,* p. 121 (I, 454 ff.).
29. Ibid., pp. 120 f. (I, 453 ff).
30. For Lessing, see below, Chapter 3, pp. 149 ff.
31. *Réflexions critiques,* p. 29 (I, 87).
32. Ibid., p. 113 (I, 424).
33. Ibid., p. 30 (I, 91 ff.).
34. Ibid., p. 31 (I, 96).
35. Ibid., I, Section XIII, pp. 28–35 (I, 84–112).
36. Ibid., pp. 110 ff. (I, 413 ff.).

37. Ibid., p. 111 (I, 414 ff.). Painting, Dubos says here, employs signs which "ne sont pas des signes arbitraires et institués, tels que sont les mots dont la Poésie se sert." I am not aware of any modern study of Dubos' concept of signs that would take into consideration the significance of the concept for the theory of painting at the time.
38. *Réflexions critiques,* p. 111 (I, 415) and p. 33 (I, 105).
39. Ibid., p. 111 (I, 414).
40. Ibid., p. 112 (I, 421).
41. *Institutio oratoria* VI, ii, 29–30.
42. Rensselaer Lee, *Ut pictura poesis: The Humanistic Theory of Painting* (New York, 1967) frequently refers to Dubos in the discussion of this well-known theme.
43. See *Theories of Art,* pp. 263 ff., for a brief summary, from the point of view of art theory, of the allegorical literature in the period between the late Renaissance and Dubos' generation.
44. Dubos presents his views on allegory in Section XXIV of the first volume of his great work. See *Réflexions critiques,* pp. 55–63 (I, 190–222). The definition of an allegorical figure is found at the beginning of the chapter, p. 55 (I, 191).
45. The "personnages allegoriques" of the first kind, he says on p. 55 (I, 192), are those "inventés depuis longtemps, et que tout le monde reconnoit pour ce qu'ils sont. Ils ont acquis pour ainsi dire, le droit de *bourgeoisie* parmi le genre humain" (italics in the original).
46. *Réflexions critiques,* 55 (I, 193).
47. Ibid., p. 58 (I, 203).
48. Ibid., p. 55 (I, 203 f.).
49. Ibid., p. 60 (I, 210).
50. Cf. Manuel's discussion of eighteenth-century religion and atheism (see note 1) and, particularly, A. Lombard, *L'Abbé Du Bos* (see note 15), pp. 53 ff.
51. For Pierre Bayle's influence on Dubos, see Lombard, *L'Abbé Du Bos,* pp. 53–68.
52. Though Shaftesbury is frequently refered to in histories of aesthetics, his contribution to the thought on art does not seem to have received sufficient study. This is particularly true of his views on painting and sculpture. Stimulating are Ernst Cassirer's views in his *Philosophy of the Enlightenment* (Princeton, 1951). For Shaftesbury's opinions on the artist and his creative imagination, cf. James Engell, *The Creative Imagination* (Cambridge, Mass., 1981). Grete Sternberg, *Shaftesburys Aesthetik* (Breslau, 1915), attempts a characterization of the individual arts according to Shaftesbury.
53. For Shaftesbury's theory of beauty, see mainly his *Advice to an Author,* passim, esp. Part 2, section 2, and Part 3, section 3. The edition used here is *Characteristicks of Men, Manners, Opinions, Times* by Anthony, Earl of Shaftesbury (1732), Vol. I, pp. 239 ff., 353. For the dangers inherent in beauty, see *Advice,* Part 1, section 2, pp. 183 ff.
54. Leo Spitzer, *Classical and Christian Ideas of World Harmony: Prolegomena of an Interpretation of the Word "Stimmung"* (Baltimore, 1963).
55. See especially *A Letter Concerning Design,* in *Characteristicks,* III, pp. 393 ff. Note

what Shaftesbury says on the artist's "liberty," pp. 402 ff. References to the artist's freedom are found in most of Shaftesbury's writings.

56. See *Theories of Art,* pp. 291 ff., with references to further literature.

57. See Soliloquy: Or, *Advice to An Author,* Part 1, section 3 (*Characteristicks,* I, pp. 207 ff.). For Shaftesbury's admiration of Prometheus, see also *The Moralists: A Rhapsody,* Part 1, section 2 (*Characteristicks,* II, pp. 192 ff., 201 ff.). To the question of why mankind has so many follies and so much perverseness, Shaftesbury replies (ironically): "Prometheus was the Cause. The plastick Artist, with his unlucky Hand, solv'd all" (p. 201).

58. See *Miscellaneous Reflections,* Miscellany IV, Chapter 1 (*Characteristicks,* III, pp. 189 ff., esp. pp. 192 ff.). See also *Advice to an Author,* Part 1, section 3, and Part 3, section 1 (*Characteristicks,* I, pp. 170 ff., 282 ff.).

59. See Shaftesbury's *A Letter Concerning Enthusiasm* (*Characteristicks,* I, pp. 3–55).

60. For the problem in general, see Samuel H. Monk, *The Sublime: A Study of Critical Theories in XVIII-Century England* (Ann Arbor, Mich., 1960; originally published in 1935). And see particularly pp. 164–202 for "The Sublime in Painting."

61. See Marjorie Nicolson, *Mountain Gloom and Mountain Glory: The Development of the Aesthetics of the Infinite* (New York, 1959).

62. See also her entries "Literary Attitudes Towards Mountains" and "The Sublime in External Nature" in *Dictionary of the History of Ideas,* ed. P. Wiener, (New York, 1973), III, pp. 253–260, and IV, pp. 333–337.

63. See *The Moralists,* Part 3, section 2 (*Characteristicks,* II, p. 396).

64. For the best survey of the problems raised by the historical phenomenon of the antiquarians, though seen mainly from the point of view of general historiography, see Momigliano's study "Ancient History and the Antiquarian" in A. Momigliano, *Studies in Historiography* (New York, 1966), pp. 1–39 (originally published in the *Journal of the Warburg and Courtauld Institutes* 13 [1950]: 285–315).

65. See *Illustrissimi E. Spanheimii . . . Dissertationes de praestanta et usu Numismatum antiquorum. Editio nova . . .* (Amsterdam, 1717).

66. Jacques Spon, *Réponse à la critique publiée par M. Guillet* (Lyon, 1679).

67. J. Addison, "Dialogues upon the usefulness of ancient models," in his *Miscellaneous Works,* III (Oxford, 1830), pp. 59–199.

68. The author was Fr. Bianchini. The work appeared in 1697.

69. For a brief but authoritative review of Baldinucci's work and significance, see J. von Schlosser, *Die Kunstliteratur* (Vienna, 1924), pp. 418 ff.

70. See Thomas Puttfarken, *Roger de Piles' Theory of Art* (New Haven and London, 1985).

71. *Idea of the Perfect Painter,* in Roger de Piles, *The Art of Painting and the Lives of the Painters* (London, 1706), pp. 67 ff.

72. *The Art of Painting,* pp. 68.

73. Though dealing with literature only, Andre Jolles, *Einfache Formen* (Halle a. S., 1930) can be productive for the theory of art as well.

74. See "Giovanni Morelli and the Origins of Scientific Connoisseurship" in Richard Wollheim, *On Art and the Mind* (Cambridge, Mass., 1974), pp. 177–201.

75. *The Art of Painting*, p. 70.
76. Richardson, Père et Fils, *Traité de la peinture et de la sculpture* (Amsterda, reprinted Geneva, 1972), I, p. 7 (p. 15 of reprint).
77. Christ's monograph was published in *Acta erudita et curiosa* (Nuremberg, And cf. Wilhelm Waetzoldt, *Deutsche Kunsthistoriker*, I, *Von Sandrart bis R* (Leipzig, 1921), pp. 45 ff.
78. A. J. Dezaillier d'Argensville, *Abrégé des vies des peintres* (n.p., 1745). Already 1768 a German translation appeared in print. And see André Fontaine, *L doctrines d'art en France* (Paris, 1909; reprinted Geneva, 1970), pp. 191–196.
79. For Hippolyte Taine, see below, pp. 320 ff.
80. Nicolas Pevsner, *Academies of Art: Past and Present* (Cambridge, 1940), pp. 140 ff.
81. For a modern assessment of Gérard's book, cf. Georg Kauffmann, "Studien zum grossen Malerbuch des Gérard de Lairesse," *Jahrbuch fur Aesthetik und allgemeine Kunstwissenschaft* II (1953): 153–196.
82. I quote from the French edition: Gérard de Lairesse, *Le grand livre des peintres ou l'art de la peinture consideré dans toutes ses parties, et demonstré par principes* . . . (Paris, 1787; reprinted Geneva, 1972). It will hereafter be referred to as *Grand livre*. Roman numerals refer to the book, Arabic to the chapter of the original edition; numbers in parentheses refer to the volume and page of the reprint.
83. *Leon Battista Alberti on Painting*, translated by John Spencer (New Haven and London, 1966), p. 43.
84. *Grand livre* I, 1 (I, 51).
85. Ibid., I, 1 (I, 55).
86. Ibid., VII, 1 (II, 133).
87. Ibid., I, 1 (I, 53).
88. *Nicolas Poussin: Lettres et propos sur l'art*, ed. A. Blunt (Paris, 1964), pp. 123–125. And see *Theories of Art*, pp. 329 ff., with additional literature.
89. Henri Testelin, *Sentiments les plus habiles des peintres sur la pratique de la peinture et sculpture mis en table de préceptes* (Paris, 1780). See *Theories of Art*, pp. 338 ff.
90. *Alberti on Painting*, p. 72.
91. See Jean Seznec, "Diderot and Historical Painting," in E. R. Wasserman (ed.), *Aspects of the Eighteenth Century* (Baltimore, 1965), pp. 129–142, especially pp. 129 ff.
92. For brief summaries of academic thought on the hierarchy of pictorial genres, see Fontaine, *Les doctrines d'art en France*, pp. 56 ff., and Karl Borinski, *Die Antike in Poetik und Kunsttheorie*, II (Leipzig, 1921), pp. 98, 101. And see also *Theories of Art*, pp. 342 ff.
93. *Grand livre* VI, 1 (II, 1): "La variété est l'âme du plaisir et la source des toutes les sensations agréables."
94. The three scenes are described in *Grand livre* VI, 12 (II, 59–83). For the description of the site, see pp. 59 ff.
95. Ibid., VI, 12 (II, 68 ff.).
96. Ibid., VI, 12 (II, 77 ff.). For the description of the natural scenery, see particularly p. 80.
97. Ibid., XI, 1 (II, 473 ff.). The sentence quoted is on p. 474.

ee Hegel's *Vorlesungen über die Aesthetik,* edited by Hotho (see *Hegel's Werke,* Vol. X, Part III [Berlin, 1831]), pp. 120 ff.

9. *Grand livre* IX, 1 (II, 315 ff.).

00. Ibid., VIII, 6 (II, 209–210).

101. Kauffmann, "Studien zum grossen Malerbuch" (see above, note 81), pp. 168 ff.

102. *Grand livre* XI, 1 (II, 473 ff.). For the definition quoted, see p. 474.

103. Meyer Schapiro, *Modern Art: 19th & 20th Centuries: Selected Papers* (New York, 1978), pp. 18 ff. The article from which the quotation is taken is Schapiro's well-known essay "The Apples of Cézanne: An Essay on the Meaning of Still-life."

104. *Grand livre* XI, 1 (II, 475).

105. Ibid., XI, 3 (II, 484 ff.).

106. Ibid., XI, 3 (II, 476).

107. Ibid., XI, 3 (II, 477 ff.).

108. Gérard de Lairesse devotes a special "book" to flower painting (*Grand livre* XII [II, 587–508]), something that was not common in this type of literature. Throughout the "book," he refers to the symbolic meaning of flowers and to the feasibility of conveying a message by the proper arrangement of flowers.

109. *Grand livre* XI, 3 (II, 480).

110. For Richardson's influence on the culture and art theory of his time, see G. W. Snelgrove, *The Work and Theories of Jonathan Richardson* (London, 1936).

111. Roger de Piles, *The Art of Painting,* p. 19.

112. I am using the French edition (see above, note 76). For the discussion of the sublime, see I, pp. 182–216 (pp. 59–67 of reprint).

113. *Longinus on the Sublime,* translated by H. L. Havell (London, 1953), Chapter XXXVI.

114. Roger de Piles, *The Art of Painting,* p. 19.

115. Samuel Monk, *The Sublime,* especially Chapter 1, pp. 10 ff.

116. See W. J. Hipple, *The Beautiful, the Sublime, and the Picturesque in Eighteenth-Century British Aesthetic Theory* (Carbondale, Ill., 1957).

117. See *The Works of the Right Honourable Joseph Addison,* (London, 1811), IV, pp. 336 ff, 340 ff. (*Spectator,* # 411 [June, 21] and # 412 [June 23]) 1712. And cf. Engell, *The Creative Imagination,* pp. 36 ff.

118. For the wider significance of the two garden types, see Erwin Panofsky, "On the Ideological Antecedents of the Rolls-Royce Radiator," *Proceedings of the American Philosophical Society* 107 (1963): 273–288.

119. Addison, *Works,* IV, p. 336.

120. *Grand livre* I, 1 (reprint I, 55).

121. Richardson, Père et Fils, *Traité de la peinture et de la sculpture* (Amsterdam, 1728; reprinted Geneva, 1972), I, pp. 131 ff. (reprint, p. 46).

122. Richardson, *Traité de la peinture,* I, pp. 204 f. (reprint, p. 64).

123. Marjorie Nicolson, *Mountain Gloom and Mountain Glory* (see above, note 61).

2

Beginnings of the New Age

What scholars call "periodization," that is, the division of the broad, continuous stream of history into "distinguishable portions," is the historian's task and burden. Students of all periods and ages will invest great intellectual effort and critical acumen in marking the "limits" of the periods they study, in establishing when and where they begin and end. It is particularly the "beginnings" that cast a magic spell, and the more so when the search is for the emergence of our own time and world. As we have already noted, in the limited domain of reflection on painting and sculpture, the new age began in the middle of the eighteenth century. In the opening pages of this book I have indicated that, to a fairly large extent, we can pinpoint the time and conditions in which modern art theory was born. Within a single decade, roughly between 1756 and 1767, ideas emerged and forms of reflection and study were shaped that decisively determined the thought on the visual arts for the next two centuries. Turning to this decade, we naturally have many questions. Where did the impulses for the new thought come from, and what were the conditions—social, cultural, institutional—that made it possible for the new ideas to develop? Did the various efforts undertaken during this short span have a common theme, or was it only their long-lasting effect, as felt over the centuries, that brings them together in our mind?

I. MENGS

Abstract theory and contemplation surely played a part in preparing the ground for a new reflection on art. The "founder" of modern aesthetics, the first author to speak of *aesthetica* as a field of experience and of study in its own right, Alexander Gottlieb Baumgarten, was a professor at a scholastic university—this at a time, one should add, when the university was not at the peak of its fame. Drawing upon the established tradition of systematic, though rather dry, reasoning, it is his historic achievement to have prepared the ground for an explicit philosophical discussion of the arts. The great impulses of creative renewal in the theory of painting and sculpture, however, came from different quarters, among them from the workshop of the practicing artist and from the studies and collections of the learned antiquarian and literary interpreter of ancient art. The interaction between these two types, the painter and the antiquarian, is magnificently represented by the close, if complex, relationship between A. R. Mengs and H. J. Winckelmann.[1]

The work of the two men was, at least in some respects, so closely intertwined that any attempt to decide who came first and who second, the painter or the antiquarian, is bound to fail. Let us for a moment recall some of the dates. In 1750, Baumgarten published the first volume of *Aesthetica,* in 1758 the second. Two years before the second volume could have reached the bookshops and its few but avid readers, Winckelmann published his first treatise, the slim volume that was to exert such a wide influence, the *Thoughts on the Imitation of the Greek Works of Painting and Sculpture* (1755). At about the same time, Anton Raphael Mengs (1728–1779), a German painter who lived in Rome, began writing down his reflections on the classical statues and Renaissance paintings that made the Eternal City a center of art. In 1762 these reflections were published as *Gedanken über die Schönheit und den Geschmack in der Mahlerey.*[2] The book was dedicated to Winckelmann, and Karl Justi, the great nineteenth-century Winckelmann scholar, declared that it would be difficult to separate the "insights of Mr. Mengs" from those of Winckelmann. Two years later, in 1764, the *History of Ancient Art* appeared in print. Winckelmann's fame has—rightly, one should say

—overshadowed that of many of his contemporaries, including Mengs. It may be useful, however, to make some acquaintance with Meng's theory of art before we approach the imposing work of Winckelmann.

In his notes, Mengs made several significant contributions to thought on art as it was known in his time. He was deeply concerned with art as a body of thought, and fascinated by the "painters-philosophers" *(Malerdenker)* of ancient Greece.[3] Art should be understood as a comprehensive structure, free from anecdotal as well as from merely individual elements. Having been asked to write a *vita* of the painter Tempesta, Mengs replied, on September 1, 1756: "We have enough *vite* of painters. To my mind it would be better to replace them by a history of art."[4]

But though Mengs, president of the Academy of Art in Rome, and a classicist painter famous throughout Europe for his murals, moves easily in the realm of art theory, that is, in the domain situated between purely conceptual, abstract notions of art and the actual execution of a painting on a canvas or a wall, his heart does not lie with merely philosophical deliberation. That he could not avoid such deliberations altogether probably resulted less from his natural inclinations than from the culture within which he was raised and was working. Eighteenth-century education in the arts involved a good deal of Platonic talk. Though we should not take such talk too literally, the impact of philosophical ideas on the artists' world cannot be disregarded. Mengs's attempts to cast the abundance of artistic forms, the variety of concrete styles into a theoretical pattern, into a comprehensive system of art, are typical of the interpenetration of concrete data and conceptual systems prevailing in the art and culture of the time.

In reading Mengs's reflections one observes that he has two systems rather than one. He makes extensive use of the concepts he inherited from Renaissance art theory, based on a system that in the fifteenth and sixteenth centuries was usually known as that of the "parts of painting." Mengs was following Renaissance tradition closely when he divided painting into five parts: drawing, light and shadow, color, invention, and composition.[5] What he has to say under these headings contains little that is new or goes beyond the limits of the Renaissance heritage.

His other system shows greater originality, and it bears the imprint of Mengs's own time. Here our author attempts to distill a few distinct

styles from the wealth of artistic impressions presenting themselves in Italy and to arrange them in some clear order. He conceives these styles as primeval patterns or aboriginal manners of depiction. Delineating them becomes a mapping of the basic possibilities of shaping art. Let us remember that Mengs does not arrange these styles in chronological order, nor does he try to show how one style may lead to another. Hegel's philosophical goal, to show that historical transformations are the manifestations of a conceptual structure, still lay in the distant future. The styles that Mengs discusses are all timeless possibilities of shaping the work, and the world, of art; they are always present, and therefore they coexist. In this trend of thought, Mengs also follows a late sixteenth-century model. Gian Paolo Lomazzo's allegorical Temple of Painting rests on seven columns. Each column, we remember, represents a painter, a style, a mineral, and so on. Since the temple rests on all seven columns, they are obviously imagined as coexisting. Mengs does not employ such images as the allegorical temple, but he envisages the different styles as simultaneous patterns. What, then, are these primeval styles?

The "high style" *(der hohe Stil),* possibly to be translated as the "sublime," comes first in Mengs's chart. It is in this style that elevated, or sublime, subjects are embodied and made available to our visual experience and intelligible to our minds. Mengs's reflections on the "high style" probably belong to the earliest discussions of the sublime by a painter and in the context of painting. He himself was a neoclassical painter, and so he naturally looked for ancient models. Yet, studying Greek and Roman paintings, he is struck and confused by what he finds. We just don't have ancient models for the "high style" in painting, he discovers. This is so, he explains, because what we have of Greek painting is fragmentary, and, in consequence, our mental image of that great art is not sufficiently clear. With sculpture the situation is different. Here Greek models have come down to us, and among them the *Apollo Belvedere,* particularly revealing. But Mengs is a painter, and painting remains at the center of his attention. He therefore goes on to show that what Greek painting does not give us, the Renaissance provides in abundance: examples and models of the "high style." Thus, in "modern art," Raphael has raised the "high style" to a level that

Mengs calls "the majestic." To the same category also belongs Michelangelo's work, displaying the quality of *terribilità*. Now, picking out these particular masters is not new, nor is Mengs's characterization of their styles original. What *is* new, however, is that Raphael and Michelangelo, instead of being juxtaposed as embodying "grace" versus *terribilità,* are now jumped together in *one* category, the one Mengs calls "high style." One cannot help feeling that the appearance of the sublime on the intellectual horizon of aesthetics involved a fundamental revision of the historical picture that had been accepted for centuries.

The "beautiful style" *(der schöne Stil)* is another of the primeval styles. In expounding it, Mengs relies, to a greater extent than in most of his other discussions, on traditional Neoplatonic ideas and literary imagery. Absolute perfection is unattainable by human beings, it rests with God alone; but God has impressed upon us the ability to perceive—and, by implication, to produce—a visible manifestation of that perfection. That manifestation is beauty. A work of art shaped in the "beautiful style," one is tempted to understand, both adumbrates the ineffable perfection of God and suggests the eternal human failure to achieve it. But how can one define beauty? It is harder to describe beauty than all the other characteristics that form the basis of various styles; actually one can only paraphrase it. It is interesting that, in trying to describe the "beautiful style," Mengs stresses highly subjective qualities. Works of art created in that style, he says, are delicate, gentle or mild, free from anything superfluous. The impression the reader obtains is that of a noble, gentle, and soothing harmony becoming an ideal of beauty.

What Mengs more specifically had in mind in speaking of the "beautiful style" we may guess by considering the examples he mentions. Annibale Carracci attains beauty in his depiction of male bodies, Francesco Albani in his rendering of female bodies, Guido Reni in his representation of female heads. As far as concrete, historical developments are concerned, Mengs's examples amount to a glorification of the academic trend in early Baroque Rome. In trying to present Mengs's proclamations in a conceptual form, one cannot help emphasizing the expressive, or suggestive, character of the beautiful style. Beauty is described not in terms of measurable proportions but in terms of pure, noble, and gentle qualities. One comes to the conclusion (which Mengs

himself may well have avoided) that what will ultimately determine beauty is the spectator's own experience.

There is still another kind of beauty, namely gracefulness. In Mengs's chart of styles this kind of beauty is represented by what he calls the "charming [or graceful] style" *(der reizvolle Stil)*. Now, the distinction between beauty and charm or grace, between *bellezza* and *grazia,* is of course a well-known one, often encountered in the history of art theory. Since Alberti, and particularly in the sixteenth century, it had become a permanent feature in doctrines of painting. There is, however, an important difference between Alberti, or even sixteenth-century authors, and Mengs. For Alberti and his followers, Beauty itself is conceived as an objective system of traceable, measurable shapes and proportions, and from this kind of beauty *grazia* is set off as a special kind of beauty, charming our eyes though it cannot be measured and traced. Does this distinction still hold true for Mengs, after he has in fact transformed Beauty itself into a quasi-subjective category?

Mengs describes the "charming style" by its expressive effects. Pictures painted in this style evoke pleasure and liking, the manner is light and lovely, the movements depicted are humble rather than proud. But, once again, one learns more about the style from the examples illustrating it. Among works of ancient art, the *Venus de' Medici* shows best what "graceful beauty" is; in "modern art," it is mainly Correggio's work that embodies this type of beauty. Here we should pause for a moment, and look at Mengs's attitude to Correggio. Except for Raphael, Mengs revered Correggio above all others; he is more strongly attracted by Correggio than by any other artist. Correggio is "the noon" of art, and ever since his death art has declined. What makes Correggio so unique? It is a little difficult to get a satisfactory answer from a literal reading of the text. Correggio, Mengs says, combines grace with greatness, daintiness (or elegance) with truth. What probably lies behind these rather general formulations is Mengs's fascination with Correggio's ability to convey the fullness and directness of live experience. Is this a somewhat dry academician's longing to attain the sensuality of Correggio? In any case, making Correggio the central exponent of the "charming style" suggests that the characteristic features of this manner, in addition to

lightness and humility, are strong sensory qualities and a direct, power-ful appeal to the beholder. Subjective elements, however formulated, become increasingly significant.

A fourth mode of painting is "the significant or expressive style." A literal interpretation of that label does not lead us anywhere. In the almost universal formulation in which it is presented—"significant or expressive"—this description fits a confusing variety of styles and movements in the visual arts, and one can apply it to almost every period in the history of art. To know what Mengs actually had in mind we turn to the masters our author evokes to illustrate his meaning. The central evidence for the "significant or expressive style" is found in Raphael's work. At first, this may seem a little surprising. We have just seen that Raphael's oeuvre illustrates the "high" as well as the "beauti-ful style." Obviously Mengs has different facets of Raphael's art in mind. But it seems that the "significant or expressive" is the major or typical feature in that venerated master's work. This indicates a certain shift of emphasis in the appreciation and reading of Raphael. For centuries, his art had been held up, described, and praised as the classic example of grace in painting. There can be no doubt that Mengs was intimately familiar with this characterization and with the time-honored prestige it enjoyed. Why then did he diverge from this model? The answer is that the meaning of the notions had changed. "Grace," or "charm," now carry the strong sensual overtones endowed by the choice of Correggio as an embodiment of this quality. Compared with Correggio, Raphael's art is solemn and even detached. It is the art of noble, significant expression. But Mengs is anxious to stress that Raphael's distance from immediate sensuality has nothing to do with the cold and empty intricacies of Mannerism. Raphael, he says, achieved the expres-sion of heart and soul *(Gemüt)* without succumbing to affection.

All this tells us, though by inference rather than directly, that the "significant or expressive style" largely overlaps with the heroic manner that the Renaissance recommended for history painting. To be sure, a Renaissance *istoria* was meant to include also what Mengs attributes to the "high style." Now, in mid-eighteenth century, after the sublime in art has come to be considered as a special category, "significant or

expressive" subject matter and mode of painting are restricted to heroic and dramatic art, but of a kind that does not attempt to suggest what cannot be represented.

The "natural style" is still another of the primeval styles. It is characteristic of the work of artists who render nature and reality "as they are," without trying to improve upon what we perceive in our regular experience. The obvious origin of this characterization is Aristotle's *Poetics*. As we remember, Aristotle outlines a hierarchy of the men whose actions are imitated in plays: "it follows that we must represent men either as better than in real life, or as worse, or as they are." And the philosopher himself compares this to painting. "It is the same in painting. Polygnotus depicted men as nobler than they are, Pauson as less noble, Dionysus drew them to true life."[6] By Mengs's time, this well-known Aristotelian distinction, repeated on innumerable occasions since the Renaissance, had become a trite, worn-out commonplace. From the literary formulation it would be very difficult to gather what Mengs had in mind. Again, it is only the examples that shed more specific light on the category. These are taken from two historical schools, Dutch seventeenth-century painting, particularly Gerard Dou, Rembrandt, and Teniers, and, even more so, Spanish painting, especially Velasquez.

In the assessment of Dutch painting a certain difference—perhaps a difference in tone rather than substance—between Mengs and Winckelmann cannot be overlooked. Winckelmann is less restrained in his criticism and outright rejection of Dutch painting. In his *Thoughts on the Imitation* he speaks critically of "Dutch forms and figures." In the subsequent *Sendschreiben,* he says, somewhat ironically, that the "so-called Dutch forms and figures" may not, after all, be altogether devoid of value. As Bernini used, and was useful, to caricature, so one may derive some advantage from what is seen in Dutch painting.[7] As compared to Winckelmann, Mengs is more restrained in his tone.

II. WINCKELMANN

The collected works of Johann Joachim Winckelmann, written within the span of barely one decade, between 1755 and 1767, constitute a nodal point in the evolution of Western ideas on art. They mark, and are part of, the turning point between the age that still followed the humanistic tradition as a matter of course, and the modern age dominated by the craving for originality and revolution. In the two centuries that have elapsed since his work began its triumphal march into European thought and letters, attitudes to Winckelmann have varied a great deal: some have praised him as the critic who established the study of art as an autonomous province, others have branded him, to borrow Miss Butler's phrase (to which we shall shortly revert), as the initiator of the "tyranny of Greece over Germany." All students will agree, however, that in his work the ages met, and, to no mean degree as a result of his work, that they parted. Since Alberti and Vasari, it can be claimed without hesitation, no other teacher, scholar, and writer has had a similar impact on reflection on the visual arts. Winckelmann's mark is clearly to be traced in a variety of domains. He is usually reckoned among the authors who shaped modern literary German; he was the pioneer and founder of modern archaeology; he had, mainly through Herder, an enduring influence on the writing of history; in his view of a culture developing "organically," through an irreversible series of periods, he adumbrated, and paved the way for, nineteenth-century historicism; in initiating the "Greek revival," he was a major force in determining modern taste; finally, he was the first author to write a book that in its title combines the terms "history" and "art," the *History of Ancient Art* (1764). These are only some of the domains that can rightfully claim Winckelmann as their own. It is not for us here to discuss the many different aspects of Winckelmann's personality and work. I shall only comment on his significance to the history of art theory.

Winckelmann's life has frequently been told, and there is no need to repeat the story. Born in 1717 into abject poverty in a forlorn, backward

Prussian village, he found his way to the summit of the refined European culture of his time, and of all ages. In 1755 he published his first composition, *Thoughts on the Imitation of the Greek Works of Painting and Sculpture,* and, eight years later, the *History of Ancient Art.* A few years afterwards, in 1768, he was murdered in a senseless incident.[8]

Let us now turn to our proper subject, and ask: may we legitimately treat Winckelmann in a discussion of art theory? Were we to tell the story of archaeology, of antiquarian studies, or of the history of art, the question would not arise. But we are here dealing with the particular field of art theory. What is Winckelmann's significance in the history of that discipline?

1. WINCKELMANN AND THE ART OF HIS TIME

Winckelmann did not start with the study of art, he ended with it. His beginnings, in actual life as well as in the structure of his intellectual world, were in the area of the word. Originally he was concerned with the Greek text (primarily of Homer), its exegesis and literary study. The places where he began his intellectual career—villages, small towns, and castles—did not have any art worth speaking of; it was only when he had already defined his way as a scholar and interpreter of the ancient world that he experienced, in Dresden, really great art, and even then it was almost exclusively "modern" art, mainly Raphael. It was only when he came to Rome that he encountered, and acquired a familiarity with, ancient art.

Seen from the vantage point of today, it may sometimes seem that the influence of Winckelmann's work radically differs from what he himself intended. It is primarily the academic world where his impact is most strongly felt and where his legacy is most keenly studied. (Here fate has played an ironic trick worth remembering: Winckelmann was inclined to ridicule professors and the academic establishment.) We consider him the father of archaeology and art history, a crucial figure in the history of numismatics, and so on. His own motivations and intentions, however, at least in the initial stage of his brief career, lay somewhere else. His aim was to bring about a radical transformation in the art of his time, a turnabout in the direction of artistic development.

This is most clearly seen in his first pamphlet, the *Thoughts on the Imitation*. Many of the passages in this influential fascicle make full sense when we read them as explicitly addressed to the artists of his time, as a theoretician's attempt to direct painters and sculptors in their work. One of his most famous sentences proclaimed: "The only way for us to become great, yes, inimitable, if it is possible, is the imitation of the Greeks."[9] This endlessly quoted pronouncement contains concepts that are firmly rooted in the tradition of practical and educational art theory as it had been practiced since the early days of the Renaissance. To be great, "if it is possible, inimitable," was the goal towards which artists had been educated since Leone Battista Alberti's day. Further, the creation of a work of art, or a comprehensive artistic opus, is carried out by way of imitating models—this would have been taken for granted by everyone holding a brush or a chisel in his hands. Addressing the artist in such a way could have had one meaning only: it was an attempt to change the character of the work of art.

In his attempts to influence practicing artists and to change the direction of their development, Winckelmann did not remain in the realm of generalities. Throughout the *Thoughts on Imitation,* and in a more general sense in his whole work, he both criticized artists who represented styles he had rejected and held up for emulation a new model to contemporary painters and sculptors. Criticism of the rejected and presentation of the new model praised as the embodiment of perfection are of course two sides of the same action. They both show that Winckelmann was not content with theorizing; he wished to bring about a change of direction in the art of his age.

Winckelmann's strictures are sharply focused; at their center stands Bernini. He disapproves of other artists as well, mainly of the seventeenth century, such as Jordaens (and Dutch painting in general) or Caravaggio. But it is primarily in association with Bernini that the principles of art are discussed. We must therefore ask what arouses this dislike of Bernini. Now, Winckelmann never doubts the virtuosity of the great Baroque sculptor, he never questions the master's miraculous ability to translate into stone or bronze what he has in his mind or perceives in nature. The reason for his censure of Bernini is the sculptor's very conception of art. It is because of what he *wants,* and

therefore also manages, to represent that he is condemned. The various specific reproaches can be reduced to one basic argument: Bernini is the artist of extreme subjectivism.

That subjectivism has many facets. One of them is the addiction to an illusion-creating sculpture, another is the fascination with images produced by chance, by an insignificant combination of circumstances. Bernini, Winckelmann believes, effaces the line of demarcation between nature and art. Quoting Baldinucci, Winckelmann asserts that, in Bernini's view, nature can provide all the beauties. "He prided himself on having lost his preconceived opinion of the superiority of the Greeks, which he had originally held because of the beauty of the Medicean Venus, when after thorough study he discovered the same beauty in nature itself." [10] In Winckelmann's view, a modern scholar has said, Bernini is the "Antichrist." [11]

The dangers of such subjectivism can be appreciated when one realizes how strongly it appeals to the young. In lively, evocative terms Winckelmann describes the taste of the young artists of his time. "Nothing earns their applause but exaggerated poses and actions, accompanied by an insolent 'dash' that they regard as spiritedness, or 'franchezza,' as they say. Their favorite concept is 'contrapposto,' which to them is the essence of everything that makes for artistic perfection. They want their figures to have souls as eccentric as comets; to them every figure is an Ajax and Capaneus." [12] It is perhaps because of these tendencies in the art of his time that Winckelmann approaches Baroque art as if it were the art of the present. Bernini, who, as we know, had been dead for over two generations, is considered a contemporary, and a dangerous one at that. It is this feeling of the immediate presence of the past that gives Winckelmann's argument a particular urgency, and turns it into something more than an academic affair.

What remedy has Winckelmann to offer to the artists of his time? His reaction to what he found in contemporary art is typical of the great tradition of art theory that was the legacy of the Renaissance. He does not concentrate on individual fallacies—or "errors," as they were then called—nor does he suggest individual remedies for these errors. Not even specific, well-outlined corrective methods are proposed, such as certain types of drawing, systems of coloring or carving. What our

author presents to the artists of his time is an inclusive ideal of art and culture. "Now the purest sources of art are open; fortunate he who knows how to find them and to taste them. To seek these sources means to go to Athens. . . ."[13]

By holding up the Greeks as the redeeming model, as "the purest sources" of art and culture, Winckelmann affected not only the art of his time; he initiated, and to no mean degree helped to bring about, a revolution in the image that had prevailed for centuries. To Europe, from the Middle Ages through the Baroque, the image of Antiquity was clearly Rome-centered. Centuries of ecclesiastical policy, of pilgrimages and legends, of sacred historiography and cultural activities in a variety of fields had gradually built up this image. Ever since the Renaissance, the same view had also been explicitly valid for the historical development of the arts. A glance at Vasari is sufficient to show that for him and for his audience it is a matter of course to consider Roman culture and Roman art as the ultimate achievement of Antiquity. *Rinascimento dell'antichità,* it goes without saying, is the revival of Roman antiquity and Roman style. This vision of Antiquity persisted in the seventeenth century, and it became crucial in the eighteenth. Montesquieu and Gibbon attest, if any testimony be needed, how central the Roman past and the Roman model are for their views of society and history. In 1725, Giambattista Vico claimed, without hesitation and without contradiction, that it was the ancient Romans, not the Greeks, who were the heroes of the ancient world.

At the very time that Winckelmann was praising Greece as the climax of ancient culture, the veneration of Rome, specifically in its role as the embodiment of *antichità,* attained a unique artistic expression. Since the 1740s, the architect and draftsman Giovanni Battista Piranesi had been singing the praises of ancient Rome in his engravings. His *Vedute di Roma* brought the grandeur of ancient Roman monuments to educated collectors and readers all over Europe. In 1756, almost exactly at the moment when Winckelmann's *Thoughts on Imitation* became available to the very few readers for whom it was originally destined, Piranesi published his *Antichità romane,* and in 1761 the splendid *Della magnificenza ed architettura de' romani* reached the markets. In these publications Piranesi defended the patriotic claim that *decoro e gravità*

are genuine Roman qualities, that they are the result of the Roman affinity for the sublime, and that they were known to Roman culture before the Latins even encountered the Greeks.[14]

It is against this background that we should weigh Winckelmann's claim that the true sources of originality and greatness in art are to be found in Greece, and that Roman art is derivative. "A statue by a Roman master compares with its Greek prototype as Virgil's Dido compares with Nausicaa of Homer on whom she is modelled."[15]

Here two questions arise and must be answered before we can understand the depth and significance of Winckelmann's work. Both questions are simple. One is: what was it that made Winckelmann search for specifically Greek art? The other is: what did he find in this search? What are the central features of Greek art, as he saw it?

The first question, obvious and uncomplicated as it appears to be, has received rather scant consideration from modern scholars. Yet what Winckelmann did by shifting his attention from Rome to Greece was not only unusual at the time; it was of great consequence in overturning a historical construction that had been hallowed for centuries. Why did he change the model of Antiquity? Were he simply a historian, intent upon finding out the "true facts," wishing to establish the correct precedence of Greece over Rome, it would be easier to explain his attempts. But Winckelmann was not in the first place a historian. As we know, he came to writing history long after his gaze had been firmly fixed on the model character of Greece. In his *Thoughts on Imitation* he clearly described Greek art as the dominant, actually as the single, model of perfection; here classical art does not even seem to have any history. The *History of Ancient Art,* where he follows the development of classical art, was written only years later. Winckelmann's turning to Greece cannot be satisfactorily explained by the historian's interest alone. His attempt, so fully vindicated by the scholarly work of subsequent generations, to replace the inherited Roman paradigm by a Greek model of perfection raises interesting questions also with regard to his personal motivations. His attitude to the Roman legacy was ambivalent. On the one hand, he was fascinated by the tradition, he loved the city of Rome because in it the great past was alive. On the other hand, his life's work amounted to a heroic endeavor to supersede the Roman by

an "original" Greek culture and artistic tradition, and he never stopped dreaming of visiting Athens, a dream that he never realized. Psychologists, one cannot help thinking, would find Winckelmann's aborted attempts to reach Athens an interesting case of internal conflict. The exaltation of Greece is hard to understand without feeling an ambiguity in his approach to Rome.

That Winckelmann was attracted to Rome, to the city and to the culture, needs no explanation; that there was an ambiguity in this relationship, however, does. There could have been many reasons for this implied criticism of the Roman model and its influence on the art and thought of Europe. Winckelmann's work, as a modern scholar has pointed out,[16] betrays a certain outrage against the despotism of the *ancien régime*. Now, both the regime and its despotism drew their legitimation from a Roman imperial model. The rejection of modern despotism may have affected also the sources of legitimation. Rome was likewise intimately linked with the Christian tradition. It was the *Roman* Catholic Church that dominated not only the Middle Ages but also the kingdoms of the present. Much has been said against a too narrow interpretation of what has been called Winckelmann's "paganism,"[17] but one wonders whether his turning to a pre-Christian culture did not, after all, imply a criticism of Rome. Winckelmann may also have felt that there was a certain affinity between a mainstream in ancient Roman, particularly imperial, art and the art of the Baroque. Was it not possible, after all, that Bernini drew from deep roots in the artistic tradition of his city? Nothing of this is explicitly stated in the writings, but the attentive reader often cannot avoid feeling these, or similar, thoughts lurking behind Winckelmann's text.

Turning to Greece, one should not forget, was not an altogether personal affair of Winckelmann's. Interest in the Greek component of classical culture began to stir in Winckelmann's time, particularly in France and in England. "The Greeks were the teachers of the Romans," Diderot remarked to Catherine the Great, and, on another occasion, he said that Thales was the first thinker who "introduced method into philosophy, and [he] is the first to deserve the name of philosopher."[18] Voltaire listed the original contributions of the Greeks: "Beautiful architecture, perfect sculpture, painting, good music, true poetry, true

eloquence, the method of writing good history, finally philosophy itself, however incomplete and obscure—all these came to the nations from the Greeks alone." [19] There was also a beginning of interest in the aesthetic aspects and artistic remains of Greek culture. In 1762 appeared the first volume of the magnificent publication *Antiquity of Athens,* a collection of drawings that brought views of the great Greek monuments to the awareness of the learned in Europe.

Winckelmann's conjuring up of Greek antiquity, one cannot help feeling, has a certain affinity to the presentation of a utopian vision. It goes without saying, I think, that our author was not aware that he was distancing his vision—to a certain extent, at least—from actual reality; surely he did not intend anything like this. Yet in spite of his lack of intention and awareness, his image of ancient Greece cannot be denied a certain utopian quality.

The undercurrent leading to the displacement of the Greece he saw in his mind from everyday, terrestrial reality can best be felt in his descriptions of ancient works of art as "sacred." Greek statues, the reader of Winckelmann's writings feels again and again, mysteriously partake of the sanctity of their sacred sites, so much so that, in fact, they carry some vestiges of that holiness into the museums where we now see them. It is of course difficult to draw a sharp line of demarcation between an outright metaphor and a statement whose literal meaning may be called in question. Thus, when Winckelmann says that Greek images of the "god and heroes are as if standing on sacred spots where silence dwells," how are we to understand this assertion? To appreciate what Winckelmann says we probably have to consider, and grant significance and weight to, that ill-defined area between metaphorical forms of expression and statements meant to be understood literally.

The sacred, in a sense nonterrestrial, character of Greek statues is strongly suggested by the recurring request for awe and silence in their presence. The appropriate way of looking at a Greek figure is that of a semisacred contemplation. Time and again, Winckelmann emphasizes, as the German literary scholar Walter Rehm has clearly seen, the silence and stillness surrounding the beautiful figures of an Apollo or an Aphrodite. Silence, in general, becomes a condition of a supernatural

beauty and perfection. Grace, the active form of beauty in human experience, he says, works "only in the simplicity and silence of the soul."[20]

Another ambiguity, more difficult to pin down but possibly more important than other features, cannot be ignored. Winckelmann holds up Greek antiquity as an ideal model for imitation. But how is the modern artist supposed to imitate this ideal hovering in a slightly unreal world and beyond his reach? Where should he start with his imitation? Which particular features or aspects is he being asked to assimilate? The careful reader notes something of a paradox. While Winckelmann presents ancient Greek art as a model for imitation, he almost completely lacks any didactic approach. He does not try to give practical assistance to the contemporary artist who would strive towards the ideal vision of mythical Greece. In this respect, I believe, he departs from the Renaissance legacy. Artists and teachers in the Renaissance also had an image of a Golden Age which they made a model for emulation. Yet to facilitate imitation, they analyzed their ideal model, they tried to isolate "principles" or "parts." Winckelmann did nothing of the kind. One cannot help wondering how he thought a modern artist was supposed to emulate what he was being shown as an ideal. Winckelmann's Greece is a divine revelation rather than a didactic model.

2. THE "CLASSICAL"

In evoking Winckelmann's work one cannot help also raising the thorny, elusive, and yet unavoidable, problem of the classical. It is Winckelmann, after all, who is generally considered as the principal founder of classicism (or Neoclassicism, as some would like to call it) in the modern world. In aesthetic reflection, there is probably no term that has been so frequently and so indistinctly used as "the classical." As a result, the so-called classical has become a Protean notion, lacking precise meaning. Surveying the literature, one sometimes wonders what has not been considered, at one point or another, as being, or belonging to, the essence of the classical. It is not for us here to attempt to cut a path through this labyrinthine wilderness; we shall not offer still another

description of "the classical." But we shall try to look into some of the major contexts in which the notion appears in Winckelmann's thought.

Let us begin with a brief glance at a distant past. Ernst Robert Curtius, the great scholar of literary traditions, has reminded modern readers how the term classicism originated and that the term *classicus* appeared for the first—and, in Antiquity, the only—time. It was a Roman author of the second century A.D., Aulus Gellius, who used (or coined) it (*Noctes Atticae*, XIX, 8,15). When in doubt as to how to use an expression, he suggests, follow a model author: "Some of the orators or poets, who at least belong to the older band, that is, a first class *[id est, classicus]* and tax-paying author, not a proletarian." Here "classical," though associated with tax paying, has the function of the model. The idea lived on in one form or another, but the word did not achieve wide currency and did not acquire its specifically modern terminological meaning until fairly recent times.[21] In the case of great historical or cultural units, such as "the Greeks," it has been applied only in the last two centuries. Thus, partly as a result of Winckelmann's work, around 1800 people began using the term "classical philology," and, a little later, "classical archaeology."

In considering Winckelmann's attitude to the classical, we should begin by making a simple statement: so far as I can see, Winckelmann never used the term "classical." Though he is deeply involved with the idea of the classical, he did not coin, nor did he take over, a particular term to designate this idea. It would be idle to speculate on the reasons —and they may have been various—for this omission. Yet whatever they were, it is certain that Winckelmann was sufficiently aware of the complexity and multivalence of the phenomena grouped together in what we call the classical that he could not file them under a single heading. Instead of using such conceptual terms as the classical, Winckelmann, as a rule, employs concrete, historical words or phrases to define what he means. Thus he speaks of "the Greeks," or of "the ancients." Even where he uses the more general formulation, he has specific groups in mind: Athenian artists, or the Greeks. Often, in fact, Winckelmann uses the *idea* of the classical in a modern sense: artists belonging to different periods of history are grouped together in the same category; the Greeks and Raphael are considered representative of

the same type or model. Yet even in this case he does not designate them by a common term. This characteristic feature of Winckelmann's terminology may tell us something about his views and ideas. He never conceived of the classical as of an abstract category. What he considered classical was always something that happened in history, in a specific place and time, in fifth-century Athens or in sixteenth-century Rome. It is part of a historical reality.

This is not the whole story however. While Winckelmann never altogether detaches the classical from history, he endows it with qualities and functions that are not completely drained off into history. Though the phenomena called "classical" unavoidably occur at a given place and time, they possess something that we should call, unashamedly, a timeless essence. The classical is not only a historical tradition, it is also a superhistorical epiphany. Here, too, Winckelmann has no special term. Nevertheless, he expresses himself clearly. He not only tells the story of Greek art, he also wants to explain what it is that makes Greek art so great. Before we can deal with the specific contents, the concrete characterizations of classical art in Winckelmann's work, we must briefly survey the major contexts of the classical in his thought, of the reasons for its being a model.

The classical, whatever else it may or may not be, has for Winckelmann the quality of the primeval, the aboriginal beginning. To be sure, this beginning is not to be understood as the origin in a purely chronological sense. Winckelmann knew, of course, that history did not start in Greece. In his *History of Ancient Art* he naturally devoted the first chapters to the art of Egypt and the ancient Near East, the great historical divisions that preceded Greek culture in time. Nevertheless, it is Greece, as follows from his text, that marks the real beginning of art. Why, and in what sense, is this so? To put it as briefly as possible, our author understands the notions of "beginning" or "origin" as the primary casting of molds for artistic creation in general. Egyptians and Phoenicians, Persians and Etrurians—this is how Winckelmann names the cultures preceding the Greeks—are in a way considered as special cases. Universality, at least in the sense of providing models for further creation, begins with Greece. It was the Greeks who articulated the central motifs and patterns in all major fields of thought and human

creation. In doing so, they opened up the continuity of culture in which we have been living ever since. Greek art had its significant part in the process. As Greek mythology established an inexhaustible repertory of themes and variations, so Greek art coined types that seem to be inexhaustible in variety and "eternal" in duration. One of the crucial features of the classical is its archetypal nature.

Encountering the aboriginal beginning in Greek art became for Winckelmann also a personal experience, which he often forcefully expressed. "A few days ago," he wrote once to a friend, "there came to light a head of Pallas that in beauty surpasses everything that a human eye can see, and that can come into a man's heart and thought. I remained stupefied as I saw it." [22]

Another contest of the classical, related to the archetypal yet in a sense opposed to it, may most appropriately be termed "canonical." The notion and term of "canon" originated, as one knows, in the field of law. From that origin it may have inherited, and still carry, certain legal connotations. Yet the term is applied to many fields. For Winckelmann it has a particular significance.

A canon consists of a limited number of models presented for imitation, application, or following. These "canonical" models, according to the nature of the domain, may be sacred texts, ancient laws, or almost any other articulation in a central domain of belief, behavior, or creation. Yet however varied they may be with regard to their nature and material, they have two basic characteristics in common: first, they are specific, distinct, and self-enclosed units. It is essential for the canon that it not be a general idea, but a series of individual paradigms. Second, the canonic models are considered as binding, their validity is not disputed. Whether there is an intrinsic order among the paradigms, thus forming a system, is a matter that need not detain us here.

A model for imitation is the cornerstone of tradition. Curtius has described in detail how the traditions of medieval learning, medieval law, and modern literature were obliged to form their respective canons in order to persist as traditions. [23]

Winckelmann's approach to Greek art conspicuously leans towards the formation of a canon. He approaches this undertaking in two ways. The first task Winckelmann set himself in Rome, so he tells us, [24] was

to describe the statues in the Belvedere. Not everything placed in that *cortile* was to be covered. Our author specifies four statues that he meant to include, and to reproduce, in his description: the famous *Apollo,* the *Laocoön,* the so-called *Antinoüs,* and what is known as the *Torso Belvedere.* He chose these pieces, he says, because they embody the "utmost perfection of ancient sculpture." The description, we further learn, was to be arranged in two parts: the first "with regard to the ideal, the other according to art." Translated into modern terms, this means that Winckelmann wished to treat the idea, or intention, behind the statues, and how that idea was executed in hard stone. This task however, he writes, proved beyond his ability.[25] Whatever the fate of this intended project, it clearly manifests the intention of severely selecting masterpieces so that they form a canon.

Another way to arrive at the articulation of a canon was to recount the whole history of ancient art. The reader witnessing Winckelmann unfolding the broad panorama of the history of ancient art sometimes feels that he is participating in a great enterprise that to some extent resembles the process of distillation: in the end he is left with a small group—a cluster, one might almost say—of select works of art. These works, in fact all statues, do not so much illustrate the different stages of ancient art; they are rather models of perfection, meant to show what it is that makes Greek art so great. It is, of course, not a matter of chance that these exemplary works are so closely interrelated, and that the list of works arrived at by surveying the history of Greek art actually overlaps the list of works our author earlier called individual models of perfection. Again we hear of the *Laocoön* and the *Apollo* from Belvedere, as well as of the *Lizard Killer* and the *Venus* of the Medici collection. The study of the history of Greek art, one might say, is a canon-producing process.

3. IMITATION

The archetypal and the canonical are not self-enclosed. They involve later developments and they presuppose an audience that has an articulate attitude towards the classical. Nothing is archetypal without the existence of later stages that fully and in many variations express what

was contained in the first *(arche)* formulation of the type, and without later cultures that consider that early formulation as archetypal. The same truth is even more obvious with regard to the canonical: without a society accepting certain laws or models as perfect and binding, there can be no canon. In the concepts of archetype and canon, past and present meet and interrelate in intricate and often tortuous ways. This relationship of the present to the past is manifested in many different ways. With regard to art and artists, it is best revealed in what we call imitation.

What "imitation" originally meant, at least in the Renaissance and Baroque, is nowadays often obscured. The reason for this obfuscation is that in our time the concept is frequently placed in a context that differs radically from that in which it originally appeared. We often hear of the "imitation of nature," mainly in attempts to provide foundations for realism. But in the centuries preceding Winckelmann, the centuries from whose literature he drew, *imitatio* was primarily used in a different context. For Renaissance and Baroque critics and men of letters the term denoted the faithful following, the "imitation," of literary and artistic models.[26] One does not have to go into a thorough discussion of imitation in order to see the difference in character and meaning of the notion that results from placing it in these two different contexts. As a model, nature is less clearly articulate than a work of art; it allows the artist, or forces him into, more choice and variation than, say, does a statue. Imitating works of art, it goes without saying, is more conducive to forming a tradition than is the imitation of nature. This is also how Winckelmann understood "imitation," and how he used the term.

On the title page of his first publication, we remember, Winckelmann uses this word. The careful reader notes, without being really surprised, that never is nature, a real object, or a live figure presented as a possible model for the artist's imitation. What is proposed to him are the works of art that form part of the canon. Moreover, for the artist the imitation of canonic works of art is more fundamental than, and precedes, the imitation of nature. The awareness of form acquired in the imitation of works of art is a condition for detecting forms, shapes, and features in nature. Without being instructed by the canonic

Beginnings of the New Age

works of art the artist would be blind to the shapes hidden in nature. In Winckelmann's dispute with the artists of the Baroque, he makes the point that without the Greeks we could not perceive the beauty in nature. It was in the statue of Venus, he says, that Bernini first perceived those beauties that he later discovered in nature. Were it not for that initial experience, Bernini "would not otherwise have sought [those beauties] in the realm of nature." This is so because "It is easier to recognize the beauty of Greek statues than the beauty of nature." [27] The concept of imitation is essentially a cultural one, and it creates a universe of culture.

Scanning Renaissance literature, one may get the impression that the authors conceived of *imitatio* as of a simple, monolithic concept. Closer reading, however, shows us that this is not the case. It will be useful for us to distinguish, in an altogether summary fashion, three major variations of the notion in the thought that the Renaissance bequeathed to later times.

The first type of imitation is based on a ceremonial veneration of the ancient model, of *sacrosancta vetustas*. This "sacramental imitation," as Thomas Greene has called it,[28] by its very nature prevents the creation of new and dynamic forms. In principle at least, no change of the model is envisioned. Imitation is seen as a faithful and precise replication of the original.

In the second variation of the notion, the heritage of the past — that is, the models — is considered as a huge repository of forms and motifs, a vast container from which the artist can freely chose whatever he needs. The model chosen has only a limited influence on the imitator. It is he who selects and combines from the legacy of the past.

A third variation of imitation, in itself rich in nuances, is one in which the imitator is aware of the distance between himself and his model; he does not entertain the illusion that he can reproduce it with precision, but he also knows that he cannot step out of this relationship to the past, that he cannot treat his model as just "material," to be handled at will. His relationship to imitating is not an innocent one; it is based on the awareness of the model's otherness and specificity, but also of its exemplary character. This kind of imitation combines the model's power to impose on the present an overall structure or direc-

tion, and the imitator's freedom to develop and create what was implied in the model. In this dialectical view, imitation is both a following of the past and a new creation.

This, in the broadest of outlines, was the framework that history provided for Winckelmann's thought on artistic imitation. What is his own view? To him, only the third variation can be called imitation, and it is only this kind that he has in mind when he speaks of imitating the Greeks. He does not conceive of sacramental replication as an artistic activity. "As against one's own thought I put copying *(Nachmachen)*, not imitation. By the former I understand slavish following; in the latter, what is imitated, if handled with reason, may assume an other nature, as it were, and become one's own."[29] Here one can clearly see the difference between medieval and modern thought. In the spiritual world of the Middle Ages, the more precise an imitation is the better it is. For modern man, the creative act should manifest itself even in imitation. It is therefore not surprising that the same Winckelmann who makes the imitation of the Greeks the highest achievement possible to the present world should also treat literal copying in derogatory terms.

Winckelmann does not speak at length about the second variety of imitation, that which considers the past as a warehouse of ready-made motifs and formulae. That he must have been opposed to such an interpretation goes without saying. Time and again he stresses the idea of the whole, of the comprehensive pattern in Greek art, considering this an essential quality of its model character. "The notions of the whole, of the perfect in the nature of Antiquity will purify and make more sensual the notions of the divided in our nature."[30] In Winckelmann's thought, wholeness and perfection are almost overlapping notions. Emphasizing the wholeness of the Greek model is probably the beginning of that trend of thought, so dominant in German classical thought and literature, that rejects the fragmentary, even if it is fascinating. Winckelmann is very far from the romantic's concern for the fragmentary and the incomplete.

What, then, is the object of imitation? What is the modern artist asked to imitate if he follows Winckelmann's advice and takes works of Greek art as his models? The emphasis on wholeness imposes on the modern student an observation concerning our author's personal conditions. Winckelmann spent most of his life looking at fragments,

studying works of art that reached him in an incomplete, damaged condition. Amidst all these broken pieces (parts of which populate our museums) he cultivated in his mind the idea of an idealized, unharmed perfection, a wholeness that belies the destruction caused by time. One is tempted to sense here another utopian streak in Winckelmann's intellectual and psychological makeup. But how, one must ask, are we to discern perfection and wholeness in works of art that have almost invariably reached us as fragments?

In grasping the wholeness hidden in fragmentary pieces of sculpture, there is little difference between the spectator who experiences a work of Greek art and the artist who imitates it. The original whole, it goes without saying, is not directly available to either of them, but it can be recreated by both the spectator and the artist. But what specific "object" are we to recreate? What Winckelmann thinks we should recreate—both as spectators and as artists—is the original intention of the artist who made the work. That intention can be divined even from a small fragment. Here Winckelmann presents what is sometimes called the *ex pede Herculem* theory: from the small fragment of a piece of classical sculpture we can divine the whole figure, and, what is more, the image that originally dwelt in the artist's mind. To recapture that elusive image is the aim of Winckelmann's cognitive and artistic efforts.

4. BEAUTY

The exploration of Winckelmann's thoughts about imitation brings us to his notion of Perfect Beauty and the Ideal. The Ideal or Beauty is a notion difficult to define, particularly as used by a writer like Winckelmann who was not a philosopher. He used the term frequently—both as a noun and as the adjective *"idealisch"*—but nowhere did he define it; as with other concepts in Winckelmann's thought, one has to learn its meaning from the context. It may therefore be best to describe the Ideal by setting it off from what it is not. The Ideal, we know, is first of all opposed to the natural, to the precise imitation of the shapes that we encounter in everyday life. Yet it would be wrong to conclude that Winckelmann tends to attenuate the Ideal into a mere intellectual notion or *idea,* that he wants to transform it into a kind of image in the mind. On the contrary, it is essential for the Ideal that it have a full

material nature, that its presence is unrestrictedly felt, even though under conditions that may seem scarcely attainable.

The philosophical status of the Ideal, or of Perfect Beauty, need not worry us too much. Winckelmann himself was not overly concerned with the theoretical status of the notion, and his writings will easily yield contradictory statements on it. What is more important for our purpose is what Ideal or Beauty actually mean in his work. It is the material specifications that count here. We must therefore ask what he saw with his mind's eye when he spoke of absolute beauty and of the ideal. What are the specific qualities he ascribed to this crucial notion? In trying to answer this question we are on firmer ground than in an effort to define notions of abstract methodology.

In attempting to describe the actual contents of the Ideal, or of Perfect Beauty, Winckelmann is aware that he is aiming at something that is perhaps beyond man's reach. In the part of his *History of Ancient Art* devoted to analyzing the reasons for the superiority of Greek over the art of any other time and nation, he dwells on the difficulties of describing beauty. "It is easier," he declares, "to say what it is not than what it is." And a few lines later, he admits: "Beauty is one of the great mysteries of nature." [31] Winckelmann's understanding of Absolute Beauty is in essence based on rejecting any specific qualities as proper descriptions. What he says of the experience of ideal beauty is comparable to some mystics' account of their experience of God. As the mystic striving to reach God by describing the divine attributes must finally conclude that all qualifications only falsify the divine source, so Winckelmann trying to describe the specific qualities of Ideal Beauty must eventually conclude that this Beauty is ineffable and cannot be captured in distinct categories. An essential attribute of lofty beauty, he tells his readers, is the absence of individuality. What does this mean? Here is how Winckelmann himself puts it:

According to this idea, beauty should be like the best kind of water, drawn from the spring itself; the less taste it has, the more healthful it is considered, because free from all foreign admixture. [32]

Only one quality can be attributed to Ideal Beauty. To designate it, Winckelmann does not employ any technical term, and the word he

does use never became a technical term. This quality is "unspecificity" *(Unbezeichnung)*. This is how he describes it:

> From unity proceeds another attribute of lofty beauty, unspecificity; that is, the forms of it are described neither by points nor by lines other than those which shape beauty merely, and consequently produce a figure which is neither peculiar to any particular individual, nor yet expresses any one state of the mind or affection of the passions, because these blend with it strange lines, and mar the unity.[33]

A dialectical, perhaps even a paradoxical, trend of thought dominates Winckelmann's work. He is a historian, but he is not content with telling a story; time and again he attempts to describe what he himself has recognized as being beyond description; he always strives to articulate what he himself has identified as ineffable. No wonder, then, that the metaphor became the central medium of his language and his thought. It has been noted that his metaphors, while describing the works and essence of Greek art, are also intensely personal.

Winckelmann's most famous description of the essence of Greek art is "Noble simplicity and tranquil grandeur."[34] This endlessly quoted epigram is clearly based on complex, tense metaphorical language. The notion and images of stillness, quiet, and calm play a particularly significant part in our author's thought and style. The choice of these expressions may also reflect some personal evidence. It was perhaps not by chance and mere scholarly objectivity that a man like Winckelmann, who could hardly control the stormy passions of his own life, discovered "calmness" and "tranquillity" to be the central values of Greek art.[35] Did he project onto Greek art what he desired but could not attain for himself? Or should we not rather come back to the comparison with the mystic? When we contemplate a work of art, as follows from Winckelmann's writings, a kind of ecstatic stillness imposes itself on us. One cannot help thinking of the mystic who, when he contemplates the divine, ceases all activity and even dramatic feeling. Historians of German literature have linked Winckelmann's elevation of stillness with the tradition of Pietism in Germany. The movement of Pietism goes back to the late Middle Ages, to mystics like Tauler and Master Eckhardt, but it was particularly strong in the eighteenth century.

Winckelmann's father came from Silesia, where Pietism was deeply rooted. Pietism made quiet and stillness the scene of divine revelation. One wonders whether Winckelmann's "stillness" is not a secular version, applied to art, of the pietist's religious stillness.[36]

The comparison of stillness with the sea is one of Winckelmann's most memorable literary figures. Throughout his work, the sea is considered the symbol of stability and quiet; it evokes the memory of extinct emotions and the sense of an anonymous silence. The sea's rough surface and stormy waves (images that play such a crucial role in the history of European literature and symbolism) are to him insignificant accessories, not revealing the true nature of the element. "As the depths of the sea remain always at rest, however the surface may be agitated, so the expression in the figures of the Greeks reveals in the midst of passion a great and steadfast soul," he said in his first composition.[37] The monumental calm and stability that are the "contents" of what the sea tells us are also a condition for our perceiving what is involved in a work of art. Speaking of looking at the masterpieces of Greek art, he says:

A state of stillness and repose . . . is that state which allows us to examine and discover their real nature and characteristics, just as one sees the bottom of a river or lake only when their waters are still and unruffled, and consequently even art can express her own peculiar nature only in stillness.[38]

Whatever the origins of Winckelmann's notion of "stillness," we must ask what this concept, as presented in his writings, means for the interpretation of art. The best way to answer the question is to say what "stillness" is not. These negations, it should be pointed out, are not purely notional. Seen against the historical conditions in which they were put forward, they acquire a material meaning. This in turn should not lead us to assume that Winckelmann's conceptual formulations are no more than a criticism of individual artistic trends.

In a discussion of the theory of art it is important to notice that Winckelmann juxtaposes "stillness" against dramatic expression. Precisely in this he marks the break with a great tradition. Ever since the early Quattrocento and up to the late Baroque, from Leone Battista Alberti to Bernini, the high regard for dramatic expression, for the convincing manifestation of the passions, was the central category of art

criticism. Art theory made the expression of emotions the highest aim of art, particularly in the noblest art form, the *istoria*. To be sure, throughout these centuries writers on art also asked painters and sculptors to be moderate in the expression of emotions. But this exigence was subordinated to the desire for clarity of expression; there was never any doubt that the expressing of emotions was the central value of a great work of art. Winckelmann, so far as I know, is the first thinker on art who explicitly rejects that demand for expressing passion in art along with the scale of values historically implied in it.

The end of art, Winckelmann claims, is beauty, "the loftiest mark and the central point of art."[39] Not the representation of reality, nor the giving of pleasure, nor the expression of emotions, as the main trends of thought had had it. Beauty is an autonomous value, its cause cannot be found outside itself.[40] That value contradicts expression. Beauty, Winckelmann says in the *History of Ancient Art*, requires "no expression of the passions of the soul." Moreover, "Expression . . . changes the features of the face, and the posture, and consequently alters those forms which constitute beauty."[41] The beautiful, it follows, is expressionless; a beauty devoid of emotional expression is the ideal.

Greek art, in its highest perfection, is indeed without expression; with some exaggeration, you might say that it is drained of emotions. This can best be seen in the most dignified works of classical art. Greek statues of the gods, we read, "show no trace of emotion," they are "tranquil and passionless."[42]

Winckelmann holds up this paradigm of expressionless beauty against the art of his time. The great antipode of beauty is Bernini precisely because of his unrestrained desire to express emotions and his marvelous skill in doing so. Bernini is not isolated, the art of his time follows him, and even the academies of art accept his scale of values.

This exaggerated style of expression is even inculcated by Charles Le Brun, in his *Treatise on the Passions*, — a work in the hands of most young students of art. In his illustrative drawings, the passions are not only represented, in the face, in an extreme degree, but in several instances the expression of them amounts even to frenzy.[43]

Ideal beauty, one should remember, is also free from personal inclination. "Those wise artists, the ancients, . . . purified their images from

all personal feelings, by which the mind is diverted from the truly beautiful," Winckelmann declares in his *History of Ancient Art*.[44] Our author does not so much stress the abstention from personal feelings as the expressionless character of ideal beauty. It is not difficult, however, to see that the two hang together. They express the same ideal.

5. THE NATURE OF THE IDEAL

What was this ideal? Modern textbooks are likely to tell us that it is the art of Antiquity, or, more specifically, the art of Greece. Yet these historical labels obviously do not provide sufficient answers, for a great variety of imports and intentions may be subsumed under them. What is it that Antiquity or Greece stand for? What remains after we have cast off the historical terms? It would be presumptuous for us to attempt here a formulation of Winckelmann's ideal in modern language. The Greek ideal that he held up as a redeeming image for imitation has many components. Summarizing the discussion of Winckelmann as a theorist of art, I should like to comment briefly on some ideas that are crucial in his intellectual world.

Nowadays Winckelmann is often seen as the forerunner, or even the founder, of a refined aestheticism, that is, of a movement that tries to isolate the beautiful from all contexts and to make it fully autonomous. Such a classification of Winckelmann, however, is completely mistaken. Beauty and art, he believed, follow from moral reasons; the very nature of great art is profoundly moral. In the spirit of the age he admired, he never detached the beautiful from the good. The term he most frequently used to describe beauty and great art, and even to designate specific components of the work of art — such as contour — is "noble." "The noblest contour unites and circumscribes all the parts of the most beautiful nature and of the ideal beauties," we read already in the *Thoughts on Imitation*.[45] But "noble," we should keep in mind, is a term taken from the domain of morals. "Nobility" belongs to the soul, though it shines forth in bodies. From Plato, Winckelmann learns that the gymnasium of Athens forms the background, and gives us an idea, "of the noble souls of Greek youth." It was in the gymnasium, we remember Winckelmann saying, that were cultivated those beautiful

bodies that became the paradigm of ideal beauty and that were a major reason for making Greek art the climax of all ages. Morality becomes manifest in the gymnasium. "Their generous human nature prevented the Greeks from introducing brutal spectacles," which were common in the pre-Greek period. This intimate connection of morality and formal beauty makes it easy for Winckelmann to say that Raphael endowed his figures with a "noble contour and a lofty soul," and to claim that the *Laocoön* manifests "bodily anguish and moral greatness."[46]

Another feature that shapes the overall character of Winckelmann's thought is his craving for wholeness, particularly for a harmonious relationship between the individual and his society. Nowhere does he clearly state this yearning, or explain what precisely it is that he yearns for, but we can detect it in his historical imagination and in what he projects as ideals presented for veneration and imitation. His image of ancient Greece is a remedial projection of utopian wish fulfillment. The pervasive longing for wholeness in an absent reality is an index to a prevailing sense of fragmentation in the present. "The concepts of the wholeness, of the perfection in the nature of Antiquity will clarify and make more tangible the concepts of the division in our nature."[47] "Our time," then, is the age of division and fragmentation.

Students of Winckelmann have noted that much of his half-utopian thought derives from motives related to the historical conditions prevailing in his time, and thus implies a far-reaching social criticism. What he perceives as lacking in his own world, he depicts as present in ancient Greece. Thus, when he claims that in Greece "the thoughts of the whole people rose higher with freedom"[48] and made possible the blooming of art, he implicitly points to the reason for the decline of the arts in "our time."

In Winckelmann's Greece, it should be emphasized, art is a thoroughly communal affair. All art was devoted to the gods only, and it was displayed solely in public places. The private homes of the citizens were characterized by "restraint and simplicity"; in them there was no room for art. This state of affairs had a direct impact on the artistic style. The ancient Greek artist was not cramped by the need "to suit the size of the dwelling or gratify the fancy of its proprietor."[49] The implied reference to the crippling effect of "modern" conditions on art

is here obvious. We also perceive an implied criticism of modern patronage in Winckelmann's description of how works of art were judged in Greece.

> The reputation and success of artists were not dependent upon the caprice of ignorance and arrogance, nor were their works fashioned to suit the wretched taste or the incompetent eye of a judge set up by flattery and fawning; but the wisest of the whole nation, in the assembly of united Greece, passed judgment upon, and rewarded, them and their works.[50]

This harmonious relationship between the artist and his community is the remedy against the fragmentary nature of the art of the modern world.

A third feature in Winckelmann's thought, the final one we should like to mention here, is perhaps the most important in the present context; it is his concept of form in great, mainly Greek, art. Ideal art, Winckelmann believed, as we have already seen, produced restricted— one could say, ascetic—forms. By their very nature, these forms are spiritual. They have a minimum of material substance and effects. It is instructive to follow what Winckelmann has to say in juxtaposing the beauties of nature and of art. The beauties of art excite us less than the beauties of nature, and they will therefore "be less pleasing to the uninstructed mind than ordinary pretty face which is lively and animated." Why is this so? The answer implies much of Winckelmann's philosophy of art.

> The cause lies in our passions,which with most men are excited by the first look, and the senses are already gratified, when reason, unsatisfied, is seeking to discover and enjoy the charm of true beauty. It is not, then, beauty which captivates us, but sensuality.[51]

Such a statement marks a radical departure from a venerable tradition. For centuries, art theory had educated readers to see a central value of art in the picture's power to arouse the passions. The claim that in arousing the passions the work of a great artist falls behind any merely pretty face is therefore surprising. Winckelmann makes this statement, one need hardly emphasize, not in order to denigrate the value of art, but to show that art is of a spiritual rather than of a sensual nature.

Because the nature of art differs from that of material reality, Winckelmann does not consider the convincing imitation of the latter an achievement of the former. The discriminating reader of Winckelmann's writings will notice that our author does not extol illusion as a summit of art, and that he does not tell the stories, endlessly repeated in the art literature of the sixteenth and seventeenth centuries, of birds being misled by painted grapes and mares neighing at painted horses. A work of art, he believes, is a piece of nature and of tangible matter absorbed, as it were, into a spiritual form. The more radical the absorption, the purer and more spiritual the form, the greater the art.

This attitude also emerges in his appreciation of the specific means of artistic production. Thus color, for centuries considered the embodiment of sensual experience, "should have but little share in our consideration of beauty." Beauty, he explains, "consists, not in color, but in shape. . . ."[52] Within the domain of line—or of "shape," as he here puts it—itself, it is the restricted that has the higher value. The idea of beauty "is like an essence extracted from matter by fire." When beauty is embodied in an image of a human figure—the great theme of Greek art—"the forms of such a figure are simple and flowing." All beauty, he goes on to say, "is heightened by unity and simplicity." Summing up his views on the simplicity of beauty and form, he uses a musical comparison. "The harmony which ravishes the soul does not consist in arpeggios, and tired and slurred notes, but in simple, long-drawn tones."[53]

A present-day student, trying to translate Winckelmann's text and images into a modern conceptional idiom, cannot help thinking of "abstraction." Needless to say, "abstraction" here should not be taken in its terminological precision. The specific images and ideas our author had in mind are not precisely the same as those that have occupied the minds of twentieth-century artists and writers. But his longing for restraint, simplicity, and purity necessarily leads to what we would today call an abstract form. The gospel of abstraction that Winckelmann preached to his contemporaries was perhaps the most important legacy he bequeathed to art theory of the modern age.

III. DIDEROT

1. ART THEORY AND ART CRITICISM

The upheaval that shook reflection on painting and sculpture in the middle of the eighteenth century had many consequences. One was the final splintering of the art-theoretical treatise. The traditional shape for presenting thought on art had been the systematic treatise. Established in the early stages of the Renaissance, this literary form flourished for centuries. The treatise commonly combined an analytical description of the "parts" (or other categories) of painting (more rarely also of sculpture), with prescriptions, usually couched in general terms, for what was considered good art, and proposals for what the artist should represent and how he should proceed. The comprehensive treatise, though often threatened by other forms of presentation, survived throughout the seventeenth century. Late in that period it was still magnificently represented by Gerard de Lairesse's *Le grand livre de peintres,* which we considered in the previous chapter.[54] In the eighteenth century, this type of presentation rapidly dwindled in significance, and after the middle of the century it practically disappeared as a central literary form for the instruction of artists or the interpretation of art for a broad public. A variety of literary forms were now taking the place of the systematic treatise, among them the history of a period (such as Winckelmann's *History of Ancient Art*), individual lectures, and so on. These forms also included art criticism.

What art criticism is and how it can be distinguished from other approaches to art is a matter that has not gone unnoticed in modern scholarly literature,[55] though certainly much remains to be done. We shall not here undertake a definition of art criticism or an outline of its problems. I shall simply presume that everyone knows what art criticism is. In the following observations, I shall be concerned with only one aspect of the subject: in what way the emerging art criticism was able to make a substantial contribution to art theory.

Before we attempt a survey of the relationship between the two fields in the middle of the eighteenth century, particularly in the work

of Diderot, it may be helpful to note briefly two areas in which art criticism and art theory radically differ from each other. The first point is the concern with, or the attitude to, the individual work of art. To many modern readers, it may seem surprising, but it can hardly be doubted, that traditional art theory, geared as it was to influence artists in their work, had little use for the individual painting or statue. To be sure, individual works of art are often mentioned in the treatises, sometimes even discussed at length; yet the primary context of the discussion is invariably provided by some broader problem, a theoretical theme such as a particular "part" of painting. The conceptual, often altogether abstract, character of the themes so presented is common in art theory and prevails whether the author of the treatise is a literary scholar or a practicing artist. To take a striking example, Leonardo's observations obviously attest to a unique familiarity with the making of a work of art; they carry the flavor of his personal imagination. Yet he does not discuss at any length the specific paintings he has actually seen (as opposed to his visions of pictures not yet painted). The themes he treats, such as color, light, movement, anatomy, expression, or perspective, are of a general, conceptual nature.[56] When traditional art theory speaks of an individual painting or sculpture, the work is treated as an illustration of a general idea rather than as a full, autonomous subject of a discussion. This is true even in the rare cases when a whole treatise is devoted to a single work of art. When in the sixteenth century Francesco Bocchi takes Donatello's *St. George* as a point of departure, he treats it as an example of depicting character and emotion in sculpture.[57] The same is true for Giovanni Pietro Bellori's treatment of Raphael's paintings in the Loggia.[58] The seventeenth-century scholar and president of the Roman Academy of Art sees in these paintings a model for the painter's treatment of subject matter and application of ideal forms. Throughout that tradition, it can thus be said, the individual work of art remains an illustration of general principles rather than the unique product of an individual artist's imagination and skill.

Art criticism, on the other hand, is essentially oriented towards the individual work of art. That it is not completely detached from general

ideas need hardly be stressed. Even without going into the philosophical problem of the individual—a thorny problem indeed, and one that has occupied the minds of thinkers for centuries—we intuitively grasp that one cannot approach an individual work of art without drawing on broad categories that go far beyond the unique piece that is presented. Once the beholder reacts to what he sees by saying more than just "I like" or "I don't like," he is indulging in some kind of art theory. Whenever he tries to explain what makes him praise or reject a work of art, he engages in art theory. It may be crude and primitive, but theory it is. It is essential to note, however, that in actual art criticism, as we know it, the general, theoretical concepts and categories usually remain implicit, or are only lightly, marginally referred to; they never become the primary subject of the art critic's discussion.

The total dependence of art criticism on the individual work of art has produced some striking historical and literary expressions. It is interesting to notice that art criticism was actually the twin sister of the art exhibition, itself equally based on the concept of the individual work of art. Art theory, one is not surprised to find, did not have the intellectual means of dealing with the art exhibition. It simply did not record the "Salon." Were we to confine ourselves to the purely art theoretical writings of the eighteenth and nineteenth centuries, we would suppose that the art exhibition had never come into being.

In literary form, art criticism is also determined by the individual work of art or an assembled group of such works. Inherent in the literary form, therefore, is a certain fragmentary character. As opposed to the systematic treatise, the presentation of criticism is, like Pascal's great work, "achevé par son inachèvement." It does not have a structure of its own or have its own problems. It is the individual work of art, present here and now, that gives art criticism its direction, raises its problems, and determines its structure.

A similar situation obtains with regard to the second area in which art theory and art criticism seem to differ radically. This concerns what is considered the most typical feature of the whole critical activity— the appraisal and evaluation of the work of art. What the audience expects of the art critic is, first of all, the passing of judgment. Crudely

put, art criticism is generally understood as the discrimination of the good from the poor.

The passing of judgment is not alien to traditional art theory. From Alberti and Lomazzo to Dubos and Gerard de Lairesse, writers and teachers of art theory passed judgments on works of art, evaluated paintings and statues, painters and sculptors. In the course of the seventeenth and eighteenth centuries, particularly in the thought prevalent in the art academies, the judging of artists—and, to a lesser extent, of individual works of art—became so institutionalized that the judgments themselves could be cast in numerical patterns. The artists of the past got marks, the ultimate achievement of judging. On a scale of 20, Le Brun (who, incidentally, obtained the highest score) got a 16 in line, in composition, and in expression, but a mere 8 in color; Dürer got only 10 in line as well as in color, but even less, an 8, in both composition and expression.[59]

Should we therefore conclude that, at least with regard to passing judgment, there is no difference between art theory and art criticism? On the contrary, here the difference between them becomes even more strikingly manifest. First we should remember that in art theory judgment was again a means of illustration. It is therefore not surprising that in classical art theory the object judged is a master's style rather than one of his individual works. Moreover, components and aspects are appraised, such as line, color, composition, expression, and so on. In singling out one aspect, one particular element, the organic unity is torn apart, in a profound sense it is transformed into an abstraction. From this point of view, and overstating the case, we could claim that the object judged by art theory is a "nonobject."

For art criticism, the passing of judgment does not serve, at least not directly and manifestly, any additional, "higher" purpose. The work singled out as either good or bad is not meant to lead us further than the lively encounter between the spectator and the work in front of him. The work of art is not analytically torn apart, no aspect or element is separated from the intricate web that constitutes the unique work of art. The work is experienced in its totality, though that totality may sometimes seem to be an irrational one.

Now let us come back to the starting point of these sketchy comments, and ask: how can art criticism make a significant contribution to the theory of art? Diderot's work as a critic may yield an answer. In trying to understand what he says about painting, let me repeat, I shall consider only what may be pertinent to art theory.

2. DIDEROT: SPONTANEITY AND MORALITY

One need hardly stress that Denis Diderot (1713–1784) was much more than a critic. Few figures in eighteenth-century thought were as many-sided as Diderot, and few, one should add, so clearly announce the coming of the modern age as he did. "A striking and appealing figure, learned, talkative, energetic, changeable, inventive, sensual, and elusive, Diderot embodies the dualism of the Enlightenment to perfection: a partisan of empiricism and scientific method, a sceptic, a tireless experimentor and innovator, Diderot was possessed by the restlessness of modern man"—this is how one modern historian has described him.[60] His many activities included art criticism. Diderot's concern with art and the philosophical problems it poses began early. Mainly in his *Lettre sur les aveugles (Letter on the Blind)* (1749), but even in earlier writings, we already find ideas that form the beginning of a concept of art. From 1759 he contributed notes on the biennial Salon to the collections of his friend, the German-Parisian man of letters Friedrich Grimm. In 1765 he attached to these notes a short *Essay on Painting (Essai sur la peinture)*. His exhibition reviews (the "Salons," as they are now commonly called) can unhesitatingly be claimed to constitute the beginning of art criticism as a literary genre. They naturally tell us much about the views on art that were held, at least in certain circles, in the 1750s and 1760s. These writings, together with some of the material contained in the *Encyclopédie* (of which Diderot was a principal editor), make it possible for us to picture his thought on our subject and to speak of his contribution to art theory.

It is characteristic of Diderot that he does not present his ideas in systematic fashion. For us, however, it may be useful to proceed from the general to the specific, stressing the unity in his thought, although it may be hidden rather than openly demonstrated. In his treatment of

the broadest problem, beauty, one already senses where the main emphasis is placed. The article on Beauty *(Beau)*, originally written for the *Encyclopédie* but published separately in Amsterdam in 1772, displays Diderot's leanings. He distinguishes between different kinds of beauty: absolute, real, and perceived. While he does not deny the existence of Absolute Beauty, his major concern is with perceived Beauty, for he cannot conceive even the metaphysical problem of Beauty except in relation to the person experiencing it.[61]

Diderot's contribution to the theory of art (the term now taken in a more precise sense) does not consist in any definite body of teachings, in a "doctrine." As I have said, he was too impulsive and passionate a thinker to present a balanced, consistent doctrine. His major contribution lies in raising certain problems and articulating certain attitudes. Some of these problems are still very much with us. Through raising them, and making them a central matter of art discussion, Diderot becomes a real founder of the modern age.

The artist's spontaneity was a persistent and central concern of Diderot's thought. Spontaneity showed him many faces. One of them is the sketch. Diderot is among the earliest critics, not themselves artists, to appreciate and love the sketch and to praise it as an art form in its own right. Why is he so attracted to the sketch? Precisely because the sketch shows the painter's spontaneity in a pure form. Thus he explains in the Salon of 1765:

A sketch is generally more spirited than a picture. It is the artist's work when he is full of inspiration and ardor, when reflection has toned down nothing, it is the artist's soul expressing itself freely on the canvas. His pen and skillful pencil seems to sport and play; a few strokes express the rapid fancy, and the more vaguely art embodies itself the more room is there for the play of the imagination.[62]

This is certainly a surprising attitude, and a statement that might well have been made in the twentieth century.

Another value of the sketch is that it allows the spectator to participate, as it were, in the shaping of what he sees in the picture. Speaking of the difference between a sketch and a finished painting, Diderot says: "in the latter the subject is fully worked out for us to look at; in the

former I can imagine so many things which are only suggested."[63] The desire to activate the beholder is another modern element, and it points in the same direction that can be sensed in Diderot's early article on The Beautiful, which had stressed the perceiver's role.

The Academy of Art constricts the artist's freedom and spontaneity. While the young artist is acquiring traditional forms and motifs, "the truth of nature is forgotten; the imagination is crammed with actions, positions, and forms that are false, prepared, ridiculous, and cold." Even if the conventional forms constituting tradition are not directly forced upon the artist, it will be difficult for him to get rid of them. "They are in stock there, and will come forth to get fixed on the canvas. Every time the artist takes up pencils or brush, these dull ghosts will awake and appear before him. . . ."[64]

The Academy is a representative of society in general. Patronage, so Diderot seems to view it, is always a constraint on the artist's freedom: society imposes limitations on him and imperils his very creativity. "For Diderot the artist's inner freedom is the impulsive, unaccountable flow of the pencil and brush, of images and ideas; verve, enthusiasm, spontaneity and naturalness are its outward signs. Without that flow there is no authentic art."[65] Meyer Schapiro has pointed out that in these views Diderot may have been influenced by Longinus, the literary critic of the third century A.D., who lived under Roman imperial rule and who also praised enthusiasm and imagination as the very origins of art. Longinus denounced the debasement of art in his own time and society, and saw the reason for this in the love of money, luxury, and pleasure.[66] In the eighteenth century, Longinus was popular among writers and intellectuals, and Diderot may well have drawn from him. However that may be, in the modern age Diderot is among the first critics to forcefully juxtapose the artist and society, and to consider society as oppressive and restrictive.

Oppressive tradition and constraining society do not remain merely in the general background of the artist's life and personality. They are represented within the process of artistic creation itself. It is the "rules" and, to a lesser extent, "the model" that embody these constricting powers. This view of artistic rules may explain Diderot's passionate denial of them. The student will remember that the debate on the

nature and status of rules in art has a long history. In the late sixteenth century, Giordano Bruno's attack on rules in art marks the end of a great period, and indicates a profound crisis in the life and art of the time.[67] A century later, the very foundations of the Academy of Art were shaken by Roger de Piles's questioning of the *règles assurées*.[68] In all these historical movements rejecting a dominant style and establishment, "rule" was juxtaposed against genius. In his late *Pensées detachées sur la peinture,* Diderot follows this example: "The rules have made of art a routine, and I do not know whether they have been more harmful than useful. Let us put it squarely: the rules have helped the ordinary man, they have injured the man of genius."[69] And somewhere else he tells of the young artist who, "before touching the least stroke to his canvas, would fall on his knees and and say, 'Lord, deliver me from the model.' "[70]

Criticism, too, can become a representative of the "rules," sometimes trying to derive its authority from genius itself.

I beg Aristotle's pardon, but it is a vicious sort of criticism to deduce exclusive rules from the most perfect works, as if the means of pleasing were not infinite. Genius can infringe almost any of these laws with success. It is true that the troupe of slaves, while admiring, cry sacrilege.[71]

Just as the tyranny of rules has a hardening effect on the artist's spontaneous imagination, so also does it dull the spectator's experience. The critic who rigorously applies aesthetic rules interposes himself between the work of art and the amateur looking at it. "What a stupid occupation it is to try ceaselessly to keep us from feeling pleasure, or to make us blush because of the pleasure we have taken in something— that is the occupation of the critic."[72]

These statements, with all their rebellious tone and surprisingly modern ring, should not mislead us, however: Diderot was not a romantic, nor did he have any consistent world view that would make of him a full-fledged citizen of our own day. I would like to illustrate the other side of Diderot, his links with traditional classicism, by a brief discussion of his views on artistic imagination and on the moral function of the work of art.

We have become used to viewing the artist's imagination as the

creative agent, and it is thus interesting to observe what imagination means to Diderot. He understands it mainly as the faculty of recalling images or the appearances of objects. It presupposes memory, and has a special affinity with visual experience. Already in his early *Letter on the Blind, For the Use of Those Who See,* he says that imagination presents to the mind pictures and streams of pictures. But these pictures are not created out of nothing. They are a distillation of previous impressions. This is true even for the most famous works of art. In his *Essay on Painting,* attached to the Salon of 1765, we read:

Michelangelo gave the most perfect form possible to the dome of St. Peter's. . . . What was it that inspired this curve rather than an infinity of others that he might have chosen? Day-to-day experience of life. . . .[73]

In general, so we learn from his notes on the Salon of 1767, the artist creates nothing (if that word is taken in a precise sense); he only imitates, composes, combines, exaggerates, enlarges upon, and diminishes various parts of nature. Here, one almost believes oneself to be listening to St. Augustine claiming that the "creature cannot create," or to Thomas Aquinas stressing that all the artist can do is change a shape, but not invent or create anything.[74]

The artist's expression of emotions is also based on his ability to recall what he saw; it does not involve his own emotions. Listen to what Diderot says in his late composition, the *Paradox on Acting,* written between 1773 and 1778, on David Garrick:

What I am going to tell you now is something I witnessed myself.

Garrick put his head through the gap between two leaves of a door, and in the space of four or five seconds his faced passed successively from wild joy to moderate joy, from joy to composure, from composure to surprise, from surprise to astonishment, from astonishment to sadness, from sadness to gloom, from gloom to fright, from fright to horror, from horror to despair, and then back again from this final stage up to the one from which he started. Was his soul capable of feeling all those sensations and of collaborating with his face in the playing of that scale, as it were? I don't believe it for a moment, and neither do you.[75]

It was only in the nineteenth century that the theory of the sincere artist, reviving the old Horatian view in a modern version, became popular.

Even more surprising is what Diderot has to say about the morality of art. He likes Greuze, so he writes in his Salon of 1763, because his work "is a painting with a moral."[76] "To make virtue desirable, vice odious, and absurdities evident, that is the aim of every honest man who takes up the pen, the brush, or the chisel," he writes two years later in his *Essay on Painting*.[77] And, one page earlier, he had said that "there is one thing that painting and poetry have in common: they should both be moral."

Morality, intimately connected with expression, becomes a yardstick for judging the value of pictures and styles. Explaining what composition is, he writes:

Composition is ordinarily divided into the picturesque and the expressive. For my part, I care not a jot how well the artist has disposed his figures in order to achieve striking light effects if the work as a whole does not speak to my heart, if the characters in the painting are simply standing about like people ignoring one another in a public park or like animals at the foot of a landscape painter's mountains.[78]

Is this the same author who praises Chardin's still lifes for their power to reveal the beauties and mysteries of visual experience in the insignificant objects he represents? Speaking of a small Chardin still life, Diderot says, "If I wanted my child to be a painter, this is the painting I should buy. 'Copy this,' I should say to the child, 'Copy it again.' "[79] And in the Salon of 1765, in front of another picture representing a subject of no consequence, Diderot exclaims: "Oh, Chardin, you are just in time to restore the use of my eyes to me after the mortal injuries inflicted on them by your colleague Challe."[80]

Yet it is the same Diderot—in fact, in the very same review—who passionately criticizes Boucher for his immoral, indecent pictures. The immorality of the paintings diminishes their aesthetic value. Boucher, he believes, has no idea of the morality of art. "I would not scruple to say to Boucher," Diderot writes in the *Essay on Painting*, "If your work

is never intended for anyone but smutty-minded eighteen-year-olds, then you are quite right, my friend; go on painting your breasts and bottoms. . . ."[81] This heavy emphasis on morality—naturally a morality of subject matter—misleads Diderot in his judgments. With the advantage of hindsight, we can now see that thanks to this moralistic dogmatism he rejected artists who have withstood the test of time, among them Boucher and Watteau, and embraced others whose names have been totally forgotten. But his emphasis on the morality of the work of art also endows the artist with an aura that goes far beyond that of providing aesthetic pleasure. The artist becomes the mouthpiece for humanity. "On the door of the painter's studio," so we read in the *Essay on Painting,* "there should be an inscription: 'Here the wretched find eyes that weep for them.' "[82]

Can the two sides of Diderot be reconciled? I doubt it. One cannot make of him a consistent, systematic thinker whose doctrine is free from contradictions. But in his unsystematic, yet passionate, way he articulated problems that impressed themselves profoundly on the modern age.

IV. REYNOLDS

The generation that laid the foundations for the new age in theoretical reflection on the visual arts came to an end with an artist who in many respects differed from the archaeologists, historians, and philosphers we have discussed so far. This is Sir Joshua Reynolds (1723–1792), perhaps the most important figure in the history of British painting, the first president of the newly established Royal Academy in London. He was celebrated in his time, the first of the "learned artists" in England. His patrons included the English court, the aristocracy, and men such as Samuel Johnson and David Garrick. Indeed, since Bernini's death no artist had occupied a position of similar social esteem and fame.

Reynolds pronounced his views on art in the course of the presidential addresses he gave to the Academy at the prize-awarding celebrations held every second year. The first and second discourses, were delivered in 1769, only a few months after Winckelmann's death and while

Diderot's *Salons* were still being published; he gave his last in 1790, at the very beginning of the age of Romanticism.

As the president of the Royal Academy of Art, Reynolds—rather like Anton Raphael Mengs—held a traditional view of painting, and advocated an art of a kind that we now call "academic." It was his expressed intention to cling to tradition, and to transmit its contents to the younger generation. "It is the principal advantage of an Academy," he said in his opening address, "that, besides furnishing able men to direct the student, it will be a repository for the great examples of the Art." [83] What he mainly had in mind was "obedience" to what the great examples can teach us.

> I would chiefly recommend, that an implicit obedience to the *Rules of Art,* as established by the practice of the great masters, should be extracted from the *young* students. That those models, which have passed through the approbation of ages, should be considered by them as perfect and infallible guides; as subjects for their imitation, not their criticism. [84]

In his explanations of art and of the artist's job, Reynolds, then, did not want to offer novel departures; his aim was to secure for the future the accepted and proven models. Nevertheless, one finds in his doctrine much that does not directly ensue from the ideas and patterns he so ardently wished to follow. It is new emphases, rather than new ideas, that sometimes make of Reynolds a borderline figure, one who— possibly against his own will—announced the coming of a new age. In approaching his *Discourses,* it would be wrong to expect a philosopher's consistency and discipline of thought. The views sometimes vary, the formulations are not always fully clear. The reader familiar with Italian art literature both of the Renaissance and the Baroque, and with seventeenth-century French doctrines, will find common views and common themes on every page of the *Discourses.* Yet through these very weaknesses, Reynolds's addresses become a faithful mirror of what was going on, subterraneously, as it were, in intellectual attitudes to art in the last third of the eighteenth century. It is this property that makes the *Discourses* a document so precious to the historian of art and ideas.

In the following pages, I shall concentrate mainly on the ideas in the *Discourses* that suggest the rising significance of new themes. Reynolds

himself would probably not have agreed that he was departing from tradition. The modern reader, however, with the advantage of hindsight, is in a good position to discriminate between what Reynolds merely repeated and what he actually transformed.

At the center of Reynolds's thought one finds, as can be expected, the idea of imitation. Nor is one surprised at his distinguishing between two kinds of imitation, called "copying" and "borrowing." Under different names, the separation of these two types is well attested in art theory at least since the sixteenth century.[85] Mere copying, Reynolds believes, is harmful to the young artist. In the first year of his tenure of the presidency of the Royal Academy, he issued this warning:

> I consider general copying as a delusive kind of industry; the student satisfies himself with the appearance of doing something; he falls into the dangerous habit of imitating without selecting, and of labouring without any determinate object; as it requires no effort of the mind, he sleeps over his work; and those powers of invention and composition which ought particularly to be called out, and put in action, lie torpid, and lose their energy for want of exercise.[86]

As opposed to mere copying, "borrowing" consists of incorporation, adaptation, and digestion of different motifs and patterns taken from the works of different artists and different periods. "The artists of all times and in all places should be employed in laying up materials for the exercise of his [the student's] art," we read in the very title of the second discourse, held in December 1769. "The sagacious imitator" borrows.[87]

These notions were of course commonplace in the second half of the eighteenth century. Yet one perceives a certain insecurity in Reynolds's tone in presenting these generally accepted truths. A competitor to imitation has arisen; it is imagination. Following the sequence of the *Discourses,* we can perceive the change in attitude. In the sixth discourse, delivered in 1774, he deplores the fashionable trend towards replacing imitation by inspiration.

> Those who have undertaken to write on our art, and have represented it as a kind of inspiration, as a gift bestowed upon peculiar favourites at their birth, seem to insure a much more favourable disposition from their readers, and

have a much more captivating and liberal air, than he who attempts to examine, coldly, whether there are any means by which this art may be acquired.[88]

It is acquired, needless to say, by imitation. Moreover, "our art, being intrinsically imitative, rejects this idea of inspiration, more perhaps than any other."[89] Now Reynolds sings the praise of imitation: "by imitation only, variety, and even originality of invention, is produced. I will go further; even genius, at least what generally is so called, is the child of imitation."[90]

By the time Reynolds delivered his thirteenth discourse, only twelve years later, some far-reaching changes seem to have taken place. Now, in 1786, the president of the Royal Academy declares in the very title of his address: "Art not merely Imitation, but under the Direction of Imagination. In what Manner Poetry, Painting, Acting, Gardening, and Architecture depart from Nature." During the 1770s and 1780s, as James Engell has pointed out, concern with the imagination increased, and was providing a theoretical backing and philosophical foundation for the growing interest in psychology.[91] The thirteenth discourse shows how strong an impact this recent concern had on the theory of painting.

Reynolds at this point downgrades reason as a measure of art. It is imagination that should inform the artist's actions and guide him in his work. Aware of the novelty of his claim, he also sensed opposition. Addressing an audience of young artists, he explained:

This is sometimes the effect of what I mean to caution you against; that is to say, an unfounded distrust of the imagination and feeling, in favour of narrow, partial, confined, argumentative theories.[92]

This is not to say that truth to nature is to be abandoned. Allegiance to the principle of verisimilitude has not changed. The question is only how to achieve truth to nature. Now Reynolds believes that the road to this cherished goal does not lead through the land of geometrical axioms or anatomical studies, but rather through that of the imagination. "For though it may appear bold to say," the president proclaims, "the imagination is here the residence of truth."[93]

It would be futile to enter a critical argument as to what precisely imagination meant to Reynolds, and whence it drew its images. Rey-

nolds is not a systematic philosopher, and perfect consistency is not his prime concern. Following the main lines of his thought, however, one concludes that he understands imagination less as a creative force that produces images out of nothing than, to use Dürer's formulation, as an "accumulated, secret treasure in one's heart."[94] We carry in our mind impressions that are "the result of the accumulated experience of our whole life." Reynolds even speaks of the "mass of collective observation." The artist's "animated thoughts," he says, follow "not perhaps from caprice or rashness . . . but from the fulness of his mind." The legitimacy of the imagination is secured by its origin in real life. "It is our happiness that we are able to draw on such funds." The ideas issuing from the artist's mind "are infused into his design, without any conscious effort."[95]

Imagination produces a new reality, however we may define it, and that reality, Reynolds declares, differs from what we experience in everyday life. What, then, about imitation?

Our elements [he says] are laid in gross common nature,—an exact imitation before us: but when we advance to the higher state, we consider this power of imitation, though first in the order of acquisition, as by no means the highest in the scale of perfection.[96]

The idea that idealization of forms leads us away from a precise representation of everyday experience is as old as Aristotle's *Poetics.* It is remarkable, however, that, with the advancing to a "higher state," Reynolds drops imitation altogether. One could perhaps believe that this is only a slip of the pen, or perhaps still another obscurity in his terminology. But in the observations that follow the reader finds further support for a superseding of imitation by a new kind of reality produced by art.

Reynolds first turns to the other arts. Poetry "sets out with a language in the highest degree artificial, a construction of measured words, such as never is, nor ever was used by man."[97] The theater, "which is said to hold the mirror up to nature," also produces an imaginary reality. To mistake "Garrick's representation of a scene in Hamlet for reality" is ignorant praise. "The merit and excellence of Shakespeare, and of Garrick, when they were engaged in such scenes, is of a different and much higher kind."[98] Turning to what was probably

the most recently acknowledged art, landscape gardening, he says that "as far as gardening is an art, or entitled to that appeallation, it is a deviation from nature." Implicitly referring to the ideology of what is everywhere called the English Garden, he continues: "for if the true taste consists, as many hold, in banishing every appearance of art, or any traces of the footsteps of man, it would then be no longer a garden."[99] All the arts, then, show that they bring about a reality that differs from the natural one. Imagination, however understood, is the handle, as it were, by which the new, artificial reality is brought about; it infuses into that reality its own character.

Making imagination the central concept indicates a disposition that pervades the philosophy of art as a whole. In fact, the same motives that led Reynolds to turn imagination into what it is in his theory also made him see the art of earlier periods, the trends and modes of representation, in a new light. This is best epitomized in the comparison of Raphael and Michelangelo, and his worship of Michelangelo.

Comparisons of the relative stature of Raphael and Michelangelo had been common in discussions on art since the sixteenth century. The results of this comparing and respective scaling often tell us much about the period indulging in the pastime. At least since the mid-seventeenth century, the superiority of Raphael's art and style had become a matter of cardinal significance, almost an article of faith, for the thought promoted and proclaimed in the academies of art. Raphael's style came to be the ultimate authority and source of the legitimacy of the academies' teaching. Believing in Raphael's superiority was, then, more than a matter of taste; it became the defense of the academic tradition against whatever might endanger it. For reasons we need not analyze here, Michelangelo's art was considered less easily imitable and standardizable. Though nobody would deny his genius, he was felt to be a kind of explosive force, endangering the continuity of the tradition. The case of Raphael versus Michelangelo, as the Academy saw it, was lucidly summed up by Fréart de Chambray.

Raphael Urbino, the most excellent of the *Modern* Painters, and universally so reported by those of the *Profession,* is the *Person whose Works* I shall propose as so many *Demonstrations* of the absolute necessity of exactly observing the *Principles* which we have establish'd in this *Treatise.* And on the contrary, *Michael Angelo,* superior in *Fame,* but far inferior to him in *Merits,* shall by his

extravagant *Compositions,* amply furnish us to discover the *Ignorance* and *Temerity* of those *Libertines,* who, trampling all the *Rules* and *Maximes* under their feet, pursue only their own *Caprices.*[100]

Even Roger de Piles, at the turn of the century considered a rebel who conquered the Academy in the name of color, the nonrational element, wrote of Michelangelo:

His *Attitudes* are, for the most part, disagreeable, the *Airs* of his *Heads* fierce, his *Draperies* not open enough, and his *Expressions* not very natural; yet, as wild as his productions are, there is Elevation in his Thoughts. . . .[101]

By 1790, when Reynolds delivered his last address to the Royal Academy, a great change had taken place. This last discourse was devoted to Michelangelo. The concluding remark has often been quoted.

I feel a self-congratulation in knowing myself capable of such sensations as he intended to excite. I reflect, not without vanity, that these discourses bear testimony of my admiration of that truly divine man; and I should desire that the last words which I should pronounce in this Academy, and from this place, might be the name of—Michael Angelo.[102]

What does this worship of Michelangelo mean for the theory of art? What does it tell us about the processes taking place beneath the surface, as it were?

Admiration for Michelangelo, it has been said, correctly, was an admiration of "subjective" art. It involved the admiration of the creative power and the expressive force of genius, of depth of feeling and of stormy passions. It was these "subjective" qualities that fascinated Reynolds, and it was natural for him to discuss them in the context of the familiar comparison of Raphael and Michelangelo. Raphael, the president of the Royal Academy knew, had more taste and fancy, Michelangelo more genius and imagination. The one, he said, excelled in beauty, the other in energy. Two qualities particularly are embodied in Michelangelo's work, in Reynolds' view, and they are both of crucial significance for the further history of any reflection on painting. Reynolds himself, it should be kept in mind, does not state his ideas on these qualities as clearly as we dare to present them here. A careful reader, however, will not fail to detect them in the text of the *Discourses.*

The first is what would today be called the artist's "originality."

Reynolds begins by describing Michelangelo's works as having "a strong, peculiar, and marked character." This assertion of course reiterates what had been said countless times about the work of the "divine artist." But Reynolds is not content with this piece of traditional characterization; he goes on to say that these works "seem to proceed from his mind entirely, and that mind so rich and abundant, that he never needed, or seemed to disdain, to look abroad for foreign help."[103]

Here, it seems, Reynolds implicitly makes two related claims: (1) that Michelangelo is the ultimate origin of his work, that—in a precise sense of the word—he is their "creator;" and (2) that Michelangelo breaks with tradition, his mind being so rich and abundant that he never needed to look for "foreign help." What is "foreign help" but what tradition provides in the way of motifs, patterns, and themes? Today we know of course that Michelangelo was not as independent of traditional motifs as the president of the Royal Academy believed him to be. Yet in our present context it is crucial that Reynolds believed in Michelangelo's autonomy. This independence of tradition is seen as a sign of genius. Raphael's materials, Reynolds says on the same page, "are generally borrowed," whereas Michelangelo's figures, images, and shapes follow from his unique mind. In his discussion of Michelangelo, Reynolds preaches the gospel of the individual artist, an idea that was to play such an overwhelming part in nineteenth-century thought.

The other quality embodied in Michelangelo's work is "greatness." The reader here clearly perceives the ideas on the Sublime, so important in the literary criticism and philosophical thought of the time, penetrating into reflection on painting. What precisely such greatness might be Reynolds does not tell us. The metaphors he uses in describing it (such as "vehemence," "heat," "vast and sublime," and so on) also do not help the reader. That it is sheer greatness, ineffable in its essence, is perhaps best indicated by what Reynolds says about how Michelangelo's works impress the beholder. "The effect of the capital works of Michael Angelo perfectly corresponds to what Bouchardon said he felt from reading Homer; his whole frame appeared to himself to be enlarged, and all nature which surrounded him, diminished to atoms."[104]

Ineffable greatness, by its very nature, is hard to fit into the artistic and conceptual patterns of tradition. This is made clear, again, in the comparison of Raphael and Michelangelo. Nobody excelled Raphael,

our author says, in the judgment that unites his own observations of nature, the energy of Michelangelo, and the "beauty and simplicity of the antique." "But if, as Longinus thinks, the sublime, being the highest excellence that human composition can attain to, abundantly compensates the absence of every other beauty, and atones for all other deficiencies, then Michael Angelo demands the preference."[105]

Beneath the surface of a classicizing academicism, and an allegiance to Raphael as its patron saint, one perceives the approaching upheaval of Romanticism that was to overturn accepted norms and in the end lead to questioning the very validity of tradition in the domain of art. This is the ultimate significance of what the president of the Royal Academy had to say about Michelangelo. The worship of Michelangelo became a disruptive force placed at the very foundations of the defense of tradition in art.

NOTES

1. For the biographical, and intellectual, interrelationship of the two men, see the still unsurpassed broad representation by Carl Justi, *Winckelmann und seine Zeitgenossen,* 3 vols. (3rd ed.; Leipzig, 1923).

2. See *Opere di Antonio Rafaello Mengs, Primo pittore della Maestà Carlo III, re di Spagna, ec. ec. ec., Publicate da D. Giuseppe Niccola d'Azara,* 2 vols. (Parma, 1780). For Mengs's art theory, see Monika Sutter, *Die kunsttheoretischen Begriffe des Malerphilosophen Anton Raphael Mengs* (Munich, 1968).

3. For Mengs's views of the painter as philosopher, cf. Sutter, *Die Kunsttheoretischen Begriffe,* pp. 190 ff.

4. See *Opere di Antonio Raffaele Mengs* (Rome, 1787), II, p. 294; also Karl Borinski, II, *Die Antike in Poetik und Kunsttheorie* (Leipzig, 1924), p. 214.

5. This division is common. For a particularly important example, see *Theories of Art: From Plato to Winckelmann,* pp. 273 ff.

6. *Poetics* 1448a, here quoted in *Aristotle's Theory of Poetry and Fine Arts,* trans. S. H. Butcher, 4th ed. (New York, 1951), p. 214.

7. See Winckelmann's "Sendschreiben über die Gedanken von der Nachahmung der griechischen Werke in der Malerei und Bildhauerkunst." I use the edition of *Winckelmann's Werke,* ed. C. L. Fernow (Dresden, 1808), I, p. 94.

8. I am using the original German edition of Winckelmann's collected works: *Winckelmann's Werke,* ed. C. L. Fernow, 11 vols. (Dresden-Berlin, 1808–1820). The first eight volumes appeared in 1801. The original German of *The History of*

Ancient Art I am quoting from the Phaidon edition: J. Winckelmann, *Geschichte der Kunst des Altertums* (Vienna, 1934). There is no complete English translation of Winckelmann's works. Parts of the *Thoughts on the Imitation* are translated in Elizabeth Holt, *A Documentary History of Art,* II (Garden City, N. Y., 1958), pp. 336–351. There is an English translation by G. Henry Lodge of *The History of Ancient Art* (Boston, 1860), in two volumes. Wherever possible, I have used these translations. In some cases, I have changed the wording to make it more closely conform to the original version.

9. Winckelmann, *Werke,* I, p. 7. The translation of that sentence in Holt, p. 337, is slightly different. It reads: "To take the ancients for models is our only way to become great, yes, unsurpassable if we can." The original reads: "Der einzige Weg für uns, gross, ja, wenn es möglich ist, unnachahmlich zu werden, ist die Nachahmung der Alten. " The term "inimitable" *(unnachahmlich),* of course, also means "unsurpassable," as the Holt translation has it, but it carries a particular tension in a sentence devoted to imitation.

10. Winckelmann, I, p. 20; Holt, II, p. 343.

11. Wilhelm Waetzoldt, *Deutsche Kunsthistoriker, I, Von Sandrart bis Rumohr* (Leipzig, 1921), p. 68.

12. Winckelmann, I. p. 34; Holt, II, p. 350. *Franchezza,* it should be noted, was already in the seventeenth century a technical term accepted in the workshops. Baldinucci, in his *Vocabolario Toscano dell'arte del disegno* (Florence, 1681; reprinted Florence, n.d.), p. 64, describes *franchezza* as *Ardimento, bravura, l'esser franco.*

13. Winckelmann, I, p. 6; Holt, II, p. 337.

14. For Piranesi in the intellectual setting of eighteenth-century Rome, cf. Henri Focillon, *G. B. Piranesi* (Paris, 1928).

15. Winckelmann, I, p.6; Holt, II, p. 337.

16. See Waetzoldt, *Deutsche Kunsthistoriker,* I, p. 56.

17. Winckelmann's paganism has been frequently discussed. In English, see especially Henry Hatfield, *Aesthetic Paganism in German Literature* (Cambridge, Mass., 1964), Chapter I. And see also E. M. Butler, *The Tyranny of Greece over Germany* (Boston, 1958; originally published in Cambridge, 1935), pp. 9–48.

18. In his *Plan d'une université pour le gouvernement de Russie,* in J. Assezat and M. Tourneaux, eds., *Denis Diderot: Oeuvres complètes* (Paris, 1875–1877), III, p. 447. And see Peter Gay, *The Enlightenment: An Interpretation* (New York, 1977), pp. 94, 72.

19. See Voltaire's *Essai sur les moeurs,* in *Oeuvres complètes,* ed. L. Moland (1877–1885), I, p. 89.

20. For the meaning of silence in Wincklemann's thought, see especially Walter Rehm, *Götterstille und Göttertrauer* (Bern, 1951) pp. 101–182.

21. For a brief survey of the origins of the term "classical," see Enrst Robert Curtius, *European Literature and the Latin Middle Ages* (New York, 1953), p. 249.

22. See the interesting discussion in Walter Rehm, *Griechentum und Goethezeit,* (Leipzig, 1936, p. 29 ff.

23. In *European Literature and the Latin Middle Ages,* pp. 256 ff.

24. For the importance Winckelmann accorded to staying in Rome, see the very detailed treatment by Karl Justi, *Winckelmann und seine Zeitgenossen,* especially Vol. II.
25. The term "Vermögen" used by Winckelmann could also mean "beyond his *means* of reproduction."
26. The notion of "imitation" has of course been discussed countless times. For a survey of the main meanings of the term in the sixteenth century, see Eugenio Battisti, "Il concetto d'imitazione nel Cinquecento italiano," in the author's *Rinascimento e barocco* (n. p., 1960), pp. 175–215.
27. Winckelmann, I, p. 20; Holt, p. 343.
28. I am here following mainly Thomas Greene, *The Light in Troy: Imitation and Discovery in Renaissance Poetry* (New Haven and London, 1982), pp. 42 ff.
29. This he wrote in an introduction ("Erinnerung über die Betrachtung der Werke der Kunst") to a collection of his short papers on ancient art. See *Werke,* I, pp. 241 ff. The sentence quoted is on p. 245.
30. *Werke,* I, p. 22. The translation of this particular sentence in Holt, p. 344, is insufficient and possibly misleading. I have therefore substituted a revised translation.
31. See J. Winckelmann, *Geschichte der Kunst des Altertums* (Vienna, 1934) (henceforth to be cited as *Geschichte*) p. 139; and the English translation by G. Henry Lodge *History of Ancient Art* (Boston, 1860) (henceforth cited as *History*), II, p. 28.
32. *Geschichte,* p. 150; *History,* II, p. 42.
33. *Geschichte,* p. 150; *History,* p. 41.
34. *Werke* I, p. 35; Holt, p. 351.
35. See Franz Schultz, *Klassik und Romantik der Deutschen,* (Stuttgart, 1959), I, p. 104.
36. Ibid., pp.104 ff.
37. *Werke* I, p. 31; Holt, p. 349.
38. *History,* II, p. 113.
39. *Geschichte,* p. 139; *History,* II, p. 28.
40. For this Platonic, or Plotinian, view that Winckelmann takes as a matter of course, many quotations could be adduced. See, for example, *Geschichte,* p. 149; *History,* II, p. 40.
41. *Geschichte,* p. 164; *History,* II, pp. 42, 113.
42. *Geschichte,* p. 168; *History,* II, p. 129.
43. *Geschichte,* p. 168; *History,* II, p. 129.
44. *Geschichte,* p. 155; *History,* II, p. 47.
45. *Werke* I, p. 24. The translation of this sentence in Holt is somewhat garbled.
46. For all the quotations in this passage, see *Werke,* I. pp. 13–31; Holt, pp. 340–349.
47. *Werke,* I, p. 22; Holt, p. 344.
48. *Geschichte,* p. 133; *History,* II, p. 14. It is interesting to note that in the *Thoughts on Imitation,* Winckelmann mentions the same reasons for the superiority of Greek art that he adduces in the *History* (climate, physical constitution, exercise, etc.)—with the exception of the social aspect ("freedom"). In the earlier work,

he speaks only of "the humanity of the Greeks that, in its blooming freedom, prevented them from introducing brutal spectacles." See *Werke,* I, p. 15.

49. *Geschichte,* p. 137; *History,* II, p. 14. The criticism of private patronage anticipates Romantic, and even nineteenth-century, attitudes. It belongs to the underlying stratum of social criticism.

50. *Geschichte,* p. 135; *History,* II, p. 18.

51. *Geschichte,* p. 140; *History,* II, p. 31.

52. *Geschichte,* p. 148; *History,* II. 38.

53. *Geschichte,* p. 150; *History,* II, pp. 40–41.

54. See above, pp. 57 ff.

55. Cf. Albert Dresdner, *Die Entstehung der Kunstkritk im Zusammenhang der Geschichte des europäischen Kunstlebens* (Munich, 1915). And see also Lionello Venturi, *History of Art Criticism* (New York, 1936; reprinted New York, 1964).

56. For Leonardo, see *Theories of Art,* I, pp. 132 ff., and the literature mentioned there.

57. See my study "Character and Physiognomy: Bocch on Donatello's *St. George.* A Renaissance Text on Expression in Art," *Journal of the History of Ideas* 36 (1975): 413–430.

58. Giovanni Bellori, *Descrizzioni delle imagini dipinti da Raffaelle d'Urbino nelle camere del Palazzo Vaticano* (Rome, 1695). Cf. *Theories of Art,* pp. 315 ff.

59. See *Theories of Art,* pp. 340 ff.

60. See Peter Gay, *The Enlightenment, An Interpretation: The Rise of Modern Paganism* (New York, 1977), pp. 47 ff. The literature on Diderot is of course very large, though one still misses a careful comprehensive presentation of his views on the visual arts. But cf. Francis Coleman, *The Aesthetic Thought of the French Enlightenment* (Pittsburgh, 1971) and Ernst Cassirer, *The Philosophy of the Enlightenment* (Princeton, 1951). Dresdner's *Die Entstehung der Kunstkritik im Zusammenhang der Geschichte des europäischen Kunstlebens,* especially Chapter VI, has good observations.

61. See his "Récherches philosophiques sur l'origine et la nature du beau," in Diderot's *Oeuvres esthétiques,* ed. Paul Vernière (Paris, 1968), pp. 391 ff., p. 402. Excerpts appear in *Diderot's Selected Writings,* translated by Derek Coltman (New York and London, 1966), pp. 51–60.

62. I use the English translation, done by Creighton Gilbert, available in Elizabeth Holt, *A Documentary History of Art,* (Garden City, N.Y., 1958), II, p. 316. For the French text, see Diderot, *Oeuvres esthétiques,* pp. 542 ff. For a brief survey of the sketch in French painting, cf. Albert Boime, *The Academy and French Painting in the Nineteenth Century* (London, 1971), pp. 82 ff.

63. Holt, II, p. 316; Diderot, *Oeuvres esthétiques,* p. 544.

64. These quotations are taken from Diderot's *Essay on Painting.* Again I use Creighton Gilbert's translation in Holt, *A Documentary History of Art,* II, p. 313. For the French text, see Diderot, *Oeuvres esthétiques,* p. 670.

65. See Meyer Schapiro, "Diderot on the Artist and Society," *Diderot Studies* V (1964): 5–11. The sentences quoted are on p. 5.

66. This is found mainly in the last chapter of Longinus's *On the Sublime.*
67. See Erwin Panofsky, *Idea: A Concept in Art Theory* (New York, 1968), pp. 73 ff.
68. See *Theories of Art,* pp. 349 ff., 352 ff.
69. Diderot, *Oeuvres esthétiques,* pp. 753 f.
70. From the *Essay on Painting,* in Holt, *A Documentary History of Art,* II, p. 313; Diderot, *Oeuvres esthétiques,* p. 670.
71. A note in the *Pensées detachées sur la peinture.* See Diderot, *Oeuvres esthétiques,* p. 753. I use the translation of the passage appearing in Francis Coleman, *The Aesthetic Thought of the French Enlightenment,* p. 88.
72. Another fragmentary statement in the *Penseés detachées.* See Diderot, *Oeuvres esthétiques,* p. 758.
73. Diderot, *Oeuvres esthétiques,* p. 738. I am using the English translation by Coleman, *The Aesthetic Thought of the French Enlightenment,* p. 114.
74. For a brief indication of what Augustine and Thomas Aquinas thought about the problem of the creative artist, see *Theories of Art,* pp. 86 ff.
75. Diderot, *Oeuvres esthétiques,* p. 328. For an English translation, see *Diderot's Selected Writings,* p. 325. The *Paradox on Acting* was written in 1769, after Diderot had already composed all his writings on painting.
76. See Diderot, *Oeuvres esthétiques,* p. 524. In the *Éloge de Richardson,* Diderot grounds the major part of his praise of Richardson in the moral purport of his fiction. Cf. Coleman, *The Aesthetic Thought of the French Enlightenment,* pp. 130 ff.
77. See *Diderot's Selected Writings,* p. 164; Diderot, *Oeuvres esthétiques,* p. 718.
78. *Diderot's Selected Writings,* p. 165; Diderot, *Oeuvres esthétiques,* p. 719.
79. This Diderot wrote in the Salon of 1763. See *Diderot's Selected Writings,* p. 150; Diderot, *Oeuvres esthétiques,* p. 483.
80. Diderot, *Oeuvres esthétiques,* p. 485; *Diderot's Selected Writings,* p. 154.
81. *Diderot's Selected Writings,* p. 163; Diderot, *Oeuvres esthétiques,* p. 717.
82. *Diderot's Selected Writings,* p. 164; Diderot, *Oeuvres esthétiques,* p. 718.
83. Sir Joshua Reynolds, *Fifteen Discourses Delivered in The Royal Academy* (London and New York: Everyman's Library, n.d.), p. 5 (hereafter cited as *Discourses*).
84. *Discourses,* p. 6.
85. The most articulated formulation of the two types of imitation is found in Vincenzio Danti's *Il primo libro del trattato delle perfette proporzioni di tutte le cose che imitare e ritrarre si possono con l'arte del disegno,* now best available in Paola Barocchi, ed., *Trattati d'arte del cinquecento,* I (Bari, 1960), pp. 209–269. And see *Theories of Art,* pp. 228 ff., with additional literature.
86. *Discourses,* p. 17.
87. Ibid., p. 86.
88. Ibid., p. 76.
89. Ibid., p. 77.
90. Ibid., p. 78–79.
91. James Engell, *The Creative Imagination: Enlightenment and Romanticism* (Cambridge, Mass., 1981), pp. 184 ff.
92. *Discourses,* p. 210.

93. Ibid., p. 209.
94. For the Dürer quotation, see *Theories of Art,* p. 218.
95. *Discourses,* pp. 209–210.
96. Ibid., pp. 213–214.
97. Ibid., p. 214.
98. Ibid., p. 219.
99. Ibid., p. 221. The concern of English thought in the eighteenth century with gardening as an art form is of course well known. From the large literature, I shall mention only Marie Louise Goithein, *A History of Garden Art* (New York, 1979; the original German edition appeared as early as 1926), and H. R. Clark, *The English Landscape Garden* (New York, 1980). Shaftesbury seems to have been the first to stress the basic contrast between "tailored" gardens and untouched nature.
100. See Fréart de Chambray, Preface to *An Idea of the Perfection of Painting,* translated J[ohn] E[velyn] (London, 1668). And cf. Samuel H. Monk, *The Sublime: A Study of Critical Theories in XVIII-Century England* (Ann Arbor, Mich., 1962; first edition, 1935), pp. 168.ff.
101. Roger de Piles, *The Art of Painting and the Lives of Painters* (London, 1706), pp. 160 ff. And see Monk, *The Sublime,* p. 172. See also *Theories of Art,* pp. 352 ff.
102. *Discourses,* pp. 263–264.
103. Ibid., p. 67.
104. Ibid., pp. 66–67.
105. Ibid., pp. 68–69.

3

Unity and Diversity of the Visual Arts

I. INTRODUCTION

That the nineteenth century is a complex historical period, combining contraries, merging continuing traditions and radical changes, is a truism that does not require further elaboration. This general character-ization of the age—the period beginning with the sixties or seventies of the eighteenth century and leading up to the traumatic upheaval of the first World War in the twentieth—is also valid for the domain of our reflections. As need hardly be said, this was the period of the museums, the great public collections, that popularized a veneration of past achievement, as well as of "new" and revolutionary movements both in the living arts and in observations on what the past had created. Conflicting attitudes and currents of thought followed one another and existed side by side, were linked to each other in succession and in simulataneous existence. Among the many facets reflecting this contra-diction of opposites is also the theory of art.

In theoretical reflections on art, two very different attitudes come to the fore. On the one hand, we may claim that talking about "art as such," art in the modern sense of that term, is an invention of the

eighteenth century that reached its full realization in the nineteenth. Not only was the term "aesthetics" coined in the eighteenth century, but its very subject matter, the "philosophy of art," was invented at that time. In the view of some historians, it can indeed be applied to the thought of earlier periods only with certain reservations. Some scholars at least have observed that art with a capital *A,* and in its modern sense, originated in the eighteenth century, and its depth and possibilities were explored in the course of the nineteenth. What is it that a poem and a picture, a musical piece and a statue have in common, although the media in which they are cast, the material nature of the products, differ so widely? This is a question asked in the nineteenth century. The notion of "Fine Arts," or, in the original French, "Beaux arts," denoting the visual arts—architecture, sculpture, painting, and the related minor arts—is also a creation of that time, and it was the nineteenth century that made this notion a cornerstone of the critical and theoretical vocabulary used in discussions of art.

As opposed to this universalizing trend, which strove to unify the various arts, the nineteenth century evinced a profound and lasting interest in the specific and unique nature of each art and the material medium in which it operated. Instead of asking what music and painting may have in common, it was asked how they differ from each other, and what is the unique medium of each. To make the uniqueness of each art more manifest, attention was often focused on the material nature of the work and the way it is perceived by the spectator. A great deal of thought and observation were devoted to the question of whether the specific work of art "exists" in a time sequence or in spatial simultaneity. A poem and a sonata exist in temporal sequence, word after word and tone after tone; a painting and probably also a statue, exist in a timeless simultaneity: they display their complex structure at a single glance. Even more important than the "dimension of being" that is the proper context of a given art or work of art is the sense to which it appeals and by which it is perceived. We obviously perceive music by a different sense than we perceive painting, but what of poetry and sculpture? The apportioning of each individual art to a different domain of sense perception was of course a powerful support in seeing that art as unique, as profoundly differing from all the others.

At the same time, however, it revealed this art's links with a broad realm of perception, and thus made possible a new and much deeper understanding of the medium and of its character and significance for the completed work of art. The association of each art with a different domain of sense perception also illustrates how thought about art in the last two centuries was intimately linked—though in ways widely differing from those accepted in the Renaissance—to the sciences, and this attitude sometimes influenced artistic development itself.

The particularizing trend did not enjoy the good fortune of the universalizing one. As a rule, philosophers did not take up what was said in the discussions of this or the other individual art, and the literature read by a wider audience remained less aware of the links between a specific artistic medium and a specific sense than of ideas about the elements common to all the arts. So far as I know, the story of these reflections has never been told in detail. I shall therefore begin this chapter with a few early opinions expressing the particularizing attitude.

The historian considering that long period between the 1760s and 1914, between Herder or Schlegel, on the one hand, and Riegl or Kandinsky, on the other, must ask himself how the two attitudes were related. Did the spokesmen of one trend simply ignore what the other had to say, or did some kind of dialogue develop between them? One cannot avoid asking, moreover, what was the impact of the very existence and articulation of the two attitudes on the arts, on aesthetic thought, and on general culture. The core question is probably this: did the polar juxtaposition of universal and particular remain the last word, or was there rather an attempt to bring the various arts into one comprehensive structure without disregarding, even for methodological reasons, the basic material and sensual differences of their media and of the patterns of experiencing their products?

The aesthetic thought of the nineteenth century has been discussed often and thoroughly. Usually, however, this has been done on an elevated philosophical level, and the questions here outlined, questions much closer to the actual arts than to purely philosophical speculation, have not been systematically investigated. It may therefore be worth

our while to study the development of these particular problems in some select and, I hope, representative examples.

I. LESSING

Lessing has been termed "a radical." Many a modern reader, acquainted with Lessing as one of the classical authors who are beyond criticism, will wonder how a writer thus venerated could have been involved in the ups and downs of radicalism. Yet the student who goes through Lessing's polemical writings with care, attentive both to the views expressed and to the tone in which they are presented, can well understand how such a characterization could have come about. "Both in tone and in intention," it has been said,[1] "Lessing's writings are always a challenge, part of a dramatic dialogue with a real or imagined opponent." But Lessing was a radical not only in tone and intention; the historical impact of his radicalism was that the intellectual and artistic scene he left behind him was in many ways profoundly different from the one he entered upon. One of the aspects of this revolutionary impact pertains directly to the subject matter of the present chapter.

We must begin by reminding ourselves of some of the chief characteristics of the history of aesthetic reflection before Lessing. For three centuries the assumption that a basic parallelism prevailed between poetry and painting, between the literary and the visual arts, was almost an article of faith. Ever since, in the fifteenth century, Italian humanism revived the ancient saying—attributed by Plutarch to the half-legendary poet Simonides—that painting is a mute poetry, poetry a loquacious painting, this idea of a close interrelationship, or even a hidden identity, of the various arts was asserted in ever-renewed formulations. Horace's *ut pictura poesis*—as is painting, so is poetry—became a credo of the humanistic tradition. Painting and poetry are sister arts, we hear time and again; they appeared at a single birth, says Giovanni Paolo Lomazzo in the late sixteenth century, to lend concreteness to the metaphor.[2] In the seventeenth and early eighteenth centuries, scholars, artists, and writers who continued the humanistic tradition clung to the

dogma of the parallelism of the arts. Let me give an example: Charles du Fresnoy opens his *Art of Painting* with the following verses:

> True Poetry the painter's power displays;
> True Painting emulates the Poet's ways;
> The rival Sisters, fond of equal fame,
> Alternate change their office and their name;
> Bid silent Poetry the canvass warm,
> The tuneful page with speaking Picture charm.[3]

And by the end of the eighteenth century, when Lessing's *Laocoön* was already known in England, Sir Joshua Reynolds could still refer quite naturally to Shakespeare as "that faithful and accurate painter of nature" or remark that "Michelangelo possessed the poetical part of our art in a most eminent degree."[4]

Dogmas have serious consequences. The dogmatic belief in the intrinsic unity of the various arts guided aesthetic reflection, largely determining where, on which problems, the emphasis of art theory—and of poetics—was to be placed. To make manifest the unity of the arts rather than to reveal the differences that separate them, one has to concentrate on those stages of the creative process and those features in the structure of the arts in which unity is stronger than diversity. Now, to put it very crudely: the arts differ most from each other in the final realization of the work they create. The completed statue and the finished poem are so different from each other that one has to make a serious effort to discover what they have in common. But at an initial stage of their conception, so at least it seems, they are closer to each other. One has to remember that the tradition that so emphasized the unity of the arts was also the tradition so profoundly concerned with *idea*. Whether *idea* is conceived in a more psychological sense, as the image in the artist's mind, or in a sociological sense, as a cultural image transmitted by tradition, in the creative process it is placed at a stage that precedes any specific artistic activity; it appears before the painter gives it pictorial form, or before the poet casts it in rhymes. The intensive concern with this early stage in the creative process fits very well with a belief in the unity of the arts.

It was the popularity of just this belief—that poetry and painting

are "sister arts"—that was profoundly shaken by Lessing's book. The basic thesis of the *Laocoön,* the essential statement he wished to make on the arts, is precisely the rejection of the centuries-old belief that the arts are intimately related to each other.

To understand Lessing's position more clearly, it may be in order to remind ourselves briefly of the obvious question: why, in the first place, are painting and poetry "sister arts"? What constituted the intimate family relationship between media that, at a first glance, are so strikingly different from each other as painting and poetry? In the tradition, an answer was adumbrated, suggested, although, strangely enough, it was hardly articulated. Both arts, it was said or intimated, imitate nature, and both create an illusion of reality. It is not for us here to take up that thorny problem, the imitation of nature in art, as seen in European thought. Yet it is surely no exaggeration to claim that this idea, taken over from Antiquity, was reformulated by every single generation from the fourteenth or fifteenth century onward, and was the focus of reflections on art. Inevitably there were also arguments as to what precisely it is that the arts imitate in nature. Is it the fragmentary piece of reality we perceive directly? Is it men's actions? Or is it, in a more general sense, nature's structures and modes of operation? The arguments over some of these questions were at times quite bitter, but the underlying assumption that the arts imitate nature was never called into question. Lessing, too, still takes this notion for granted. Painting and poetry are to him specifications of a single aesthetic type of representation: both are mimetic arts. "Poetry and painting, both are imitative arts"—so he writes in one of the earliest sketches for *Laocoön.*[5] It is true that Lessing does not make art's imitation of nature a special subject of discussion, but it is obvious that he accepts the thesis as the framework of his general theory.

Of greater concern for Lessing is the second reason for the sisterhood of painting and poetry, namely, that both create illusions. The opening paragraph of the *Laocoön,* the paragraph that sets the tone for the whole work, makes the creation of an illusion the central aim, the true *telos,* of the arts. Both painting and poetry, we here read, produce a "similar effect" on their audience, both place "before us things absent as present, appearance as reality."[6] In his *Briefe antiquarischen Inhalts,* written

two or three years after the publication of the *Laocoön,* he recapitulates the central thesis of the former work. His task, he says in the second letter,[7] is to examine how both the poet and the painter undertake "to arrive at the same goal of illusion by entirely different paths." Illusion, then, is the goal of the arts. While Lessing takes it for granted that the imitation of nature is the essence of art, he does not discuss the matter; to illusion, however, he frequently returns, and considers how it is produced.

Illusion in art, in the authentic sense of the term, refers to instances where an image is taken by an observer to be the physical object it represents. It gives rise to the sort of mistake Zeuxis made when he tried to lift the painted curtain from Parrhasius' picture. Renaissance texts provide us with many examples of this view of illusion. Here we often read of birds picking at painted grapes or of horses neighing at the pictures of mares. If such perfect illusion—a real *trompe l'oeil*—occurs at all in reality, it is obviously very rare. Our main interest in such effects, or the stories about them, is theoretical; they are presented as the extremes of a particular species of pictorial effect. Otherwise, in the Renaissance this could not have been. It is difficult to believe that an educated observer, let alone a Leonardo or an Erasmus, could actually have assumed that a piece of painted surface could ever be mistaken for a living person or for a wide landscape extending into depth. Unfortunately, there is no detailed study of what such state-ments as "misleading the beholder" or "mistaking a painting for reality" actually meant in fifteenth- and sixteenth-century parlance. But one can be sure, I think, that, whatever the semantic scope and emotional connotation of such phrases, they were primarily meant to express a theoretical attitude. What is this attitude? A detailed analysis would go far beyond the limits of the present study, but one thing stands out clearly: it is the tendency to blur the dividing line between actual, physical reality (what is portrayed) and its representation in art. How could the painted image be mistaken for the real object if they did not have an identical structure? It is the artist's merit to show that identity, to make the structure of nature manifest in the forms of his work.

It is here that Lessing clearly deviates from the tradition, even if he does not explicitly say so. It is also here that he becomes a source of

modern trends of thought. I shall try to put the idea underlying Lessing's treatise freely, without strictly following his own wording. The illusionary reality produced by art is not a duplication of external reality; a painting does not duplicate a piece of nature. The line separating one domain from the other can never be obscured. What is presented to us by even the most faithful artistic imitation of nature is a translation of that nature, or a piece of it, into another language. This of course is not to say that Lessing in any way rejected the idea that the creation of illusion is the final aim of the arts. We have just seen that, in his view, all the arts strive to present something absent as present. But his way of seeing the nature of the aesthetic illusion differs from what had been accepted for centuries.

Lessing used the term "sign" to describe the means of creating a work of art, and from his scattered remarks it clearly follows that the painting or the poem is a system of signs. Modern semiologists have good reason for their intensive concern with Lessing's doctrine of signs.[8] Unfortunately, he never explained what precisely he understood by "signs;" he did not give us, as one would say today, a theory of signs. But since the early eighteenth century, it should be kept in mind, the term was occasionally used in aesthetic reflection, and in discussing certain themes it even acquired a kind of currency. Because Lessing was familiar with these uses, a brief look at what it meant before him may help us to better understand his own usage. Originally the term was rarely applied to the visual arts; yet in those rare cases its connotation is obvious. In 1708, Roger de Piles wrote in his *Cours de peinture par le principe* that "words *(les paroles)* are never held to be the things themselves . . . the word is only a sign for the thing."[9] This statement still breathes Renaissance air. But only a decade later, the learned and influential Abbé Dubos—that somewhat diffuse who anticipated so much of modern thought—claims that "painting never employs artificial signs, as does poetry, but uses natural signs." Now, it would seem that both artificial and natural signs imply a certain distance between the reality represented and its representation in art. But here Dubos hesitates: "Maybe I am not speaking correctly when I say that painting employs signs: it is nature itself that painting places before our eyes."[10] Few definitions could illustrate as clearly the true nature of illusion as

Dubos' retraction. If painting uses signs, it follows from what he says, it does not cancel the gap between itself and the nature represented; but because it places nature itself before our eyes, it has no need, and also no room, for signs. There is, then, no sign without a basic difference between what signifies (the work of art) and what is signified (nature).

Lessing, it need hardly be said, was familiar with the tradition we have here represented by Roger de Piles and the Abbé Dubos. As is well known, he was attentive to discussions among the scholars and critics of his time, and he refers to them whenever he raises some controversial ideas or notions. Like Dubos, be speaks of "artificial" and "natural" signs, but without hesitation he includes the "natural" ones in the domain of signs. Artificial and natural signs differ from each other in many respects, and to some of them I shall shortly return; but both of them are signs; that is, in no way are they identical with what they portray. A crucial passage in the sixteenth chapter of *Laocoön* begins: "If it be true that painting, in its imitations, makes use of entirely different means and signs from those which poetry employs. . . ." The question, then, is not whether the painter in his work uses signs; it is only whether the signs he employs are, or are not, different from the signs the poet employs. As a modern semiologist would claim that an "iconic sign" is no less a sign than an "aniconic" one, so Lessing says that the pictorial sign is essentially no less a sign than the poetic one. Now, if you remember what a sign means, you cannot help concluding that in painting as well as in poetry an unbridgeable gap remains between nature and art. Lessing rejects a basic, though often only implied, assumption of Renaissance aesthetics.

In outlining Lessing's view of the sign as the central notion of artistic creation we have emphasized the difference between the sign and what it signifies, a difference that is of the very essence of the sign. But here we run into a paradox. If the sign is in its very essence different from what it signifies, how then does it manage to produce an illusion? Illusion, however interpreted, suggests a unity, or at least a close relationship, between the representation and what it represents.

To dissolve this paradox, we have to remember what, in Lessing's view, actually happens when we aesthetically experience a work of art.

A work of art, it has been said in a recent analysis of Lessing's aesthetic doctrine,[11] exists on two levels. One is the material stratum, the piece of matter in which the work is shaped as a material object, that is, the carved stone, the painted surface of a panel or a stretch of wall. The other is the image of an immaterial appearance, the mental picture dwelling in the imagination that has been produced by our experiencing the shaped material object. This appearance exists, of course, only in the beholder's mind; it is, needless to say, an illusionary object.

The subject of aesthetic experience is only that imaginary, illusionary object that dwells in the spectator's (or reader's, or listener's) mind. Whenever the aim of art is achieved and we perceive the absent as present, it is that illusionary object, the appearance in our mind, that does the job. The art work as a material object only excites our imagination, it only awakens the images of the absent things. Aesthetic reception passes through, and goes beyond, the sensible stratum of works of art in order to reach the appearance. At that stage, we can say, the spectator's imagination actualizes the aesthetic object. Or, as Lessing puts it, "for that which we discover to be beautiful in a work of art is not discovered by our eye, but by the force of our imagination, through the eye" (p. 93).

Lessing's attitude, it should be noted, is not "psychological" or "subjective" in the sense these terms have acquired in everyday talk. The true aesthetic object, dwelling in our imagination, may be intangible, it may remain a mere "appearance" that cannot be precisely pinpointed and measured, yet it is far from being arbitrary or a matter of chance, not subject to strict laws. On the contrary, Lessing believes that the very emergence and forms of these appearances are a matter of predictable regularity.

The ability to form in the mind an aesthetic object is a gift granted to man only, setting us apart from all other creatures. It is an ability that elevates man beyond the stage of immediate perception, above a close and immediate dependence on nature. "Animal eyes," Lessing writes in a preparatory note for the *Laocoön,* "are harder to deceive than human eyes; they see nothing but what they see; we, on the other hand, are seduced by the imagination so that we believe we see even what we don't see."[12] Here Lessing's historical position becomes strikingly man-

ifest, and, as in a flash, we become aware of how far removed he is from the humanistic tradition that originated in the Renaissance. Fifteenth- and sixteenth-century authors endlessly repeated the well-known stories of birds and horses being misled by painted grapes or √ mares. The purpose of telling these stories is clear: they were intended to state how close to nature, and therefore how "convincing," a good artistic representation can be. The lifelikeness of a good representation seemed to be rooted in nature itself, and therefore the criterion of the *trompe l'oeil* is a universal one, valid for all creatures. Lessing reversed that position. The bird and the horse, it follows from what he says, are unable to see anything that is not actually there. They are blind to art because they cannot see the absent as present. The gift of aesthetic experience is a hallmark of man's distinct place in the world.

Our perception of the work of art, it also follows, is no passive reception of an imprint made by the work of art that exists "out there," beyond the reach of the beholder. What we see in aesthetic experience is, in actual fact, the product of an interaction between the work *qua* natural, material object and the beholder. If ever there was a thinker who granted the beholder a real share in aesthetic experience, it was Lessing. It should be noted in passing, although we cannot discuss this here, that he does not accord a similar interest and attention to the artist. While Lessing comes back time and again to the spectator (or reader), he has little use for the artist.

The significance of the beholder's share should be one of the artist's leading concerns. In shaping his work, the artist should avoid anything that prevents the spectator from contributing his full share. Thus, a painter should never represent the highest degree of passion. This is so because "Beyond this [the highest degree of passion] there is nothing, and to show the most extreme point is to bind the wings of Fancy, and to compel her, inasmuch as her power cannot go beyond the impression on the senses, to busy herself with feeble and subordinate images, beyond which is that visible fulness of expression which she shuns as her boundary" (p. 71). The beholder's aesthetic experience and his active contribution to it have, then, a direct impact on the artist's consideration, a subject to which we shall return in the course of this chapter.

From a presentation, even if only in the most general terms, of Lessing's broad aesthetic principles, let us now turn to the arts themselves. In his view, what are the criteria for distinguishing between one art and another? And what are the principles governing the grouping of the individual arts into larger, more comprehensive units? Two groups of arts, Lessing claims, are irreducible to each other, and they are thus the ultimate constituents of the world of art. The two groups are more distinctly represented by painting and poetry. The reason for distinguishing them is not any specific, even if most important, characteristic; rather it is something that involves their whole existence. The best way to grasp what distinguishes between them is to try answering the question, what is the mode of existence of the work pertaining to one or the other groups? In what dimension of being is a painting, as opposed to a poem, located? Lessing attempts, so it seems, to make this difference not a matter of subjective impression but one of objective being (though, as we shall immediately see, he cannot avoid the spectator's or reader's perception. Painting and sculpture, which is affiliated with it, exist in space; poetry and all the literary arts, as well as music, exist in time. This well-known division is clearly formulated. "But I will try to consider the matter upon first principles," Lessing says at the opening of the sixteenth chapter of the *Laocoön*. "I reason in this way. If it be true that painting, in its imitations, makes use of entirely different means and signs from those that poetry employs; the former employing figures and colors in space, the latter articulate sounds in time . . . it follows that painting and poetry represent objects of a different nature" (p.131).

The problem has frequently been discussed; nevertheless it may not be altogether superfluous to ask what Lessing means by "space" and "time" in connection with the arts. It should be noted that, about twenty years before Kant published his *Critique of Pure Reason,* Lessing does not conceive of space as some kind of imagined container within which objects are placed. To put it boldly—and disregarding a great many philosophical subtleties—we could say that Lessing understands space as a way of perceiving objects. Instead of being a container, it is a type of intuition. The character of this type of perception is best described by saying that it shows us everything as coexisting, that it is

a simultaneous kind of vision. Space is simultaneity of things in a synoptic view, in the homogenoous form of vision. Things in space are "what the eye surveys at once" or that "which in nature would be seen at once" (pp. 140-44).

It is interesting for the study of Lessing's psychology that in the reality of vision, as he believes, simultaneity is only an illusion. What really happens when we view objects in space is not a simultaneous grasp of the various parts, but a process in time. This process, however, takes place so quickly that we are left with the illusion of timelessness, of instant and simultaneous vision. "How shall we attain to the clear representation of a thing in space?" Lessing asks, and answers "First we consider the separate parts of it, then the combination of these parts, and lastly the whole." The object, then, is not really seen at once, but in a sequence of steps: first the individual parts, then their combinations, finally the whole. Lessing here pictures visual, spatial perception as the building up of the object in the spectator's mind. "Our senses achieve these different operations with so astounding a speed, that they appear to us to be but one, and this speed is necessarily indispensable when we have to attain a conception of the whole, which is no more than the result of the conception of the parts, and of their combination" (p. 140).

The student of perceptual processess, Lessing might have agreed, will be interested in the rapid surveying that lies behind a seemingly simultaneous impression; to the naive spectator, to the person standing in front of a view of nature or a painting, this invisible process does not matter. To him, spatial perception is and remains simultaneous. Because the arts depend on the way they are perceived, the student of art and aesthetics necessarily disregards what lies beyond the realm of perceptibility. To him, space is completely different in structure from time.

Poetry, unlike painting, materializes in time; its very structure is that of succession, which is necessarily a temporal succession. Poetry, Lessing tells his readers, fashions its signs from "articulate sounds in time" (p. 131). You can see this best by simply reading a poem aloud: the former sound, or word, must altogether disappear from the world, must become a remembered past, for the next sound or word to be heard and to be intelligible. The listener or reader slowly builds up in his

mind the whole poem or narrative. The temporal structure of poetry and narrative is too well known to be described here in detail. Let us only emphasize that, in Lessing's view, the astounding speed of scanning —necessarily a process in time—that makes viewing a picture appear as timeless is absent from the literary arts. The reciting of a poem or the telling of a story takes place at a slow pace, it is extended over a considerable stretch of time. In other words, the passing of time becomes a perceptional quality in literature. "Let it be granted," Lessing says in the seventeenth chapter of the *Laocoön*, "that the poet leads us in the most perfect order from one part of the object to another; let it be granted that he knows how to make the combination of the whole clear to us,—how long a time does he require for the purpose? That which the eye at once surveys he ennumerates to us with marked slowness by degrees, and it often happens that we have forgotten the first when we have arrived at the last" (p. 140).

Does this juxtaposition of the arts—those materialized in space and those realized in time—in any way imply a difference in the value with which each of them is endowed? Lessing's explicit aim is not to pronounce value judgments on the arts; what he sets out to do is to describe their boundaries. And yet the student cannot disregard the fact that Lessing's attitude is not altogether "value-free." Behind the analytical description there is an attitude of evaluation. Usually this attitude remains in the background, but sometimes it is made manifest. Having read through the *Laocoön* as well as some other of his writings pertinent to our themes, one cannot help feeling that Lessing has some image of a hierarchy of the arts. In fact, he may well have paved the way for such systematic constructions as were presented only one or two generations after his death. It may therefore be justifiable to ask what his criteria were for placing an art on a higher or lower level.

Lessing does not tell us what his yardsticks are for measuring the value of the individual arts, or how they are linked to his overall view of art. An attentive reader, however, cannot fail to discover both the nature of the criteria employed and the reasons for using them. In the following observations, I shall attempt to present—in a short schematic way that Lessing would immediately reject—both his criteria and their justification in his thought.

The Beholder's Share. The aesthetic object dwelling in the beholder's mind is, we have just seen, the result of an interaction between the work of art as a material object and the spectator. It follows from Lessing's doctrine that the greater the spectator's activity stimulated by the work of art, the better the work. This seems to be true for the arts in general. The different arts allow, and even call for, different degrees of creative activity on the part of their audiences. The "natural sign," though a "sign" in the full sense of that word, requires of its audience less "translation" into a different idiom than does the "artificial" sign. When the poet describes an object, that object is not fully present, it doesn't arrest the imagination. "With the poet," Lessing says, "a garment is no garment: it covers nothing: our imagination sees entirely through it" (p. 90). The literary description of an object expands, it is built up in the reader's mind, and in that process his share is obviously increased. In a long passage devoted to another subject (the temporality of literary description), Lessing deals with a famous example of the literary description of a material object, Homer's account of the shield of Achilles — "that famous picture," Lessing writes, "in consequence of which more especially Homer has from all antiquity been considered as the teacher of painting." It is worth our while to follow his description:

A shield, it will be said, is surely an individual corporeal object, the detailed description of the successive parts of which cannot be allowed to belong to the province of the poet. And yet Homer has described this shield in more than a hundred admirable verses. . . . Homer does not paint this shield as perfect and already made. He has availed himself of the much praised artifice of changing that which is co-existent in his design into that which is successive, and thereby presenting us with the living picture of an action instead of the wearisome description of a body. We do not see the shield but the divine master as he works. . . . We do not lose sight of them (the figures) till all are finished. Now they are finished, and we stand amazed over the work, but it is with the believing amazement of an eye-witness who has seen the work wrought. (p. 149)

The eyewitness is, in fact, a partner in the poet's conjuring up of the object, he is an associate in the creative process of the literary description. Had he been presented with the shield itself, or had he been looking at a material depiction of the finished shield, he could not have

participated to the same degree. In poetry the beholder's share is larger than in painting.

The Material Nature as a Constraint. The work of the visual arts, unlike the product of poetry and narrative, necessarily has a material substratum —the carved stone, the cast bronze, the painted panel. This material layer Lessing conceives as a boundary, as a limitation on the spectator's creative imagination. Frequently he speaks of the painting's or the statue's "material confines" *(materielle Schranken.)* It should be remembered that Lessing was no Platonist; his rational mind was opposed in many ways to the mystical leanings that characterize the Platonic trend in medieval and Renaissance tradition. And yet he seems to have taken over some attitudes that originally belonged to mystical Platonism. In that tradition of thought, matter was conceived as an ultimate boundary, a "prison," as it was sometimes called. Without going so far, Lessing views matter in a similar way, even where aesthetic matters are concerned. He does not stress, for example, that the material character of the painting or the piece of sculpture confer on the picture or statue a greater concreteness; what he stresses is that the material layer is a confining limitation.

Matter is not only a metaphysical limitation, as the Platonists saw it; it also has direct aesthetic implications. The artist, we remember, should devote great attention to choosing the right moment of an action for representation, and he should avoid showing "the most extreme point of action." Why should this be so? "I believe," says Lessing, "that the single moment to which the material limits of art confine all her imitations will lead us to such considerations" (p. 70). The poet's position is altogether different. The material confines do not seem to be valid for his work. Even where he uses personifications, they are not subject to material confines. "Although the poet likewise makes us think of the goddess as a human figure, he has nevertheless removed all ideas of coarse and heavy matter and he has enlivened her body with a force which exempts her from the laws of human locomotion."

What Can Be Represented? Perhaps the most crucial difference between the arts is what one or the other can, or cannot, represent. The range

of the various arts is not identical; what lies within the reach of one may well be beyond the reach of the other. Both groups of arts, the pictorial as well as the poetical, have their limitations, but the boundaries are not the same. Many a direct sense perception may well be beyond what the poet can directly describe. How can he, to adduce an example that has had a long history, describe in words the apparently simple sensation "red"? But Lessing is not so much concerned with pointing out the poet's limitations; what he mainly wants to show is what the painter cannot do. There are large parts of reality that poetry can describe and literature can narrate but that the visual arts cannot represent. Lessing's treatise on *fables,* an early work that in many respects is a precursor of the *Laocoön,* "puts the painter in his place," to use Gombrich's formulation (p. 141). The test of a good fable, Lessing here declares, is that it cannot be properly illustrated. "A fable is an action," consisting of a series of changes that form one whole. "I can consider it as an infallible test that a fable is poor, that it does not deserve the name fable, if its supposed action is capable of being completely depicted." [13] In an image, he says a little earlier, "I can well detect a moral truth, but this does not mean that it [the image] is a fable." Tantalus, thirsting while standing in a stream, is an image showing that one can starve in the midst of plenty. But is this image therefore also a fable?—so runs Lessing's rhetorical question. The answer cannot be in doubt. The fable cannot be depicted.

Lessing's denial of the picture's ability to fully illustrate the story is not only a theoretical statement; it takes place within a definite cultural context. It has convincingly been said that Lessing here specifically directed his argument against the tradition of emblems. An emblem, we remember, combines word and image in order to convey to the reader-spectator a moral message. It is of course not a matter of chance that the tradition—one is tempted to say the culture—of emblems evolved within the humanistic movement, from the sixteenth to the late eighteenth century, and that the audience for emblem books consisted of those learned circles we usually call "humanists." The popularity of the emblem book in the humanist tradition cannot surprise us. The organic combination of word and image, the very essence of the emblem, is yet another version of the humanistic credo in the arts, namely that they

are parallel to each other. An emblem is, as a matter of principle, a concrete example of *ut pictura poesis*.

As we know, Lessing rejects this principle. He therefore also rejects the emblem and denies that the fable can be illustrated. The difference in range between painting and poetry is made manifest in many ways. Let us come back to the *Laocoön,* where Lessing deals with one striking example of this difference. Homer, he says, "creates two classes of beings and of actions, visible and invisible. Painting is incompetent to represent this difference. . . ." He polemicizes with Count Caylus, who placed the invisible actions in unbroken sequence with the visible ones. Painting is plainly incapable of representing the invisible. "The worst consequence," he goes on to say, "is this, that as the distinction between visible and invisible is taken away by the painter, all the characteristic features are immediately lost, by means of which this higher kind is elevated above the lesser" (p. 119).

Representation of Complexity. A particular case of the different range of the individual arts, of what each of them can or cannot represent, is of such significance in our context that it must be considered separately. To what extent can painting and poetry render the complexity of a subject, particularly of a figure, without becoming unintelligible? Some of Lessing's most interesting observations are made on this particular point.

We have just seen that painting cannot depict the invisible, that it has no means of dealing with what goes beyond sheer, regular visibility. This is also true for the images of the gods. Painting reduces the various ontological levels of the Homeric world to the homogeneous world of everyday visual experience "Greatness, strength, speed, qualities which Homer keeps in reserve for his gods in a higher and more wonderful degree that those which he attributes to his best heroes, sink down to the level of the common measure of humanity, and Jupiter and Agamemnon, Apollo and Achilles, Ajax and Mars, become entirely beings of the same kind . . ." (p. 121). To keep them apart from each other, the painter endows them with what we would today call "iconographic attributes," Zeus's thunderbolt, Apollo's lyre or bow, and so on. But are not these very attributes admissions of painting's inability to mani-

fest the gods' essence directly, to make their appearance intelligible without external aids?

And how can the painter represent the complexity of a single figure? How can he show that the very same figure has different, often even conflicting qualities of character? Lessing enters into vigorous debate with Joseph Spence (1699–1768), a representative of the school of speculative methology that continued some Neoplatonic trends into the late eighteenth century. In his *Polymetis* (1747), Spence attempts to explain the nature of the Greek gods on the basis of their representation in Greek art. This leads Lessing to his own subject, the relations between the arts, and what each art can represent. "Of the mutual resemblance which subsists between Poetry and Painting, Spence has the most extraordinary notions" (p. 102). Lessing here comes back to his old claim: Spence does not see the difference between the arts, he does not notice that even where they portray the very same subject, each of them slightly modifies it. In fact, the poet and the painter do not show or represent exactly identical gods or spiritual beings. "The gods and spiritual beings, as represented by the artist, are not entirely the same as those whom the poet makes use of." Here Lessing does not speak of the difference of medium, but of a difference in content, a change in the nature and identity of the figure. "To the artist they are personified *abstracta,* which must always maintain the same characteristics if they are to be recognized. To the poet, on the other hand, they are real acting creatures, which, in addition to their general character, have other qualities and affections, which, as circumstances afford the opportunity, predominate" (p. 104).

At a first reading, this seems rather shocking. The visual arts, the works of which have a material, tangible substratum, which operate with natural signs, which provide an immediate, direct sensual experience—it is these arts that create abstractions. The reason for Lessing's view is of course obvious. The visual arts, freezing the figures they depict into one moment, one unchangeable view, do not have the ability to manifest the variety of aspects, the multitude of properties that actually belong to the nature of a mythological figure, and, were they to try to express that variety, they would necessarily become illegible.

2. HERDER'S PLASTIK

It is perhaps best to start a brief review of thought devoted to the individual arts with the treatise by Herder known as *Plastik*. This is among the earliest modern documents attesting to the attempt to interpret the particular nature of an artistic medium by referring to a specific field of sense experience. *Plastik* was a long time in the making; the first drafts predate the final version, published in 1778, by a decade. This was a creative decade in the young Herder's career, a time when he wrote his important *Über neue deutsche Literatur* (Concerning Recent German Literature) (1766–1767) and *Critical Forests* (Kritische Wälder). Yet frequent rewriting did not necessarily lead to a clear and simple diction; *Plastik,* written in a fervent style, lacks the lucidity and transparence that sometimes accompanies slowly formed masterpieces of thought. In spite of some repetitiveness and ambiguity, however, Herder's *Plastik* is a signpost in the evolution of modern thought on the arts; it anticipates a great deal of nineteenth- and twentieth-century reflection, and has certainly merited more attention that it has received.

Herder himself tells his readers what motivated him to write *Plastik*. "When philosophizing about the arts was still the fashion," he discloses, "I searched for a long time for an actual concept that would distinguish between beautiful shapes and colors, sculpture and painting, and—I did not find one."[14] Painting and sculpture were always considered in one and the same context. In that short passage, Herder both describes his historical position and the aim of his investigation. His historical position is clearly defined by his taking the system of the "fine arts," the *beaux arts,* for granted. The long periods preceding the modern age, periods in which artists had to prove the inherent value of their occupation and to set themselves off from mere craftsmen, had long passed. That there is some basic common value uniting the visual arts is no longer doubted. What really concerns Herder is the underpinning of the individual arts, an underpinning that has nothing to do with the social or intellectual standing of painting or sculpture, but rather with their very nature as unique arts. He is well aware of the profound differences between painting and sculpture, and he sets out to inquire

into the basis of these differences. His answer, put in a nutshell, is this: "To sight belong only planes, paintings, figures of one plane, but bodies and shapes of bodies belong to touch" (p. 249). In other words, the two-dimensional art of painting appeals to sight, whereas the three-dimensional art of sculpture appeals to the sense of touch. Simple and self-evident as such a statement may seem to a twentieth-century reader, in actual fact it constitutes a far-reaching revolution, and reveals still another facet of Herder's originality.

Students of the eighteenth century need not be told of the innovativeness and significance of Johann Gottfried Herder (1744–1803), and I shall not attempt here to draw his portrait.[15] In the present context, I should like only to emphasize one characteristic of his thought—his looking, in every field of study, for the aboriginal sources, for the primitive and first layers. Because Herder's interest were so diversified, the "sources" and origins he deals with are of a sometimes bewildering variety. What these sources have in common, however, is that, whether referring to religion or painting, poetry or world history, they are always presented as specific and real, never as abstract ideas. A good example is his interpretation, undertaken together with his teacher, the German philosopher Hamann, the "magus of the North," of the Book of Genesis. It has correctly been said that the aim of this interpretation is not to discover some abstract notion; Herder and Hamann studied the Bible for its graphic portrayal of the primitive Hebrews. The key to this exegesis, it has been maintained, lies in the "inversion of the common eighteenth century appraisal of the relative merits of the concrete and the abstract. The concrete now became the natural; the pictorial was not crude and obfuscatory but more powerfully human. The abstract was incomprehensible and arid."[16] In the same vein, he approached Ossian almost with veneration, placing him on the same lofty height as Homer.

The same trend of thought is seen in Herder's attempts to derive the arts from some primeval layers of human experience. And what could be more primeval and concrete than the specific senses, and the experience of the surrounding world that they transmit to us? "Were all our notions in the sciences and the arts," writes Herder, "reduced to their origins, or could they thus be reduced, connections would be separated

and separations would be connected, as we don't find them in that great confusion of all things we call life or reality" (p. 249).

The eighteenth century was not indifferent to the sense of touch. Even though that sense was not analyzed in any detail comparable to Herder's, an object's tangibility seems to have been accepted as the ultimate proof of its independent existence as well as of the ability of our senses to provide us with reliable and irrefutable information about the surrounding world. The term "object" regained its original meaning: something thrown in our way, something sensually encountered, without knowing or expecting it. Touch, even if not sufficiently distinguished in its nuances, thus becomes a major source of knowing the world. In his treatment of touch, Herder went far beyond what the eighteenth century had to say, but in essence he continued an inherited trend of thought.

Vision and touch, the senses that are the sources of the two basic arts of painting and sculpture, these Herder juxtaposes in various respects. We have already seen that lines and colors appeal to vision, shapes and bodies to touch. But Herder goes further and dwells with particular emphasis on two additional aspects. First, vision makes us perceive a *dematerialized* world, and it is therefore of particular affinity to the world of phenomena, of bodiless appearance. "A body that we would never experience as such by touch ... would remain to us forever a handle of Saturn, a sling of Jupiter, i.e. a phenomenon, an apparation. The ophtalmit with a thousand eyes, without a feel, without a touching hand, will all his life remain in Plato's cave" (p. 244). The dematerialized representation does not evoke real reactions. You do not wish to grasp the radiant image (p. 247). Because images lack material reality, Herder believes, vision is "the most artificial, the most philosophical sense." (p. 250). No wonder therefore that the art based on vision, that is, painting, shares with its sensual origin its philosophical, ultimately unreal, character.

The two-dimensionality of painting, and of vision, reveals that its reality is incomplete. "That a statue can be seen, nobody has doubted; but can one determine from vision what is a beautiful shape? ... This one cannot only doubt, but outrightly deny" (p. 251). Vision, he later says, "destroys the beautiful statue instead of creating it" (p. 252).

The seeing eye is opposed by the touching hand, and it is to the feeling, touching hand that the fullness of reality opens up. This is a general human trait, and it can be seen in all stages of life. "Come into the child's playroom," Herder addresses his reader, "and watch how the little empirical creature seizes, grasps, takes, weighs, touches, measures with his hand and feet, in order to acquire for himself faithfully and securely the heavy, first and necessary concepts of bodies, figures, magnitude, space, distance" (p. 245). What is impenetrability, hardness, smoothness, form, shape, roundness—of all this the eye cannot tell you much, of this you learn from "the grasping, touching hand" (p. 245). What you can learn from the hand is the "tangible truth." While vision destroys the statue, touch revives it. The introvert lover who apparently wanders around a statue or a column aimlessly experiences its beautiful round shape. "His eyes become hands, the light ray a finger. . . . The statue lives . . . it speaks, not as if he would (only) see it, but as if he would feel and touch it. A column coldly described gives us as little idea as painted music; better let it stand and go on" (p. 253). Sculpture, born of touch, is able to capture in a single statue the full reality of the object represented.

The antithesis between painting and sculpture, or vision and touch, is stated in an aphorism: "In vision there is dream [that is, a lack of all reality], in touch there is truth" (p. 247).

Here it may be worth our while to stop for a moment and look at Herder's sources or predecessors for this particular comparison. How does he relate to these forerunners? The comparison between the arts, I need hardly repeat, is a venerable topic, one that surfaces at several stages of European intellectual history. The best-known version is probably the literary genre that the Italian Renaissance called *paragone*. For our purpose it will be sufficient to remind the reader of the most famous Renaissance text in the *paragone* literature, Leonardo da Vinci's notes concerning the comparison of the arts. Leonardo, too, bases the arts on our senses, though he is not as systematic and consistent in this respect as Herder. But for him, too, painting follows from vision, and music from hearing. But here some interesting differences between Leonardo and Herder strike the careful student. For Leonardo, the major confrontation is that between painting, on the one hand, and

poetry and music, on the other, that is, between the art of spatial simultaneity and the arts of temporal succession. Sculpture occupies a rather marginal place in Leonardo's thought. How does he compare it with painting?

"After painting comes sculpture," says Leonard, "a very valuable art, but it is not produced by minds of such excellence as is painting." He goes on to mention the aspects in which painting excels, and which are altogether absent in sculpture. These are perspective and shadow. In both respects, the statue is just an object, like any other material object, and the artist does not have to create anything; nature herself helps him.[17] "The first marvel that appears in painting is that it appears to be detached from the wall. . . . In comparison with this, the sculptor creates his works so that they appear as they are" (#54). A statue, produced by nature and man, belongs in greater part to nature (#50). Without going into detail, we can say that Leonardo conceives of sculpture as being, in some respects, closer to nature than is painting. In this respect, there is a certain affinity between him and Herder. The appreciation of the fact may be quite different: to Leonardo it is a reason for criticism, to Herder a reason for praise; on the fact itself they agree.

Another distinction between painting and sculpture that Leonardo mentions is of a social nature. Painting is a "liberal art," sculpture a "mechanical art" (#49ff); while a painting is produced by "mental analysis," a statue is produced with great physical effort, causing "physical fatigue" (#51); the sculptor sweats, he is covered with paste and powder, he looks like a baker; the painter works in the quiet of his workshop, wearing his fine clothes. Of this social distinction, it should be noted, nothing survives in Herder.

Herder's further distinction between painting and sculpture, continuing of course his distinction between vision and touch, is in some of what it proclaims even more problematic than the first one. Parts of the argument can easily be criticized and refuted on the basis of well-established facts and stylistic analysis. However, in the intellectual world of Herder and his time this second distinction was of profound symbolic significance, and it provides an important insight into the thought of that formative stage in modern notions of art.

Herder not only asks what dimensions of reality the different senses and arts are able to capture; he also wishes to establish and describe their particular modes of being. He thus distinguishes among three modes of artistic being, or, as he calls them, three "species of beauty." "Parts next to each other result in a surface; one after another are, most purely and most simply, the tones; parts at one and the same time, next to each other, one into another, altogether, are bodies or shapes" (p. 257).[18] The distinction, then, is between surface, tone, and body, or, if you wish, between painting, music (or poetry), and sculpture. These are the borders nature herself has devised, they should not be transgressed, and the arts rooted in each of the individual modes should not be confused. "A music that paints, and a painting that sounds, a sculpture that dyes, and a depiction that wishes to carve in stone, these are degenerations that will remain without impact or that will have a false impact" (p. 257).

Now, the art of the surface, painting, is the art of simultaneity, of "one next to the other." In making this statement, Herder also makes the tacit assumption that it is discrete units, well distinguished, that are placed next to each other on the picture surface. In other words, when speaking of painting, Herder has a specific style in mind, that which, following Woelfflin, we would call the "linear style." In that style, it is true, outline plays a central part, the components of the composition are well defined in themselves, sharp boundaries are an essential constitutive element. Needless to say, Herder here disregards style of a different character.

Sculpture, Herder thinks, works on a model other than that of painting. Boundaries cannot be sharply defined in the statue: "Sculpture works [surfaces] into one another" (258). The touching hand cannot clearly distinguish between adjacent parts, the surfaces are continuously transformed into one another. In sculpture, Herder says, "one is all, and all are only one" (p. 259).

Herder here comes close to applying to the visual arts a notion that was to be among his most important contributions to aesthetic thought, the notion of "organicism." A work of art, aesthetic organicism assumes, may be compared to a living organism. Though the work displays a great wealth of subtle distinctions and, in fact, no part is full

identical with any other, no part of the work can be fully separated from the rest, no definite limit can be set to it. Herder, it has been claimed, was the first critic to make use of the concept of organic form in practical criticism. I think we can take one step further and say that this is also true of his attitude to the visual arts. Here sculpture is the full embodiment of organic form. It is an art in which one form or part is gradually transformed into the other; we cannot indicate the limit that separates one form from the next. Even where materials of an altogether different nature are portrayed—for instance, the human body and the drapery covering it—the distinction between them is often obscured. Here Herder adduces the Greeks who made dress reveal rather than hide the shape of the body wearing it, the so-called "wet drapery" (he uses the term *nasse Gewänder*, p. 267), and this particular device seems to him symbolic of the nature of sculpture in general.

II. RECONSTRUCTING THE UNITY OF THE ARTS

The questions raised by Lessing and Herder, as well as the answers they provided, clearly illustrate, I hope, one of the central processes that dominated thought on art in the last third of the eighteenth century. That process was of crucial consequence for aesthetic reflection in the two centuries following; we clearly feel its impact in the ideas put forward and debated in our own day. In the eighteenth century, it was a process in which the notion of *one* art—comprising all media of artistic expression—was broken up into a multitude of individual arts. The gap between one art and another was widened. The arts were shown to be of an altogether different structure, rooted in different dimensions of experience (space, time), and, finally, addressing different senses. Even when we disregard what the humanists called "poetry" and concentrate our attention on the mimetic arts in the visual domain, we still encounter a cleavage, an abyss that seems to remain unbridgeable. Herder showed that painting and sculpture originated in different areas of human experience and addressed different senses. Could all the arts still be seen as forming one comprehensive untiy? Was this not the end of the doctrine claiming that all the arts hang together?

To artists, writers, and critics around 1800 this conclusion seemed unacceptable. To be sure, even they knew—as we nowadays know much better—that from Lessing and Herder, and from the critical movement they initiated, a great deal could be learned about the specific nature of each individual art, about the kind of problems encountered in creating works of poetry and music, sculpture and painting, and, most important, about our experiencing works of art carried out in these different media. But what seemed to be the result of that process—the breaking up of the great organic unity of art into different techniques—could not be accepted as the final message of a profound and long-lasting concern with the problem. The individual arts could not remain altogether separated from each other, isolated and scattered fragments never again to be connected. The more the unique character of an individual art became manifest, the more strongly the need was felt to link it with another, equally unique, art. A way had to be found to reconstruct an overall unity of the arts. This was the psychological origin of the great systems of aesthetics that fully dominated the thought of the next generation.

I need not waste many words in convincing the reader that a renewed putting together of the arts could not possibly mean the restoration of the—perhaps naive—belief that all the arts are, in fact, one and the same creative entity. The lesson taught by the generation of Lessing and Herder could not be so easily forgotten. The one, universal great art that the Renaissance bequeathed to ensuing periods was split into the arts of time and the arts of space; it became obvious what the arts of space can and cannot do, as the abilities and inabilities of the arts of time also became manifest. Even within the arts of space a chasm was opened up between the art that addresses vision and the art that addresses touch. What had been learned from the *Laocoön* and from *Plastik* could not just be forgotten. If once again the arts were to be linked to each other, this could not be achieved by obscuring the borders separating one from the other, or by blurring the distinct character of each. It was felt that the arts should be linked on the basis of their very variety; a system of the distinct arts was required.

The age of the great systems that was approaching contained many attempts to answer these questions. In the following pages I shall

adduce two such attempts, both from the generation following that of Lessing and Herder. The systems I propose to survey establish their theoretical constructions on totally different bases. Nevertheless they may be linked in presentation: one of them opens the brief period of intensive search for a system of the arts; the other is the outcome—many would say, the final result—of these searches and concludes the creative phase of system building in the theory of the arts.

<div align="center">1. SCHLEGEL</div>

Our first document is a series of lectures delivered by the German poet, critic, and scholar August Wilhelm Schlegel (1767–1845) at the University of Jena, preserved mainly in the notes of a gifted student, Friedrich Ast, who was to become a leading Platonist and aesthetic philosopher of the early nineteenth century. Though Schlegel's lectures were published under the title *Philosophische Kunstlehre* (Philosophical Doctrines of Art), they are in fact devoted mainly to a discussion of poetry and some other forms of literature. The nonliterary arts play only a minor, marginal part in Schlegel's thought. Nevertheless, what he says in the few pages devoted to the visual arts allows us to detect the outlines of a system comprising all the arts, a system based on a clear principle. In the following observations I shall disregard the detailed discussion of poetry to concentrate on the system as a whole, its principle, and what it says about the visual arts. Unfortunately, Schlegel nowhere formulated his principle, and I shall therefore have to put it forward in my own words.

Schlegel wants to establish a "natural history of art."[19] By the end of the eighteenth century, "natural history" was a popular term. It meant the singling out and recording of the essential stages of a development. "History" without any further qualifications—to put it simplistically—means mainly the recording of individual events, and these, superficially at least, do not seem to follow by necessity from any underlying structure. "Natural history," on the other hand, lays bare fundamental structure, and shows the necessity, or law, by which one stage follows the other. A "natural history of art," says Schlegel, cannot be derived from historical experience only. Experience—that is, the

consideration of concrete events—can explain only what happens by chance (p. 8). Natural history is meant to explain what follows of necessity, the very laws governing the stages of the unfolding of a process.

It is interesting to note that at this early stage Schlegel seems to have suggested a methodology that will remind the modern reader of anthropological procedures. "What is here called natural history of art," we read, may be seen historically, that is, as a succession of stages remembered and narrated, but it may also be seen spread out simultaneously. There are new peoples, "peoples of child- and at the most youth-age," says an early commentator on Schlegel (p. 7 n. 16). Like a good anthropologist, he believes that what we observe in primitive peoples of today is an analogy of earlier periods of history.

Schlegel himself says that the concept of a "natural history of art" is an "exposition and explanation of the necessary origins of art in the particular existence and the natural environment of man" (p. 7). Behind this rather general claim the distinctive nature of Schlegel's model may be felt. Let us put this in a modern formulation: The model is man himself. The original medium of artistic creation is man himself, his gestures, sounds, and words. The original manifestations of the human drive to artistic creation are not symbols or arbitrary forms, echoes the commentator (p. 8, n. 19). Nor was the original work of art thought out in advance. "The original poems," Schlegel says, "were inspired by a real, present emotion." That emotion, or passion, "was too tempestuous to permit a prudent preparation, and it did not need it" (p. 33). A crucial note is here struck, a note that was to resound with increasing force in the nineteenth and twentieth centuries. An important myth of our modern age begins to stand out against a historical background: the original artist created the primeval work of art in a kind of trance, in a paroxysm of overwhelming emotions. The artist begins to be altogether detached from the workshop tradition; as with premeditation, the "work" thus created literally need not go beyond the artist himself.

"All the arts the instruments of which are external to man suppose physical observation and an arbitrary act of evaluation" (p. 9). Here, in these fragmentary remarks, a system of the arts is foreshadowed. Man is not only the producer of art, he is also—to a certain, changing

extent—the medium in which the work is carried out. The closer an art is to man—so it follows—the more authentic it is; the further removed from man—his body, his voice, his movements—the more artificial, the less primeval it is. Schlegel is of course aware that even the most authentic arts cannot do without some elements of arbitrary shaping. Thus he knows that the human voice is put to threefold use: shouting, singing, speaking. Shouting is fully instinctive, it lacks arbitrariness. Singing, however, would not be what it is without an arbitrary structuring of the sounds produced by man. Speaking, finally, is an activity employing symbols and conventions. Take away the symbolic and conventional features from language, and there will be no speech.

The visual arts, as we have just said, played only a marginal part in Schlegel's thought. Yet what he says in the few pages devoted to this subject is often unexpected and anticipates certain notions that have achieved broad popularity in the modern world. I shall disregard Schlegel's interesting discussion of whether or not architecture belongs to the visual arts (pp. 227-233), and shall concentrate only on what he has to say about painting and sculpture. His views are worth consideration not only because they are crucial to the emergence of modern aesthetics but also for what they contribute to present-day discussions.

Painting and sculpture are of course conceived as having a great deal in common, and the great masters of the Renaissance, as Schlegel points out, have shown this in practice. But to his way of thinking, sculpture occupies a more important place. Sculpture, in his definition, is the art that creates "forms and figures that can be viewed from all sides, that do not appear singly" (p. 238). In other words, sculpture is the art that shapes three-dimensional bodies. One perceives the echo of Herder's doctrine when one reads that in a statue the borders of the planes are fluid, that surfaces cannot be sharply defined. To know a statue you must undertake a long process of experiencing it. This idea may be behind Schlegel's claim—at first glance surprising—that sculpture "eternalizes movement" (p. 239).

The "forms and figures" produced by the sculptor can be of different types. Schlegel anticipates twentieth-century thought when he says that the forms shaped by the sculptor can be either "organic" or "mathematical" (pp. 233-234). When "organic" forms are produced, the

model is taken from the world of living bodies. Greek sculpture has shown what the organic body can mean to the artist, both as a direct model to be imitated and as a comprehensive principle. The living body dominates Greek art in all its manifestations. Even lifeless matter is informed by the organic principle. When the Greek artist shows draped figures, the folds of the cloth follow the organic forms of the body and manifest, rather than obscure, its structure. Even heavy stuff becomes a carrier of the organic spirit pervading Greek art.

The other type of form into which three-dimensional objects may be cast Schlegel calls "mathematical." Once again, the student cannot but regret that our author nowhere defined what he meant by that term. Carefully reading the rather few and brief observations he makes on the subject, one cannot help concluding that he did not have precisely mathematics in mind. What he calls "mathematical" we would probably term "abstract." Mathematical forms are set apart from all other forms by their origin: they are not derived from regular experience, they are not collected from the outside world. It is their signature that man himself—more specifically, his mind—is their origin. It is characteristic of the mathematical form that "the model is taken purely from the human mind." We speak here of "regular forms the human mind itself constructs" (p. 234). To be sure, Schlegel also has something to say about the character of the forms themselves. They are straight and angular and "manifest expediency." A modern reader, used to the present-day vocabulary of artistic terms, would immediately think of "functional." No wonder, then, that mathematical forms can best be observed in tools. It is in tools that both the expediency and the calculability of mathematical forms is most obvious. But in following Schlegel's thought one can see, I believe, that the major characteristic of mathematical forms is not the character of the actual forms (angularity, calculability, expediency) but rather their origin in the mind alone.

In juxtaposing organic and mathematical forms, Schlegel wants to map out the essential possibilities, or options, facing the artist. Using the language of late eighteenth-century German philosophy, we should say that he is constructing a system. But in fact he also used this juxtaposition of forms taken from external nature and others originating purely in the mind in order to detect and outline the direction of a

historical development. Once more, he makes only a brief observation, but it is one that is well worth our careful attention, particularly in the light of recent discussions.

Schlegel is concerned with discussing, in most general terms, the direction in which Greek sculpture unfolded. He accepts the three-stage model of this development that, we are accustomed to describing by the terms "archaic," "classical," and "late" or Hellenistic. "Greek sculpture," Schlegel observes, "went the great systematic course" (p. 238). What is the characteristic of the art of the early stage, the one we call "archaic"? The humanistic tradition, which still held sway in Schlegel's time, knew little of archaic art. Winckelmann explicitly tells his readers[20] that he had never seen any piece of sculpture produced at this early age. The humanists' attitude to the archaic age was one of principle, and it was based on the model of growth and decay. An old tradition had it that the feature characterizing the initial stages of the great historical process is the inability of art to do full justice to nature when portraying it. "The arts," says Vasari, started from "modest beginnings, improving them little by little, until they finally perfected them."[21] Schlegel suggests an altogether different attitude. "Greek sculpture," he says, "did not begin with a slavish imitation of nature, but instantly grasped the idea of a human form, carrying it out with great severity, according to rule and systematically in the highest degree" (p. 238). Art does not begin with an observation of nature, and archaic art is not like the child's fumbling while he is assembling details and fragmentary pieces of reality that eventually, in a distant future, will fall into a pattern. Whether or not this model of child development is correct, it cannot be used for understanding the history of art. On the contrary, says Schlegel, what art begins with is a rather abstract pattern, clearly and sharply present in the artist's mind. The early Greek sculptor, who carried this image in his mind, also had the ability—the acuteness of vision as well as the manual dexterity—to carry it out in hard stone.

The second stage of that development, that is, so-called "high classical" art, is conceived as a union of the severity and loftiness of archaic art and "the charms of life" (p. 239). In this period, the images of the gods and the heroes were the main concern of the artists. Schlegel

describes the expressive qualities of these images when he speaks of "calm divinity," and says that "circumspection, self-assuredness" were characteristic of them.

Of the last period Schlegel has very little to say; we don't even know whether he had Hellenistic or Roman art in mind. We learn only that this was a period of decline, and that the specific art form it created was the portrait: "only late," says Schlegel in his lectures, "art condescended to the portrait, the beginning of its downfall." (p. 239).

2. HEGEL

The process I am trying to outline in this chapter—the combining of the distinct arts into a comprehensive system—reached a climax with the great German philosopher Georg Wilhelm Friedrich Hegel (1770–1831). Hegel is a hurdle equally difficult to take or to evade. In many fields of thought and reflection, his mark on the life of the modern mind is inescapable. This, I believe, is also true with regard to the visual arts. Perhaps the most striking proof of Hegel's "relevance," to use the contemporary cant expression, is the debate over the truth or falsity of his views. The ideological shrillness of the polemics surrounding Hegel's theory is the best indication that he touches a nerve in modern life. In recent decades, the argument has been particularly intense. Some students of visual images have undertaken to expose the weaknesses in Hegel's doctrine and to point out the dangers behind it, thus again demonstrating how topical his thought remains, and to what an extent present-day reflection cannot avoid having to come to terms with it. But Hegel's significance for our subject is often also directly acknowledged. Recently, Ernst Gombrich, who has contributed his fair share of Hegel criticism to the literature on art, even declared that Hegel rather than Winckelmann "should be called the father of art history."[22]

In Hegel's system, it is by now notorious, no single part can be detached from the whole doctrine and discussed separately. Nevertheless, I shall attempt to limit my observations to one subject only, namely the visual arts. Moreover, I shall emphasize one aspect of that subject: how Hegel conceives the relationship between one art and the other. It

is the *system* of the arts with which we shall here be concerned. Our main source will be the *Vorlesungen über die Aesthetik* (translated into English as *Aesthetics: Philosophy of Fine Art*),[23] though in Hegel's case, even more so than with other thinkers, his entire oeuvre should be taken into account. The *Vorlesungen über die Aesthetik* (Lectures on Aesthetics) were delivered four times at the University of Berlin (between 1820 and 1830). They are known to us through the reconstruction made by Hegel's devoted disciple Hotho, who used the philosopher's own lecture notes together with notes taken by some of the students who attended the courses. This origin of the text makes us somewhat hesitant to place crucial emphasis on any single formulation. On the whole, however, the text bears the stamp of indisputable authenticity.

What does Hegel have to say to the student of art theory and its history? Nobody familiar with Hegel's thought will be surprised to find that, here as in so many other fields of reflection, the answer cannot be easily given. While there is little in his system that explicitly and directly pertains to art theory in the traditional sense of that term, most of what he says has an indirect yet essential bearing on our subject.

In a study of theories of art, one of the most important features of Hegel's *Aesthetics* must be emphasized: it is devoted exclusively to a philosophy of art, and in this respect it is probably the first work of its kind. Hegel begins his lectures by a critique of the term "aesthetics." As we remember, A. G. Baumgarten gave the first volume expounding his doctrine the title *Aesthetica* (1750), but what he had in mind had little to do with art. What Baumgarten in fact tried to propound was a theory of perception, and for the notion of "perception" he employed the Greek term *aisthenastai* (to recognize, perceive). Were we to take the term literally, it would be altogether unsuitable for what Hegel has in mind. He uses it because it has become customary. Another term has been suggested, he remarks, "Kallistics" (derived from the Greek *kallos* = beautiful). This term, too, is inappropriate, and Hegel's rejection of it is of importance in our context. The subject matter of his theory is not the Beautiful as such. What he is concerned with is Art. His "Aesthetics" is, as he explicitly says, a philosophy of art, or, in his words, a philosophy of fine arts. He therefore excludes the beauty of

nature from his consideration. The beauty of art is a beauty "born of the spirit." The work of art, he says later, is not a product of nature, but of human activity; it is produced for man; and it has its goal within itself.[24]

Concentrating on art as a human activity, on the work of art as a man-made object, is essential, but it is not sufficient. In actual life, works of art often fulfill different functions. They may serve to decorate our environment, they may be intended to provide us with pleasure. In performing these functions, art is not what Hegel has in mind; it is not "free art," it does not bear its purpose in itself. Such declarations should not mislead us into reckoning Hegel among the philosophers of "l'art pour l'art," of "art for art's sake." He is not a thinker who considers art a self-enclosed domain. It is Hegel's basic assumption— one that follows from the central ideas of his philosophical system as a whole—that art and religion have the same essential substance and subject matter; they differ from each other only in form. Art, he says, "has first of all to make the Divine the focus of its representations."[25] Art is free, and it is altogether true art only when it fully devotes itself to this supreme task, the articulation of the Divine. It is precisely because art is concerned with the most basic issues of man that different nations have embodied their most substantial intuitions and mental views in works of art.[26]

The great religions themselves, Hegel was fully aware, have not always acknowledged their kinship with art. Some of the great faiths openly display hostility to artistic endeavor and artistic production. Judaism and Islam are, of course, the best-known examples of such an attitude, but Hegel also mentions the iconoclastic movement that shook the foundations of Eastern Christendom, and the Protestant hostility to images that impressed itself on the culture and thought of the modern West. In spite of these weighty, sometimes even violent, rejections of art by certain religions, Hegel does not doubt that within religion as such the basis for images is to be found.

To be sure, "the Divine, explicitly regarded as unity and universality, is essentially present only to thinking and, as in itself imageless, is not susceptible of being imaged and shaped by imagination." Yet he continues:

Nevertheless, on the other hand, however far unity and universality are the characteristics of the Divine, the Divine nevertheless is essentially determinate in itself, and since it therefore disencumbers itself of abstractness, it resigns itself to pictorial representation and visualization. If now it is seized in its determinate form and displayed pictorially by imagination, there at once enters a multiplicity of determinations, and here alone is the beginning of the proper sphere of ideal art. [27]

What is the meaning of this statement? Let us disregard the metaphysical terminology and instead look for the thought behind its strange and possibly obscure wording. What is of significance for our present purpose is, first, that art is not merely some kind of decoration, but rather follows from the innermost structure and life of the Divine. Second, and more important for the modern student, is the location of art in Hegel's intellectual chart. Art, and particularly the image, dwell in the domain of tension that extends between the pure notion, necessarily devoid of any image and material realization, and the objectification of the idea in material substance and sensory experience.

We encounter here the symbol as the central problem of Hegel's thought on art. Throughout the *Aesthetics,* he deals with symbol and symbolism, whether or not he uses these particular terms. Disregarding his terminology, we can say that he considers art as a whole as symbolism. The symbol is the mediation between the invisible and visible, mind and matter. Beauty is symbolic. Hegel's famous definition of the beautiful as "the sensory appearance [or manifestation] of the idea"— "das sinnliche Scheinen der Idee"—could be translated by the statement: the beautiful is symbolic. So is art. In the Introduction to the *Aesthetics,* where he first suggests the idea of "free art," he paints a metaphysical canvas of how the Spirit, breaking apart thought and matter in its unfolding, is able to heal the breach. "It generates out of itself works of fine art as the first reconciling middle term between pure thought and what is merely external, sensuous, and transient, between nature and finite reality and the infinite freedom of conceptual thinking." [28] There is an intrinsic affinity between the two halves in the work of art. In the chapter on symbolic art to which we shall presently return, Hegel says that the symbol is also a sign ("das Symbol is zunächst ein Zeichen") and then goes on to distinguish between the

symbolic and semiotic functions. There is no doubt as to where in this dichotomy art is situated: "When symbol is taken as a mere sign with such an indifference between meaning and its expression, we may not take account of it in reference to art, since art as such consists precisely in the kinship, relation, and concrete interpenetration of meaning and shape."[29]

The second part of the *Aesthetics* is called "Development of the Ideal into Particular Forms of Art," a title that in itself indicates the historical bent of the philosopher's thought. In Hegel's monumental work, however, we are not faced with a regular history of the arts, not even of the Winckelmannian type. Hegel tries to discover meanings within the unfolding historical process itself. The process is not simply recorded, it is interpreted. The fundamental conceptual structure within which this interpretation is carried out is made up of the three major art forms that correspond to the three stages of the historical unfolding of the arts. Hegel calls these three art forms "symbolic," "classic," and "romantic." The doctrine of the art forms—both as a comprehensive principle for patterning the history of the arts, and in the specific characterization of each individual "form"—may well prove to be his most interesting and lasting contribution to the theory of the arts, particularly of the visual arts. In the following observations, I shall be concerned with the art forms only.

At first, the theory of the art forms seems a dramatic departure from the traditional attitudes to studying art, a true revolution in artistic reflection. When considered in the full articulation and systematic shape it assumes in the *Aesthetics,* the doctrine may indeed approach the revolutionary. Yet in building up this theory, Hegel was drawing on several intellectual traditions, mainly art theories current in his time. A glance at his sources, at the historical context of the *Aesthetik,* may help us to better understand what he says about the art forms themselves.

The categories of the classical and the modern, or post-classical (what Hegel calls "romantic"), are of course well known from that long-standing debate the *Querelle des anciens et des modernes,* which played such an important part in the intellectual life of the seventeenth and eighteenth centuries. As we have seen,[30] in late seventeenth-century France, the *Querelle* was a central topic in theories of painting. In late

eighteenth-century Germany it was less significant for reflection on the visual arts, but it played a major part in theories of literature. Some of the most important minds of that period, among them Lessing and Schiller, took part in the attempts to describe the meaning and character of "ancient" and "modern."[31] This polarity, then, belonged to the familiar intellectual coinages of the time.

In Hegel's thought, however, the dualism is transformed into a tripartite system; to the polarity of ancient and modern ("romantic"), he adds an initial category, or stage, the pre-classical. He calls this the "symbolic" art form. This category seems altogether new, but closer inspection shows that even here Hegel was not creating something out of nothing. Though the origins of the concept "symbolic art form" are not as obvious as those of the two other art forms, they are present. We shall not, of course, here trace those origins in full (in the chapter on Symbolism we shall have to make some observations on the subject); we shall only briefly indicate some major contexts.

Hegel accepts Winckelmann's characterization of Greek antiquity as a climax of artistic development. Greek art was an instant — never to recur — in which the ideal attained full realization. But precisely because Greek art is so perfect, it cannot, in our philosopher's view, be the beginning of the historical process. Greek art was not miraculously given as a divine revelation, complete and perfect from the very first moment of its appearance. It emerged in a process; there must have been preceding stages. Those early periods are combined into the concept of the "symbolic" stage or art form.

The generation of Hegel's teachers was attracted by the treasures and mysteries of the ancient East. Thus Herder was profoundly interested in pre-Greek, Oriental art and mythology. His studies of biblical poetry quickly became famous. In his great work, *Contributions to the Philosophy of the History of Mankind* (1784–1791),[32] he devotes an extended discussion to the cultures of the Far East (Book XI) and the Near East (XII). Friedrich Creuzer, to whom we shall revert in the next chapter, tried to decode the mythologies of pre-Greek cultures.[33] The Indological researches of Friedrich Schlegel[34] left their mark on the nineteenth-century picture of world culture.

I have mentioned only some of the most prominent essays pertinent

to our present theme. They show that since the last decades of the eighteenth century, German poets, thinkers, and students had become increasingly aware of the pre-Greek world, of its rich cultures and their significance for an understanding of "world art." It is interesting to note, however, that these considerations of early cultures were not made in the context of, or in relation to, the "querelle" between the ancients and the moderns. It was Hegel who saw the three great phenomena—pre-Greek cultures, Greek art and civilization, and the modern world—as interrelated, and in so doing he initiated the tripartite system of his view of art. It is also worth noting that the German students and poets who were fascinated with the pre-Greek cultures mainly knew texts; what they had in mind were verbal, literary expressions. To Hegel, by contrast, the visual arts were the media by which the central expressions of these cultures were transmitted.

After these few observations on the cultural context of Hegel's system of the arts, let us now turn to what he says about those art forms themselves.

The Symbolic Art Form. Symballein (συμβαλλειν), the origin of our "symbol," the dictionary tells us, initially meant to throw together, to bring together. However, it was Hegel's view, as well as Schelling's, that in the symbol the infinite and the finite, the idea and the form, never completely coalesce. Every symbol, then, contains a tension that has not been fully dissolved. In his not very simple language, Hegel says:

Symbol is an external existent given or immediately present to contemplation, which yet is to be understood not simply as it confronts us immediately on its own account, but in a wider and more universal sense. Thus at once there are two distinctions to make in the symbol: (i) the meaning, and (ii) the expression thereof. The first is an idea or topic, no matter what its content, the second is a sensuous existent or a picture of some kind or other.[35]

Because the two parts of the symbol—the meaning symbolized and the object or shape symbolizing that meaning—do not completely overlap or merge, there remains a tension in the relations between them. Shape and meaning are not necessarily altogether external to each other; their connection is not necessarily an arbitrary one, but a

Illustrations

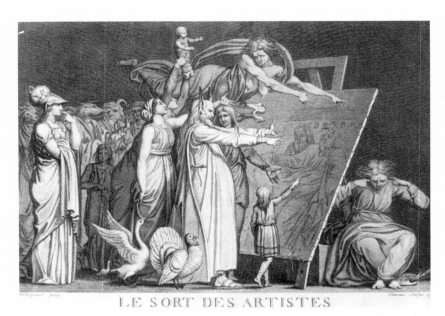

LE SORT DES ARTISTES

The Fate of the Artist, a late eighteenth-century engraving, shows the artist (and his work) approached by the shining figures of reason, including a Minerva, and by dark grotesque figures with beasts' heads. Author's photograph.

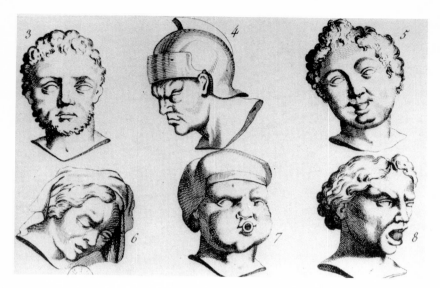

Gérard de Lairesse, *Detail of a Model Sheet,* reproduced in the *Grand livre.* Though drawing from nature was considered the artist's highest achievement, the copying of model sheets, customary in workshops since the late Middle Ages, continued to be practiced. Author's photograph.

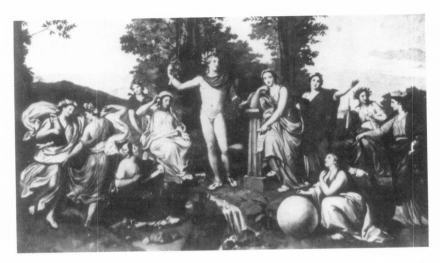

Mengs's *Parnassus,* painted in 1760–1761 on the ceiling of the Gallery in the Villa Albani, Rome, is the pictorial proclamation of academic classicism, borrowing subject matter and formal motifs from Antiquity and transforming them into Neoclassical images. Author's photograph.

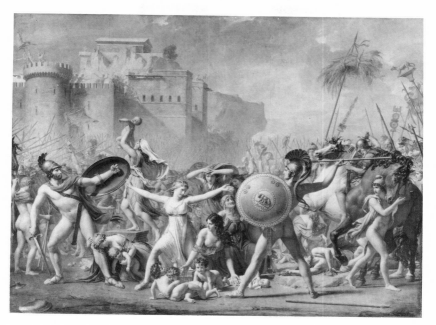

Jacques Louis David, *The Sabines,* 1799, Louvre, Paris. In representing this dramatic story David manages to indicate the understanding of, and high regard for, archaic art that at the turn of the century was beginning to emerge on the cultural horizon. Permission Musées Nationaux, France.

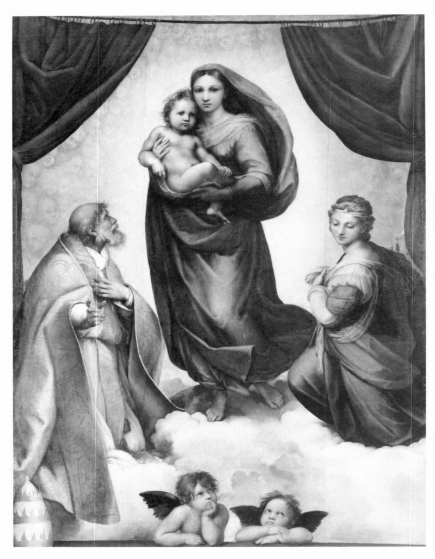

Raphael, *Sistine Madonna,* 1515, Dresden. The *Sistine Madonna* appeared to Winckelmann as the perfect imitation of the Greek Ideal; in her face and figure he discovered the noble tranquillity he believed to be characteristic of the ancient images of the gods. Permission Staatliche Kunstsammlungen, Dresden.

Venus Medici (detail), Florence, Uffizi. Carried away to Paris in 1802 and returned to Florence in 1816, this famous statue, considered at the time an embodiment of female beauty, exerted a profound influence on nineteenth-century sculpture and theory of art. Author's photograph.

Apollo Belvedere, Rome. For generations the *Apollo Belvedere* was the ultimate example showing art overcoming nature. The statue served both as an ideal to be sought after and as a yardstick for judging the value of recent works of art. Author's photograph.

Laocoön, Rome. Perhaps no other work of ancient art was as influential, both on artists and on writers on art. In the Enlightenment the *Laocoön* gave rise to a crucial conflict of interpretations, best known in the clash between Winckelmann's and Lessing's views of what the visual arts can, or cannot, achieve. Author's photograph.

J. B. C. Chardin, *The Smoker's Kit,* 1737(?), Louvre, Paris. Detached from noble literary connotations, modern still life could proclaim a program: by accepting insignificant objects as the main subject matter of pictures critics could be led to admit that the values of painting are not necessarily those of content. Permission Musées Nationaux, France.

(Left) Correggio, *Jupiter and Io,* ca. 1532, Kunsthistorisches Museum, Vienna. Artists, critics, and philosophers between the middle of the eighteenth and the middle of the nineteenth centuries were fascinated by Correggio's evocative power, and referred to this painting as an example of the impact of art on the beholder. Permission Kunsthistorisches Museum, Vienna.

J. B. Greuze, *The Village Bride,* exhibited in the Salon of 1761 (now in the Louvre, Paris). Painted in the same year as Mengs's idealized vision of the Parnassus, Greuze's everyday-life image of a family occasion celebrates marriage as a social institution of contemporary life. Author's photograph.

Gustave Courbet, *The Stone Breakers,* 1849. Formerly State Picture Gallery, Dresden. An embodiment of programmatic realism, the picture elevates everyday figures to a monumental level. The socialist Proudhon, Courbet's friend and defender, likened the painting to a parable from the Gospels. Author's photograph.

Wilhelm Tischbein, *Goethe in the Roman Campagna*, 1786–1787, Staedelsches Kunstinstitut, Frankfurt-am-Main. Goethe's sojourn in Italy marks a turning point in his intellectual development, and is expressed by the painter who portrayed him. Preserving the antiquarian's faithfulness to details (we can identify the tomb of Cecilia Metella in the background), the painting becomes an image of meditation upon a lost classical past. Permission Staedelsches Kunstinstitut, Frankfurt.

Drawing by Charles Baudelaire, private collection. Inscribed in Baude-laire's hand: "Specimen of Antique Beauty, dedicated to Chenavard." Chenavard was a classicistic academic painter, and Baudelaire's inscrip-tion clearly carries a satirical undertone. Author's photograph.

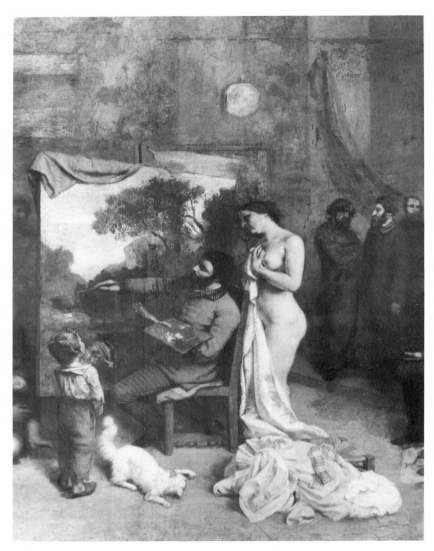

Gustave Courbet, *The Painter's Studio* (detail), 1854–1855, Louvre, Paris.
In a letter to Champfleury (January 1855) Courbet explained this as-
then-unfinished painting and his ideas on art in general. Reality includes
both everyday scenes and allegories. Permission Musées Nationaux,
France.

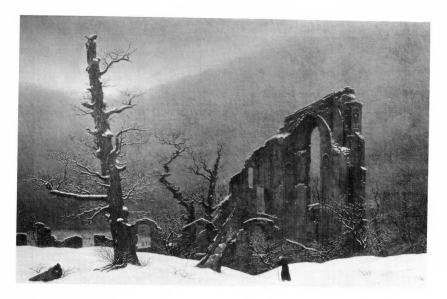

Caspar David Friedrich, *Winter,* 1808, formerly Munich (destroyed 1931). That decay and death are the universal fate of every creature and have cosmic validity is best expressed by means of landscape: the decaying ruin, the tree stripped of foliage, and the old man merge into one "natural symbol." Permission Bayerische Staatsgemäldesammlung, Munich.

A. L. Richter, *The Passage at the Stone of Terror,* ca. 1837, Dresden. People of different ages traveling on a small boat may suggest the old theme of the passage of life. The boat, one notes, travels into the darkness of evening, making a symbolic statement about nature and the natural cycle of time. Author's photograph.

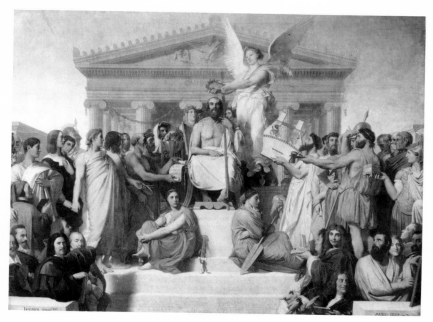

J. A. D. Ingres, *Apotheosis of Homer,* 1827, Louvre, Paris. Against the backdrop of an Ionic temple, a hierarchy of great artists throughout the ages is topped by the figure of Homer, the inward-looking poet. In this painting Ingres made a powerful pictorial statement concerning the artist and the immutable aesthetic authority of classical Greece. Permission Musées Nationaux, France.

J. A. D. Ingres, *The Dream of Ossian,* drawing, Louvre, Paris. The Ossianic poems, at the time believed to be genuine records of Nordic mythology, provided Ingres with themes of dreams and visions. Permission Musées Nationaux, France.

Henry Fuseli, *Artist Despairing at the Greatness of Ancient Remains,* drawing, 1778–1780, Kunsthaus, Zurich. Fuseli sharply criticized academic classicism. In this drawing the rebellious Fuseli created a striking admission of the indestructible greatness of Antiquity as an expression of his own loneliness. Courtesy Kunsthaus, Zurich.

J. A. D. Ingres, *Raphael and the Fornarina,* 1814, Fogg Art Museum, Cambridge, Mass. The cult of Raphael becomes a eulogy of the creative artist. Permission Fogg Art Museum, Harvard University, Cambridge, Mass. Bequest of Grenville L. Winthrop.

Louis Hercole Sisco (after L. C. A. Steinheil), *Dürer Followed by Demons,*
1840, illustration for Victor Hugo's *Les voix intérieurs.* Dürer is pictured
as a lonely rambler in the depth of a horrible forest, haunted by
fantastic, frightening demons. The artist as a martyr, suffering from
hallucinations, became one of the major types in the imagination of the
period. Author's photograph.

Eugène Delacroix, *Michelangelo in His Studio*, 1850, Musée Fabre, Montpellier. An example of the Michelangelo veneration so characteristic of romantic thought, the painting also attests to the conception that the artist who created the titanic figures was himself an introspective figure. Author's photograph.

Eugène Delacroix, *Tasso in the Madhouse*, 1839, Collection Oskar Reinhart, Winterthur, Switzerland. The artist's, and the poet's, link with insanity was an old motif. Delacroix here combines the traditional imagery of melancholy contemplation (resting the head on the hand) with the more modern institution for the detention of the insane. Courtesy Collection Oskar Reinhart, Winterthur, Switzerland.

Eugène Delacroix, *Paganini*, 1831, Phillips Collection, Washington, D.C. Probably painted shortly after Delacroix attended Paganini's first concert in Paris, the painting documents Delacroix's fascination both with the images of the artist and with other arts, especially music. Permission The Phillips Collection, Washington, D.C.

Eugène Delacroix, *Chopin,* drawing, private collection. Delacroix rarely painted portraits on commission; his finest examples are of his friends. In Chopin's image he combined features of the conquering hero and of the disturbed madman; it is a statement about the genius consumed by his own fire. Author's photograph.

Charles Meryon, *Le Stryge,* Bibliothèque Nationale, Paris. Nineteenth-century restoration of medieval monuments, particularly in France, brought about a unique mixture of medieval motifs and modern interpretations, such as the many visions of demons. Author's photograph.

Medieval grotesque figures appealed to the taste of Champfleury. A piece of late medieval woodcarving he saw in the palace of justice in Rouen showed him how powerful and primeval was the figure of the juggler in medieval imagination. Author's photograph.

The cathedral of Rouen, Champfleury discovered, abounds in images depicting composite creatures. It is the incongruence of the clumsy bestial head and the delicate human hand that reveals the nature of the grotesque. Author's photograph.

"A hooded figure with the head and body of a pig, playing a musical instrument (the old woman with the fiddlestick)"—in these words Champfleury described one of the grotesque figures he saw in the cathedral of Rouen. Author's photograph.

A grotesque image from the cathedral of Rouen, used as an illustration by Champfleury. The distorted and deformed mirror the Middle Ages seemed to hold up to humanity was endowed with a mysterious power of expression and exercised an aesthetic fascination over the modern spectator. Author's photograph.

certain alienation cannot be overcome. Were this otherwise, the object or shape we take as a symbol would be an image of the meaning, not a symbol.

Hegel now turns to an internal history of the symbolic art form. In the earliest stages of culture, men directly endowed with meaning certain material objects or phenomena they found or observed. They were not aware of the incongruence of what they encountered in sensory experience and the meanings they attributed to it. The ancient Persians, for example, worshiped light as such; the sun itself, they believed, was God. This is a presymbolic stage of consciousness. It follows from Hegel's reasoning, though he does not say so explicitly, that at this stage no great art can emerge. The artistic image requires a certain distance between the object represented, or the meaning referred to, and the representation itself. So long as the spiritual and the material are not sundered, there is no room for art.

Even at this stage, however, it dawns upon man that the Divine is more than the natural object considered as the god. Indian art reflects the initial expressions of this early awareness. On the one hand, the Divine was detached from all material links; God was conceived as the absolute infinite, as "nothingness." But nothingness, however lofty it may be, cannot be captured by the artist; thus Indian art took refuge in the most luxuriant sensuality. "In order, as sensuous figures themselves, to reach universality, the individual figures are wildly tugged apart from one another into the colossal and grotesque." [36]

Actual symbolism begins in Egypt; here we find a full elaboration of the symbolic art form. "Egypt is the country of symbols," Hegel says, "the country which sets itself the spiritual task of the self-deciphering of the spirit, without actually attaining to the decipherment." [37] Symbolism could emerge here because in Egyptian culture and imagination the immediate unity of object and idea was shattered. In their religious practices the Egyptians did not project divine dignity onto real natural objects, nor did they consider actual creatures as themselves gods. The Egyptians, Hegel stressed, required that there be a definite correspondence, a congruence, between the meaning invested in an object and the object as such. The very demand for congruence implies that, in reality itself, a certain incongruence prevails between nature and spirit.

The "Age of Egypt," as Hegel calls it, was caught up in a conflict: on the one hand, it sensed the contrast between nature and spirit, and on the other, it wished to make the spiritual manifest in the natural and material. Here, he believes, is the origin of the visual arts.

Only when the inward being becomes free and yet preserves the impulse to picture to itself, in a real shape, what its essence is, and to have this very picture before itself also as an external work, only then does the impulse towards art, especially towards the visual arts, properly begin. [38]

In order to make the spiritual manifest in a material object, one cannot simply take what one finds *(vorfinden)* in nature. To make the material object transparent, as it were, so that the inward, the spiritual, can shine through, one has to invent *(erfinden)* that object. Symbols— that is, objects or shapes suggesting the Spirit, the Divine, the Infinite, and so on—have to be "produced," "made," "invented." [39] It was in Egypt that man made this discovery, and therefore Egypt is the country of the symbol.

Both Egyptian religion and Egyptian art are dominated—to use Hegel's metaphysical wording, so hard to translate into ordinary speech —by the spirit's striving for self-understanding, by man's endeavor to decode his own mystery. Usually man tries to understand himself by thinking; the Egyptians did so by building. They erected the huge cities of the dead, they built the pyramids, they shaped the sphinxes. In all these works, mute and veiled in mystery as they are, one senses the powerful drive towards self-understanding.

I shall conclude this brief survey of the "symbolic art form" with two of Hegel's observations on Egyptian art. The first concerns the image of the human figure. Hegel must have been among the earliest authors to attempt to place the Egyptian rendering of the human body between what he conceived as pre-Egyptian and Greek representations. In contradistinction to Indian art, where the human figure is either grotesquely sensual or a mere personification of an abstract idea, in Egyptian art the image of the human body acquires a certain autonomy. The human form, he says, "acquires a quite different formation and therefore already reveals the struggle to rise upward to the inner and spiritual life. . . ." But Egyptian art has not yet reached the stage where

the human body can be the mirror of the spirit. "The shapes remain colossal, serious, petrified; legs without freedom and serene distinctness, arms and head closely and firmly affixed to the rest of the body, without grace and living movement."[40]

This particular stage of consciousness, as reflected in images of the human body, is expressed in some legendary works of art. Hegel refers to certain statues, known to him from Greek or Latin literature. "Especially remarkable," he says, "are those colossal statues of Memnon which, resting in themselves, motionless, the arms glued to the body, the feet firmly fixed together, numb, stiff, and lifeless, are set up facing the sun in order to await its ray to touch them and give them soul and sound." When the rays of the sun touch the statues, so the legend went, they automatically emitted a sound. This story seems to Hegel symbolic. That the colossi must await the sun's rays to produce a sound shows "that they do not have the spiritual soul freely in themselves." There *is* a soul in the human body, "but the inner life of the soul is still dumb in Egypt and in its animation it is only a natural factor that is kept in view."[41]

Hegel concludes his discourse on Egyptian art with an interpreta-tion of the Sphinx. No other work, or motif, in Egyptian art expresses the struggle between matter and mind more forcefully than does the Sphinx. This unique work is, in his own words, "the symbol of the symbolic."[42] From the dull power of that tremendous mass of the resting, passive beast the human frame, the proper seat of the spirit, gropes to emerge, and to come into its own. Not for nothing did Greek mythology picture the Sphinx as a monster posing riddles. The solution to the Sphinx's riddle was to be given by the Greek mind.

The Classical Art Form. Can the life of the spirit be perceived in sensory experience? There is only *one* form that can make this possible—the human body. The human figure, Hegel believes, is the single medium through which the spirit can shine. He proposes a metaphysical expla-nation for this state of affairs. "The center of art is a unification, self-enclosed so as to be a free totality, a unification of the content with its entirely adequate shape."[43] In other words, there is *one* theme in which

meaning and shape fully overlap. This theme is the human figure, and it formed the very essence of Greek art.

The complete overlapping of content and form, of meaning and shape, cannot be attained immediately. Nor can it form the starting point of history. "The first point to which we must direct our attention," says Hegel, "is this, that the classical art-form is not to be regarded, as the symbolic, as the direct commencement of *beginning* of art, but on the contrary as a *result*.⁴⁴ Not only is the classical art form preceded by the symbolic; it also has an internal history of its own.

Classical art begins with the overcoming of the merely natural. First comes the deposition of the animal. In this respect, the Greeks distinguished themselves from Asiatic and Egyptian cultures. Orientals believed that the Divine was revealed to them in animal form. Thus, in India hospitals were built for aging cows and apes, while human beings were left to starve at the road side; in Egypt, the sacred beasts were preserved for eternity by embalmment. The Greeks overcame this reverence for the beast, and made the undoing of the animal the content of religious ideas and of works of art. Hegel here gives an interpretation of Greek iconography that is well worth the modern student's attention. The representation of animal sacrifice plays a major part in the artistic repertoire. The subduing and slaying of the wild beast is glorified, it is considered a heroic deed, and it is represented many times in all media. Finally, transformation into a beast is considered a severe punishment. In all these respects, the Greeks are fully opposed to Orientals and Egyptians.

Another—and in Hegel's view, a higher—stage of overcoming the merely natural is mirrored in the struggle between the old and the new gods of which Greek mythology tells us. The old gods were merely nature gods, the appearance of brute natural forces; the new gods appeared as spiritual creatures. The myth of the overthrow of the giants by the new gods reflects the Greeks' substitution of a more rational ethos for one that glorified sheer might as right.

Yet though mere nature is overcome in this battle, a natural element is retained in the Greek gods. But that residual of nature is transformed. To give but one example, in Poseidon "lies the might of the sea that streams around the earth, but his power and activity stretches further:

he built Troy and was a safeguard of Athens; in general he was worshipped as the founder of cities, because the sea is the element for shipping, trade, and the bond between men."[45]

The degradation of the beast, the fall of the Titans, the overcoming of the merely natural gods and their transformation into spiritual beings —all this converges to reveal, in direct sensory experience, the classical ideal, the embodiment of a perfect balance between nature and spirit. This brings us back to the starting point of the classical art form, the human body.

The Romantic Art Form. The third art form is the "romantic." It goes without saying that the meaning of "romantic" as Hegel employs it differs radically from what we are accustomed to designate by this term today. When using Romantic or Romanticism as historical terms, we have a few decades of the late eighteenth and early nineteenth century in mind. In Hegel's usage, the term has an incomparably broader scope: it denotes the whole postclassical world. The romantic art form thus includes several historical periods and several artistic styles. The classical art form was the product of one nation (the Greeks) only, and of one, comparatively brief, period. As against such homogeneity, the romantic art form, like the symbolic, comprises different historical stages and artistic styles. Hegel distinguishes, of course, between the different periods (Middle Ages, Reformation, modern times) that he lumps together in the comprehensive notion of "romantic art form." He is also aware of the differences between the styles he includes in that category. He does not forget how far removed a Byzantine image of the virgin, or a Raphael Madonna, is from, say, the "merry-making of peasants" in a Dutch genre piece.[46] That his notion of "art form" differs from that of style or period becomes here almost tangibly obvious. What then, one asks, do these different periods and styles have in common that makes it possible for Hegel to bring them together into the one art form?

The answer seems obvious: "romantic" is the art of the Christian world. That Hegel casts all the styles and periods of Christian art into one comprehensive "form" should not surprise us. The Divine, we remember, is the supreme subject of all art; the periods and styles of the history of art are therefore ultimately determined by the nature and

image of the god who is worshiped in the age. In seeing the whole of European art as, in the last analysis, shaped by Christian ideas, beliefs, and images, Hegel reveals how close he is to what the romantics in our modern sense actually thought.[47]

Hegel interprets the formation of Christian art in metaphysical terms. What he says here reads almost like the description of a cosmic process. "There is something higher than the beautiful appearance of the spirit in its immediate sensuous shape," we are told at the beginning of the lectures on the romantic art form, "even if this shape be created by the spirit as adequate to itself." As history unfolds, the perfect "reconciliation" between spirit and form is found wanting. The spirit "is pushed back into itself out of its reconciliation in the corporeal into a reconciliation of itself within itself." The modern reader need not be put off by this kind of wording, which partly belongs to the period, and partly results from Hegel's particular intuition of abstract beings. What he means follows clearly from his statement that "the simple solid totality of the Ideal [as embodied in Greek art] is dissolved [in Christianity] and it falls apart" into a spiritual, internal part and a material, external part.[48] The disintegration of classical art, then, means the end of the aesthetic autonomy of art (based on the full unity of subject and form); this process marks the severing of body and soul.

Christian art, Hegel says, is religious art. At a first glance, this would not seem to be a very far-reaching statement. As we remember, *all* art is concerned with the image of the Divine. In making this seemingly obvious statement, however, Hegel has something particular in mind, and we shall best be able to discern it when we compare classical and Christian art. In Greece, art was the medium of the gods' revelation. It was only in sculpture that the Greek gods attained that perfect balance between the physical and spiritual which is a hallmark of their divinity. In Greece, therefore, art was the medium of religious revelation. Not so in Christianity. The Christian icon is not essential for the revelation of the Divine. On the contrary, when the artist takes up his job (or, as we might add, when the work of art is presented to the audience), the revelation is presupposed as a completed and well-known event, it is considered as given; the artist has no part in bringing it about, in articulating or manifesting the divine figure. The religious contents and

even the images are not shaped in art itself; the artist finds them ready and completed.[49]

This change in the status of art follows from the religious development itself. In Greek religion, as we have just said, the full fusion of the human and the Divine was supposed to take place in art. Christianity radicalized the fusion of the human and the Divine, and carried it to its ultimate conclusion: God became a real man. The incarnation was no longer an artistic achievement, an aesthetic experience; it became the reality of a living, individual being.

Can the work of art still mirror the Divine under these conditions? If judged by Greek standards, art now cannot attain its goal. "External appearance cannot any longer express the inner life, and if it is still called to do so it merely has the task of proving that the external is an unsatisfying existence and must point back to the inner, to the mind and feeling as the essential element."[50] Romantic art is an art of the "inner life," of *Innerlichkeit.*

Hegel also looks at the difference between Greek and Christian art from the spectator's point of view. The classical ideal figure "is complete in itself, independent, reserved, unreceptive, a finished individual which rejects everything else." The spectator approaching these figures "cannot make their existence his own." Therefore, Hegel concludes, "although the shapes of the eternal gods are human, they still do not belong to the mortal realm, for these gods have not themselves experienced the deficiency of finite existence. . . ." Christianity teaches that God became a real man. No wonder that "empirical man acquires an aspect from which a relationship and point of linkage [with God] opens up to him. . . ."[51]

From all this follows the subject matter of Christian art: religious imagery in general, particularly the image of Christ, and foremost the Passion. The image of Christ, Hegel suggests, cannot be depicted with the means and forms of classical art. Those artists who have tried to make of Christ an almost classical figure have proceeded in the worst possible way. Though the proper images of Christ "do display seriousness, calm, and dignity, Christ should have on the one hand subjective personality and *individuality,* and, on the other, inwardness and purely *universal* spirituality; both these characteristics are inconsistent with the

imprint of bliss on the visible aspect of the human form."[52] Even more than in iconlike images of Christ, this becomes obvious in depictions of stages of the Passion. "Christ scourged, with the crown of thorns, carrying his cross to the place of execution, nailed to the cross, passing away in the agony of a torturing and slow death—this cannot be portrayed in the forms of Greek beauty. . . ."[53]

We now turn to the last part of Hegel's aesthetics, the system of the individual arts. The "art forms," we have seen, are comprehensive and general units. Though we clearly perceive their main characteristics as well as the differences among them, it is difficult to grasp them directly. They can perhaps best be described as propensities that determine the typical subject matter, typical forms, and historical development of the arts of the ages. The individual arts, on the other hand, are more easily perceived; they are defined by concrete, specific materials, by the senses with which we experience the works created in them. It is obviously easier to grasp what sculpture is than to grasp what the classical art form is.

Hegel's philosophy, however, is too profoundly dominated by the notion of internal relationships to allow his consideration of the arts to be set apart from his concept of the art forms. Each art runs a cycle of three stages in its history, and these Hegel calls the "severe," the "classical," and the "pleasing."[54] These styles represent, in a sense, the art forms. Yet although all the art forms are thus present in every single art, *one* of the arts is particularly suited to express the spirit and character of *one* age and art form. To best understand each particular art, its character, possibilities, and limitations, we have to see it in its most appropriate historical "home," as it were, in the art form it is particularly suited to express.

Architecture. As distinctly fitted to manifest the ideas and mental attitudes of the symbolic stage, architecture is the proper medium of the symbolic art form. That affinity follows from a common feature that dominates the respective structures of the symbol and the building: "architecture corresponds to the *symbolic* form of art, and, as a particular art, realizes the principle of that form in the most appropriate way, because the meanings implanted in architecture it can in general indi-

cate only in the externals of the environment that it creates."[55] Put more simply, as the object or shape that serves as a symbol is alien to the idea it symbolizes, so the building as such is alien to the purpose for which it is erected. It is the intrinsic tension between the two poles that symbolism and architecture have in common, and it is the dominant position of this tension that makes architecture the ideal medium for the symbolic culture and art form.

Architecture, Hegel says, has an "external" reason. The building is not an end in itself, its goal is "external," it lies outside the building or even the art of architecture. Architecture begins with putting up a hut as a human dwelling, and the building of a temple as an enclosure for the god and his community. There is a profound difference, therefore, between architecture and sculpture. Works of sculpture, he believes, carry their meaning in themselves; to works of architecture the meaning is external.[56]

In sculpture, as we know from what Hegel said in connection with the classical art form, the unity of spirit and matter is as fully achieved as is given to mankind. Sculpture is the art of individual, self-enclosed bodies. This definition is, of course, not new. Fifty years earlier, Herder had described statues as "figures of space,"[57] as objects of full, independent reality, whereas paintings only try to catch phenomena. But once again Hegel brings long-standing inherent tendencies to full fruition in systematically appraising the work of sculpture as the well-rounded object par excellence.

What Hegel says about architectural sculpture is of particular interest in this context. Our philosopher is intimately familiar with those stages in the history of sculpture in which the statue is still closely related to the building. It is impossible, he thinks, to wholly detach a statue from its environment. Nevertheless, "the sculptured shape is . . . emancipated from the architectural purpose of serving as a mere external nature and environment for the spirit and it exists simply for its own sake."[58] The piece of sculpture, existing for its own sake, is the pure artistic embodiment of being an object.

Precisely for this reason, however, the statue is built on a tension, as it were, and, in Hegel's terminology, requires a "reconciliation." "While sculpture does indeed seem to have the advantage on the score of

naturalness, this naturalness and corporeal externality presented in terms of heavy matter is precisely not the nature of spirit as spirit."[59] But the sculptor's aim is not to manifest the nature of heavy material, but rather to infuse into it life and spirit. This is made obvious by the fact that the subject matter of sculpture is man himself, the human figure and face. In seeing sculpture as the art of shaping bodies, Hegel anticipates a great deal of modern twentieth-century thought; by seeing the human figure as the central, perhaps the only, subject matter of sculpture, he shows how deeply committed he was to the thought of his own time. He is following Winckelmann in making the human figure the sole theme of the sculptor, but he goes beyond his sources by explaining the reason for his choice: "instead of taking for its expression in a symbolic way modes of appearance merely *indicative* of the spirit, sculpture lays hold of the human form as the *actual* existence of the spirit."[60]

How should the body be shaped in order to express the spirit? A major part of Hegel's discussion of the art of sculpture is devoted to answering this question. The question itself has an obvious affinity to the spirit and traditions of art theory; it is a question to which a prescriptive answer is feasible. Hegel, true to the principles of his philosophy, does not give an "abstract"—that is, purely prescriptive —answer; rather, he analyzes carved imagery, particularly Greek sculpture. But the student of humanistic art theory, as it was known from the early Renaissance to the Enlightenment, feels at home, in spite of the philosopher's esoteric language and the introduction of the "spirit." What Hegel says about the arts, particularly about sculpture, is art theory.

A characteristic indication of Hegel's didactic attitude is his procedure: he breaks up the human figure into its principal parts and analyzes each part separately. In so doing, he relies on the authority of Winckelmann. It was Winckelmann, he says, who "put an end to vague chatter about the ideal of Greek beauty by characterizing individually and with precision the forms of the parts [of Greek statuary]—the sole undertaking that was instructive."[61] Hegel will proceed accordingly. "Our considerations of the ideal forms," he announces, "will begin with

the head; then, secondly, we will go on to discuss the position of the body, and then we end with the principle for drapery."[62]

We shall not here go into the details of the ideal human figure as a sculptural theme; that would require a monograph on its own. By way of example, I shall however look at two motifs. In his discussion of the formation of the head, Hegel draws both on works of art and on scientific studies. He tries to understand the Greek profile by analyzing Greek statues, by adducing views on the functions of the individual parts of the face (forehead, nose, mouth), and by studying physiologists of his own time[63]—a combination of sources typical of the traditional theory of art.

Our second example is the long excursus on the difficulties encountered by the sculptor in shaping the eye. He begins by describing what the spectator of Greek statues sees. "We can take it here as incontestable that the iris and the glance expressive of the spirit is missing from the really classic and free statues and busts preserved to us from antiquity." In Greek statues we find "only the wholly external shape of the eye and . . . not its animation, not a real glance, the glance of the inner soul."[64] Why is this so? In real life, Hegel believes, the eye is the manifestation of the inward soul. We know a man's "inmost personality and feeling" by his glance. The gaze, he says in another formulation, manifests "the whole inwardness of feeling." But sculpture, we remember, is not the manifestation of the spirit in its inmost feeling; rather it aims to show the spirit in its spatial extension. In other words, concentration on spirituality and emotional life is not the business of sculpture. "The work of sculpture," the reader is told, "has no inwardness which would manifest itself explicitly as this ideal glance, in distinction from the rest of the body or thus enter the opposition between eye and body." To put it differently, sculpture cannot treat the eye differently from any other part of the body, however nonspiritual that part may be. "Sculpture has as its aim the entirety of the external form over which it must disperse the soul."

Moreover, the eye looks out into the external world. In life it is by means of a glance that we establish contact with other objects, with the outside world. Now, establishing contact with the outside world is

opposed to the nature and aim of sculpture. The genuine sculptural figure, Hegel tells us, "is precisely withdrawn from this link with external things and is immersed in the substantial nature of its spiritual content, independent in itself, not dispersed in or complicated by anything else."[65] While this is presented as an explanation of why Greek statues look as they do, it is not merely historical. Hegel wishes to show what sculpture can, and what it cannot, do. The implication for the artist is obvious.

The third art is painting. It belongs to the romantic art form, and is the first of the three "romantic" arts—painting, music, and poetry. The nature of painting is easily understood when we compare this art with sculpture. It was the aim of sculpture, we have seen, to show the perfect balance between body and mind, between spirit and matter. The task of painting is to show the mind itself. Painting, he says, "does not afford, as sculpture does, the fully accomplished coalescence of spirit and body as its fundamental type, but instead the outward appearance of the self-concentrated inner life."[66] The character of the two arts is reflected in the specific aims of the sculptor and the painter: the former tries to achieve purity of form and beauty of line; the latter aims at animation in color and grace in grouping.

The more spiritual character of painting is, first of all, seen in the very structure of the medium. The primary medium of pictorial representation is the surface. Painting transforms three-dimensional objects into two-dimensional images that can dwell on a flat surface. This of course had been said countless times since the early fifteenth century; one can hardly open an art theoretical treatise without encountering this commonplace. But Hegel takes the reduction in dimensions as indicating a reduction in sheer materiality. Sculpture, one knows, strikes a balance between spirit and matter; in painting, matter is reduced and the spirit attains superiority.

The specific medium of painting also indicates the more spiritual nature of the art. Painting of course has components in common with architecture and particularly with sculpture. What chiefly distinguishes it from them are color and composition. Architecture and sculpture are devoid of color. Even where color was used in those arts—which was rare—it remained marginal; it never became a structural element of

either architecture or sculpture. In painting, needless to say, matters are otherwise. Now, color has a close connection to the spiritual and the inner life. Hegel sees color as "the particularization of the *appearance* in the picture," and it demands a "particularization of the inner life."[67] Color, Hegel says, following a great tradition, is based on light and darkness. Light is not merely a condition of visibility, as it is for architecture and sculpture; for painting it is an intrinsic component of the art itself.

In sculpture and architecture the shapes are made visible by light from without. But, in painting, the material, in itself dark, has its own inner and ideal element, namely light. The material is lit up in itself and precisely on this account itself darkens the light. But the unity and mutual formation of light and darkness is color.[68]

With regard to the other specific feature of the medium of painting, composition, Hegel is not as explicit as one would wish him to be, but his main thought is easily followed. Sculpture, we recall, is the art creating the single, isolated, self-enclosed object. Painting, dealing with appearances, catches the web of relations between figures, occasionally even between the past and future stages of an event or an action. Relations between the figures of a large painting, Hegel says, "betray and mirror feeling, and therefore can be used in the happiest way for the purpose of making the subject of the picture intelligible and individual." Raphael's *Transfiguration* shows what the philosopher means. Though both halves of the composition are clearly kept apart, "a supreme connection is not to be missed."[69] It is this connection that makes the picture intelligible. The use of relations as an essential means of artistic creation is, so Hegel believes, characteristic of painting only.

The spirituality of painting is also seen in its particular affinity to the expression of emotions, of the life of the soul. Painting "takes the heart as a content of its production." To be sure, painting "does indeed work for our vision," but what it shows us is not only an object or figure in space "but a reflection of the spirit." The principle of painting is, to quote Hegel's somewhat involved wording, "the subjectivity of the mind which in the life of its feelings, ideas, and actions embraces the whole of heaven and earth. . . ."[70]

The nature of an art, in Hegel's view, cannot be detached from the specific place of that art in history. An art such as painting could attain full realization only in the romantic age and art form—in an art form, that is, in which the spirit has superiority over matter. The abstraction that is the principle of painting—the reduction of dimensions—is not "a purely capricious restriction or a lack of human skill in contrast to nature and its productions"; rather it is "the necessary advance beyond sculpture."[71] In simpler words, among the visual arts painting is the art most appropriate to the Christian world. The spiritual nature of painting makes that art best suited to represent the spiritual nature of Christ and the Christian saints. Hegel attempts to derive from his philosophical principles a comprehensive system of the subject matter of Christian art. His interpretation of Christian iconography is well worth careful study (which it does not seem to have received so far) both for the light it may shed on Christian iconography and as a document of early nineteenth-century thought. It is not for us here to go into these iconographic intricacies. To give one example of Hegel's belief in the suitability of painting for representing the Passion of Christ I should like to quote his observations on a picture representing the suffering Christ.

I have in mind in particular a head in the Schleissheim gallery in which the master (Guido Reni, I think) has discovered, as other masters too have done in similar pictures, an entirely peculiar tone of color which is not found in the human face [and placed it between or above the brows]. They had to disclose the night of the spirit, and for this purpose fashioned a type of color which corresponds in the most splendid way to this storm, to these black clouds of the spirit that at the same time are firmly controlled and kept in place by the brazen brow of the divine nature.[72]

Some modern critics may find this overinterpretation, as they would call it, somewhat ridiculous; some have smiled condescendingly, perhaps a little too easily. The gospel Hegel preaches is clear: it is the intimate relationship between the particular nature of a medium and the specific character of a type of subject matter. To speak in modern terms, it is the gospel of the perfect fusion of form and content. Nobody in his right mind will today deny that some, or even many, of Hegel's

individual conclusions are farfetched and arbitrary, that they do not carry conviction. But the main lines of his thought on art exerted an almost magic power, decisively shaping the thought on art in the last two centuries, the centuries that form the modern world.

III. MERGING THE ARTS

1. NEW TRENDS

The comprehensive, worldwide view of the arts, so magnificently presented by Hegel, had a profound and far-reaching influence. Nobody, it seemed for a while, could withstand the constructive, system-building force of an intellect that assigned a place to every art, every medium, and every style, and yet let the universe of the arts appear as a lucidly structured whole. Was this not the final word about the interrelation of the arts? In the 1830s, many thought so. But before the middle of the nineteenth century an altogether different approach to the search for the hidden and complex relationships between the arts became perceptible. While the Hegelian system, in origin as well as ramifications, was primarily a German phenomenon, the new trend appeared and developed mainly in France.

It differed from the philosophical system in many respects. The Hegelian construction was based upon a clear and sharp distinction between one art and the other, making it possible to ascribe a particular stage in the historical process to each specific art. Hegel here drew from, and brought to a conclusion, the process of juxtaposing the arts that began with Lessing's *Laocoön*. The system was constructed on an analytical basis. Painting or sculpture, it was taken as axiomatic, belong to an altogether different dimension than that of the literary arts; poetry has a wholly different basis than architecture or music. The more sharply one art is distinguished from the other, the better it can be made to fit into the overall design. The new trend that appeared in mid-century France adopted a completely different attitude. It did not dwell on the unbridgeable gap between one art and the other, but rather stressed their partial fusion, the possibility of one art changing

into another. It is not a matter of chance that the double perception sometimes called "synaesthesia" was often considered a proper way of experiencing a work of art, and of accounting for that experience.

The fusionist trend did not enjoy that high level of conceptual thinking and philosophical articulation that was the hallmark of the analytical tradition culminating in Hegel's system. In studying this new approach we are faced with an intellectual and emotional atmosphere, or climate, rather than a philosophical system. Yet students of history do not need to be told that intellectual and emotional climates, even if not fully articulate, are often more powerful as historical motivations than are highly articulate abstract systems. It was only towards the end of the nineteenth century, that is, at a time that lies well beyond the limits of the present discussion, that the new trend came to full fruition. At the middle of the century, only its bare outlines had become visible.

Like the analytical trend, the trend that seeks to merge the arts takes its departure from the axiom that each of the major arts is rooted in one of the senses; there is an art of the eye, an art of the ear, an art of touch. Now, if the perceptions of the different senses can, to a certain degree, merge into one another, so can the respective arts that are based on them. It is a matter of experience, or so it was believed, that perceptions arising from two or more senses *can* be linked together. Two modes of sensation can be affected when only one sense is being stimulated. Describing one kind of sensation in terms of another is known as synaesthesia. Here color is attributed to sounds, taste to colors, sound to odors. The underlying assumption in this way of thinking is that it is possible to translate, even if metaphorically, experience in the domain of one sense into that of another. A famous example, frequently repeated, is the old story of someone born blind having explained to him what the color scarlet is by being told that it is like the sound of a trumpet.[73]

Synaesthesia, then, naturally tends towards the merging of the senses. The translation from one sense into another has been explained as a survival from an earlier, comparatively undifferentiated sensorium. We cannot go into what the scientists say, but as far as the theory of art is concerned, we can be sure that this notion leads to breaking through the barriers separating one art from the other in the analytical trend.

The effects of such ways of thinking could have been observed in the late nineteenth century and in the twentieth.

The idea of merging the senses, or translating the impression received by one sense into that of another, is of course not an invention of the modern age. Ever since Antiquity, such translations were projected onto nature and used in the arts. One of the most famous examples is the "music of the spheres." It was even used as a scientific hypotheses: Robert Fludd explained the "harmony of the spheres" by assuming the existence of a "sphere pipe," on which light—the breath of the Creator, as it were—acts as the breath of man acts on the air. Particularly since the late Renaissance, attempts were constantly made to convert such beliefs into tangible reality: Vincenzo Galilei, the father of the famous physicist Galileo Galilei, tried to build and perfect the color piano.[74] In art theory of that period, synaesthesia was an approach often used. Poussin's famous letter concerning the different modes of pictorial expression is perhaps the most important testimony to it: basing himself on the Greek theory of musical modes, he translated them into types of pictorial expression.[75]

In the mid-nineteenth century the leaning towards merging the senses and the arts, or at least finding some analogies between them, played an important part in artistic creation. Historians of the visual arts as well as students of the other arts and of aesthetic thought often spoke of "correspondences" between the arts or of the *Gesamtkunstwerk* (the comprehensive work of art). Here I shall consider only some of the most conspicuous formulations of the subject in art theory.

2. CHEVREUL

I shall begin with Michel Eugène Chevreul (1786–1889), a professor of organic chemistry famous in his time for his study of the components of fats and the nature of soap. In his youth he was appointed director of a laboratory in a large Gobelin factory and made a significant study of dyes. He summed up his findings in a large tome, *De la loi du contraste simultane des couleurs,*[76] which appeared in 1839 and became the basis for many nineteenth-century color studies. Chevreul obviously deals with sense impressions from a point of view different from that of the

student of art. However, in what he adduces from the questions he investigated, the historian of aesthetic thought will find much that is new and also significant for the study of art. Perhaps most important are his emphases.

Chevreul, we must remember, worked in an industry; he was therefore concerned both with how objects in which dyes play a major role are produced and with how the spectator—here one should perhaps say the prospective customer—perceives them. In principle, he accepts the common wisdom of his time: to form a harmony, colors must be perceived in a succession of tones. We recall that from precisely the same observation—that is, the difference between the senses—Lessing concluded that the arts of space and time, that is, of simultaneity and succession, can never be united. What is permitted to literature (like music, an art of time) is not permitted to sculpture and painting, arts of space.[77] What is appropriate for one art cannot be transferred to or translated into another. What Chevreul added to this general principle does not always observe the official line; it compels the student to devote some careful attention to his work.

Among Chevreul's contributions to the theory of art (though it was not his intention to discuss the arts), two points should be considered in our present context. First, he does not see the difference in the perception of the different senses as an unbridgeable abyss; there are similarities as well as differences between the perceptions of the eye and the ear, touch, taste, and smell. He begins his discussion of the differences between the senses with what sounds almost like an apology: "If it is philosophical to explore what the senses, in their structure and function, have in common, it is not less so to find out what are the special differences that distinguish between them" (531;967). It is under the heading of a "double relationship" *(double rapport)* that he investigates the impressions of all the senses, and particularly the perception of color, his major subject.

The second point is even less revolutionary. It consists in explicitly making the spectator a kind of last resort in investigating the relationships between colors and sounds. No words need be wasted to show that the spectator, in one form or another, was always at the back of art theoreticians' minds. It is, however, true that in modern times the

emphasis in assessing relationships between different media has been shifted to the spectator or the audience in general. Chevreul reflects this shift, and he does so particularly clearly in his treatment of the interaction of the different senses.

The greatest proximity, Chevreul believes, prevails between hearing and sight. Everybody "knows the reconciliation *(rapprochement)* one has made between sounds and colors" (535;973). In our present context, it may be worth recalling that in the comparisons of the senses and of the arts based on them that had been made throughout the ages, sight and hearing, or painting and music, were as a rule considered the main protagonists. "Which is the more damaging to a man, to lose his sight or his hearing?"—so Leonardo asks, taking the selection of these two particular senses as a matter of course.[78] Chevreul is naturally aware of the opposition between these two senses; he cannot have failed to note that placing them side by side in this way only deepens the contrast between them. And yet he finds parallels, or "analogies," as he has it, between the two senses.

There are to Chevreul two principal kinds of analogies between hearing and sight, one in the domain of what may be described as the "objective" existence of the sense impressions, the other "subjective," pertaining to our perception of sounds and colors. The first analogy, only briefly indicated, is anchored in the science of the time: both sound and colors are propagated by waves (535;973). The theory of waves refers to something taking place outside the spectator; it warrants an "objective" analogy between colors and sounds.

More space is devoted to the other analogy, which is in the way we perceive the objects of the two senses. In dealing with perception, it is true, Chevreul claims that "today the specific difference between sounds and colors strikes me more than their generic resemblance" (535;974). For the study of nineteenth-century art theory, however, his view of the "generic resemblance" is of more interest. It is significant, I think, that Chevreul founds this kind of resemblance primarily in *aesthetic* experience. It is the harmony of beautifully ordered colors that is analogous to the harmony of beautifully ordered sounds (537;977).[79] He recalls the eighteenth-century French Jesuit priest, Louis Bertrand Castel (whom Rousseau called "the Don Quixote of Mathematics"), who

invented the so-called ocular clavecin, in which colored tapes representing harpsicord or clavecin wires presented a color pageant in a darkened room. (Incidentally, it may be worth recalling that in our own time Scriabin and Schoenberg have experimented with the projection of light by color organs).[80]

Chevreul's comparison of colors and sounds is on a high conceptual level, and, at least implicitly, raises questions of far-reaching consequence. Sounds, he believes, have an existence of their own, their reality is independent of anything else (536;975). Do colors also have an existence of their own, a being that would be comparable to that of sounds? Chevreul, we should not forget, does not speak of the use of colors in painting; his concerns are tapestries and carpets. And yet he sometimes anticipates much later developments both in painting and in the theory of art. Before following Chevreul's comparison of sounds and colors, we should make clear to ourselves what is actually being asked when one wonders whether colors have an existence of their own, comparable to that of sounds. An analysis of Chevreul's formulation necessarily leads us to the conclusion that what his question actually amounts to is whether color can be perceived as detached from the objects "on" which it is normally seen (536f;976).

The formulation is not as strange as it may seem at first. The student of color theories will remember the view, so often expressed, to the effect that we cannot see colors as such, only colored objects. For ages, the Aristotelian tradition, which had such an overwhelming influence on European scientific thought, claimed that color is a quality of objects and therefore cannot be detached from them. The precise terminology of the Aristotelian tradition declares that color is "the surface of objects."[81]

Now, there are conditions under which we do perceive pure colors. A ray of sun refracted in a prism and reflected onto a white surface shows us pure colors. The color is here "pure," so we understand, because it is detached from any specific object and does not evoke the association of an object. But does this also hold true for ordinary experience? Science, isolating its object from everyday experience, creates artificial conditions. Are we likely to experience such pure colors

outside the laboratory? Chevreul doubts it. The reason for his scepticism is that the vast majority of people will confound the color with the object on which it appears; when people retain the memory of colors, these colors are always attached to material objects (537;976). It is this adherence to objects that prevents colors from having an independent existence. Sounds do have such an existence because they are not attached to anything besides themselves. If we voice this idea in the terminology of aesthetics, we will have to say that colors fulfill a mimetic function (they conjure up an object), while sounds do not. Colors portray objects, but sounds do not.

The modern reader cannot help speculating as to what Chevreul would say if he were to see a twentieth-century "abstract" painting. How would he reflect on the color in a Kandinsky, say, or a Rothko? Would he deny independent existence to the colors in the works of these two painters? Any hypothetical question of this kind remains, of course, unanswerable. We have nothing to rely on but Chevreul's logic. But were we to follow out his logic, we would have to conclude that he would accept such paintings as equivalent to music, and thus concede to their colors the same full and independent existence that, in his time, he granted to sounds only.

In conclusion, I shall make a more general observation. Chevreul represents the thought and mentality of the "scientist," as the early nineteenth century understood that term. His turn of mind was clearly influenced by the positivistic trend then beginning to make itself felt. What counted for him were "facts" and objective findings. It is interesting to note that in precisely these conditions the idea of the spectator, and of his seemingly "subjective" reactions to external stimuli, emerges so powerfully. The decisive facts Chevreul adduces in order to grant or deny independent existence to sound and color are not their —objective, measurable—mode of propagation; in this, as we have seen, they are identical. Where they differ is principally in how the spectator perceives them, and he perceives them differently not only because he perceives them by different senses (hearing or sight) but mainly because he perceives them in different matrixes, as it were. Colors evoke associations of objects, sounds do not. It is this reaction

or behavior of the spectator that ultimately decides the philosophical standing of color and sound and, by implication, of the arts based on them.

The intellectual climate of the early and mid-nineteenth century made it possible for the ideas of synaesthesia to permeate the thought of the artists themselves. Among the painters of that time one will hardly find a better example of this learning than Eugène Delacroix. I shall try to outline Delacroix's significance for the art theory of his century in a later chapter.[82] Here I shall only comment on his views concerning the relationships between the arts. For Delacroix, as for Chevreul, this primarily meant the relations between sound and color, that is, between music and painting, though he also made some interesting observations on the role of touch in his reflections on painting.

Delacroix was concerned with music, both in listening to it and in trying to come to terms with the theoretical problems it presents to the music lover and more specifically, to the painter. He entertained friend-ships with musicians, primarily with Frédéric Chopin, and derived a great deal of inspiration from these contacts. All this followed, of course, from a general disposition of the times. It has been pointed out that Delacroix was deeply affected by the trend of thought, prevailing in large parts of French culture in his time, that saw in the depiction of the intangible the major aim of painting.[83] Now, if painting is to express the intangible, it is music rather than any of the other arts (such as sculpture or poetry) that becomes the main model, that shows most affinities. The new prestige of music as a model for the arts, which has not gone unnoticed by scholars,[84] also led to a certain blurring of the outlines dividing the specific values of painting from those of music.

Delacroix's awareness of the other arts, of their character and inter-relations, is often manifested in his *Journal*. However, it would be difficult to claim that he had a consistent and unified approach to the intricate problems posed by the doctrine of synaesthesia. Sometimes he compares the arts with each other, thus bringing out the individual, unique nature of each rather than what they have in common. In such

notes one cannot help feeling the survival of the Renaissance *paragone* tradition, which, as is well known, stressed the differences between the arts, not their common nature. More often, however, he softens the juxtaposition, transferring features from one art to the other. This is particularly true for music and painting.

From music he learned about the relationship between science and the arts in general. On April 7, 1849, a conversation with his friend Frédéric Chopin revealed to Delacroix the profound identity of science and art. What establishes logic in music?: this was the question the painter posed to the musician. Chopin made Delacroix feel "what counterpoint and harmony are; how the fugue is like pure logic in music. . . ." That feeling, he notes, gave him an "idea of the pleasure in science that is experienced by philosophers worthy of that name." Science "is not what is ordinarily understood under that term, that is to say, a department of knowledge which differs from art." It is, as he puts it, "reason itself, adorned by genius."[85] Science itself, then, acquires an aesthetic quality. It is not an accumulation of individual cognitions about the world, a kind of stocktaking of what is encountered in reality, but rather perfect order of the kind that music makes accessible to the senses. No wonder that Delacroix felt he could apply the same insight to painting as well as to music.

A few years later, on December 12, 1856, he looks to Mozart for guidance in a matter of great consequence for a Romantic artist, particularly in that late stage where awareness of the autonomy of art was gaining increasing significance. Delacroix was not concerned with the question, so important for the artists of many ages, of how to express passion convincingly without endangering the genuine character of art as such. To put it in present-day terms: how do you convincingly express emotions without turning your picture into a poster? Here, it seemed to Delacroix, the great composer of music holds an answer. "Mozart writes in a letter somewhere, speaking of the principle that music can express all the passions, all the sorrows, all sufferings: 'Nevertheless, the passions, whether violent or not, should never be so expressed as to reach the point of causing disgust; and music, even in situations of the greatest horror, should never be painful to the ear, but should flatter and charm it, and thereby always remain music.' "[86] The

idea itself is of course not new, it has often been expressed and reformulated. What is here of significance is that Delacroix turns to a musician for an answer, obviously believing that what is true for music can also be valid for painting.

Delacroix's synaesthetic reflections are not limited to the mutual connections and influences of painting and music. It is true that, for reasons we have indicated, music played a particularly significant part in the thought of painters who aimed to render the intangible, but sheer tangibility was a dimension of experience they could ill afford to neglect. And indeed in a lengthy entry in his *Journal,* made on January 13, 1857—one of the notes he wrote down in preparation for the dictionary of pictorial terms he planned to compose—we find some interesting observations on touch and on what touch can mean for painting. Delacroix made this entry at least four decades before the problem of touch—whether real or imagined—arose conspicuously in the writings of art historians and interpreters of style. It was only in 1901 that Alois Riegl, mainly in his *Spätrömische Kunstindustrie* (Late Roman Arts and Crafts), contrasted "tactic" (or "haptic," as he later called it) experiences, that is, impressions appealing to the sense of touch, with what he called "optical" impressions.[87] In speaking about "tactic," Riegl did not mean actual tangibility; rather he used the term in a way that can be described as metaphorical. Riegl's "haptic" forms are totally located in painting, in an art that, in actual fact, is experienced by the eye only. A few years before Riegl, another writer on art, Bernard Berenson in his influential work *The Florentine Painters* (1896), described Giotto as "giving tactile values to retinal impressions."[88] Riegl and Berenson, and the many students following in the footsteps of these unequal scholars, were drawing the specific, critical conclusions from the development of synaesthetic thought in earlier parts of the nineteenth century. In the 1850s, when Delacroix was reflecting on touch in painting, many of the ideas that were to dominate later thinking existed only in embryonic form. The main line of thought, however, can be clearly discerned.

That we are here witnessing an important idea in a very early stage can best be seen when we consider what is missing in Delacroix's thought; it suffers mainly from insufficient analytical distinction be-

tween the different aspects of the notion. In speaking about touch, Delacroix has two different things in mind, and sometimes they cannot be clearly distinguished from each other. In one sense of "touch," it is the picture as an artifact that is considered. There are many ways of studying a painting, we read in the *Journal,* and one of them is to observe the painter's way of touching the canvas. These touches leave traces on the work of art, and the spectator, or connoisseur, can follow them. The painter's touch, Delacroix believes, "gives to the painting an accent which the tints, melted together, cannot produce."[89] Moreover, when touch is "applied vigorously," it makes some of the objects or figures depicted "come forward." He notes critically that "many masters have taken care not to permit the spectator to feel" the painter's touch. These masters believe that complete finish is an embodiment of perfection. It is not difficult to sense in these remarks the echo of Delacroix's antagonism to academic art, perhaps particularly to Ingres.

The traces left by the painter's hand, however, are not the only meaning of "touch." In another sense, that term refers to the material reality depicted in the painting, and it evokes feelings and memories of texture. In other words, here "touch" refers to a dimension of reality that can really be experienced by physical touch alone. Some artists, Delacroix says, obviously referring to representatives of the academic trend, believe that by avoiding touch "one gets close to the effect of nature. Such a belief is 'puerile.' " In an illuminating aside, he adds: "One might just as well put real colored reliefs onto one's picture."[90] This implicit juxtaposition of real nature and colored relief shows, I believe, that in speaking about touch Delacroix did not have bulging volume in mind. Sheer mass and volume are common to the natural object and the colored relief. Where they differ is in the material character of the bulging body. As opposed to the colored relief, bodies and objects in nature have an infinite variety of textures: they are hard or soft, smooth or rough, solid or hairy or fluid, and so on. Now, all these qualities one experiences only by real touch, by actual tactile experience. It is the imagined tactile experience that the painter conjures up by a proper representation of the object. In an engraving, he says, "the whole wealth of nature is expressed without employing the magic of color—not for the purely physical sense of sight, but for the

eyes of the mind and the soul; they behold the fresh splendor in the skin of the young girl, the wrinkles of the old man, the soft depth of clothes, the transparence of waters, the faraway look of skies and mountains." It is obvious that "touch" here refers to the material nature itself. Delacroix clearly assumes the transfer, or translation, of experience in the domain of one sense into that of another.

4. BAUDELAIRE

Among the most profound and, with regard to nineteenth-century theory of art, probably the most influential articulation of the synaesthetic approach is that given by the great French poet and critic of many arts, Charles Baudelaire, who in several respects marks a watershed of aesthetic thought in the modern age. The scope and range of Baudelaire's theoretical reflections on the arts are very wide. The interrelation between the arts, though not devoid of significance, is not the center of his thought, which is dominated by other themes, such as the artist's imagination. We shall therefore not present Baudelaire's aesthetic thought here; we shall do that in the last chapter of this book.[91] At this stage, I shall only summarily outline his reflections on the topic here discussed, the relationship between painting and sculpture and the other arts.

Baudelaire's celebrated collection of poems, *The Flowers of Evil (Les Fleurs du mal)*, contains a poem called "Correspondances" that was to exert a great influence on modern poetry. A poem, of course, is usually not a theoretical text, but in this case Baudelaire was making an important statement about the links between the senses, and, by implication, between the arts. This rhymed statement, as Wellek claims, served as a starting point for a renewed interest in synaesthesia.[92] The opening stanzas of the poem should be quoted in our discussion.

> Nature is a temple where living pillars
> At times allow confused words to come forth;
> There man passes through forests of symbols
> Which observe him with familiar eyes.
>
> Like long echoes which in a distance are mingled
> In a dark and profound unison

Vast as night and light,
Perfumes, colors and sounds answer one another.[93]

In this poem Baudelaire proclaims an occult theory. In a broader discussion of Baudelaire, in the last chapter of this book, we shall see how wide the range of his sources was. Important among them were esoteric doctrines and mystical trends, particularly the theories of the Swedish scientist and seer Emanuel Swedenborg. But it was from sources closer to his own time and to the arts with which he was concerned that he could derive inspiration as to the correspondences between colors, sounds, and smells. From the German Romantic poet and composer E. T. A. Hoffmann he learned a great deal about the correspondences between colors and sounds. In his Salon 1846 review, Baudelaire quotes a long passage from Hoffmann. This passage is so important for the understanding of Baudelaire that it is worth giving at length.

It is not only in dreams [so Hoffmann writes], or in that mild delirium which precedes sleep, but it is even awakened when I hear music—that perception of an analogy and an intimate connection between colors, sounds, and perfumes. It seems to me that all these things were created by one and the same ray of light, and that their combination must result in a wonderful concert of harmony. The smell of red and brown marigolds above all produces a magical effect on my being. It makes me fall into a deep reverie, in which I seem to hear the solemn, deep tones of the oboe in the distance.[94]

Considering Baudelaire's stature as a critic, we must ask what these and similar statements actually meant. To take an example; what did he actually wish to say when he wrote that "no musician excels as Wagner does in painting space and depth, both material and spiritual"?[95] Or when, in a long and serious study, he asserted that "color speaks"?[96] For Baudelaire, a divinely inspired poet, the synaesthetic metaphor had semimagical power. This real charm of going beyond the boundaries separating the senses may also have been reflected in his personal experience. Color induced in Baudelaire a state of euphoria comparable to the state to which he was brought by music.[97] While all these suggestions may be true, one finds it difficult to accept them as a full explanation. Baudelaire was not only a poet; he was also a great critic.

He may not have been a philosopher intent on establishing sharp lines of demarcation between one domain and the other, as Hegel had been, yet his thought is not devoid of a specific severity and strictness. What, then, did he mean by the synaesthetic metaphors?

The answer is not easily given. Some of Baudelaire's theoretical statements seem to plainly contradict any serious synaesthetic consideration; they indicate that he at least hesitated to take his metaphors at face value. Thus he declares that "the encroachment of one art upon the other" is a vice. "Every art," the reader is told, "must be sufficient to itself and at the same time stay within its providential limits." There is in his age, he admits, a tendency towards the fusing of the arts, but this tendency is a symptom of an age of decadence.[98] Reading such sober warnings, the modern student wonders whether he should not consider all Baudelaire's statements ascribing sounds to color, or color (and space) to sounds, as mere literary flourishes, metaphors that are not to be taken seriously.

Other considerations, however, seem to point in the opposite direction. Though Baudelaire may not have taken his metaphors literally, he does seem to have believed that there is a kind of real translation, based on hidden affinities, from one sense into another and from one art into another. To some contemporary critics who claimed that music, unlike painting and poetry, is "not able to translate all or anything with precision," he answers that, up to a certain point, this is indeed so, but this is not the whole story. "Music translates in its own way and using means that are proper to it."[99] Seeing how consistently Baudelaire employs the synaesthetic metaphors makes one hesitate to assume that they were merely meant as embellishments, devoid of real substance. But we do not have to rely on occasional metaphors only. In the theoretical essays he made some statements of principle, which, even if not taken at face value, demand to be considered seriously. To adduce an obvious example, I shall mention the discussion of color in his review of the 1846 Salon. "In color are to be found harmony, melody, and counterpoint." This is not meant in a general way. Baudelaire explains:

Harmony is the basis of the theory of color.
Melody is unity within color, or overall color.
Melody calls for a cadence; it is a whole, in which every effect contributes to the general effect.[100]

Where precisely is the link between color and sound, or between painting and music? Where do the two senses meet and interpenetrate? It is difficult to say. Baudelaire seems to imply that it is the experience of the spectator that provides the link. To the significance of the spectator in his thought we shall come back at a later stage of our survey.[101] Here I should like only to mention that in his essay on the *Tannhäuser* performance in Paris,[102] he makes a single, but rather clear, suggestion. As we have already noted, he says that "music translates in its own way and using means that are proper to it." To this he makes an important, if brief, addition: "In music, just as in painting and even in the written word, which is nevertheless the most positive of the arts, there is always a lacuna which is filled by the listener's imagination."[103] Here then, in the spectator's or listener's imagination, the "translation" takes place.

In Baudelaire's reflection on the relationship between the arts, color and sound hold primacy of place. He also devoted some attention to the art of sculpture.

The nineteenth century, particularly in France, has little to show in the way of theory and criticism of sculpture. Only early in the century do German philosophers deal with sculpture as the art typical of Greek culture, as we have seen in Hegel's deliberations on art forms.[104] In mid-nineteenth-century France, Viollet-le-Duc, architect and theoretician of architecture, as a matter of course treated sculpture as an art supplementary to architecture.[105] At the end of the century, however, we do not find a theory of sculpture. Baudelaire, it has recently been said, seems to have been the only author to produce a "romantic theory of sculpture."[106] To be sure, sculpture is not a major theme in Baudelaire's art theory, but he returned to the subject several times, devoting short sections to sculpture in his reviews of the Salons of 1845, 1846, and 1859.[107] In the years between 1845 and 1859 his views on many subjects may have changed, but they remained remarkably stable with regard to sculpture. In the three reviews mentioned, the careful reader can detect the outlines of a theory of sculpture. I shall present them briefly.

I shall begin with the position Baudelaire assigns to sculpture. In general, he was not given to ranking the arts; he stresses their possible merging much more than their possible hierarchy. When he speaks of

sculpture, however, he often suggests its low rank, sometimes using very strong words to express his disregard for it. A section in his review of the 1846 Salon bears the memorable title "Why Sculpture is Tiresome."[108] And he has good reason to find sculpture boring. It is in fact, he thinks, inferior to all the other arts, particularly painting.

Baudelaire's low opinion of sculpture can be summed up in three points. His reasons refer to features that are central to the character of sculpture, and these, he believes, are all "disadvantages." They are not accidental features; rather, they are, as Baudelaire explicitly points out, "a necessary consequence of its [that is, sculpture's] means and materials."

The first point—and it seems to be the most important—is that sculpture is close to nature. This claim offers the historian an excellent opportunity to appreciate the intellectual distance between the beginning and the climax of the modern age, that is, the distance between the Renaissance and the nineteenth century. In the Renaissance, an author could hardly pay a greater compliment to a work of art, or to an art form, than to declare that it was close to nature. (This, incidentally, was true regardless of how sophisticated, or primitive, the work of art or the art form might be.) For the mid-nineteenth century, "closeness to nature" is no longer a complimentary description. With Baudelaire, it rather sounds like a censure. Sculpture, he says in his 1846 essay, is "as brutal and positive as nature herself." To properly understand what Baudelaire means, we should keep in mind that he is not speaking of a style—say, realism—that makes the work of art *appear* like nature; he is speaking of the very medium of sculpture, of the art form itself.

The statue is close to nature because it is a real object, a three-dimensional thing or body. That a piece of sculpture is a real object, a material thing rather than an image conjured up by art, is reflected in the way primitive people react to it. In reviewing the Salon of 1859, Baudelaire offers the following piece of anthropological speculation:

Faced with an object taken from nature and represented by sculpture—that is to say, a round, three-dimensional object about which one can move freely, and, like the natural object itself, enveloped in atmosphere—the peasant, the savage or the primitive man feels no indecision; whereas a

painting, because of its immense pretensions and its paradoxical and abstrac-
tive nature, will disquiet and upset him.[109]

Primitive people and savages—so we can explicate Baudelaire's thought
—are used to handling material objects, and therefore a piece of
sculpture, which is such an object, does not cause them feelings of
anxiety. Painting, on the other hand, is a more abstract, a more
"spiritual" art, and it is precisely this spirituality that upsets the
primitive mind.

A second reason for Baudelaire's low esteem of sculpture is what he
calls the "vagueness and ambiguity" of this art.[110] Sculpture is ambigu-
ous, while painting is not. That vagueness is located in the way the
spectator looks at the work of art. Painting requires the spectator to
take up one single point of view, and that vantage point is prescribed:
necessarily it is in front of the painting. Sculpture allows—and some-
times even invites—the spectator to move around the figure, offering
him "a hundred different points of view." Ultimately, then, it will be
the spectator, not the artist, who will choose the point of view from
which to look at the statue, and, as a result, the spectator will also
determine what he will actually see of the work of art.

This, of course, is no novel observation. That painting offers but one
vantage point while sculpture offers many—this was a regular *topos* in
the art literature of the Renaissance and Baroque, and was repeated a
great many times. In these periods, advocates of sculpture stressed the
multitude of viewpoints a statue offers the spectator as a reason for the
superiority of sculpture over painting. The carving of the statue, they
said, is a more complex and difficult affair than the painting of a
picture. "I maintain," wrote Benvenuto Cellini in a famous letter, "that
among all the arts based on design, sculpture is seven times the greatest,
because a statue must have eight show-sides and all should be equally
good."[111] In the nineteenth century, the criteria for assessing the value
of an art form have changed. Now, the difficulties overcome (possibly
still a craftman's outlook) can no longer serve as a yardstick for
measuring the value of a work of art or an art form. Now other
yardsticks are employed, among them also "spirituality."

There is still another reason for Baudelaire's small regard for sculp-

ture. In moving around a piece of sculpture, "it often happens that through a chance trick of the light, an effect of the lamp, [the spectator] may discover a beauty which is not at all the one the artist had in mind —and this is a humiliating thing for him."[112] It is worth noting: Baudelaire does not question that the configuration so accidentally discovered is really beautiful; what humiliates the artist is not the lack of beauty in his work; it is rather that the beauty that is really there is not the one he had in mind. The ultimate value of the work of art— this is the idea that underlies all Baudelaire's aesthetics—follows from its being altogether the intentional product of man. A beauty that is not intended belongs to nature rather than to art.

Given all these reasons, it follows that the audience of sculpture consists, as we have already seen, of "the peasant, the savage, or the primitive man." This is the type of person who cannot grasp the spirituality of painting. Used to handling material things, the primitive spectator cannot comprehend something that is mere appearance. Look how the primitive reacts to painting, Baudelaire seems to be saying. He tells the story of the native chief whom an American painter represented in profile. The chief's friends accused the painter of having robbed half of the chief's face, and laughed at the chief for losing it. They could not grasp the abstraction in painting. "In the same way monkeys have been known to be deceived by some magical painting of nature and to go round behind the picture in order to find the other side."[113] Sculpture, the author says, is thus restricted by "barbarous conditions." Save for exceptional cases, it "will only produce the marvellous object which dumbfounds the ape and the savage."

Baudelaire's treatment of sculpture, fragmentary and sketchy as it may be, has a significance that goes beyond his opinions of that particular art. What follows from it is that Baudelaire, in addition to his belief in the ultimate unity of art (and it is this underlying unity that makes the "translation" from one art into another possible), also believed in a hierarchy of the arts. His notion of such a hierarchy is even less articulate and explicit than his concept of the potential unity of the arts. But even though the concept is vague, our author obviously assumes that there are arts (such as painting and music) that are more spiritual and another (sculpture) that is less so.

This image of a hierarcy of the arts, vaguely and hazily outlined

somewhere in the background of Baudelaire's thought, is not historical. To him, sculpture is inferior to painting in all times and ages. And yet this vague hierarchy is not devoid of a suggestion of a historical order. It is especially the remarks on sculpture that make this clear. To be sure, in Baudelaire's writings on the arts we cannot find anything comparable to Hegel's detailed historical construction. However, Baudelaire clearly links sculpture with the early stages of history. Sculpture, then, is not only the art closest to nature, it not only appeals to the least developed of audiences, it is also the art typical of the initial stages of mankind. "The origin of sculpture is lost in the mists of time": thus begins the section on sculpture in the review of the 1846 Salon. "We find, in fact," so he continues, "that all races bring real skill to the carving of fetishes long before they embark upon the art of painting, which is an art involving profound thought and one whose very enjoyment demands a particular initiation." Here, then, the primitive character of sculpture is clearly linked with its origin in the beginnings of history, and with its being the art intelligible and appealing to primitive peoples. Painting, an art demanding thought and involving an initiation, came a long time after sculpture was practiced. It is not an exaggeration to say that for Baudelaire sculpture is the art typical of the early states of mankind. It is not surprising, then, that in later times sculpture could not remain an independent art. "Once out of the primite era, sculpture, in its most magnificent development, is nothing else but a *complementary* art." [114] Vaguely in the background, we perceive the idea of a progress of art, a progress that leads from a more primitive to a more sophisticated art form. Did any influence from the Hegelian historical philosophy of aesthetics reach the synaesthetic approach of the French poet? It is not for us here even to attempt an answer. [115] Be that as it may, it is perhaps permissible to see Baudelaire as completing the development that began with Lessing.

NOTES

1. By E. H. Gombrich, in "Lessing," *Proceedings of the British Academy* 43 (1957):133–156. For the sentence quoted, see p. 135. This paper is reprinted in Gombrich's

Tributes (Oxford, 1983). I shall use the original edition; page references will be given, in parentheses, in the text.

2. See G. Paolo Lomazzo, *Trattato dell' Arte de la Pittura* (Milan, 1584; reprinted Hildesheim, 1968), p. 282 (in Chapter 2 of Book 6, devoted to the *prattica* of painting). For this subject in general, see Rensselaer W. Lee, *Ut pictura poesis: The Humanistic Theory of Painting* (New York, 1967), and Mario Praz, *Mnemosyne: The Parallel between Literature and the Visual Arts* (Princeton, 1970).

3. *The Art of Painting of Charles Alphonse de Fresnoy,* translated into English verse by William Mason (York, 1783), p. 1.

4. See Joshua Reynolds, *Fifteen Discourses Delivered to the Royal Academy* (London and New York, n. d.), pp. 132 on Shakespeare (eighth discourse) and 252 on Michael Angelo (fifteenth discourse). For Reynolds's views on art, see above, pp. 132 ff.

5. The full text of this early sketch is reprinted in Hugo Blümner, ed., *Lessings Laokoon* (Berlin, 1880), pp. 358–359.

6. See G. E. Lessing, *Laocoön,* translated by R. Phillimore (London, n. d.), p. 3. All quotations from *Laocoön* will be taken from this translation. References in the text, given in parentheses, are also to this edition.

7. Lessing's *Briefe antiquarischen Inhalts* have, of course, frequently been reprinted. I use the edition of *Lessings Werke,* edited by Theodor Matthias (Leipzig, n. d.). For the passage referred to, see Vol. V, pp. 133 ff. So far as I know, the *Briefe antiquarischen Inhalts* have not appeared in an English translation.

8. For an interesting discussion of Lessing's text from the point of view of present-day semiotics, see David E. Wellbery, *Lessing's Laocoön: Semiotics and Aesthetics in the Age of Reason* (Cambridge, 1984).

9. Roger de Piles, *Cours de peinture par principes* (Paris, 1708), II, p. 358. The English translation of this work, *The Principles of Painting* (London, 1743), was not available to me. For Roger de Piles (though dealing mainly with different problems), see Thomas Puttfarken, *Roger de Piles' Theory of Art* (New Haven and London, 1985).

10. See Du Bos, *Réflexions critiques sur la poésie et sur la peinture* (reprinted Geneva, 1967), p. 111 (p. 415 of the first volume in the original edition). For Dubos, see above, pp. 000 ff. Historians of semiotics will be interested in the distinction between "aniconic" and "iconic" signs that is implied in Dubos's thought.

11. See Wellbery, *Lessing's Laocoön,* pp. 105 ff.

12. Blümner, *Lessings Laokoon,* p. 447, for the text of the preparatory note. See also Wellbery, *Lessing's Laocoön,* p. 106.

13. Translations from the first chapter of Lessing's treatise on the fable, for which see 'Abhandlung über die Fabel" in *Lessings Werke,* ed. Matthias, V, pp. 5 ff. Cf. especially pp. 16 ff.

14. The full title of Herder's treatise is *Plastik. Einige Wahrnehmungen über Form und Gestalt aus Pygmalions bildendem Traume.* I use the edition *Johann Gottfried von Herder's sämmtliche Werke. Zur schönen Literatur und Kunst,* Part Eleven, *Zur römischen Literatur. Antiquarische Aufsätze* (Tübingen, 1809), pp. 239–363. Hereafter, page references to this edition will be given, in parentheses, in the text. There seems

to be no English translation of *Plastik*. There are not many modern discussions of this text, but see Bernhard Schweitzer, "Herders 'Plastik' und die Entstehung der neueren Kunstwissenschaft," in Schweitzer's *Zur Kunst der Antike: Ausgewählte Schriften* (Tübingen, 1963), I, pp. 198–252.

15. Though the literature on Herder is very large, we still lack a thorough discussion of his contribution to our specific field of study. Interesting in a general sense are Isaiah Berlin's observations in *Vico and Herder: Two Studies in the History of Ideas* (New York, 1976). H. B. Nisbet, *Herder and the Philosophy and History of Science* (Cambridge, 1970), is useful for understanding the broader contexts of Herder's theories of art.

16. See Karl Borinski, *Die Antike in Poetik und Kunsttheorie,* II (Leipzig, 1924), pp. 240 ff.

17. See Leonardo da Vinci, *Treatise on Painting,* translated and annotated by Philip McMahon (Princeton, 1956), pp. 32 ff. In subsequent references to this edition, I shall give, in parentheses, the number of the fragment rather than of the page on which it appears.

18. He makes these distinctions in *Plastik*. Page numbers cited in parentheses in the text are to the 1809 edition mentioned in note 14.

19. In his opening observations on "Dramatic Art and Literature," A. W. Schlegel says that the wants to combine the theory and the history of the art he is discussing. For his theory of art, see mainly his *Vorlesungen über schöne Literatur und Kunst,* I, *Die Kunstlehre.* References in parentheses in the text are to the recent edition (Stuttgart, 1963).

20. In the first chapter of his *History of Ancient Art,* Winckelmann admits that art probably began "with a sort of sculpture." But he arranges the shaping of different materials in a hierarchic as well as chronological order. Thus shaping begins with clay, progresses to working in wood, then to working in ivory, and ends up by carving in stone (see Winckelmann's *Geschichte der Kunst des Altertums* [Vienna, 1934], pp. 25, 30). Only carving in stone is considered full-fledged sculpture.

21. Vasari several times articulates his well-known construction of history, as, for example, in the introduction to the *Vite* (see Giorgio Vasari, *Lives of the Painters, Sculptors and Architects,* trans. A. B. Hinds [London and New York, 1980], I, p. 5).

22. In E. H. Gombrich, *Tributes* (Oxford, 1981). Gombrich's criticism of Hegel is best summed up in the lectures entitled "In search of cultural history," reprinted in E. H. Gombrich, *Ideas and Idols: Essays on Values in History and in Art* (Oxford, 1979), pp. 24–59. See particularly pp. 28 ff.

23. I shall quote the German text from the edition *Vorlesungen über die Aesthetik,* (Berlin, 1835–1838), I–III, henceforth to be cited as *Aesthetik;* the English translation by T. M. Knox is quoted from *Aesthetics: Lectures on Fine Arts* (Oxford, 1975), hereafter abbreviated as *Fine Art.*

24. *Aesthetik,* I, pp. 4, 34; *Fine Art,* pp. 1, 25.

25. *Aesthetik,* I, p. 225; *Fine Art,* p. 175.

26. *Aesthetik,* I, p. 11; *Fine Art,* p. 7.

27. *Aesthetik,* I, p. 225; *Fine Art,* p. 175.
28. *Aesthetik,* I, p. 12; *Fine Art,* p. 8.
29. *Aesthetik,* I, p. 393; *Fine Art,* p. 304.
30. In *Theories of Art,* pp. 360 ff.
31. See, for instance, H. R. Jauss, *Literaturgeschichte als Provokation* (Frankfurt am Main, 1979), pp. 67 ff.
32. Titled, in German, *Ideen zu einer Philosophie der Geschichte der Menschheit.*
33. Creuzer's *Symbolik und Mythologie der alten Völker* (1810–1812) deals mainly with Greek mythology, but the very title of the large work indicates his awareness of additional nations and their mythologies. For Creuzer, see below, pp. 233–238.
34. For an English translation of Schlegel's "On the Language and Wisdom of the Indians," see *The Aesthetic and Miscellaneous Works of Frederick von Schlegel,* trans. E. J. Millington (London, 1860), pp. 425–495.
35. *Aesthetik,* I, p. 392; *Fine Art,* pp. 303–304.
36. *Aesthetik,* I, p. 436; *Fine Art,* p. 338. An important source for Hegel's studies of Indian culture and art was the research of Wilhelm von Humboldt, but he used also other works.
37. *Aesthetik,* I, p. 456; *Fine Art,* p. 354.
38. *Aesthetik,* I, p. 452 ff.; *Fine Art,* p. 351.
39. *Aesthetik,* I, p. 453; *Fine Art,* p. 351.
40. *Aesthetik,* I, p. 463; *Fine Art,* p. 360.
41. *Aesthetik,* I, p. 461; *Fine Art,* p. 358. Hegel, obviously quoting from memory, ascribes the story of the sounding colossi to Herodotus, but, as the English translator notes, his source was probably Tacitus, *Annals,* II, 61.
42. *Aesthetik,* I, p. 464; *Fine Art,* pp. 360–361.
43. *Aesthetik,* II, p. 3; *Fine Art,* p. 427.
44. *Aesthetik,* II, p. 21; *Fine Art,* p. 441.
45. *Aesthetik,* II, p. 62; *Fine Art,* p. 473.
46. Virgin: *Aesthetik,* III, pp. 13 f.; *Fine Art,* pp. 800 ff. Dutch genre painting; *Aesthetik,* III, pp. 120 ff.; *Fine Art,* p. 886.
47. This has been suggested by Peter Szondi in *Poetik und Geschichtsphilosophie* (Frankfurt a. M., 1974), p. 424.
48. *Aesthetik,* II, pp. 121 ff.; *Fine Art,* pp. 517–518.
49. Hegel emphasizes this mainly in his introduction to the discussion of the romantic art form. See particularly *Aesthetik,* II, pp. 121 ff.; *Fine Art,* pp. 524 ff.
50. *Aesthetik,* II, p. 133; *Fine Art,* p. 527.
51. *Aesthetik,* II, p. 144; *Fine Art,* p. 532.
52. *Aesthetik,* II, p. 145; *Fine Art,* p. 536.
53. *Aesthetik,* II, p. 147; *Fine Art,* p. 538.
54. *Aesthetik,* II, 254 ff.; *Fine Art,* pp. 615–620.
55. *Aesthetik,* II, p. 268; *Fine Art,* p. 632.
56. This idea seems so important to Hegel that he stresses its originality. "This is a point of supreme importance which I have not found emphasized anywhere. . . ." See *Aesthetik,* II, p. 268; *Fine Art,* p. 632.

57. Herder, *Plastik* (see above, note 14), p. 241.
58. *Aesthetik,* II, p. 354; *Fine Art,* p. 702.
59. *Aesthetik,* II, pp. 355 f.; *Fine Art,* p. 703.
60. *Aesthetik,* II, p. 359; *Fine Art,* p. 705.
61. *Aesthetik,* II, p. 381; *Fine Art,* p. 723.
62. *Aesthetik,* II, p. 386; *Fine Art,* p. 727.
63. *Aesthetik,* II, p. 387; *Fine Art,* p. 728.
64. *Aesthetik,* II, pp. 392 ff.; *Fine Art,* p. 732.
65. *Aesthetik,* II, pp. 393 ff.; *Fine Art,* p. 733.
66. *Aesthetik,* III, p. 7; *Fine Art,* p. 795.
67. *Aesthetik,* III, p. 15; *Fine Art,* p. 802.
68. *Aesthetik,* II, p. 259; *Fine Art,* p. 626.
69. *Aesthetik,* III, pp. 89 ff.; *Fine Art,* p. 860.
70. *Aesthetik,* III, pp. 12 ff., 17 ff., 20; *Fine Art,* pp. 799, 803, 805.
71. *Aesthetik,* III, p. 20; *Fine Art,* p. 805.
72. *Aesthetik,* III, p. 43; *Fine Art,* p. 824.
73. The literature on synaesthesia is large but unwieldy. Cf. the useful remarks in Charles Osgood, George Suci, and Percy Tannebaum, *The Measurement of Meaning* (Urbana, Ill., Chicago, and London, 1967), pp. 20–24. A thorough discussion of synaesthesia from the point of view of art theory is still missing. Interesting observations on the function of synaesthesia in symbolism may be found in Edwyn Bevan, *Symbolism and Belief* (Boston, 1957).
74. The literature on the subject is not easily comprehended in its main lines. For "harmony of the spheres," see Leo Spitzer, *Classical and Christian Ideas of World Harmony* (Baltimore, 1963). For application of synaesthesia to the arts, see Albert Wellek, "Renaissance- und Barock-Synaesthesie: Geschichte des Doppelempfindens im 16. und 17. Jahrhundert," *Deutsche Vierteljahrsschrift für Literaturwissenschaft und Geistesgeschichte* 9 (1931):534–584 (with further literature).
75. For Poussin's letter, see *Theories of Art,* p. 329.
76. I use the reprint (Paris, 1969). Page references will be given in the text. Because in this work the paragraphs are numbered, I shall also give the number of the paragraph referred to. The first figure in parentheses will represent the page number, the second, after the semicolon, the number of the paragraph.
77. See above, pp. 158 ff.
78. *Leonardo da Vinci: Treatise on Painting,* translated by Philip McMahon (Princeton, 1956), pp. 7, 14 ff., ## 13, 26–28.
79. Sometimes Chevreul speaks about the harmony of "beautiful colors" and "beautiful sounds" (535;974). It is however obvious, I believe, that here too he has in mind the *arrangement* of colors and sounds. The harmony and beauty resides in the arrangement.
80. For Castel, see Wilton Mason, "Father Castel and His Color Clavecin," *Journal of Aesthetics and Art Criticism* 17 (1958); 103–116. For modern attempts in the same direction, see Edward Lockspeiser, *Music and Painting: A Study in Comparative Ideas from Turner to Schoenberg* (New York, 1973), esp. pp. 121 ff.

81. See my *Light and Color in Italian Renaissance Theory of Art* (New York, 1978), esp. pp. 160 ff.
82. See below, pp. 348 ff.
83. See George P. Mras, *Eugène Delacroix's Theory of Art* (Princeton, 1966), p. 37.
84. See, for instance, M. H. Abrams, *The Mirror and the Lamp: Romantic Theory and the Critical Tradition* (London, 1971), p. 51.
85. I am using the English translation by Walter Pach, in *The Journal of Eugène Delacroix* (New York, 1972), pp. 194–195.
86. *The Journal of Delacroix,* p. 521.
87. Alois Riegl, *Spätrömische Kunstindustrie* (Vienna, 1927), pp. 32 ff. I abstain from going into an analysis of the large literature (not always successfully dealing with a very complex problem) that tries to elucidate Riegl's concepts. Here I should only like to point out when, at what stage of research and intellectual development, the problem appeared.
88. Included in Bernard Berenson's *Italian Painters of the Renaissance* (New York, 1957), p. 63.
89. *The Journal of Eugène Delacroix,* p. 538: entry of January 13, 1857.
90. Ibid., p. 537.
91. See below, pp. 362 ff.
92. See René Wellek, *A History of Modern Criticism,* IV, *The Later Nineteenth Century* (Cambridge, 1983), p. 444.
93. These two stanzas were quoted by their author in an article on Richard Wagner's opera *Tannhäuser,* published in March 1861. An English translation can be found in Charles Baudelaire, *The Painter of Modern Life and Other Essays,* trans. Jonathan Mayne (New York, 1964), pp. 111 ff. The quotation is on p. 116.
94. Charles Baudelaire, *Art in Paris 1845–1862,* trans. Jonathan Mayne (Oxford, 1965), p. 51.
95. Baudelaire, *The Painter of Modern Life,* p. 117.
96. The phrase appears in a lengthy study of Théophile Gautier that is not included in any English translation of Baudelaire's critical writings. See Charles Baudelaire, *Curiosités esthétiques. L'art romantique,* ed. H. Lemaître (Paris, 1962), pp. 659 ff. (the passage quoted being on p. 676).
97. See Lockspeiser, *Music and Painting,* p. 73.
98. For all these quotations, see Wellek, *A History of Modern Criticism,* IV, p. 445.
99. *The Painter of Modern Life,* pp. 113 ff. The French text is in *Curiosités esthétiques. L'art romantique,* p. 694.
100. *Art in Paris,* pp. 49–50; *Curiosités esthétiques,* p. 108.
101. See below, pp. 363 ff., 375 ff.
102. See note 93.
103. *The Painter of Modern Life,* p. 114; *Curiosités esthétiques. L'art romantique,* p. 694.
104. See above, pp. 187 ff., 193 ff.
105. For Viollet-le-Duc, see below, pp. 380 ff.
106. See H. W. Janson, *19th Century Sculpture* (New York, 1985), pp. 126–127.

107. See *Art in Paris 1845–1862*, pp. 29 ff., 111 ff., 203 ff.; *Curiosités esthétiques. L'art romantique*, pp. 78 ff., 187 ff., 381 ff.

108. *Art in Paris 1845–1862*, p. 111; *Curiosités esthétiques. L'art romantique*, p. 187.

109. *Art in Paris 1845–1862*, p. 204; *Curiosités esthétiques. L'art romantique*, p. 383.

110. *Art in Paris 1845–1862*, p. 111; *Curiosités esthétiques. L'art romantique*, p. 188.

111. The letter is frequently published. I quote from the English translation of it in Elizabeth Holt, *A Documentary History of Art* (Garden City, 1958), II, p. 35.

112. *Art in Paris 1845–1862*, p. 111; *Curiosités esthétiques. L'art romantique*, p. 188.

113. *Art in Paris 1845–1862*, p. 205; *Curiosités esthétiques. L'art romantique*, p. 384.

114. *Art in Paris 1845–1862*, p. 111; *Curiosités esthétiques. L'art romantique*, p. 189.

115. For the influence of German Romantic thought on French letters, see Albert Beguin, *L'âme romantique et le rêve: Essai sur le romantisme allemand et la poésie française* (Paris, 1939). The few pages on Baudelaire (pp. 376–381) do not touch on our subject.

4

The Symbol

"Iconology" has become a household word in modern critical language. "Symbol" and "symbolism," the terms most often used to indicate the relationship of the visible to something that in itself is not seen, have been so frequently and so carelessly employed that they have almost ceased to have any meaning. I shall not here attempt to define these heavily charged notions; yet I must explain in a few words why, to my mind, the student of eighteenth- and nineteenth-century reflections on art should devote careful attention to what might be called the tradition of symbolic reading of works of art.

The first reason for devoting a chapter to symbolism in this book is simple enough. Between the early eighteenth and the late twentieth century, symbolism played a central part in aesthetic reflections, and this seems to be particularly true with regard to painting and sculpture. When in our day one speaks of the predecessors of modern iconology, one usually thinks of Renaissance mythography and emblematics (such as Andrea Alciati's work) and of Baroque manuals of the personifications of abstract notions (such as Cesare Ripa's *Iconologia*). There is little doubt that these Renaissance and Baroque traditions did indeed pave the way for a modern contemplation of pictorial symbolism. Yet the reader following this presentation may get the impression that the notion of iconology so popular in our century is a direct, unmediated

continuation of that early humanistic legacy, in other words, that modern scholars took up precisely were sixteenth- and seventeenth-century authors left off. Such an impression, however, is not only incorrect; it also deprives iconological thought of significant and productive layers in its history. The eighteenth and nineteenth centuries possessed a rich and continuous tradition of the symbolic reading of images. There was also a great deal of questioning and soul searching as to how one could be sure that these readings were correct or whether they were the mere projections of a modern spectator. Many of the connotations that so amply enrich the notion of "image" in modern thought actually originated in the reflections of Enlightenment philosophers, Romantic poets, and scholars of anthropology and religion in the course of the nineteenth century.

The thinking of eighteenth- and nineteenth-century students and artists about the symbolic dimension of works of art is important for us not only because it happens to be part of the story we are telling. In fact, they made a lasting contribution, placing the "image" in a new light. Let us for the moment not worry about the scope of that notion. Later we shall come back to the question of whether by "image" nineteenth-century authors understood only paintings and statues, or whether they also included what is perceived by the mind's eye. Whatever "image" may mean, by considering it as a symbol we discover that it has a power that goes far beyond what is instantly perceived in our experience. The symbolic image shows levels of reality that normally cannot be seen. The work of art becomes a testimony to an absent—or supernatural—being. Earlier ages tried to come to terms with this property of images by telling stories of miracles performed by icons. In the eighteenth and nineteenth centuries, some secular notions replace the miracle stories. The painting or the statue "show" the artist's personality, as if he were present; they are also believed to reveal the wishes or memories of a collective subconsciousness. We need not discuss these concepts themselves. What I should like to point out is that to claim that the work of art can perform these functions is to endow it with a particular power. The belief in such a power, hidden in the image itself, is a lasting contribution of aesthetic reflection in the centuries between the Baroque and our own time. It is another reason

for studying carefully what these centuries had to say about the symbolic function and might of art.

I. WINCKELMANN

In more than one respect, Winckelmann marks the beginning of the modern study of art.[1] This is also true for a new consideration of subject matter and the symbolic dimension of works of art. What role do symbolism and mythology play in the art of a period? What was their significance for the art of his own time? Winckelmann was concerned with these questions, and he returned to them at different stages of his intellectual life. Already in his first treatise, *Thoughts on the Imitation of Greek Works of Art* (1756), he deplores the fact that the contemporary artist has no useful compendium on symbolism at his disposal.[2] In one of his last works, *Versuch einer Allegorie, besonders für die Kunst* (1766), he tried to provide the artist with just such a work.[3] In its aim, then, the latter work completely adheres to the line of traditional art theory; ostensibly, it is meant as a help for the practicing artist, as were similar manuals in the Renaissance. In its underlying approach, however, it lays the foundations for a modern view of symbolism in the figurative arts. In its achievements and failures it reflects the strengths and weaknesses of Winckelmann's aesthetics.

Subject matter plays a major role in Winckelmann's views on art. It is a criterion of value judgment; rendering the subject appropriately and manifesting it clearly is the artist's supreme goal. Winckelmann rejects Dutch painting because it has a "merely sensory air." He criticizes rococo pictures because they are "paintings that mean nothing."[4] His aesthetics, it has frequently been said, is an "aesthetics of content" *(Gehaltsästhetik)*. It is against this attitude to subject matter that we should see his attempts to formulate a doctrine of allegory.

The signs of allegory, Winckelmann believes, are to be found far beyond the confines of literary subject matter proper. Good taste has recently deteriorated, we must infer from what he says, because of the fashion of painting objects devoid of meaning. That taste can be restored, however, by a thorough and devoted study of allegory. Certain

noble kinds of poetry find a parallel in visual allegories. The subject of an ode, Winckelmann already declared in 1756, can be represented visually only in an allegorical painting.[5] (In this context it is worthwhile remembering, as Bengt Algot Sorensen has shown in a fine study, that eighteenth-century, mainly English, views linked the ode with the Sublime.)[6] In a broader sense, Winckelmann continually stressed the importance of reason and rational understanding for art. "The brush the artist uses should be dipped in reason," he said in his first treatise. "The artist should leave to thought more than what he shows the eye."

What is an "allegory" in Winckelmann's thought? He begins the *Versuch* with a formal definition of the concept. It is thus particularly surprising that our simple inquiry does not receive a simple answer. In fact, Winckelmann gives, or at least implies, two different answers to the question what is "allegory" or, more generally, the symbolic mode. The main tendency of one answer is toward the past, of the other to the future. And it is perhaps characteristic of Winckelmann's singular position in the history of his subject that he does not seem to perceive the conflict between his two views.

In the very first sentences of the work, Winckelmann describes allegory in linguistic terms. Taken in its broadest sense, he says, allegory is a "suggestion of concepts by images, and thus it is a general language, primarily of the artists. . . ." The term "allegory," he reminds his readers, originally meant "to say something that is different from what one wants to indicate, that is, to aim somewhere else from where the expression seems to go." Later in the same opening paragraph, we learn that the usage of the term was broadened, and now "we understand by allegory everything that is indicated by pictures and signs." Winckelmann does not tell us how he thinks these signs work or what makes them intelligible to the spectator. A careful reader of his text cannot help feeling, however, that he understands allegory as essentially based on convention. To continue his metaphor, cultural inheritance taught us the language, and therefore we are able to read and understand the message.

This conclusion is supported by the modes to which Winckelmann refers, the venerable tradition he acknowledges as his ancestor. He calls pictorial symbolism a "science," as did the great symbolists of the

Renaissance, and from the past of that science he singles out "three great heroes." They are Pierio Valeriano, the mid-sixteenth century humanist, Cesare Ripa, of whom we have spoken in an earlier stage of this study, and the Frenchman Jean-Baptiste Boudard.[7] These scholars understood symbolism as a cultural, that is, a man-made, tradition, based on deliberate, commonly known and accepted conventions. They would all have agreed that you cannot read the symbols if you don't know the conventions on which they are based. This is also how Winckelmann understood their legacy. Pierio Valeriano called his great work on symbolism *Hieroglyphica* because he wished to explain the symbolic signs of the Egyptians. The Egyptians, as the Greeks said, invented allegory, and among them this form of expression was more common than in other nations. The Egyptians called allegory their "sacred language." Again it follows from the overall context, though Winckelmann does not say so expressly, that this "invented" language (or script) is a convention, deliberately set up. Frequently Winckelmann is critical of his predecessors. Cesare Ripa's symbolism, for instance, relies too much on literary sources, and does not draw sufficiently on images. But this criticism does not call into question the basic assumption underlying all interpretations, that is, that symbolism is a convention.

In addition, however, Winckelmann holds yet another view of symbolism, and, in some respects at least, that other view is the very opposite of the first. "Nature herself," we are told, "was the teacher of allegory, and this language is more appropriate to her than the signs later invented by our thought" (p. 441). He also says that nature speaks in allegories. How are we to understand this statement? The answer is indicated in another definition of allegory. "Every allegorical sign or picture should contain in itself the distinctive qualities of the thing signified." The simpler this relationship (of containing or displaying) is, the better (p. 441). What this latter statement, if thought through consistently, amounts to is a complete reversal of the understanding of symbolism as a convention, and of the definition of allegory formerly given. That former definition, as we remember, was based on an assumption that the object that serves as a symbol and the idea that is

symbolized are altogether alien to each other. This, as we have just seen, is what the word "allegory" means.

The new concept of allegory also implies a new way of reading symbols. We have seen that you cannot read a symbol if you don't know the code in which it is written. Acquiring the code is a matter of cultural achievement. The significance of the signs, or of the principles governing that significance, is transmitted from one generation to another, from one period to another. It naturally follows that some people understand the signs, others do not. The Renaissance belief that only the educated and the initiated are able to read the "sacred sign" is still valid. The other concept of allegory reverses this belief. "Allegory should therefore be intelligible by itself," Winckelmann says, "and should not be in need of an inscription."

How can we account for such a blatant contradiction? One may suspect, as has indeed been suggested, a certain carelessness, or even clumsiness, in the use of terminology. Winckelmann was not particularly concerned with consistency in his use of terms. Though this may be true, the contradiction we have just seen is too significant to be explained away as a mistake. It is therefore important to note that wherever Winckelmann speaks of an allegory that has a certain identity with what it refers to — in his language, the symbol that contains in itself the quality of what it symbolizes — he has images in mind. In other words, in these cases he is thinking of allegories that address the audience by means of visual experience. The image is not detached from its contents, it carries its meaning within itself, and does not send the spectator beyond what he visually experiences. Visual allegories, like nature itself, are "true images of things" (p. 441).

Winckelmann writes for artists. Should we forget this basic fact, we would quickly recall it by reading the *Versuch einer Allegorie*. With all his antiquarian erudition and with all the subtle memories from ancient literatures and arts that, whether explicitly stated or vaguely alluded to, give such a rich texture to his text, he never forgets that he is addressing his work to the creative artist. That the artist who shapes new works always draws upon inherited tradition — whatever the period in which he lives — is for Winckelmann a matter of course. But

the learned Roman antiquarian also knows that for the creative artist the task of shaping *new* symbolic visions is never done. There will always be the need to create new symbols. It is therefore mandatory to inquire how new allegories can be developed. In writing the *Versuch,* Winckelmann has this question uppermost in his mind. To be sure, in the course of his work on allegory he summarizes a great deal of traditional wisdom. He knows that the Renaissance tradition cast inherited images into definite didactical patterns. Cesare Ripa's *Iconologia,* we read early in Winckelmann's book, attained such wide fame that it became "the artist's Bible" (p. 476). Ripa, however, does not tell us how new allegories should be fashioned. Here our author tries to fill the gap. He outlines three principles that should govern any new creation in the symoblic mode. Allegories, he says, should be simple, clear, and lovely.

Simplicity is not a new concept. We have already encountered it in Winckelmann's *History of Ancient Art,* and there, as we remember, he considered simplicity as the supreme value and central achievement of the classical age.[8] Now, one can perhaps understand what simplicity is as a quality of style, in the rendering of figures or landscapes. But what precisely constitutes the simplicity of an allegory? It consists, Winckelmann says, in "designing a picture so as to express the thing referred to with as few signs as possible" (p. 484). Such simplicity is "like gold without further addition." Simplicity, then, is to express much by little. The opposite is a sign of confused and immature conception.

Clarity, the second requirement, follows from simplicity, as Winckelmann believes (p. 485). Considered in the context of symbolic imagery, clarity is a complex notion, not pertaining only to the making of the work of art, and thus to the artist, but also to understanding it, and thus to the spectator or audience. In the brief passage Winckelmann devotes to clarity in *Versuch einer Allegorie,* he indeed switches from the artist to the spectator. What is it that ensures the clarity of an allegorical image? In an age so intensively concerned with hermeneutics, one can now hardly refrain from formulating the problem more pointedly: is an artistic symbol (or allegory) grasped intuitively, or does the spectator have to learn the code in order to clearly understand what he perceives in the work of art he is looking at? The question, implied by Winckelmann's wording, is no explicitly asked. So far as can be deter-

mined from the text, the author does not see the dilemma clearly, or else he wavers in his answer, he does not take a definite stand. The clarity of symbolic images, Winckelmann says, "should be taken relatively." One cannot ask that a picture "be fully intelligible at a first glance to a completely uneducated person," he says as something self-understood. The twofold qualification ("fully intelligible" and "completely uneducated") shows that Winckelmann was not of one mind on the central question of interpretation, a question he had not fully spelled out. Nevertheless, it seems that he here tends to a reading of pictorial symbols primarily as cultural signs. If you are not familiar with the cultural code—if you are "uneducated," that is—you cannot properly grasp what you are seeing in the allegorical painting or statue. In the very next sentence, however, Winckelmann makes a claim that seems to contradict what he has just said. The allegorical picture will be clear, we are told, "if it bears a close relation to what is to be represented." The example he adduces may astonish the modern student. The white radishes in Guido Reni's painting of Mary Magdalen "signify her strict life" (p. 485). Everybody, Winckelmann obviously assumes, is familiar with the harsh taste of white radishes and therefore intuitively applies this knowledge as a reminder of Mary Magdalen's "strict life." It is, Panofsky would say, the object known from "practical life" that seems intuitively intelligible.

The third requirement, finally, is loveliness (pp. 485 ff.). This demand, of course, is no specific to an allegorical or symbolic mode; we ask loveliness of any work of art, whether or not symbolic. In a symbolic work of art, however, the aim of loveliness is to make teaching pleasurable. This is particularly true, Winckelmann insists, for the visual symbol. Literature can afford descriptions of horror and ugliness that painting cannot.

II. THE SCIENCE OF MYTHOLOGY

The historian trying to follow the increasing concern with symbolism in modern artistic reflection cannot disregard certain traditions of scholarship that, in a narrow sense, had little to do with the theory of art.

First and foremost among these is the study of mythology, mainly Greek but sometimes also of other cultures, as it blossomed particularly during the period of Romanticism. The "science of mythology," emerging in the last two decades of the eighteenth and the first decades of the nineteenth century, articulated concepts of visual symbolism and approaches to painting and sculpture that did not find comparable expression in any other field of study or reflection. Some of these concepts and approaches, we shall shortly see, became major factors in the interpretation of art. In the present section, I shall first briefly outline some of the major contributions the science of mythology made to the theory of art; by way of example, I shall then analyze the influence of some of the Romantic students of mythology on art doctrines.

What is an artistic symbol, and how does it work? The question in itself was not new; it had agitated the minds of artists and scholars since the Renaissance. Yet in those centuries the question was perceived in a somewhat vague, not fully articulate way. Some of the analytical distinctions made by Romantic scholarship, particularly those setting the symbol in art apart from symbolism in other fields of thought and science, were new. It was these distinctions that later became important components of a modern approach to the reading of an artistic image.

These distinctions, as well as the modern understanding of the work of art as a symbolic expression, we should remember, were not propounded in the philosophical schools; rather they emerged from the labors that some scholars invested in the study and interpretation of mythographical texts and monuments. In our century, these early scholars have sometimes been criticized for their logical inconsistency and for hypotheses that, admittedly, are occasionally "wild." However that may be, their impact on thought on art was both profound and extensive. The questions they asked electrified artists, critics, and audiences. In posing these questions, and in pursuing certain lines of thought in an attempt to answer them, these scholars became the mouthpiece of subterranean trends that were to shape an important part of the modern world.

Another contribution to the theory of art made by these scholars was the transmitting to modern culture of a comprehensive repertory

of distinct mythological images and visual symbols. This educational activity, however, was a by-product rather than the major goal of the Romantic scholars. What they sought was the "truth," what they achieved was the forming of the imagination of the modern world.

A final point I should like to stress is their emphasis on what was *collectively* believed in ancient times. This may seem trivial to any present-day student, but in the early nineteenth century it was of major significance. The Romantic period was, as we all know, fascinated by the unique, creative individual, by the "genius." The art historian does not have to be told what Romanticism contributed to the psychology of the genius, and how it revolutionized the discovery of the individual artist's imagination and experience in his work. As opposed to the "religion of genius," to which we shall come back in the next chapter, the scholars of the "Wissenschaft der Mythologie" emphasized the beliefs of whole communities and cultures. In so doing they were, in fact, preparing a great deal of the modern approach to art and its symbols.

I. CREUZER

Friedrich Creuzer's *Symbolik und Mythologie der alten Völker, besonders der Griechen* (Symbolics and Mythology of the Ancient Nations, Particularly the Greeks) (Leipzig and Darmstadt, 1810–1812) was more than just another learned book; it was a historic event. In it, Georg Friedrich Creuzer (1771–1858), a professor of ancient literature at the University of Heidelberg and a friend of Hegel's, attempted to give a scientific basis to the Neoplatonic reading of Greek mythology. Though his great work (in four volumes) was soon dismissed by professional scholars, especially philologists, its impact was far-reaching and deeply felt, and it played an important part in the development of mythological studies. Enthusiastically greeted by Schelling, it stirred a controversy that affected several scholarly disciplines, and led to the rethinking of their foundations. The struggle over Creuzer's *Symoblik* was a *cause célèbre* that left its mark on the intellectual life of the nineteenth century.[9] The role of this work in the articulation of views concerning pictorial symbolism, though not sufficiently appreciated, is of significance.

The first "book" of the *Symbolik* is devoted to a discourse on the symbol in general. At the center of Creuzer's views on the symbol stands the image. By "image" he means what we perceive with our "inner eye," what we see in introspection, as well as the literary metaphor; but he also means real, material images of the gods, statues carved in stone or in wood. The visually perceived symbol is a focus of religious imagery. A carved image of the god was placed in almost every Greek temple. Reading the image, Creuzer believed, was among the oldest functions of the priests. The teachers of ancient times, the priests, had a kinship with the gods: they presented to the community, and interpreted, the sacred images received (miraculously? Creuzer does not say) from the gods themselves, or else they themselves shaped the images of the visible gods (I, pp. 15 ff.).[10]

The symbol image, Creuzer believes, dwells in the zone of ambiguity and conflict. This is so because the symbol is perceived by the soul, and the soul itself dwells in that zone. As the soul "hovers" between the world of ideas and the world of the senses, we read, so everything it desires or achieves must partake of that "double nature" (I, p. 67). Such hovering, the author stresses, is "the fate of the symbol."

The "incongruence between essence and form" is a characteristic of the symbol image. Now, that the symbol entails a tension, or even a conflict, between the visible shape and the invisible content, between the form that serves as a symbol and the idea that is symbolized by that form—this had frequently been said in earlier periods. Nothing new was added to that basic conception by Romantic thought. What is characteristic of Creuzer is his endowment of this abstract cognition with a live, immediate psychic urgency. The attentive reader of Creuzer's discourse on the symbol often wonders whether the author's subject is a philosophical notion or an alarming experience in front of an expressive, almost magical, work of art. To communicate this immediate experience of the symbol, Creuzer has recourse to a famous ancient treatise by Demetrios, known as *On Style*. Translating rather freely, Creuzer says that "anything that is only portended is more terrible than what, stripped of all veils, is presented to the eyes. Therefore mystery doctrines are set forth in symbols, as night and darkness" (I, pp. 68 ff.).[11]

"Darkness" cast a spell on Creuzer; he was enchanted with the mystery and images of the night. This also applied to the historical and cultural topics that, metaphorically, can be described as "dark." He had in mind particularly the mystery religions. In classical religion, he was fascinated with the trends known as Orphic, Bacchic, Dionysian, and, to a lesser degree, with some Oriental cults. What all these religious trends have in common, he believed, was the aspiration for the ineffable. The images they employed, therefore, show the intrinsic conflict of the symbol in general. The symbol "wants to measure the immeasurable, and to squeeze the divine into the narrow space of the human forms" (I, p. 73). In the final event, this is a tragic enterprise; our author knows that the attempt to utter the inexpressible is doomed to failure. The striving to adequately symbolize the divine will eventually lead to the destruction of the symbol itself. "Here," he writes, "the ineffable prevails that, seeking expression, will by the infinite power of its essence ultimately explode the terrestrial form that is too weak a vessel." Exploding the vessel is obviously the end of symbolizing. "Herewith the clarity of looking is itself destroyed, and only speechless wondering remains" (I, p. 73).

Symbols, nevertheless, exist. How are we to account for them? The symbol is there, it can be experienced—this is the essence of Creuzer's teaching—because we are able to perceive it intuitively, without first breaking it up into its individual components. It is an essential property of expression by means of images that it proceeds differently from analytical separation. It gives, he says, "a unique and undivided" whole. Whereas analytical reason dissects the object it wishes to present into its component parts, assembles the individual characteristics, and adduces them successively as a series of features, the intuitive mode presents all at once. "In a simple glance,"Creuzer writes, "in one stroke the intuition is completed" (I, p. 66).

The symbol, our author claims, is "the root of all expression by images" (I, p. 80). This he wishes to show by comparing the symbol, as he understands it, with the other major products, or forms, of "iconism."[12] He thus compares symbol with allegory. In what he calls "allegory," an essential distinction remains between the sensory form and the idea; in the "symbol," they are fused. In allegory, to use his

own wording, there is "a reference to a general notion, the symbol is the sense-perceived, embodied idea itself." So close are Creuzer's words to the time-hallowed terms employed in Christological doctrine that one feels certain our author was aware of the powerful historical and theological connotations he was evoking. In allegory, we read, there is "substitution" *(Stellvertretung)*, in the symbol the concept itself "descended into this world of bodies, and in the image *(Bild)* we see the notion itself and directly" (I, p. 83).

The problem of the symbol is not one of formal structure and shape; it is also, and perhaps primarily, that of reading. In other words, the symbol lives, and acts out its possibilities, in what it does to the audience and in how it affects the spectator. The difference between the two modes of symbolizing is also reflected in the ways people read the symbolic image. In reading allegory, Creuzer says, there is "more freedom," the impulse to play—that is, the urge to try out different possibilities of interpretation—"hovers around the idea," before we settle on a definite solution. Figuring out what an allegory means is the free act of the interpreting beholder. Something altogether different occurs when we look at what Creuzer calls the "symbol." In writing about how the symbol affects us, Creuzer abounds in metaphors of dominance and compulsion. His language shows how deeply he believed that man is at the mercy of the symbol. The play-drive has disappeared, and now we are under the symbol's spell. Our soul is deeply stirred by the symbolic image we are regarding. So profound is the impact of the symbol that, in Creuzer's words, "the necessity of nature [here] prevails upon us" (I, p. 64). We do not know precisely how the symbolic image dominates our soul and mind, but we deeply feel that it does. The image was not produced in order to dominate us, but the power of revelation contained in it makes it inexorable. "Just as nature in her unchanging laws silently reigns, so rules, silently and involuntarily, as it were, an eternal truth in that significant image." Creuzer calls this compelling power of the image "the natural language of the symbolic" (I, p. 85).

What were Creuzer's sources for his doctrine of the visual symbol? It has been claimed that he revived the Neoplatonic approach to ancient religion.[13] This seems to be particularly true for what he says about the

symbol that is intuitively perceived. He derived a great deal from the major text of ancient Neoplatonism, Plotinus's work. Already comparatively early in his life, in 1805, Creuzer had translated long passages from Plotinus.[14] He must have been particularly impressed by what Plotinus says about Egyptian hieroglyphs as images of thought. As we know, Plotinus explained the hieroglyphs as the images of ideas. They show, in his own words, "the absence of discursiveness in the Intellectual Realm. For each manifestation of knowledge and wisdom is a distinct image . . ." (V,8,6).[15] Creuzer felt the affinity of the hieroglyph to the visual arts. In the *Symbolik* (I, p. 321), he treats hieroglyphs, conceived as ideographic images, as part of sculpture.

The mythological tradition in Romantic scholarship, represented by Creuzer (and in which he played a significant part), placed art on a high metaphysical level. These students of ancient mythologies extolled the image far beyond the merely aesthetic object or the didactic device; they tried to understand and to reveal the magic powers with which the painting and the statue are endowed. In thus viewing the image, these scholars paved the way for what was to be called the "religion of art." The present-day historian wonders, however, how the secure metaphysical position of the image derives from Creuzer's doctrine. To use an old Platonic term, did he indeed "save" art?

In his doctrine of the symbol, Creuzer is a radical. He exposes the inherent conflicts and he pushes the clash between the contrasting tendencies to an extreme point. Yet we have also seen that he was aware of the danger for the image, and for the "clarity of vision," that the attempt "to measure the immeasurable" entails. When Creuzer comes to actual art, he looks for a "reconciliation," to use Hegel's term, between the ineffable and the form, he tries to find a way to bridge the total "incongruence" between spirit and matter.

In the final analysis, Creuzer seems to believe, the very condition necessary for the coming into being of an expressive, symbolizing work of art is the mitigation of the conflict between the visible and the invisible, between the two contrasting features of the symbol. For the radical philosopher of mythology there is no way to soften the clash. The student of art sees this differently. If the symbolic drive restricts itself and, as Creuzer says, "modestly keeps to a delicate middle line

between spirit and nature," it will be able to make the divine visible "to a certain degree" *(gewissermassen)* (I, p. 74). The symbolic image— obviously he has the image of the divine in mind—draws, "with irresistible force," the spectator to itself, ineluctably it "touches our soul," as does the World Spirit itself. In rather poetic language more suitable to a mystic visionary than a sober professor, he says that what causes that image to act is "the exuberance of upwelling ideas." But here, in the image, the "essence" does not strive at "boundless super- abundance"; rather, it yields to form, it permeates and animates it. This yielding, a solving of the conflict between the infinite and the finite, Creuzer conceives as a purification. "From the purification of the image-realm *(Bildliches),* on the one hand, and from the voluntary re- nunciation of the boundless, on the other, there blossoms forth the most beautiful fruit of all symbolism, the symbol of the god. That symbol of the god marvellously combines the beauty of form with the highest abundance of essence. Since it occurred in most perfect form in Greek sculpture, it may be called the *plastic* symbol" (I, pp. 74 f.).

We shall not here attempt to assess in detail whether or not the "reconciliation" Creuzer suggests is a valid solution. The philosopher may have his doubts as to whether the Romantic "mythologist," as Friedrich Creuzer called himself, actually showed how the incongruence inherent in the symbol can be overcome. But whatever the philosophical weaknesses, the mythological school, and quite particularly Creuzer, became a significant factor in shaping ideas on the image. Though his name is not known to many artists and critics, the ideas he introduced into modern thought on the visual arts have enjoyed a long and powerful life.

2. BACHOFEN

Bachofen's *An Essay on Ancient Mortuary Symbolism (Versuch über die Gräber- symbolik der Alten)* appeared in 1859, almost fifty years after the first volume of Creuzer's *Symbolik.* This half-century was a productive time for mythological research, but the direction it took led away from Creuzer's mystical Neoplatonism. The study of the Greek gods became the concern of academic institutions. There is no denying that, under

the new tutelage, the scholarship improved, the evidence was more carefully and cautiously weighed, and the conclusions reached brought scholarship closer to "truth." Yet it is also true that, as the flights of fancy sometimes characteristic of Creuzer and his predecessors were restrained by responsible scholarship, the Greek gods became less fascinating to artists. Mythological symbolism was slowly losing its hold on the formation of art theoretical concepts.

Besides the main trend of mythological scholarship, however, another tradition of reading mythical symbols was alive throughout the nineteenth century. As far as strict scholarly consistency is concerned, that other tradition may have been less responsible than the learning of the professors, and the conclusions it drew from the evidence could not always be fully supported. But it was charged with imagination and retained something of the vivid belief that hidden mysteries were revealed, or in some ways at least indicated, in the appearances of the ancient gods and in the classical monuments portraying them. That was a modern mythography, breathing something of the late antique and sixteenth-century spirit. This slightly esoteric mythography of the nineteenth century is not only an important testimony to the culture of that time; it has much to say about what was thought and believed about the art and the image. Bachofen well represents this kind of mythological scholarship in the modern world.

Johann Jakob Bachofen (1815–1887), the son of an old Basle family of wealthy manufacturers, was a colorful figure. His life, and particularly his "afterlife," were eventful. A jurist and professor of Roman law as a young man, he left the university early to devote himself to studies, and other activities, that are not easily placed in a specific academic pigeonhole. Bachofen had the rare luck of being discovered twice. Both "revivals," if this is the right word, were focused on his famous work *Mother Right* (1861). Friedrich Engels drew important conclusions from Bachofen's picture of primitive society for his own view of the historical process as spelled out in *The Origin of the Family* (1884). Later, in the 1920s and 1930s, German right-wing thought tried to appropriate Bachofen unto itself.[16] But his rediscovery in the twentieth century was the act of a group of creative artists and literary men. That it was precisely artists and writers who rediscovered him was, one feels, not a matter of

chance. Bachofen, to quote Joseph Campbell, "has a great deal to say to artists, writers, searchers of the psyche, and, in fact, anyone aware of the enigmatic influence of symbols in the structuring and moving of lives."[17] If Bachofen is mentioned today, it is because his name is attached to a theory of social development that claims that the first period in human history was matriarchal. In the present context, I shall completely disregard this theory to considering Bachofen only as a particularly significant witness to the esoteric mythological tradition; we shall try to see what it was in that tradition that so powerfully appealed to artists and art critics. I shall therefore comment only on his *Essay on Ancient Mortuary Symbolism.*

Bachofen was a prophet of the creative imagination. He read mythology as a residue of that imagination. In 1854, he wrote an autobiographic sketch for his teacher, the great jurist and historian of law Friedrich Karl von Savigny, and in it he explained what fascinated him in the tombs. One passage, at least, is worth full quotation.

> Ought I, by way of explaining my interest in the ancient tombs, to speak of epigraphy and epigrammatics and many other related fields? I prefer to think of the enjoyment I have derived from my visits to tombs. There are two roads to knowledge—the longer, slower, more arduous road of rational combination and the shorter path of the imagination, traversed with the force and swiftness of electricity. Aroused by direct contact with the ancient remains, the imagination grasps the truth at one stroke, without intermediary links. The knowledge acquired in this second way is infinitely more living and colorful than the products of the understanding *(Verstand).*[18]

In this brief passage we still clearly perceive the echo of Creuzer's voice, but we also see that the intervening decades had brought about a change in emphasis that amounts to a significant shift in outlook. Bachofen juxtaposes learning (epigraphy, epigrammatics) to the direct experience, and he clearly rejects the former in favor of the latter. Creuzer did not yet envisage a clash between erudite scholarship and immediate experience, though the conflict was adumbrated in his thought. Moreover, by explicitly making "enjoyment" the major justification for looking at the tombs Bachofen betrays an aesthetic attitude that was not yet within Creuzer's intellectual grasp. But what does Bachofen look for in these tombs? What does he hope to find in their murals?

The walls of the columbarium of the Villa Pamphili, he believed, presented to the inquirer the record of an ancient nature religion. That record was written in symbols, and the symbolism has not yet been deciphered. But to find the key to these secrets, one has to take the images seriously. Bachofen was impatient with the claim—so frequently made by twentieth-century spectators—that forms and motifs we do not understand and that strike us as strange derive from the sheer will to ornament. "Where we [nowadays] are accustomed to see artistic caprice, at most an intention to decorate, the earliest human beings required a thought expressed in symbols. . . . We are not yet advanced far enough to read directly from the page, the symbolic language of the ancients like a script with present-day characters." [19]

Now, are Bachofen's studies in Greek and Roman sepulchral symbolism regular iconographic essays? In other words, does he propose to find out what people at a given time and in a given culture expressed by certain symbols? No doubt he was affected by the great iconographic tradition, but he aimed at something else. The symbols he was trying to decipher were not just another cultural product, just as important and just as limited as so many other products of cultures. Bachofen held that the columbarium murals contained the records of a primary and universal language of symbols. In decoding the meanings of the murals, he writes, "I attempt to disclose a meaning far beyond the sphere of art and archaeology." The symbolism of these tombs, he continues,

> rooted in the oldest intuitions of our race, passed unchanged, though ultimately no longer understood, into the era of waning paganism, and even the new era opened by the Incarnation of Christ. . . . The symbol of the egg provides a remarkable example of the transcending of time, while the motif of Ocnus the rope plaiter passes beyond national barriers and is encountered in Egypt, Asia, Greece, and Italy. [20]

And as if this were not already sufficiently clear, he adds: "It is this character of permanence that makes the ancient tombs so very meaningful." Painted images as the universal and eternal records of the human soul—one can understand why the historians shuddered, and why the artists rejoiced.

To understand how Bachofen looked at ancient images, it is perhaps

best to have a look at his reading of one scene, Ocnus the rope plaiter. We know of Ocnus from several ancient sources belonging mainly to late Antiquity, the period that looked for hidden meanings in objects as well as in stories. Ocnus repents in Hades, punished by having to twist a rope of straw that is continually consumed by an ass. It is this subject that is represented on one of the murals in the tomb structure of the Villa Pamphili.

Bachofen starts with the image. The picture, he says, is "hiero-glyph."[21] This probably means that it expresses an idea in a form that is both esoteric and concise. Myth, that is, the story told, is the explanation—the "exegesis," as he says—of the visual symbol. The image, it follows, comes before the story; it represents a more primor-dial layer than either the myth or the text. Trying to record and explain what we see, we have to stick to the visible. Therefore, "the meaning can only be physical." It is in this line of thought that Bachofen declares "Ocnus the rope plaiter is a nature symbol." His support of this claim is characteristic.

The meaning of rope plaiting, he is sure, cannot be doubted for one moment. "Rope plaiting is frequently a symbolic action, based on the same conceptions as the spinning and weaving of the great mothers. The symbol of spinning and weaving represents the creative, formative power of nature." Though he naturally does not find in ancient litera-ture an explicit definition of plaiting as the symbol of the creative power, his wide and profound erudition allows him to adduce many examples from Greek mythology in which plaiting can be understood as the process of shaping, of casting the amorphic into articulate form.

The destructive power of nature is represented by an animal, the donkey that eats Ocnus's rope. That this beast is specifically a donkey strikes our author as particularly meaningful. In Antiquity, as Bachofen's wide learning tells him once again, the ass is the "phallic" beast, the typical representative of primary natural urges. Basing himself on Plu-tarch as well as on several mythological stories, he also describes the ass as the beast of the swamp. Moreover, the howling and fury so typical of it "confirm the demonic destructive nature of the ass."[22]

The conclusion Bachofen derives from what he sees in the sepulchral mural is that in nature "Two forces are locked in eternal battle." The

meaning of the two poles, to put it briefly, is that "Creation is an art; destruction is the work of brute force. Creation rests in the human hand; destruction is attributed to the demonic animal nature." [23]

We shall not here follow the author's enthralling explorations of the Ocnus story in ancient religions. Nor can we trace his impact on some modern psychological theories. (Jung's notion of "archetypes" has many affinities with Bachofen's doctrine of the symbol.) In the present context we should like only to analyze briefly how Bachofen looks at the ancient pictures, and on what he focuses his attention. In the following comments we are not studying Bachofen's scholarly "method"; rather we are concerned with what his procedures may disclose about the theory of art implied in the nineteenth-century tradition of esoteric mythology-research and interpretation. I shall briefly summarize four issues in Bachofen's study of ancient art that seem to me important for understanding the theory of art that underlies his studies.

(1) "Nature symbol" *(Natursymbol)* is one of Bachofen's expressions. It is a notion that does not seem to occur, as a conventional term, in earlier mythological literature; it is also not meant as a symbol for "nature." It refers, as has been suggested,[24] to the motif or to the painting as a whole. To stick to our example, the juxtaposition of Ocnus plaiting the rope and the ass eating it up together form a "nature symbol." This, we are to understand (though Bachofen nowhere explicitly says so), is not a conventional sign or attribute. If we are not mistaken, the notion of symbol is here used in a very free and vague way. It does not exclude the spontaneous creation of images and the forming of new relationships between the features and motifs of an image. "Nature symbol" is a notion that has been further developed, though under different names, in twentieth-century thought.

(2) Of particular interest is Bachofen's idea of personification. The forces of nature, recognized as such, are not represented in abstract forms but become personifications. In this intellectual world, personification has two aspects. On the one hand, the term indicates that Bachofen himself is not concerned with the individual, that he is not interested in portraiture. Rather he looks for the typical. Already in 1851, speaking of his trip to Greece, he said that what he wishes to study are "species" *(Arten)* rather than individual figures or single works

of art. He also invented, though he rarely used, a notion he called "Elementarismus" to indicate concentration on the type. Personification is a way of presenting the generic to the eye. On the other hand, personification assures that the generic will not stay abstract, that it will be real in the sense that it is available to the spectator's direct experience. The reality of personification is of a particular kind: it is a creation of the mind that assumes sensory qualities. Ocnus as the personification of art and the ass as an embodiment of the beastly in nature are cases in point.

(3) Unusual in mythological as well as in archaeological literature is Bachofen's emphasis on the psychological expression of the figures portrayed in the ancient murals, and of the moods these paintings convey. What we have in mind is expression in the modern sense of the term, that is, a mood or an emotional state that is manifested, not by employing conventional attributes but by an overall quality that is hard to pin down to this or that detail. This is how Bachofen opens his discussion of the mural in the Villa Pamphili sepulcher:

A bearded man is shown sitting in the open country. . . . His attitude suggests repose after the day's work, and a profound earnestness. . . . The whole scene, the old man, the animal, the farm, is bathed in the tranquillity of evening. Deep stillness prevails. The silence of the tomb seems infused into the picture.[25]

Traditional studies of mythology made extensive use of ancient monuments, but they had little use for the moods conveyed by these paintings. Whatever art historical writings existed at his time also paid more limited attention to the overall expression. Such consideration of the expressive quality as we find in Bachofen's work may be considered an element of a theory of art.

(4) What is the mythological symbol meant to show, one finally asks. The aim is to understand the ideas of Antiquity as a whole, and to grasp them intuitively. Quoting Plutarch once again, Bachofen claims that in mythological images the initiate sees, "as in a mirror, the more sublime truths of the mysteries." These truths are expressed in the sepulchral murals, they are conveyed, as he says, in "the language of the tombs." Here Bachofen once again extols the power of the image, a power that

remains unmatched by any other medium. Equating "symbol" and "image," he claims that

Human language is too feeble to convey all the thoughts aroused by the alternation of life and death and the sublime hopes of the initiate. Only the [static] symbol and the related myth can meet this higher need. The symbol awakens intimations; speech can only explain. The symbol plucks all the strings of the human spirit at once; speech is compelled to take up a single thought at a time. The symbol strikes its roots in the most secret depths of the soul; language skims over the surface of the understanding like a soft breeze. The symbol aims inward; language outward.[26]

The study of mythology eventually flows into a psychological theory of ancient painting.

III. THE SYMBOLIC LANDSCAPE

1. ROMANTIC CONCERN WITH LANDSCAPE

In the preceding pages we have been following, if only in outline, a historical process that in the century between Winckelmann and Bachofen transformed thought on painting and sculpture. This process, or at least some of its major aspects, can be described as a secularization of sorts: conventional symbolism, deriving from firmly established, time-honored signs and attributes, was being gradually replaced by the expression of moods and emotions that could be grasped directly by the spectator. The belief that some symbols can be understood without relying on an acquaintance with cultural codes permeated the depiction and reading of mythological figures and themes. Naturally it also affected other fields of study and creation. It goes without saying that these new views of the reading of symbolic shapes involved, or were determined by, significant changes in subject matter. As far as actual painting is concerned, it is well known that emphasis was placed on new themes. This is also true for theoretical reflection. Landscape painting was among the new themes of art theory, together with the possibilities of intuitive symbolism that it offered. Reading early nineteenth-century theory of landscape painting, one senses the writers'

fascination with this newly discovered country, its unknown vistas and horizons; one also watches, as in a sharply focused mirror, the unfolding of the major problems of Romantic thought.

Concern with landscape painting, it is well known, did not begin with Romantic art theory. In the first volume of this book, I have commented briefly on the conceptual categories of landscape painting as they emerged between the Renaissance and classicist academism.[27] Here I can therefore concentrate on the period that begins with the late eighteenth century.

Around the turn of the century, landscape fascinated the minds of artists, philosophers, and students of literature. While to some extent this was also true of natural vistas (seas, mountains), interest was mainly concentrated on pictorial renderings. I shall select a few examples of this concern with landscape painting, discussing aspects that throw some light on the emergence of a new symbolism. I shall start with what literary men and philosophers had to say and will then come to the painters.

In the traditional hierarchy of pictorial genres, landscape painting occupied a low rung of the ladder. In eighteenth-century workshops, the status of landscape painting was that inherited from earlier generations, as we have seen in Gerard de Lairesse's treatise on painting (see above, pp. 67 ff.). Writing at the end of the century, Lessing does not seem to have doubted the validity of this schema. The representation of nature is not valuable in itself. Only if it passes through the filter of poetic imitation does it acquire value. In landscape, Lessing notes, there is no ideal beauty.[28]

At the beginning of the nineteenth century, from 1802 to 1804, Friedrich Schlegel composed his *Description of Paintings in Paris and the Netherlands,* also commenting on the general nature of landscape painting. Landscape, he remarks, was known first as the background of symbolic paintings (he is obviously referring to religious art), but it "is in its proper sphere and endowed with its full force of expression when thus introduced alone." Without symbolism, usually provided by some figures recalling sacred events, "landscape and still-life painting becomes a mere exercise of mechanical facility in surmounting difficulties, or even declines into a discordant and worthless medium for the bare copying

of visible and sensible charms."[29] In Schlegel's comments one clearly observes the ambivalence characteristic of the Romantic position. On the one hand, he clings to the dogma according to which landscape as such is without inherent value; on the other, he senses that it can carry powerful expression. If landscape painting is to be a branch of painting in its own right, Schlegel prefers "a simple confined style," like that of the Dutch landscape painter Ruysdael.

At the same time the *Description* was composed, the young philosopher F. W. J. Schelling was delivering his lectures on the philosophy of art *(Philosophie der Kunst)* in Jena (1802–03), and repeated them shortly afterwards (1804–05) in Würzburg. In the course of these lectures, he too made some comments on landscape painting. Schelling does not rate landscape painting any higher than does the traditional hierarchy of pictorial genres. However, he interprets it in a new way and stresses aspects that anticipate future developments in art theory. Among the philosophers it was Schelling who stressed that landscape painting is a "subjective" art form. In the landscape, he says, "only subjective representation is possible, because the landscape has reality only in the spectator's eye."[30] Gone, then, is the traditional idea of correctness, and of measuring nature. Landscape painting, it turns out, is elevated above nature, and thus, perhaps paradoxically, becomes a specifically human type of painting. It necessarily focuses on empirical reality, as Schelling admits. But the mountains and valleys, the rivers and forests and skies that compose it are only a "cover" *(Hülle)*. In a landscape painting that is a great work of art the inner core is able to shine through. "The true object, the idea, remains without shape," he says. How, then, can a painting convey that idea? In a great landscape painting, the spectator becomes an active partner in bringing about the effect achieved by the work of art. "It depends on the beholder," our philosopher asserts, "to pick it [the idea] out from the misty and shapeless" reality, which is what the landscape painting directly shows.

Among artists and art critics, new interest in the landscape picture stirred even earlier. Following the process of painters' changing attitudes to landscape, one witnesses the gradual crystallization of a modern view of art. The Swiss painter, poet, and critic Salomon Gessner (1730– 1788), who published his *Brief über die Landschaftsmalerey an Herrn Fusslin*

(Letter on Landscape Painting to Mr. Fuseli) in 1770, still belonged to the period of classicism. Classicism, as we know, did not give pride of place to landscape painting, and this is still Gessner's explicit opinion. His practical attitude is shaped by the modes of thought prevailing in the workshops. He looks to other artists, particularly great artists of the past, for "models." Thus, he tells his reader, he had copied, and learned from, Claude Lorrain's dusky distances, from Philips Wouwerman's soft, flowing hills, and from Claesz Berchem's rocky grounds (note the ecclectic combination of painters belonging to different schools and traditions). His attention to details and isolated motifs that can provide models for imitation also extends to nature, such as the trunk of a tree, or even only a part of it. Salomon Gessner is probably the last painter to repeat Cennino Cennini's advice to carefully portray a piece of stone "when you wish to paint a mountain." [31]

For our present discussion it is more important to note that, in spite of Gessner's traditional outlook, some types of landscapes, particularly what he calls "ideal" landscapes, acquire a utopian quality in his mind. Nature as the blissful environment of innocent man: this is the message at least one type of landscape painting conveys. It was this view that in the early nineteenth century provoked sharp criticism. "Where are there shepherds like these?" sarcastically asked the poet and painter Friedrich Müller.[32] Salomon Gessner, it has occasionally been noted, did not excel by his analytical mind, but his influence on painters and writers on art theory was wide and stimulating.

The Swiss aesthetician J. G. Sulzer (1720–1779) belonged entirely to the world of classicism (he was only two years younger than Winckelmann). It is not surprising that he considered landscape a rather primitive kind of painting. Very attentive observation of lifeless nature, he thought, is the "first step man takes to reach understanding and a proper disposition of mind." In his article entitled "Landscape," [33] he not only collected a considerable amount of information about landscape painting in modern times (adducing the names of the artists who excelled in this field), but he also stressed the close connection between nature and the character *(Gemüt)* of man. Even in nature itself, when not represented in pictures, landscapes are able to evoke aesthetic experiences in the spectator. Noble feelings stir our souls when we look

at certain vistas, while other views of nature fill us with fear and trembling. Painting therefore, he concludes, finds in natural landscape the materials, as it were, "to affect the dispositions of men." Landscape painting thus becomes the art of producing moods. In Sulzer's article this notion is only intimated, but the line of thought cannot be mistaken. A series of landscape paintings, in which appropriate figures of men and beasts are seen, "would be a true *orbis pictus* that would provide to youth and to more mature age all the useful basic notions *(Grundbegriffe),* and would tune each string of the mind *(Gemüt)* to its proper tone."

A climax in the discussion of the nature and position of landscape painting is reached in an article, "Über die Landschaftsmalerei" (On Landscape Painting), published in 1803. The author, Karl Ludwig Fernow, was not himself a painter, but what he said can be considered a true reflection of the artistic thought of his time. A friend and biographer of Asmus Jacob Carstens, Fernow also attentively listened to what other artists had to say. The article on landscape painting is dedicated to another painter, Johann Christian Reinhart, who was also a friend of the author. Addressing Reinhart, Fernow writes that the article is "the fruit of many instructive hours I spent, in contemplation and in conversation, in your workshop, among your works, studies, and sketches." [34]

Fernow distinguishes between two types of landscape painting: "prospect painting," and the "representation of ideal nature scenes." Only the latter can be considered art. But Fernow is too much rooted in neoclassical thought to approach landscape painting with an altogether open mind. Reading his article, one still clearly senses the tyranny of the belief that the human figure is the only truly appropriate subject of painting. The "landscape in itself," says Fernow, "is to be considered as an empty scene." The more important the figures populating the scene, and the more poetically they are treated by the painter, "the greater [also] the interest in the landscape." [35] He tries to introduce a hierarchy of types within landscape painting itself. The lowest type is found in Dutch painting. Here, he believes, the natural view represented is never treated in a "poetic" spirit. The next type is represented by Swiss and Scottish landscapes. In the former, nature is grandiose (this is particularly true for mountain pieces); the latter are

populated, and enlivened, by Ossianic myths. In Fernow's views of both Swiss and Scottish landscapes, one perceives, as has been observed, the impact of the *Sturm und Drang* movement and of the late eighteenth-century fascination with the Sublime.[36] The third and highest type of landscape is provided by the South, mainly Italy. Here we not only see nature in its full amplitude, in harmoniously soft color, but ennobled by the ruins of classical temples, aqueducts, and tombs.

While Fernow's hierarchy of landscape types is essentially informed by neoclassical thought, another aspect of his attitude to landscape indicates a possible clash between that thought and fascination with the Sublime. Fernow distinguishes between what he terms two "styles" of landscape painting, the "beautiful" and the "great." In the beautiful style, the shapes and colors are always endowed with "grace and charm." In the great style, nature appears as a "great, active power either in the menacing seriousness of an approaching storm . . . or in the traces of the destructive effects it leaves behind."

The expressive qualities of landscape are not explicitly treated by Fernow, but they underlie most of his discussion of this art form. How does landscape produce a mood? This is the question that occupies his mind. Sometimes he tries to apply to the analysis of landscape painting categories developed for the discussion of figural art. Thus, to produce an aesthetic mood, he believes, a landscape must have "character." By this he means the configuration of permanent features (the structure of the ground, vegetation, buildings), these features being seen under changing conditions (light, seasons). With regard to character, one understands, landscape painting is not different from figure painting. In figure painting, too, beauty depends on the figure's character.[37]

In the present context, however, the means by which the painter of landscapes evokes certain moods are not as important as the very fact that landscape painting is a mood-creating art form. Fernow is over-come by emotion when he sees remarkable sights in nature as well.[38] He understands landscape painting as an art form that aims, though maybe only implicitly, at shaping moods. It is precisely in this respect that he compares landscape painting with that most abstract of arts, music. "One is in the habit of comparing landscape painting to music," he writes in the introduction to his *Römische Studien*. He goes on to stress

the difference between the two. What he accepts is only the similarity of effect they have on the spectator. "This comparison," we read further in the introduction, is based on "the similarity of the effects that colors and tones produce, both individually on the sensations *(Empfindungen)* and, in harmonic association, on the feelings *(Gefühl)*." A landscape painting, like a piece of music, sets our mood, and it does so even before our reason is able to grasp what is represented or how the effect is achieved.

In seeing landscape painting as an almost abstract mood-producing art form, and in comparing it with music, a great deal of nineteenth- and even twentieth-century thought on art is anticipated.

The first decade or so of the nineteenth century saw a further deepening of artists' concern with landscape painting, and, particularly, further explorations of the power to produce moods that seemed inherent in this art form. The spectator's expectations and attitudes were also considered. Much depends on the "disposition of mind" *(Gemütsbeschaffenheit)* with which the spectator approaches a landscape painting, said the painter Philipp Hackert (1737–1807), whose fragmentary observations on this subject were edited and published by none other than Goethe.[39] Hackert admits that he was moved to write down his "theoretical-practical" observations by reading Sulzer's article on the subject.

Landscape painting, Hackert boldly declares, has the same value as all other fields of painting. He may well have been the first artist to explicitly make this claim. Landscape portrayal, he seems to have believed, requires scientific preparation and painterly skill. He himself was trained in optics, perspective, and even geology. Yet he was aware that it is not scientific correctness that endows a landscape painting with its particular value. In opposition to Lessing, he claims that there *is* ideal beauty in nature. The landscape painter makes this beauty visible.

"It is hardly open to doubt," wrote another painter, Carl Grass, in 1809, "that the notions concerning this branch of art [landscape painting], which has been so popular particularly in modern times, were, and are, vaguer than those concerning any other field of painting."[40] Here, then, we learn both of the popularity of landscape painting and of the

feeling that its "notions" are not well enough defined. A few years later, Carl Grass published a great book, *Sizilische Reise oder Auszüge aus dem Tagebuch eines Landschaftsmalers* (Sicilian Journey or Excerpts from the Diary of a Landscape Painter) (Stuttgart and Tübingen, 1815), which tries to come a step closer to the old ideal of an *orbis pictus.*

Landscape painting, says Carl Grass in the earlier article, has a wide range; it offers the spectator a ladder that leads from the simplest imitation of the insignificant object (of "the true"), "through the pleasant and charming, to the highest poetry of the Romantic and the sublime." But Carl Grass, more than any other artist or writer before him, makes landscape painting into a mirror image of the artist's mind. A work of art will move the beholder, he says, only if it shows "traces of independent life," only if it emerges from the amplitude of the artist's disposition *(Gemüt).* This quality, our painter-writer thinks, becomes more pointed in landscape painting. He asks: Is not landscape painting the art "in which infinitely much still remains to be done, and in which the genius can still, if not break new ground, at least pave new paths of his own?"

2. CARUS

It is at this stage that the most important of treatises on landscape painting was written, Carus's *Letters on Landscape Painting.*

Carl Gustav Carus (1789–1869) was such a many-sided personality that it is difficult to fit him into any regular category. Professor of obstetrics in Dresden, personal physician to the king of Saxony, author of a popular textbook on zootonomy (the anatomy and dissection of animals), he was a prolific writer on a variety of subjects; his book on the symbolism of the human figure (1853) is perhaps the last representative of a hermetic, Neoplatonic approach to the physical structure of man. In addition to all this, he was also a painter. His philosophy, as stated in his memoirs (in itself an interesting document of mid-nineteenth-century intellectual life), was informed by one idea: it is "the thought, already surmised by many philosophers of Antiquity, concerning the inner, necessary, and unconditional compounding of the world-

structure into a unique, infinite, organic whole, in one word: the idea of the world-soul, which then was again introduced into science by Schelling's great and luminous mind."[41] He turned to painting, as he said, to set himself free from the "turbid conditions of the soul." In his *Lebenserinnerungen und Denkwürdigkeiten* (Memoirs) (I, pp. 169 ff.), he argues that "the more heavily trouble of the soul or lonely, deep pain are manifested in some ingenious, dark painting, and appear there as a kind of secret reflection, the sooner peace of mind returns."

In 1831, Carus published his *Briefe über Landschaftsmalerei* (Letters on Landscape Painting), and a second edition appeared only four years later. The book was written much earlier, however, the major part of it in 1815. That Carus should have composed his theory of landscape painting in Dresden at that time seems, in retrospect, not a matter of chance. The collection of paintings in Dresden contained representative works of the acknowledged masters of that art; here Carus could have seen important paintings by Ruysdael, Poussin, and Claude Lorrain. Just as two generations earlier this collection had stimulated the young Winckelmann to write his *Thoughts on the Imitation of Greek Works of Art,* it may now have influenced Carus to compose his treatise on landscape painting. Moreover, precisely in 1800, the Academy of Art in Dresden —the first real academy of art in Germany, as Nicolas Pevsner puts it[42]—appointed Johann Christian Klengel professor of landscape painting, probably one of the very first appointments of its kind. In 1801, Caspar David Friedrich exhibited in Dresden his first landscape painting. Later, Carus was closely connected with Friedrich, and wrote particularly about his landscapes. The *Briefe über Landschaftsmalerei* were obviously written out of the concern with landscape painting that occupied an important place in the reflections of artists and critics in his city and his time.

The *Briefe* are written in an easy, personal style. The careful reader, however, is not misled by the conversational tone; behind the colloquial presentation there lies a system of analytical distinctions. To be sure, these distinctions are not always carried out consistently; sometimes notions overlap, sometimes they appear rather surprisingly, without being sufficiently prepared for in the previous stages of the discussion.

The main line of Carus's thought, however, is clear. In the following observations, I shall discuss those of his views that are related to the major theme of this chapter, the transformation of the symbol in art.

In landscape painting, Carus believes, we must distinguish between three major components; he calls them Truth, Meaning, and Object.[43] "Truth" provides the "body of the work of art," it conjures up the portion of nature represented; in more scholastic terms, it is also called "the correspondence of art and nature." A landscape painting, however, is not just the reflection of a piece of nature in a picture. In the landscape picture, we feel the impact of a creative mind. It is the mind that selects a given piece of visible nature and transforms it into an organic whole. By so doing the mind endows the landscape with "Meaning." Landscape, it appears, expresses a psychological state or condition. To express a given condition of mind, you have to select the appropriate objects. Not every object is able to express all mental conditions. Here, then, we see the role of the "Object."

On the basis of these distinctions, Carus describes, in the third letter, the aim of landscape painting. It is the "representation of a certain mood of the soul (meaning) by the imitation of a corresponding mood of nature (truth)" (p. 41). What he terms "the mood of nature" is a new notion, not previously discussed; influenced by a great tradition of natural philosophy, it will occupy us later on.

The very feasibility of landscape painting, Carus says, depends on our understanding—possibly even solving—three problems. These problems are related to, but not identical with, the three distinctions I have just mentioned. I shall put these problems, the core of Carus's philosophy of landscape painting, in question form. They are then: (1) How do the stirrings *(Regungen)* of the mind (or soul) correspond to the states of nature? (2) What effects do the individual objects represented in the landscape have? (3) In what way is the idea of beauty achieved in the representation of the life of nature? Let us briefly discuss the answers Carus offers to each of these questions.

Without going into the broader philosophical context and foundation of these problems, let us first remember that whenever Carus speaks about what we see in the open landscape or what we observe on the painted canvas, he always means what resides in our minds and souls.

Whatever else the objects and notions discussed may represent, they are always "mental images" *(Vorstellung)*, and they are always planted in the context of our consciousness (p. 44). It is only after having stressed this point that we can ask how the correspondence between moods and natural states becomes feasible.

Both man and nature, the Romantic philosopher believes, are ruled by the same vital rhythm; their life cycles show the same stages of unfolding or becoming and the same essential states of being. In the organic life cycle, no matter in what particular domain it may be found, Carus distinguishes four basic states. He calls them: (1) development; (2) consummate representation (maturity); (3) wilting; and (4) complete destruction. In nature, we encounter this rhythm everywhere, in the seasons of the year, in the times of the day, and so forth. Does something in man's mind and heart correspond to these states and their sequence? Carus, it seems, constructs a psychological counterpart. In our emotional life, he distinguishes four major groups of moods and states of mind. There is, first, the feeling of soaring; then, the feeling of inner clearness and tranquillity; third, the feeling of wilting and depression; and, finally, lethargy and apathy. There is, then, a correspondence between the states of nature and the states of the mind (pp. 45 ff.).

The idea of the life cycle, a particular version of the philosophy of organic life, dominated Romantic thought. It is not for me here to survey the significance of what might be called the "organic model" in Romanticism. It is a well-known subject, and, in literary aesthetics, it has been frequently studied and assessed.[44] I should like only to stress that Carus's thought, in all the fields of his inquiry and reflection, clearly shows the influence of that model. The cycle of organic life appears to him the image of an all-encompassing ideal. He frequently uses such expressions as "life-form," or even "the forming, unconscious life," where the Platonic tradition, from which he drew, asked for "Idea." The development of the individual from embryo to old age appeared to him as a mirror image of the life and unfolding of the Idea.[45]

Coming back to our specific subject, the correspondence between states of nature and states of mind, we may ask, what artists or critics were likely to have learned from Carus's treatment of the congruence

of nature and the human soul. One conclusion would have imposed itself upon any reader who took the *Briefe über Landschaftsmalerei* seriously: emotions, or moods, are the characteristics of states in nature and man; they are also the criteria of the congruence of the two domains.

The general parallelism between states of nature and states of mind possibly remains an abstract reflection, removed from the artist's practical concerns. Carus's discussion of the second problem, however, is of direct, immediate significance for the painter. Here, we remember, the question is, what are the effects of individual landscape features ("objects") on our mind. The principle of these "effects" is again the belief in a correspondence between the character of a given natural state and the mood it evokes in the person who experiences this state. Speaking in very general terms, the unorganized has a chilling effect upon us; objects that are in the state of self-formation (or of being formed) are stimulating; and, finally, the accomplished has a calming effect (p. 50). Carus does not tell us what makes him think that the states of nature he mentions do indeed induce in the beholder the particular moods described. In the present context, we cannot attempt to guess, or infer, what his reasons were for these assertions that he enunciates so firmly, nor can we investigate whether or not his theses are correct. For the student of art theory, these broad ideas are less fruitful than what Carus has to say about individual characteristics of the landscape.

In his discussion of specific features, Carus covers the major themes of landscape painting, as he knew it, including the Dutch, Italian, and German traditions. Looking at a bare rock, which does not provide food or protection to organic life, we feel "strangely withdrawn and hardened." But if the rock is weathered down, begins to crumble, and shows the first traces of vegetation, our feelings become milder and warmer. The clear sky—the essence of air and light—is the proper image of infinity. Being the dome of landscape as a whole, it "attracts us deeply and powerfully." Clouds, or even other objects towering up on top of each other, restrict our gaze at infinity, or obstruct it completely. The spectator whose view is thus blocked is overcome by oppressive moods. Water, insofar as it is the source of life and the reflection of the heavens on earth, is ambivalent in its effects; it evokes both serene and dark longings. The world of vegetation—located

between heaven, water, and earth—is particularly diversified in the moods it induces. The lush plant life of the valley elicits feelings of abundant life; the tree whose foliage has turned yellow, or the dead tree, produce a mood of melancholy and gloom (pp. 50–53).

Reading Carus's observations on the moods induced by the individual features of landscape, one wonders what his ultimate intentions were. His procedures remind us of the symbolic tradition that for centuries informed both artists and critics, the production and the reading of works of art. The very foundation of the symbolic tradition was the existence of a store-house of motifs that carried articulate meanings. From Cesare Ripa's *Iconologia* to Winckelmann's *Versuch einer Allegorie,* writers repeated that a given figure, or motif, has a specific meaning.[46] Carus, in his theory of landscape painting, differs from the symbolic tradition in claiming that a certain motif "induces a mood," rather than saying that it "has a meaning." This difference, however, is not profound. That a motif, or a work of art, "has" a meaning was often understood as the spectator's undergoing a certain experience. Carus's affinity to the symbolic tradition, then, is rather obvious.

Carus departs from the mythographic tradition not so much in his procedures and modes of thought as in the material to which he applies himself. The concern of humanistic mythographers was concentrated almost exclusively on the human figure and its attributes. Carus himself, in his late work on the symbolism of the human figure, represents perhaps the last stage of this tradition.[47] In his *Briefe über Landschaftsmalerei,* however, he extends this mode of thought to nature. Landscape is thereby endowed with the dignity hitherto reserved for the human figure, and it is conceived as an equal to man in richness of hidden dimensions and meanings. Carus's symbolic approach to nature also derives, though indirectly, from the age-old belief that natural objects have hidden meanings, and can be read. The metaphor of the Book of Nature, as we have learned from important recent studies, has a long and very rich history.[48] But so far as we know, these beliefs had never been systematically applied to landscape painting as an art form. This was what Carus did.

The third question—how is the idea of beauty represented in natural landscape?—is not as directly pertinent to the painter's job as

is the second one, but it sheds light on the aims of landscape painting. Generations have asked what beauty is, and their answers and the definitions they have proposed have only obscured the problem. Carus accepts the irrational as an irreducible quality of reality. Beauty, like life, cannot be explained. While we do not know what beauty *is,* we know what it does; and by its effects we can set it apart from all the other components making up our world. Beauty, Carus says (p. 56), is what stirs our perception of the Divine in nature. Beauty, it follows, is not an established pattern; it is rather a mode of experience. It must necessarily be a "triad" consisting of God, Nature, and Man. There can be no beauty without man, that is, without somebody who experiences beauty, who perceives it. But there cannot be beauty without nature. We can experience and sensually perceive only what is a real embodiment in nature. An abstraction—like a mathematical point—cannot be beautiful; "beautiful" is only what appears to the senses.

Carus's rejection of the abstract, his insistence on the organic, on the individual figure or object that can be immediately experienced, is also reflected in his attitudes to specific notions of art theory. Thus he rejects the view of beauty entertained by classicism, and he does so precisely because this is an abstract beauty. William Hogarth, as one knows, presented a "waving line" as "the line of beauty,"[49] and this theory of his was widely known and influential. Attacking Hogarth more fiercely than anybody else, Carus says that "there can be no line beautiful in itself, it becomes beautiful through the body that it surrounds (and therefore it is not easy to conceive of a less felicitous idea than Hogarth's concerning the waving line as the sole line of beauty)" (p. 147).

We need not go into the details of Carus's doctrine of beauty as such. We shall stick to landscape painting. The beauty of nature, he says, is closer to God, the beauty of art is closer to man (pp. 62–63). Art, we then understand, is the creation of man, as nature is the creation of God. From here it follows that art mediates between nature and man. Now, if this is valid for art in general, it is particularly true for landscape painting. Landscape painting opens up our senses to the experience of nature (p. 63). To mediate between nature and man, the artist "has to learn the language of nature." This, however, one can do

only in the open, in forest, field, and sea, among mountains, rivers, and valleys. When the artist's soul, Carus says, is filled with "the inner meaning of these different forms," the "secret divine life of nature has dawned upon him" (pp. 157–158). This, then, is the ultimate aim of landscape painting: to reveal to the spectator the divine life hidden in nature. Landscape paintings achieving these ends will "raise the spectator to a higher contemplation of nature, [a contemplation that is] mystical, orphic" (p. 158).

3. CASPAR DAVID FRIEDRICH

The popular image of the Romantic artist is that of a highly literate man, using words almost as frequently and as expertly as colors. Some texts on art written by painters in the Romantic period are indeed of great literary density and charm; they are precious documents, a mirror to the mind of the time. On the whole, however, the literary legacy of Romantic painters is rather slim; notwithstanding the common image, the Romantic painter felt less need to record his ideas in writing than did artists of some other periods. This is particularly true of Caspar David Friedrich. Nevertheless, some isolated remarks—they have come down to us in fragmentary form—may shed light on our specific problem, the meaning of landscape.

They reveal, in adumbrated rather than crystallized form, a comprehensive background of thought and reflection. Central is the belief that every object in nature, no matter how humble and insignificant in itself, is capable of reflecting the Divine. "The Divine is everywhere," said Caspar David Friedrich, the great German Romantic landscape painter, "also in a grain of sand, so I depicted it in the reed."[50] The guardians of traditional concepts were suspicious; they were not slow to perceive that such a striking transgression of the inherited genres contained an explosive power. As early as 1809, the chamberlain Basilius von Ramdohr attacked Friedrich and the trend he represented. This trend, our learned chamberlain said, with particular reference to landscape painting, "is the unfortunate brood of the present time, and the terrible preview of quickly approaching barbarity." He epitomized the landscape painter's part in this sinister scenario in a sentence combining moral

disgust with vivid language: "It is truly a presumption if landscape painting wishes to creep into the church and crawl onto the altar."[51] But the artists and writers who would today be termed "progressive" understood the message. The great poet Heinrich von Kleist had this to say about Friedrich's famous painting *Capuchin Friar by the Sea:* "I am convinced that, in his spirit, one could represent a mile-long stretch of sand from the Mark [province], with a [single] barberry shrub on which a lonely crow ruffles its feathers, and that this picture would have a truly Ossianic . . . effect. Could one paint this landscape with its own chalk and its own water, then, I believe, one could make foxes and wolves howl."[52]

Caspar David Friedrich himself stressed the significance of introspection in the process of painting a landscape. "The painter," he said, "should paint not only what he sees in front of him, but also what he sees within himself."[53] This, one cannot help feeling, is strange advice from a landscape painter. In another fragment, consisting of only two lines, he addresses the practicing artist: "Close your bodily eye, in order that you may see your image first with your spiritual eye. And then, bring to light what you have seen in the darkness, so that it can affect other [images], brought from outside into the interior."[54] These sentences, the reader feels, might have been versions of a text by Plotinus.

What Carus, Friedrich's friend and apostle, tells us about the painter's procedures is surely motivated by the desire to corroborate the artist's method. Friedrich, he says, "never made sketches, cartoons, color outlines *(Farbenentwürfe)* of his pictures, because he claimed (and surely not without justice) that by these auxiliary means the imagination cools down. He did not start his painting until it was vividly present in his soul, and then he first rapidly drew on the neatly stretched canvas with chalk and pencil the whole [composition or image], then cleanly and completely with reed pen and China ink, and proceeded immediately to underpainting. His pictures therefore, in each stage of their emergence, looked distinct and well ordered, and always bear the impression of his peculiar [character], and of the mood in which they first appeared to his mind."[55] Whether or not Carus's description of how Friedrich produced his landscapes is correct in every detail—it is not our task to deal with this particular question—it is a significant

theoretical statement, and it shows how powerful were Neoplatonic trends of thought in early and mid-nineteenth-century reflection on landscape painting.

But what does the artist whom Friedrich addresses see within himself? This is an old question, one that already played a crucial part in sixteenth-century thought. Albrecht Dürer, the artist whom German Romanticism adored,[56] coined the phrase "secret treasure in the heart" to describe what the artist finds in the depths of his mind.[57] It is this accumulated "treasure," one assumes, that provides the artist with the images he draws upon from within. Friedrich does not explicitly say what the artist finds in his mind, but it seems that what he means is the mood that ought to pervade the painted landscape.

A critical remark of Friedrich's on the work of another artist is suggestive. Carus, who published this remark, did not disclose the identity of that artist, replacing the name by a discreet "N. N." The picture Friedrich refers to must have been a truly Romantic work: it represented a moonlight scene. But the subject matter alone is not enough for him. "One sees in this large moonlight picture by the rightly famous virtuoso artist N. N. more than one would wish to see, more than one actually can see by moonlight." In spite of the sarcasm, this is not the core of Friedrich's criticism. He continues: "But what the surmising, feeling soul searches for, and what it seeks to find in every picture, of this one sees here as little as in all the paintings by N. N."[58] What "the surmising, feeling soul searches for" is, of course, the mood, the reflection of an inner, human experience that is projected onto the natural objects that compose the landscape.

In his fragmentary observations, Friedrich epitomizes two points that, though not identical, hang closely together. They are not new, they form part of the trend of ideas common to Romanticism. But Friedrich gives them a particularly concise and suggestive formulation. First, landscape painting is not primarily a record of nature; it is the projection of psychic life. The historical origin of landscape painting—the faithful recording of objective natural data, closely related to cartography—is altogether forgotten. It is now the emotions and moods evoked, or suggested, by the landscape that are the core of the art form.

The second point is that landscape painting is seen as the medium

particularly suited for the manifestation of moods. The historian cannot help noting that this is, in fact, a revolutionary claim. Making landscape painting the expressive medium par excellence marks the end of the venerable tradition of humanism that for centuries dominated thought on art. The humanistic tradition, it should be kept in mind, considered the figure of man as the principal medium for expressing emotions and moods in art. It is only the human figure that reflects experiences; the landscape is merely the background, the spatial frame in which the figure is placed. In principle, at least, landscape has little to contribute to the revealing of moods. This attitude is completely reversed in Romantic thought. In Romanticism in general, and in the views of Romantic painters in particular, comparatively little attention is paid to the human figure as an expressive medium. It is now the landscape, animated by a mysterious life and miraculously reflecting human moods, that takes the place and traditional function of the human figure. The bells of a new age are tolling.

4. VISCHER

Did the tendency to understand landscape painting as mirroring human moods represent more than the ideas of a few Romantics? Did such views ever become an influential trend in the interpretation of art? The historian, looking back at the bewildering amplitude of opinions that flourished in the decades after Romanticism, cannot help wondering. An important witness is Friedrich Theodor Vischer (1807–1887). He was no painter, nor did he have Carus's colorful personality. On the contrary, he was a typical professor, lecturing for decades on aesthetics at the University of Tübingen. In a sense, he can be seen as the link connecting the ages: he was himself a belated disciple of Hegel; his late essay on the symbol deeply affected Aby Warburg. Vischer's huge work on aesthetics, alarming both for the bulk of the six enormous tomes and for their scholastic form of presentation, was written in the middle of the nineteenth century, when the author was still quite young.[59] Though he is far from unriddling all the problems he set out to solve, his work is a fine mirror of creative academic thought. Wishing to be comprehensive and to contain all the arts and their variations in his

system, Vischer also had to deal with landscape painting. Though the subject is clearly marginal in his thought, the pages devoted to it bear important testimony to the further development, even eventual triumph, of the trend we have been outlining in this section.

Landscape painting, Vischer says in his systematic treatise, idealizes a given complex of natural features, belonging to inorganic and vegetative nature, "transforming it into the expression of a surmised mood of the soul" (III, p. 648). Before we come to the central assertion—that landscape painting should be an expression of human moods—it is worth our while to note that the author here proposes a process of painting landscape that is opposed to time-honored workshop procedures. It was accepted workshop custom that the artist choose individual motifs and objects from nature, and that he then combine them in an order that, with regard to nature itself, may be arbitrary. This, it was believed, is the secret of "composition" in the landscape picture. But this procedure, the Tübingen professor thought, misses the truth. It is in nature itself that we must find the overall unity of the scene and the overall composition of the picture. But does not the painter of panoramas *(Vedutenmaler)* do precisely this? And yet Vischer, like Carus, excludes the painter of panoramas from the community of artists. What distinguishes the true landscape painter from the painter of panoramas is that he transforms the depiction of a landscape into the expression of a mood.

In 1842, seven years after the second, and enlarged, edition of Carus's *Briefe über Landschaftsmalerei* was published, F. T. Vischer devoted a lengthy discussion to the nature of landscape painting (in a review of a publication of watercolors).[60] In this discussion, which is still interesting today, and not only as a historical document, Vischer treats landscape painting as an expression of human emotions and moods. In everything we look at, he says, we see man. This is also true for landscape painting; beautiful nature reminds us of human conditions. And yet we sense— vaguely, but surely—that the human moods permeating nature are only lent to it by ourselves.

"The proper content *(Inhalt)* of a landscape painting is, therefore, a reflection of the subjective life [of the human soul] in the domain of the objective life of nature."[61] The belief that landscape painting is, in its

very essence, an art of expressing moods was, then, held not only by eccentric painters and poets, who took their metaphors literally, as it were; it was also endorsed by the acknowledged aesthetic philosopher of the age. The essence of landscape painting is complex, however, and Vischer was more aware of this complexity than were poets and painters. Landscape painting expressing human moods serves, in fact, as a model of the way in which aesthetic or expressive objects exist. The landscape permeated by moods is based on the interaction of two different moments: on the one hand, I am aware that it is I who lend the landscape its seeingly human characteristics and moods. On the other, in spite of this knowledge, I—whether spectator or artist—go on investing mountains, trees, rivers, or whatever other objects make up a landscape picture, with these characteristics and moods. The spectator is not mistaken; he knows that the subject matter of landscape is nature, not man. This awareness, however, does not counteract the expressive illusion.

Vischer, heir to a great philosophical tradition, could not accept the expressiveness of nature in a landscape painting as a mere projection of human emotions onto objects that, in themselves, are altogether alien to anything not merely material. Hegel claimed in his *Aesthetics* that in painting, God "appears as a spiritual and living person who enters the Church and gives to every individual the possibility of placing himself in spiritual community and reconciliation with him."[62] Referring to this statement by Hegel, Vischer widens the range of God's appearance in the arts. For sculpture, Hegel's assertion may be correct, Vischer says, but in painting, God also appears in nature. In his *Ästhetik,* Vischer writes: "Air, earth, water, tree, the last reed stalk at the pond trembles and weaves in ominous shimmer, and seems to wish to say something significant" (III, p. 525). It is this state of affairs that makes landscape painting possible and significant.

What matters to the spectator looking at a landscape painting, however, is only the expression of mood. In an untranslatable German phrase, Vischer says that the painter whose landscape pictures do not affect us in our emotions has achieved nothing (III, p. 649).[63] This painting is like music, he continues, "where our heart is full and yet has no word for it, or as it is in lyrical poetry, when one disregards the

specific contents and considers only the resoundings and weavings that go through a poem" (III, p. 649). The comparison of landscape with music recurs in the late nineteenth and in the twentieth century. That Vischer employs this comparison—he does so several times—shows, I believe, how close he came to altogether modern ideas about an art that is abstract in subject matter, yet distinct and powerful in expression. It is with this vague adumbration of an abstract art that we must close our brief survey of reflections on landscape painting as a symbolic art form in early nineteenth-century thought.

IV. COLOR SYMBOLISM

1. THE CONCERN WITH COLOR

The generation around 1800 witnessed a revival of concern with the significance and "essence" of color. Painters and poets, scholars and critics once again vigorously discussed questions such as what color actually is and what psychological effects can be achieved by correctly using tones and hues. The problems, we remember, are not new. The history of theoretical reflection on painting can be imagined as a series of swings of the pendulum: one period extolled line and composition, another rather saw color as a major factor in the art. In the late seventeenth and early eighteenth century, the very foundations of the Academy of Art, particularly in France, were shaken by the famous "Débat sur le coloris" and by the quarrel between the so-called Poussinists and Rubenists. These debates, as we know, were in fact a contest between those who thought line and composition the supreme value in painting and those who upheld color as the supreme pictorial value.[64]

Neoclassicism, the style that acquired a dominant position in the art and aesthetic thought of the late eighteenth century, shifted the pendulum once more in the direction of line. "The lines of a Grecian composition," said John Flaxman (1755–1826), the English sculptor and influential draughtsman, "enchant the beholder by harmony and perfection. . . ." He praised Michelangelo for the master's great "sensibility to the play of lines in his picture."[65] Of color he had nothing to say.

Johann Joachim Winckelmann, who deserves, more than anybody else, to be considered the founding father of the ideology of Neoclassicism, speaks of "noble outline;" in the contour he sees the highest value of both natural and ideal beauty; and he praises Raphael's *Sistine Madonna* for her "great and noble outline." [66] He ignores color in his first treatise, but in the *Sendschreiben* that followed he claims that the "charm of color" helps to conceal the artist's faults. [67] At best, then, color is of rather dubious value.

In Romantic thought the pendulum once again swung back. Reading what painters, critics, and poets of the early nineteenth century said about painting, we witness a return to the high regard for color and an intensive concern with coloristic phenomena. The range of color interests is striking. A systematic study of color symbolism, as conceived and practiced in past ages, marks one end of this range. It is not for me here to go into the long and enthralling history of color interpretation. Ever since biblical times, and probably even earlier, people have reflected on what colors "mean," what is revealed by them, and how they act upon the spectator. Color, it has been felt in past ages, is able to express the most sublime ideas. So intimate, it was believed, is the connection between color and the Divine that some modern scholars, studying the history of our problem, have been tempted to speak of a "theology of color." [68] The symbolic character of color seems to be a universal phenomenon, too broad to be discussed in our context. Even if we stay within the limits of the Western world, a historical outline of the "theology of color" would demand a heavy tome. Color symbolism was not only explicit; it is also implied in descriptions of a vast variety of objects and visions. To give but one example, it has been noticed that the visions of mystics, particularly between the late Middle Ages and the seventeenth century, show a definite leaning toward detailed color descriptions, toward conceiving the hues as manifestations of spiritual life. [69] The early decades of the nineteenth century were very attentive to these descriptions; as we shall see, painters and poets sensed what these color visions meant to convey.

The study of color in the past, needless to say, was not limited to religious symbolism, and the early nineteenth century was fully aware of the great variety of approaches to the chromatic phenomenon. To

indicate the range of the interest in color evinced in this period, it will be enough to mention the work of Michel Eugène Chevreul (1786–1887), a professor of organic chemistry, celebrated in his day for his studies of the components of fats and the nature of soap. Appointed director of the dye laboratories at the Gobelin tapestry factory, he immersed himself in a study of color relations. Though motivated by the desire to find a scientific clue for the proper application of colors in the famous factory, the great work that he composed was essentially theoretical. The heavy volume containing this study, called *De la loi du contraste simultane des couleurs,* appeared in Paris in 1839.[70] Chevreul's investigation, though seemingly directed only toward technical applications, and objectives, timeless truth, provides the historian with many clues concerning the effects, psychological and otherwise, that color was in his time believed to have on the spectator. His color studies, in spite of their altogether nonsymbolic character, are in fact linked in many ways to the spiritual world of the Romantic period.

Attempts to understand color, and to uncover the meanings allegedly inherent in hues, were then a common feature in the culture of the period, particularly in views on painting. I shall try to illustrate this trend by a few outstanding examples.

2. RUNGE

With regard to the use and meaning of color in painting, perhaps nobody in Romantic thought is as revealing as the painter Philipp Otto Runge (1777–1810). One of the most radical Romantics in German, even in European, painting, he also had a speculative mind, profoundly attracted to reflecting on what he was doing in his art. The two volumes of his *Hinterlassene Schriften,*[71] edited by his brother, reveal a searching soul and intellect that harbored many more tensions and conflicts than the commonly accepted image of Runge would lead one to expect. We shall come back to some of the broader aspects of his views on art in the next chapter; here we shall glance only briefly at what he has to say about the magic and meaning of color in painting.

Runge's theoretical concern with color was not short-lived or marginal; it seems to have lasted throughout his life, and it influenced his

spiritual world and artistic work. He was acquainted with the great traditions of color study and interpretation of the past. "What Albrecht Dürer and, above all, Leonardo da Vinci had written about color was very well known to him," so writes the scientist Henrich Steffens,[72] with whom he corresponded on color. Other authors of past centuries fascinated him in this context, though they had nothing to do with painting. Here one thinks especially of the German mystic Jakob Boehme, whose color descriptions (of what he perceived in his visions) seem to have struck Runge particularly. But Runge's color studies were not limited to the distant past; in addition to his own observations, he also looked for living sources. His correspondence with Goethe is devoted almost exclusively to the problems of color.

Runge tried to establish a comprehensive color system, and to present it in both words and graphic form. To elucidate color relations for himself, and to present his views clearly, he invented his "color sphere" *(Farbenkugel),* a model to illustrate the ratios of color mixtures. He arrived at this model through years of empirical study, of patient and careful observation of color phenomena in nature and their treatment in the workshop. The "color sphere," so he wrote to his brother in 1808, "is not a work of art, but a mathematical figure of a few philosophical reflections." This description hits the true nature of his construction, perhaps more than he himself knew. As compared to, say, Leonardo da Vinci's color observations (on which he relied so much), Runge's comments, detailed and specific as they are, sometimes have a curiously abstract, theoretical quality. They lack the full saturation with observation of nature so characteristic of the great Renaissance artist.

Coming from the workshop, and familiar with Renaissance art theories, often so close to the artist's actual work, Runge intended his "color sphere" to be of practical use to the painter. The "decline of art," he believed, follows from the decline of our knowledge of color.[73] Naturally, therefore, he wished to revive the knowledge of color in order to improve the quality of art. Considering the complicated ratios and relationships between colors that he describes in his theoretical reflections, however, one cannot help wondering what kind of profit an artist standing in front of his canvas could have derived from Runge's explorations. Rather than a set of practical prescriptions meant to help

the "user" directly, Runge's deliberations appear as attempts to understand the very foundations of the painter's métier. Here, the modern reader feels, is an artist who is profoundly serious in his desire to understand the real nature of the strange, evocative power he is handling with his brush, and what it is that makes for the magic of color. The painter's atelier, in Runge's thought, is not so much the ultimate destination to which he is trying to bring an easily applicable know-how; it is rather the point of departure of his investigations, one could almost say, of his intellectual and artistic adventures. In the painter's workshop, color phenomena and color relations become visible that in other contexts and other places are either dim and confused, or remain altogether hidden from sight. But what he perceives in the context of the workshop is less nature itself than what he rightly calls "philosophical reflections."

A somewhat similiar situation obtains with regard to color symbolism. Reading his notes, one inclines to use this term, and in fact this is often done. Yet the term "symbolic" should here be taken with a grain of salt; it needs qualification. For Runge, color in general, and the hues and tones in a painting in particular, are more than just sensual impressions, more than mere chromatic experience of the eye. Color, he says, is not "matter like a stone or a piece of wood," it is "in itself . . . movement and a natural force which related to the form as a tone relates to the word."[74] While this comparison may not be altogether clear, it is obvious that Runge conceives of color as a matter through which something else, something that is nonmaterial and nonsensual, shines forth. Colors go beyond themselves, they manifest, indicate, or evoke. On the other hand, Runge's recognition of the symbolic character of colors does not mean that he accepts the dictionary version of symbolism. He does not associate a certain color or tone with a certain meaning or emotion. In other words, he does not conceive of color symbolism as a codified system from which we can pick out, or isolate, any particular element. It is the *whole* of the color system that is symbolic, that indicates an overall unity, something that "holds the world together." In color he finds an analogy of such a comprehensive, overall unity, a metaphor of the ladder from the invisible God to the humblest part of nature.

3. GOETHE

Goethe was not a declared theoretician of painting. We know, of course, that he was interested in the visual arts, that occasionally he himself painted and made drawings, and that his writings on art, though consisting mainly of occasional pieces, fill a heavy tome. But in his great work on color—and this is the text we are here dealing with—he paid only scant attention to painting, at least explicitly. In spite of all this, however, we cannot overlook Goethe in this brief survey of pictorial color symbolism of the early nineteenth century. In his color studies he said so much that is relevant to art that the student trying to explore contemporary views on painting has to consider some aspects at least of the poet's work as if he had been writing directly on art.

The *Theory of Colors (Farbenlehre)* was not a marginal product of Goethe's restless mind. He devoted to it many years of study and writing. The completed work fills a large volume in the Propyläen edition, and this tome does not include many preparatory studies. He himself considered it one of his major achievements, and on occasion he intimated that he placed his scientific work on color above his poetry. More than half the book is devoted to his own findings and to the conclusions he draws from them; the rest is given over to the famous dispute with Newton. We need not here go into that dispute; it has clearly and without any qualification been decided in favor of the great British scientist. If one still returns, time and again, to Goethe's mistaken position, this is because it provides a classic example of an artist's approach to science and to the study of nature. As such, it also reveals a great deal about painting, and of what was thought to be the painter's attitude to color.

The mental approach that Goethe wholly and violently rejected— the approach that Newton personified for him—essentially consists in the study of natural phenomena by means of quantification. "Mathematics" as a way of studying the diversified amplitude of natural experience—this seemed to him a kind of primeval fall. "In the Middle Ages," he said, "mathematics was the chief organ by means of which men hoped to master the secrets of nature, and even now, geometry in certain departments of physics, is justly considered of first importance"

(722).[75] The study of various natural phenomena has suffered from this exaggerated mathematical approach, Goethe believes. This is particularly true in the study of color. Color doctrine has suffered from "having been mixed up with optics generally." Optics, Goethe admits, is a "science which cannot dispense with mathematics." The theory of color, however, "may be investigated quite independently of optics." (725).

Modern scholars have noted that in Newton's *Optics,* as opposed to his other great work, the *Principia,* mathematics in fact plays a rather minor role. What Goethe so vehemently rejects in the treatment of color is, then, not precisely an exaggerated use of mathematics proper. It is the very foundations of an abstract approach to nature, the "artificiality" of the experiment, that he cannot accept. The revolt against the application of mathematics to the arts is of course not new; as we know, it had already given rise to significant expressions in the theory of the visual arts. It would obviously be wrong to consider Goethe's *Theory of Colors* as a link in the tradition of art theory. Nevertheless, one cannot forget that when artists and art theorists revolted against the rule of mathematics, they saw it mainly as an imprisonment of the imagination, and an impoverishment of the amplitude of natural phenomena in favor of some lifeless abstractions.[76] Goethe's rejection of mathematics in the treatment of color is not so far removed from those attitudes in former ages.

In the preface to the first edition of the *Theory of Colors,* 1810, Goethe reveals at least part of his sources. "We should try in vain," he says, "to describe a man's character, but let his acts be collected and an idea of the character will be presented to us." And he goes on. "The colors are acts of light; its active and passive modifications." The old Neoplatonic view, however modified by modern science, is still felt. Early in the work, after making some color observation, he says: "An important consideration suggests itself here, to which we shall frequently have occasion to return. Color itself is a degree of darkness; hence Kircher is perfectly right in calling it *lumen opacatum*" (69).[77]

The trinity of light, darkness, and color forms the content of Goethe's color doctrine. Many nineteenth- and even twentieth-century commentators, strongly influenced by the fashionable admiration of scientism,

were inclined to depict Goethe's book as a regular "scientific" enterprise. This, however, is only partly true. In discussing light and color, Goethe is thinking of the arts just as much as of science. "From these three, light, shade, and color, we construct the visible world, and thus, at the same time, make painting possible, an art which has the power of producing on a flat surface a much more perfect visible world than the actual one can be," he says at the beginning of his introduction to the first edition of the *Theory of Colors*. What he wants to discover is the common root of nature and art—an old wish of Neoplatonists throughout the ages.

Art, it was claimed in Neoplatonic thought, follows the *principle* of Nature, it acts like nature. Plotinus, in his later treatise on the Beautiful, said that "the arts are not to be slighted on the ground that they create by imitation of natural objects; for, to begin with, these natural objects are themselves imitations; then, we must recognize that they give no bare reproduction of the thing seen but go back to the Reason-Principles *(logoi)* from which Nature itself derives. . . ." A little later in the same treatise, he further explains: "the artist himself goes back, after all, to that wisdom in Nature which is embodied in himself. . . ."[78]

Goethe's work on color, though surely a study in natural science (as he understood it), is an outstanding document of the humanistic approach to the world of visual experience. At the center of his concern is the question of how man perceives, and emotionally reacts to, color. He is largely concerned with the effect of colors "on the eye, by means of which they act on the mind." Colors "are immediately associated with the emotions of the mind." Therefore, "We shall not be surprised to find that these appearances presented singly, are specific, that in combination they may produce an harmonious, characteristic, often even an inharmonious effect on the eye, . . . producing this impression in their most general elementary character, without relation to the nature or form of the object on whose surface they are apparent. Hence, color considered as an element of art, may be made subservient to the highest aesthetical ends" (758).

At the end of his own observations, Goethe comes to reflect on the subject of color symbolism. The foundations of this symbolism are found in nature herself, in the way we perceive colors. This is also the

foundation of their use in art. What makes it possible for us to employ colors for moral and aesthetic ends is "that every color produces a distinct impression on the mind, and thus addresses at once the eye and feelings" (915). When we deliberately exploit the distinct and character-istic impressions that each color makes, we are "coinciding entirely with nature." Such a use, that is, the application of color "in conformity with its effect," so that it "would at once express its meaning," Goethe calls the symbolic use of color. Color symbolism, then, is not artificially —or, as we often say, conventionally—established; it follows from nature. It is not difficult to conclude, even without the author spelling it out in detail, that the spectator intuitively grasps the meaning of such colors and color combinations. Color symbolism, in other words, is a heightened form of artistic expression (916).

Goethe is also aware of a different kind of symbolism, the one we call artificial or conventional. He sees it from the point of view of application. We know that, as William Heckscher put it, he was "fascinated" by emblems.[79] To color, too, he applies an emblematic approach. Conventional color symbolism, it follows from what he says, is close to, but not identical with, the natural symbolism of colors. Another application, he says, "might be called the allegorical application [of colors]. In this there is more of accident and caprice, inasmuch as the meaning of the sign must be first communicated to us before we know what it is to signify; what idea, for instance, is attached to the color green, which has been appropriated to hope?" (917).

In a "Confession of the Author" that Goethe appended to the historical part of his *Theory of Colors*, he explained the reasons that moved him to his investigation of colors, and the circumstances under which his interest in color phenomena was originally aroused. His familiarity with painting is here adduced as a major factor in awakening his fascination with colors. From childhood on, he says,[80] he used to visit the workshops of painters; several pictures "were invented, com-posed, the parts . . . carefully studied" in his presence. He himself never felt, he says, the urge to practice painting,[81] but he searched "for laws and rules that would govern" that art. This reads like a faithful descrip-tion of the way in which some humanistic art theories were formulated. Yet both in conversing with living artists and in studying textbooks,

Goethe adds, he could find no clear advice and instruction with regard to colors. Even what Gérard de Lairesse said, he specifically notes, is modest indeed.[82] It was this state of affairs, as he says, that brought him to the study of color.

The intimate connection of Goethe's color concepts with the art of painting is not only a matter of how his interest in the subject arose, a question that can be answered by reference to his biography; the connection also persists in his fully developed views. He concludes the first, essential, part of his *Theory of Colors* with some "Concluding Observations" in which he speaks of art and the work of art. A work of art, he here says, "should be the effusion of genius, the artist should evoke its substance and form from his inmost being, treat his materials with sovereign command, and make use of external influences only to accomplish his powers."[83] This is not how a physicist, even in Goethe's day, would end a study of color. Our poet-scientist wrote for (or of) people for whom color had become an inner experience. Chromatic sensations stream from the depth of consciousness rather than from the "raw" outside world. No wonder, then, that from the beginning they are endowed with meaning and emotion.

4. LATE ROMANTICISM: RICHTER

Symbolism of all sorts, including the symbolism of color, goes beyond the emotions and experiences of a single individual; it contains an element of broad tradition. In a culture such as Romanticism, in which the significance of the subjective and the individual was strongly emphasized, symbolism was bound to lead to a conflict with the rising tide of subjectivism. This unavoidable clash can be shown in many examples. In color symbolism, the notes of Richter provide a fine illustration. Adrian Ludwig Richter (1803–1884), a late Romantic artist, is best known for his landscape paintings. Suiting the tastes and wishes of the German lower middle class, he became one of the most famous painters of the mid-nineteenth century. His personal literary testimony, *Lebenserinnerungen* (Memories of a Life), was well known and widely read. Richter has not the intellectual and moral profundity of a Runge, let alone the unique and overwhelming personality of Goethe, but his notes

have the value of a popular document. The problems that occupied the minds of artists and critics in the 1830s and 1840s are clearly reflected in the *Lebenserinnerungen*.[84]

Richter never questioned the significance of a theory for the painter. "I see," he said in 1823, "how important a healthy, clear theory is for an artist." But theory should not remain something external, or self-enclosed. He therefore continues: "But actually he [the artist] must create it [the theory] for himself, or at least he must assimilate the views of others in such a way that they become his own property, and are suited to his mode of thinking and become part of it" (p. 494). The problem is obvious here: on the one hand, he accepts the need for a general, valid theory; on the other, he makes it a personal theory, differing from one artist to the other. But such an individual theory, suiting only a single artist, ceases to be a theory at all. In other words, Richter wants to reconcile the general theory and the individual temperament. He does not know, however, how the gap between the two can be bridged.

As a rule, Richter does not deal with the great philosophical problems of art; to the degree in which they can be found in his written legacy, they are implied rather than explicitly presented. His notes and letters smell of the atelier. And it is precisely in this respect that we see how much he is indebted to tradition. This is clearly illustrated by his views concerning the application of color in the process of producing a picture. Workshop tradition from the early Renaissance to high academism required a firm and clear outline before the painter touched a brush dipped in color. This is also what Richter repeats: "The picture should be drawn with the pen, precisely and powerfully." The demand that the outlining should be done with a pen (unusual advice indeed) epitomizes, as it were, the strict boundaries imposed upon the application of color that comes in the next stage. But Richter inserts still another stage. "Before one puts the hand to the canvas, one must evoke once again the idea [obviously of the color distribution], if it has not already been laid down in a color sketch. Then apply the colors in broad masses" (p. 575). Now, all this surely does not read like the views of an artist who is freely following his subjective fancy and working under the impact of an irrational inspiration.

In spite of such traditional roots, Richter declares that "the major point, however, on which everything in an artist depends, is to form *(ausbilden)* his genius, his proper, spiritual self . . ." (p. 494). The rising trend of subjectivity is getting the upper hand.

He is aware of the dangers inherent in what he calls "subjectivity." In 1850, he notes that "subjectivity is the general disease of our time, and it makes us sick ourselves." Subjectivity is deviating from an objective norm that does not depend on an individual, or seeing processes from an individual point of view. Using energetic language, he says: "Everybody wants to decide the time after his own, more or less defective, watch, because he negates the sun. We have only opinions and beliefs, but no positive, norm-establishing truths . . ." (p. 601). Awareness of these dangers does not rescue him, however, from fascination with the subjective. He shares the late Romantics' belief in developing the individual personality, regarding this notion as a supreme ideal.

We sense an overall, profound conflict in Richter's views on landscape painting, the field to which most of his own pictorial work belongs. The impression visible nature makes on man, he holds, is one of divine revelation; landscape, in his own words, is a "living hieroglyph of God's laws and sacred intentions." The painter depicting a landscape, however, apparently cannot follow the divine intentions blindly. To avoid making his landscape painting an "artificial allegory," the painter must rely on his subjective feelings and impressions. Nature, Richter advises the painter, should be perceived "in such moments in which it moves me, and everybody, most powerfully (for instance, seasons of day and year)" (pp. 516–517). The artist, then, interferes with the divine law, even if only half-consciously, by selecting the moments and sights that reveal more or less of the divine. It goes without saying that such a selection is directed by the artist's individual personality.

But the landscape painter is also a mediator, as it were, of God's revelation to man, and therefore the intensity of his experience is crucial. Addressing an anonymous artist, or perhaps himself, Richter notes: "In order for your work to act on the mind [of the spectator], it must emerge unfaded *(ungeschwächt)* from the [artist's] mind. Therefore, invent and work with profound love and belief" (p. 517). This, of

course, is still another version of the old Horatian formula, requiring that poets should themselves experience the emotions they wish to evoke in the minds of their readers. But the classical origin of Richter's demand does not alter the fact that the artist's emotions, the intensity and power of his feelings, become a criterion for the efficacy of the landscape's expressiveness, of its ability to reveal what God has hidden in nature.

When it comes to color, some of the trends and conflicts I have tried to describe become even more manifest. Richter adheres to traditional color symbolism. As if he were stating an undisputed fact, he remarks: "It is fully clear how each color separately produces a special effect on the soul *(Gemüt)*" (pp. 517–518). So little does he doubt the validity of this assertion that he suggests something of a dictionary of emotional color effects. "So, for instance, green is fresh and vivid, red cheerful or magnificent, violet melancholic (as in [the work of Caspar David] Friedrich), black most nations have accepted as the color of sadness and of death" (p. 518).

Observations on the meanings and emotional qualities attributed to individual colors are of course not new. Precisely the same comments recur in the tracts composed during the Renaissance on the same issue.[85] What is new in Richter is the attempt to discover emotional characters in color *combinations*. What does the relationship of, say, green to red evoke or express? Says Richter: "Magnificence, amplitude." And "green to blue—serene, serious, sublime" (p. 518). It is possible, he obviously believed, not only to establish the meanings of individual hues, but also to build up a comprehensive system of color relations. At precisely the time that Chevreul was considering color relations on a scientific basis, Richter was looking at the same phenomenon from the point of view of artistic expression.

Color combinations appear to Richter in the guise of expressive landscape motifs. "How gloomy, mournful is the dark gray-green of the lime tree; how serene the light green of the beech tree! What feelings do the yellow trees in the fall evoke, with black branches, withered foliage and grass. How ghostlike the black oak forest in the winter, when the snow is widely spread and hangs on the boughs" (p. 518).

In spite of this interlocking of expressive color and expressive land-

scape motifs, Richter is aware that color relations can evoke emotions even independently of the representation of material objects or pieces of nature. In modern terms, color compositions can be expressive patterns of an abstract nature. For the expressive relationships of colors he uses the phrase "the spiritual arrangement of colors." One cannot help thinking of Kandinsky, who is the ultimate descendant of the tradition so forcefully represented by Richter. The "spiritual arrangement of colors," one is not surprised to read, "has much similarity to music, in treatment as well as in effect. Colors are sounds" (p. 518). The fusion of colors and sounds, it is well known, is a frequent feature of Romantic thought on art.[86]

It is also not surprising that Richter characterizes the work and style of individual painters by the emotions the color scales they use evoke. "What life, what freshness, what blooming amplitude Titian's color excites," our painter exclaims. The emotional tone of Poussin's color is altogether different. "A sweet sadness and yearning come over us [when looking at] Poussin's landscapes. These are gray, blended, somewhat dark colors" (p. 518).

What follows from all this is obvious: the range of color symbolism becomes broader, it is applied to more and more aspects of nature and art; experiences of nature and works of art are grasped on the basis of what the colors say or intimate or evoke. At the same time, however, the character of color symbolism changes almost imperceptibly: instead of distinct, firmly codified color "meanings," we are now faced with fascinating but somewhat indistinct color evocations. Conventional color symbolism becomes more of a psychological experience. The age of subjectivity has begun.

NOTES

1. See above, pp. 97 ff.
2. See *Winckelmann's Werke,* herausgegeben von C. L. Fernow, (Dresden, 1808), I, p. 56. "That painter who thinks further than his palette wishes to have a learned stock to which he can turn to take important signs, made sensual, of things that are not sensual. A complete work of this kind does not yet exist. . . ."

3. The *Versuch* is printed in *Wickelmann's Werke,* II (Dresden, 1808), pp. 429–762. Figures in parentheses, given in the text, refer to the page numbers of this edition. So far as I know, there is no English translation of the *Versuch.*

4. Winckelmann expressed these views frequently. See, for instance, *Wickelmann's Werke,* I, pp. 56 ff., 59 ff.

5. See *Winckelmann's Werke,* I, pp. 53 ff.

6. B. A. Sörensen, *Symbol und Symbolismus in den ästhetischen Theorien des 18. Jahrhunderts und der deutschen Romantik* (Copenhagen, 1963).

7. For Cesare Ripa and Pierio Valeriano, see *Theories of Art,* pp. 263 ff. Jean Baptiste Boudard was a professor at the Royal Academy in Parma. His major work, *Iconologie tirée de divers auteurs. Ouvrage utile aux gens de lettres, aux poètes, aux artistes, et généralement à tous les amateurs des beaux-arts* (Vienna, 1766), was both learned and well illustrated, and quickly achieved great popularity. Cf. Ludwig Volkmann, *Bilderschriften der Renaissance* (Leipzig, 1923), pp. 106–108.

8. See above, pp. 119 ff.

9. The major documents of the dispute were collected by Ernst Howald in his *Der Streit um Creuzers Symbolik* (Tübingen, 1926).

10. The reference to the *Symbolik,* in the first editon, are from this point on given in parentheses in the text; Roman numerals indicate the volume. For Creuzer's views, cf. Marc-Matthieu Munch, *La 'Symbolique' de Friedrich Creuzer (Association des publications près des universités de Strasbourg,* fasc. 155), (Paris, n. d.).

11. Because Creuzer's translation is not precisely literal, I have adapted his wording rather than make a correct translation of Demetrios. For the original text, see Demetrios, *On Style,* ## 99–100.

12. The term "iconism" *(Ikonismus)* is one Creuzer himself employs (I, p. 81). I am not aware of earlier occurences. Creuzer himself does not seem to employ it again (but I may be mistaken).

13. By Arnaldo Momigliano, in "Friedrich Creuzer and Greek Historiography," *Journal of the Warburg and Courtauld Institutes* 9 (1946): 152–163, reprinted in the author's *Studies in Historiography* (New York, 1966), pp. 75–90.

14. In his *Idee und Probe alter Symbolik* (1806). This work was not available to me while writing the present chapter.

15. Plotinus, *The Enneads,* translated by S. MacKenna (London, n. d.), p. 427. And see *Theories of Art,* p. 35.

16. See Friedrich Engels, *The Origin of the Family, Private Property, and the State* (New York, 1964), p. 7. For information on the attitudes of the German right, particularly Nazi ideologists, to Bachofen, see Lionell Gossman, "Orpheus philologus: Bachofen versus Mommsen on the Study of Antiquity," in *Transactions of the American Philosophical Society,* vol. 73, part 5 (1983), p. 6.

17. See Campbell's introduction to *Myth, Religion, and Mother Right: Selected Writings of J. J. Bachofen* (Princeton, 1967), p. xxv. This seems to be the only edition of (a selection) of Bachofen's writings in English. Hereafter it will be cited as *Myth, Religion.*

18. *Myth, Religion,* pp. 11 f.

19. Translated from C. A. Bernoulli, *Urreligion und antike Symbole: Systematische Auswahl aus Bachofens Werken* (Leipzig, 1926), I, p. 274. Bachofen wrote this passage in the report of his journey to Greece (1851). See also J. J. Bachofen, *Mutterrecht und Urreligion*, ed. Hans G. Kippenberg (Stuttgart, 1984), p. xiv.

20. *Myth, Religion*, p. 22.

21. Ibid., p. 59.

22. Ibid., p. 56. Bachofen probably has Plutarch's *De Iside et Isiride*, Chapters 49–64, in mind. That Bachofen should have felt a special attraction to Plutarch, a writer of the late first and early second century A.D., who combined great interest in Oriental (Egyptian) mysteries with his Greek culture, is in itself remarkable, and deserves further study. Cf. Kippenberg's introduction to *Mutterrecht und Urreligion*, pp. xvi ff.

23. *Myth, Religion*, p. 56.

24. By C. A. Bernoulli, in *Johann Jakob Bachofen als Religionsforscher* (Leipzig, 1924), p. 73.

25. *Myth, Religion*, p. 51.

26. Ibid., pp. 49–50.

27. *Theories of Art*, pp. 281 f., 343.

28. Lessing suggested this idea several times. See, for example, *Laocoön*, Chapters II and XVII. And cf. also David E. Wellbery, *Lessing's Laocoön: Semiotics and Aesthetics in the Age of Reason* (Cambridge, 1984), p. 121.

29. See *The Aesthetic and Miscellaneous Works of Frederick von Schlegel*, translated by E. J. Millington (London, 1860), pp. 66 ff.

30. F. W. F. v. Schelling, *Schriften zur Philosophie der Kunst*, ed. O. Weiss (Leipzig, 1911), p. 192. I am not aware of an English translation.

31. Salomon Gessner, *Brief über die Landschaftsmalerey an Herrn Fuesslin* (1770), reprinted in Salomon Gessner, *Schriften*, III (Zurich, 1795), pp. 291–328. For Cennino Cennini's advice, see his *The Craftman's Handbook: Il libro dell'arte*, translated by D. V. Thompson, Jr. (New York, 1933), Chapter 88. And cf. *Theories of Art*, pp. 118 ff.

32. Maler Müller, *Idyllen* (Leipzig, 1914), pp. 9 ff. And cf. H. von Einem, *Deutsche Malerei des Klassizismus und der Romantik: 1760 bis 1840* (Munich, 1978), p. 41.

33. See Johann Georg Sulzer, *Allgemeine Theorie der schönen Künste* (Leipzig, 1793), pp. 145–154.

34. The long article, "Über die Landschaftsmalerei," was originally published in *Der teutsche Merkur* (1803), pp. 527–557 and 594–640. It is reprinted in *Römische Studien*, II (Zurich, 1806), pp. 11–130. I am quoting from the reprinted version.

35. "Über die Landschaftsmalerei," p. 95.

36. See von Einem, *Deutsche Malerei*, p. 61.

37. "Über die Landschaftsmalerei," pp. 24 ff.

38. Cf. Rudolf Zeitler, *Klassizismus und Utopie (Figura, 5)* (Stockholm, 1954), pp. 35 ff. And see also Marjorie H. Nicolson, *Mountain Gloom and Mountain Glory: The Development of the Aesthetics of the Infinite* (Ithaca, N.Y., 1959), for the general background.

39. "Über die Landschaftsmalerei," in "Philipp Hackert: Biographische Skizze," in Goethe's *Werke,* Sophienausgabe, Part I, Vol. 46, pp. 356–375. A first edition appeared in a volume of Goethe's works in Tübingen, 1811.

40. Carl Grass, "Einige Bemerkungen über die Landschaftsmalerei," *Morgenblatt fur gebildete Stände,* December 22/23 (1809), pp. 1217–1218, 1223–1224.

41. C. G. Carus, *Lebenserinnerungen und Denkwürdigkeiten,* (Leipzig, 1865), I, p. 70. So far as I know, there is no extensive discussion of Carus as a theoretician of art. Hans Kern, *Die Philosophie des Carl Gustav Carus* (Celle, 1926), does not even mention the author's concern with art theory. E. Wasche, *Carl Gustav Carus und die romantische Weltanschauung* (Düsseldorf, 1933), pp. 101–127, discusses the theory of landscape, but is not very useful for our purpose. The dissertation by B. Kirchner, *Carl Gustav Carus: seine 'poetische Wissenschaft' und seine Kunsttheorie, sein Verhältnis zu Goethe und seine Bedeutung fur die Literaturwissenschaft* (Bonn, 1962), pp. 36–43, also refers to his discussion of landscape painting, but does so from the point of view of the literary historian.

42. N. Pevsner, *Academies of Art: Past and Present* (Cambridge, 1940), p. 118.

43. C. G. Carus, *Briefe über Landschaftsmalerei* (Heidelberg, 1972, a reprint of the second edition, 1835), pp. 37 ff. All page numbers, given in parentheses in the text, refer to this edition.

44. See, for example, M. H. Abrams, *The Mirror and the Lamp: Romantic Theory and the Critical Tradition* (London, Oxford, New York, 1971), pp. 218–225; and Thomas McFarland, *Romanticism and the Forms of Ruin* (Princeton, 1981), pp. 34–43.

45. See Kern, *Die Philosophie des Carl Gustav Carus,* pp. 37 ff.

46. To be sure, that meaning could be complex, it could have different shades; a certain motif, in combination with others, could assume a meaning quite different from what it would have if it had been viewed in isolation. But all these qualifications, one should bear in mind, do not abrogate the basic pattern of mythographic thought, namely, that a given figure has a certain meaning.

47. See C. G. Carus, *Die Symbolik der menschlichen Gestalt* (Leipzig, 1853).

48. See, for instance, Ernst Robert Curtius, *European Literature and the Latin Middle Ages* (New York, 1953), pp. 302–347; and Hans Blumenberg, *Die Lesbarkeit der Welt* (Frankfurt a. M., 1981).

49. Particularly in his *The Analysis of Beauty.* I here quote from *Anecdotes of the celebrated William Hogarth,* ed. John Nichols (London, 1813), in which *The Analysis of Beauty* is reprinted on pp. 101–262.

50. As quoted in L. Förster, *Biographische und literarische Skizzen aus dem Leben und der Zeit Karl Försters* (Dresden, 1846), pp. 156 f. And see also von Einem, *Deutsche Malerei,* pp. 92 ff.

51. Quoted from H. von Einem, "Die Symbollandschaft der deutschen Romantik," in the author's *Stil und Überlieferung: Aufsätze zur Kunstgeschichte des Abendlandes* (Düsseldorf, 1971), p. 210.

52. Quoted in H. Borsch-Supan, *Deutsche Romantik* (Munich, 1972), p. 76; and H. von Einem, *Deutsche Malerei,* p. 92.

53. See *Friedrich der Landschaftsmaler: Zu seinem Gedächtnis* (Dresden, 1841). This little

pamphlet, edited and partly written by Carus, also contains some fragments of Friedrich's literary observations. For the sentence quoted, see p. 11.

54. *Friedrich der Landschaftsmaler,* p. 19.

55. Ibid., p. 24.

56. See below, pp. 296 ff.

57. See *Theories of Art,* p. 218.

58. *Friedrich der Landschaftsmaler,* p. 18.

59. See F. T. Vischer, *Ästhetik oder Wissenschaft des Schönen, zum Gebrauch von Vorlesungen* (Stuttgart, 1847–1857; a second edition appeared in 1922–1923). References to the first edition will be given in the text, in parentheses; Roman numerals refer to the volume.

60. See F. T. Vischer, *Kritische Gänge* (Tübingen, 1844), I, pp. 207–287. See particularly pp. 222–224.

61. Vischer, *Kritische Gänge,* I, p. 223.

62. See Hegel, *Vorlesungen über Aesthetik* (Berlin, 1837), III, p. 10; and the English translation (*Aesthetics: Lectures on Fine Arts,* trans. T. M. Knox [Oxford, 1975]), p. 798. See also *Aesthetik,* II, p. 258, and *Aesthetics,* p. 625.

63. The original text reads: "Ein Maler, dessen Landschaft nicht so auf uns wirkt, dass uns irgendwie *zu Mute wird,* hat nichts geleistet."

64. See *Theories of Art,* pp. 355 ff.

65. John Flaxman, *Lectures on Sculpture* (London, 1892), Lecture VI, esp. pp. 150 ff. Excerpts are now easily accessible in Elizabeth G. Holt, *From the Classicists to the Impressionists: A Documentary History of Art and Architecture in the Nineteenth Century* (Garden City, N.Y., 1966), pp. 22 ff. The sentences quoted are on p. 25.

66. Said in his first work, *Thoughts on the Imitation of Greek Works of Art in Painting and Sculpture.* I quote from *Winckelmann's Werke,* ed. C. L. Fernow (Dresden, 1808), I, pp. 23, 24, 38.

67. The full title reads "Sendschreiben über die Gedanken: Von der Nachahmung der griechischen Werke in der Malerey und Bildhauerkunst," as it appears in *Winckelmann's Werke,* I, pp. 63–116. For the sentence quoted, see p. 97.

68. The literature on this subject is wide, but has not been properly presented for handy use. But see the recent volume, edited by A. Portmann and R. Ritsema, *The Realm of Colour - Eranos 41-1972* (Leiden, 1974).

69. See particularly the article by Ernst Benz, "Die Farbe im Erlebnisbereich der christlichen Vision," *Eranos 41-1972,* pp. 265–323.

70. The first English translation, *The Principle of Harmony and Contrast of Colours and their Applications to Art,* was published in 1854. There were two translations in the nineteenth century, each going into three editions.

71. Philipp Otto Runge, *Hinterlassene Schriften,* (Hamburg, 1840–1841). A facsimile edition was published in Göttingen in 1965.

72. H. Steffens, *Was ich erlebte* (Munich, 1956), p. 213. The original edition appeared in Breslau, 1844, in ten volumes.

73. See the chapter on this subject in Rudolf M. Bisanz, *German Romanticism and Philipp*

Otto Runge: A Study in Nineteenth Century Art Theory and Iconography (De Kalb, Ill., 1970), pp. 86–96.

74. Runge, *Hinterlassene Schriften,* I, p. 80, from a letter written December 22, 1807. And see Bisanz, pp. 68 ff.

75. *Goethe's Theory of Colours,* translated from the German with notes by Charles Lock Eastlake (London, 1840). The figures in parentheses given in the text are the numbers of the paragraphs. The paragraphs are numbered in both the German original and the English translation.

76. See *Theories of Art,* pp. 291 ff., esp. p. 298.

77. The Greek term that Goethe used is a Plotinian concept, well known in the Neoplatonic tradition. Athanasius Kircher (1601/2–1680), Jesuit, scientist, and the most famous Egyptologist of his century, claimed—in Neoplatonic vein— that the Egyptians were the source of Plato's philosophy and the wisdom of Pythagoras. Goethe is referring to Kircher's *Ars magna lucis et umbrae* (Rome, 1646), in which he described the colors as "the children of light and shadow." This work by Kircher is permeated by traditional Neoplatonic thought.

78. See *Enneads* V,8,1 and V,8,5. I am quoting the English version of MacKenna. See *Plotinus: The Enneads* (London, n. d.), pp. 422 ff., 426.

79. See William S. Heckscher, "Goethe im Banne der Sinnbilder: Ein Beitrag zur Emblematik," in *Emblem und Emblematikrezeption,* ed. S. Penkart (Darmstadt, 1978), pp. 355–385.

80. I am here using the Berlin edition, 1879, of *Goethe's Werke,* Vol. 34 *Naturwissenschaftliche Schriften,* III, pp. 259 ff., esp. p. 261.

81. We know, however, that he did practice painting, and even arrived at some proficiency in it. For Goethe's familiarity with, and attitude to, the visual arts, see Herbert von Einem, *Goethe-Studien* (Munich, 1972).

82. For Gerard de Lairesse, see above, pp. 57 ff.

83. *Goethe's Theory of Colour,* p. 264.

84. See Ludwig Richter, *Lebenserinnerungen eines deutschen Malers: Selbstbiographie nach Tagesbuchnachschriften und Briefen* (Leipzig, 1909). I shall quote from this edition, giving the page numbers in the text (in parentheses). The copy I use is a reprint of the "Volksausgabe des Dürerbundes," that is, of a popular series. The work originally appeared in 1884, and two years later, in 1886, there was already a fourth edition.

85. For some of the literature, ancient and modern, on this subject, see my forthcoming study "Renaissance Color Conventions: Liturgy, Humanism, Workshops." Originally a lecture at a symposium, and will be included—as an article—in the volume that resulted from that symposium (held in Philadelphia, Pa.).

86. Cf. Edward Lockspeiser, *Music and Painting: A Study in Comparative Ideas from Turner to Schoenberg* (New York, 1973), esp. Chapter I.

5

The Artist

The century between 1750 and 1850, so we are accustomed to believing, opened up a new period in Western history. In the domain of the present study—attitudes to, and the interpretation of, the visual arts —the Enlightenment and Romanticism, those complex and multifaceted historical movements, indeed marked the emergence of a new stage. The revolution brought about by these movements affected every corner and aspect of the philosophy of art and of art criticism. It may seem obvious, yet it is not superfluous to emphasize again that in no respect was the upheaval more radical than in its effect on views of the artist. A new image emerged, far from simple or unequivocal, yet powerful and enduring; it is still with us today.

The "image of the artist," the conceptual label used here to designate a broad and unwieldly complex of attitudes, beliefs, and ideas, should not be taken in any narrowly limited sense. What we are here concerned with is not only the artist's social and legal position—an aspect that has attracted the attention of students dealing with late medieval and Renaissance art. In the period of Enlightenment and Romanticism, the "image of the artist" affects other, and broader, fields. It largely concerns the artist as a psychological type, and his relation to his work.

I. PHILOSOPHERS AND POETS

1. WILLIAM DUFF

Fascination with the artist's creativity and productive imagination was of course not an eighteenth-century invention. Yet in the second half of that century the problem acquired a significance it had hardly enjoyed in previous periods, becoming the central issue in the aesthetic reflections of Romanticism. This intensive concern with the artist's creative nature did not emerge first in the theory of the visual arts. Even when a painter or sculptor was the subject of discussion, the question of how an artist produced a work of art out of shapeless material did not arise, at this period, in the workshops or academies of art, and was not posed by an artist holding a brush or a chisel. In the eighteenth century the subject was mainly the province of philosophers and teachers of poetry, and from there was brought to bear on the painter's and sculptor's work. An interesting and significant document of this turn of mind in eighteenth-century Europe is William Duff's *Essay on Original Genius* (1767). William Duff (1732–1815) was a Presbyterian minister, prolific writer, and an important representative of the Scottish school of philosophical thought. The *Essay* surely represents his principal claim to fame.

That Willaim Duff was deeply rooted in the classical tradition goes without saying (the authors he most frequently quotes are Aristotle and Quintilian). It should be added, however, that he was also seriously concerned with the discussions of problems in psychology that were going on in his day. In fact, it is the combination of his two major sources, classical learning and "contemporary" psychological discussion, that formed his particular approach to the arts. He had no immediate connection or particular familiarity with the arts themselves. What occupied his mind was the general problem of creativity and genius; the arts were only the field where this problem could best be studied.

"The empire of genius," William Duff believed, "is unbounded" (91),[1] but his major concern was with poetry. "Poetry, of all the liberal arts," he assures his readers, "affords the most extensive scope for the display of Genius truly Original" (124–25). Yet he also considers some

of the other arts. "Though it is Poetry that affords the amplest scope for the exertion of the powers of Imagination," he says in a later chapter, "a very high degree of this quality may be discovered in some of the other fine arts" (188). The notion of "art," it should be kept in mind, is still fairly traditional in his usage; it encompasses philosophy, science, and also some of the mechanical arts. Yet, differing from the mainstream of the terminology accepted in the seventeenth and eighteenth centuries, it also includes part of the "fine arts." Of these, he says, "the art of Painting claims our first attention" (189). Painting, then, is also a recognized field for the display of genius, imagination, and the creative faculties.

Although the artist's creativity is the central issue of Duff's thought, he chooses a psychological term to describe his theme, speaking mainly of imagination. "That Imagination is the quality of all others most essentially requisite to the existence of Genius will universally be acknowledged," he says at the beginning of the treatise (6). But what precisely is imagination, particularly with regard to the artist? Our author's answer, though clearly indicating a direction of thought, is not without a certain ambiguity. "Imagination is that faculty whereby the mind not only reflects on its own operations, but which assembles the various ideas conveyed to the understanding by the canal of sensation, and treasured up in the repository of memory, compounding or disjoining them at pleasure; and which, by its plastic power of inventing new associations of ideas, and of combining them with infinite variety, is enabled to present a creation of its own, and to exhibit scenes and objects which never existed in nature" (6–7). Imagination, we understand, does two things. On the one hand, it assembles images (what Duff, perhaps influenced by the Greek of Plato, calls "ideas") and stores them in a repository, ready for use. The historian of art theory will remember Dürer's "assembled hidden treasure in the heart," [2] a description of what Duff calls the "repository." On the other hand, imagination also produces the radically new, it conjures up "scenes and objects which never existed in nature." The idea of a repository, and of reviving stored-up images in different combinations, is one that is very much in accord with the associationist psychology of Duff's time and school. [3] The idea of creating the radically new, though certainly not

new in itself, is the more important part of Duff's theory, and it is the part that had the greatest impact on theories of art in the eighteenth and nineteenth centuries.

Genius, to Duff, means creativity, which is synonymous with "original." By "the word Original when applied to Genius, we mean that native and radical power which the mind possesses, of discovering something new and uncommon in every subject on which it employs its faculties" (86). Every genius, then, is original. However, "original genius" refers only to the degree of the creative faculty: "the word Original, considered in connection with Genius, indicates the Degree, not the Kind of this accomplishment, and . . . it always denotes its highest degree" (87).

Duff uses yet another term to denote the inventing, mold-shaping function of the genius's fantasy: he speaks of "plastic" imagination. Thus, "a vigorous, extensive, and plastic imagination is the principal qualification of genius," he says (58). "Extensive" here probably refers to the range of images assembled in the repository of memory, while the adjective "plastic," it seems, indicates the very ability to invent, to create a mold where originally there was none. The latter is a specific quality of the genius's mind, and it should not be confused with imagination as such. Genius, Duff says, "is characterized by a copious and plastic, as well as by a vivid and extensive Imagination." And as if he felt that these terms were not self-explanatory, he adds: "by which means it [the imagination] is especially qualified to invent and create, or to conceive and describe in the most lively manner the objects it contemplates" (47). The inventive imagination, the ability to create an image out of nothing, is the ultimate criterion of genius.

In poetry, as we already know, the imagination of genius "is altogether absolute and unconfined" (125). What are the imagination's power and significance in the visual arts? Duff considers painting only. In a lengthy footnote, amounting to an independent little article (191–198), he compares the imagination of the poet and of the painter. The tradition of *ut pictura poesis* (as in painting, so in poetry), seeing literature and the visual arts as close parallels, was still a live, unquestioned reality in the mid-eighteenth century. The modern reader is, therefore, not surprised to find Duff immediately proclaiming that a very close affinity

prevails between the poet and the painter. But there are also differences, and in discussing how a poet differs from a painter our author foreshadows some modern trends of thought. "In most respects," we are told, poetry and painting are similar. It is the task of both to represent "human characters, passions, and events." To do this, both the poet and the painter employ imagination. But they use it to a different extent and in a different manner.

Let us first look at the extent to which the imagination is used. "A greater compass of Fancy is required in the Poet than in the Painter." The reason for this is the different way in which the two artists shape their works. The poet, Duff claims, must encompass a greater amount of reality than the painter. The object of his description does not stand still; what he wishes to show us are "fleeting objects," ever-changing situations. It is from these objects and configurations that the poet must "catch the evanescent form." The painter, on the other hand, is not involved in an unceasing struggle with the vanishing of his objects, he does not have to extract a form from fleeting, disappearing sights and events. He is rather "ingrossed by that single idea," whatever it may be, which he intends to express in his picture. Duff is referring here, of course, to the well-known idea that the structure of poetry follows the sequence of time, whereas the structure of painting is based on the simultaneity characteristic of spatial perception. This idea, needless to say, had frequently appeared in the preceding centuries, and it attained crucial significance in the decades that followed *An Essay on Original Genius.*[4] Duff approaches this familiar topic in a rather unusual way. The temporality of poetry as well as the simultaneity of painting were usually taken to refer to the modes in which a work in the respective art is experienced. We *read* the poem word *after* word, while we *see* all the parts of the picture at the *same* instant. Poem and picture exist, as it were, in different dimensions. What Duff says is something different. He does not deal with the mode of the work's existence; he asks rather how it comes into being.

It is not the whole art of painting, however, to which Duff accords the gift of imagination. The idea of a hierarchy of pictorial genres, one may be surprised to see, proves of enduring vitality. There are, we read, "inferior departments in the art of Painting," to be omitted from the

discussion as "foreign to our purpose" (189 f.). The noblest part of painting is, not surprisingly, history painting, and it is only there that the distinctions concerning "original genius" apply. They "will exclude all portraits in Painting, however excellent," they will also exclude "many descriptive pieces in poetry, though copied from nature, from any pretensions to originality, strictly considered" (190). The history painter, as well as the epic poet, take their theme from "an authentic or traditional relation of some important event," that is, from traditional lore, but what traditon provides them with is only the "groundwork of the picture," or, as we might say, the subject matter. "The superstructure however must in both cases be the work of those ingenious Artists themselves" (196 f.). If an artist, for instance, takes the "groundwork" from Scripture (what Duff calls "the sacred Writings"), he finds only a short description; "the Painter must imagine the rest" (199).

This restriction of original genius to history painting, and to epic poetry, perhaps more precisely indicates what Duff understands by "originality." It is the power of comprehensive invention, or, to use the medieval term, *creatio ex nihilo*. Painted portraits, and descriptive poetry, "may discover great vivacity and strength of Imagination; but as there is no fiction, nothing invented in either, they can only be regarded at best as the first and most complete copies of true originals" (190).

2. SULZER

The problem of creative genius preoccupied thinkers in all the centers of intellectual life of late eighteenth-century Europe. Though they all dealt with the same problem, their attempts to unriddle the mystery of how a genius produces a new reality took different forms. The contribution of the Swiss school, particularly that of Johann Georg Sulzer (1720–1779), is significant both as a reflection of how the problem was seen in another part of Europe, and as a source of continuing influence. Like William Duff, Sulzer was not primarily interested in the visual arts; his main concern was with literature. His discussion of how a genius shapes his work had a broad impact on the thought of his time; it also shaped the thinking of painters and sculptors.

The historical context of Sulzer's doctrine is the need to argue against the most famous and most deeply rooted interpretation of art, namely, as the imitation of nature. In the eighteenth century, the age-old imitation theory of art was reformulated in Batteaux's popular work, *Les beaux-arts réduits à un même principe* (The fine arts reduced to a single principle).[5] The principle at the basis of the fine arts, says Batteaux, is the imitation of beautiful nature. It is this principle that Sulzer rejects. "In my dictionary [that is, the systematic work] I shall show," Sulzer wrote to a friend in 1756, "that Batteaux's principle is no principle at all." What Sulzer rejects is not the qualifying word "beautiful" (in "beautiful nature") but rather the basic idea itself: that art is an imitation, and that the work of art emerges in a process of imitating an external reality.[6]

But what can replace Batteaux's principle? It is here that Sulzer's notion of a "pre-forming art" appears. As against the time-honored theory, surrounded by the aura of Aristotelian authority, that art is essentially an imitative activity, that it reproduces the images and appearances of objects in nature, Sulzer suggests that art does not at all imitate the individual object encountered in the outside world. To be sure, art does follow nature, but it does so in a broad and general way, not by portraying the objects that surround us, but rather by imitating the manner in which nature acts and produces the objects and creatures we see. The idea that "Nature" is not simply a collection of material objects, that it is, rather, a comprehensive system of interacting forces —this idea was not new. Creative nature was a well-known theme in European thought on art.[7] The juxtaposition of *natura naturans* (active nature, creative forces) and *natura naturata* (passive nature, material objects) was also employed in order to understand, and explain, the mystery of the artist's production. Sulzer, inheriting these thoughts from former generations, believes that by "pre-forming" in his mind the objects and shapes he will later represent in his works, the artist acts like Nature herself.

Sulzer's notion of a "pre-forming art" clearly derives from Platonic thought, even though his doctrine does not precisely correspond to Plato's system. The late eighteenth century here draws directly from that great tradition of aesthetic reflection that was concerned with the

artist's *idea,* and that tradition, as we know,[8] was profoundly determined by Platonic thought. It was from this tradition that the modern notion of "ideal" emerged. Sulzer is one of the links connecting the tradition of the artistic *idea* with the modern "Ideal" in aesthetics. He regards the Ideal as the artistic vision from which the work of art emerges. "By this word [Ideal] one expresses every original image *(Urbild)* of an object of art which the artist's imagination has shaped with some likeness to natural objects, and after which he [the artist] works."

Given these contexts and sources, one is not surprised to find that Sulzer sharply distinguishes imagination from imitation, or the image produced in the artist's mind from the images he perceives in his visual experience. The former, also called the Ideal, is the source and origin of the work of art. "Of any object of art that has not been drawn after an object present in nature but has received its essence and shape from the artist's genius, one can say that it is made after an Ideal," says Sulzer. This is so, it seems, even when the shapes seen in the work of art are "similar" to the shapes of objects seen in nature.

Sulzer takes up, and strongly rejects, the age-old metaphor of painting as a mirror of nature. Originally the metaphor indicated how fully and precisely the artist imitates nature. Thus, when Leonardo da Vinci requires that the artist be a mirror, he wishes to emphasize the value of the work of art when representing, fully and precisely, what one sees in the outside world. To Sulzer the mirror has an altogether different meaning: he sees in it the passive reflection of what happens to stand in front of us, the lack of spontaneity. The artist, he says, is not a "dead mirror." The mirror cannot help reflecting precisely, without change or transformation, what happens to be in front of it. The artist does the very opposite: he spontaneously produces his object, and he may therefore be said to act as Nature acts.

Emphasizing the productive, creative nature of genius in art leads Sulzer to a discussion of still another ancient theme. This is the so-called "election doctrine," which attempts to explain how the artist is capable of producing a perfect, "ideal" form. Ever since Antiquity it has been suggested that the artist chooses the most beautiful and most appropriate parts in nature, and combines them into one single figure. Best known is the story of the classical sculptor who, given the task of

carving an image of Aphrodite, chose the five most beautiful maidens, and then copied from each of them "the most beautiful parts," to combine them into the ideal statue of the goddess.[9] This theory prevails in a great deal of Renaissance and Baroque reflections on art. In the eighteenth century, too, the election doctrine was the primary model for explaining how an artist is capable of shaping an ideal form. Mengs, himself a celebrated artist and president of the Roman Academy of Art, as we have seen, upheld the orthodox doctrine. By the Ideal, he says "the artist is understood, to make a good selection in nature, not to invent new things."[10]

Here, one is not surprised to find, Sulzer sharply disagrees. To be sure, the artists who, "with consideration and taste, choose the best in nature" are superior to those who "stick precisely to nature, and pick the objects [models] they need as these happen to be encountered, without selecting the better ones." Yet even those artists who have "consideration and taste" do not reach the zenith of art. To the highest class belong only those artists to whom, as Sulzer put it, "nature can no longer be sufficient, and who, by the creative power of their genius, shape ideal forms of their own."

Sulzer seems to have held—though he was never quite clear in this respect—that he had a different view of the nature of the Ideal from that accepted in his time. To Winckelmann, the Ideal primarily indicates perfection, the full attainment of the aim. The art of the ideal, therefore, is roughly concomittant with rendering the essential in nature, the complete and typical character of the phenomena we experience. It was this aim that Greek art achieved with flawless purity. Sulzer, on the other hand, stressed time and again that the true Ideal transcends Nature. What he probably meant by this was not only that the Ideal does not depend on the individual object or shape in nature (that would have been generally accepted), but that it does not derive from Nature at all, even if we understand Nature as an overall system. Pefection in art, the very essence of the Ideal, he says, derives not from nature but from genius. Perfection is a quality by which "the works of great artists acquire a power higher than the one found in the natural objects of taste and emotion."[11] Only men of great genius, our author claims, are able to produce ideal shapes, superior to nature in perfec-

tion. Goethe ridiculed Sulzer's views; his ideal shapes, the great poet said, hover "high up, in the empyrean of transcendental beautiful value." [12] While Sulzer's attempt to detach the Ideal from nature invites criticism, it nevertheless shows where the focus of his thought, and largely that of his generation, lay.

3. WACKENRODER

In reading William Duff and Johann Georg Sulzer, we have seen the beginnings of a Romantic theory of art. This theory reached a climax in the thought of a young German writer, Wilhelm Heinrich Wackenroder. His literary work was composed during a very short span, from 1792 to February 1798, when he died at the age of twenty-five. In quantity, Wackenroder's work is rather limited: including letters and travel diaries, it consists of no more than five hundred small printed pages. The modest volume of this oeuvre, however, stands in marked contrast to its influence, in breadth as well as in depth, on intellectual life in Europe, and particularly on the spiritual climate of discussions of art during most of the nineteenth century.

Wackenroder's impact was felt in many fields. He is one of the founders of a particular literary genre, the "novel of the artist" *(Künstlerroman),* that lives on to our own day. He played an important part in engendering a renewed interest in early German art, particularly Dürer. His image of that artist will hardly be accepted by the historian (he pictured Dürer, the great humanist who admired Italy and was attracted to the new message coming from it, as a deeply pious artisan who humbly clung to the supposed local traditions of workmanship), but it exerted a profound influence. Wackenroder strongly influenced the pre-Raphaelite movement in painting and its literary interpreters. His most important legacy, though it is difficult to pinpoint precisely, is his contribution towards placing a new theme in the center of aesthetic reflection—the theme of conflict between the artist and his audience, or society. It is now common knowledge that this was to become a central *topos* in Romantic thought on art, a cardinal part of the modern world's inheritance from Romanticism.

Wackenroder's emotional style—effusive in wording, exalted in tone

—does not make for easy reading. The modern reader often wonders how these texts could have had such an effect. Wackenroder's best-known composition, the *Confessions from the Heart of an Art Loving Friar* (1797), reveals both the author's views on painting and poetry and the atmosphere he wishes to create in the contemplation of works of art.[13] The mask of an "art-loving friar" may well be assumed in answer to a desire for anonymity. It also suggests how closely, in Wackenroder's view, art is related to religion. The writing is rich in connotation. What it lacks in clarity of exposition and directness of statement, it makes up in what may be called "atomspheric effect" and evocative power.

Wackenroder devotes a great deal of attention to the spectator's experience, and to what should be the beholder's appropriate attitude to the work of art he contemplates. It marks his historical position that he takes it as a matter of course that the spectator's experience is part and parcel of the theory of art. The interest in the spectator's experience should not however be mistaken for any kind of critical attitude. On the contrary, with a truly religious fervor, he asks the spectator to forego any criticism, not to pass judgment, but to open up his heart to the work of art he is experiencing. Even praise of a painting is not a proper attitude. "It is not sufficient to say in praise of a work of art: 'It is beautiful and excellent,' for these general phrases apply to the most varied works;—we must be able to surrender ourselves to every great artist, look upon and comprehend the things of Nature, with *his* senses and speak in *his* soul: 'The work is *correct* and *true* in its way' " (129; 85). As the spectator fervently desires to identify with the specific work of art he is looking at, he necessarily gives up any attempt to compare it with any other work of art; he resigns, as it were, his position outside the work of art he is seeing. Experiencing a great work of art becomes a kind of *unio mystica*.

The spectator who fully "surrenders" to the work of art before him, Wackenroder was certain, is granted an intuitive grasp of its essence and character. This notion, to be sure, is not discussed in theoretical terms, but the belief reverberates through most of Wackenroder's writings. Our whole person, he suggests, takes part in intuitively grasping the work of art to which we are surrendering. In his article on Dürer, included in the *Confessions,* we read: "All of the figures speak;

they speak openly and with refinement. No arm moves superfluously or merely to please the eyes and fill up the space; all of the limbs, everything speaks to us as if with force, so that we comprehend with genuine firmness the meaning and the soul of the entire picture. We believe everything which the artistic man presents to us; it is never blotted out of our memory" (113;59). In devotedly experiencing a picture we perceive its message, as we understand the will of God while we are immersed in devotional contemplation. "I compare the enjoyment of the more noble works of art to prayer," said Wackenroder (126;79). Looking at a work of art has an affinity to witnessing a revelation.

What precisely is it that is revealed in the work of art? After the spectator has fully "surrendered" to the work he is contemplating, what does he actually perceive? Put in less metaphorical terms, the question might read: what are we looking for when we look at a work of art? The answer is far from obvious. The reader notes that a considerable part of Wackenroder's literary legacy, particularly in the *Confessions*, consists of descriptions of paintings. So significant is the part played by these descriptions that one is tempted to see here a revival of *ekphrasis*, that ancient literary genre that consisted of the description of—real or imaginary—paintings. The *Confessions* even include a chapter on "How and in what Manner one actually must regard the use of the Works of the Great Artists of the Earth for the Well Being of his Soul" (125–127). But if one now turns to his descriptions in the hope of finding some information about the paintings described, one is bound to be disappointed. Our author altogether neglected the material nature, the sensory aspect of the paintings he was describing. In Wackenroder's *Confessions*, Heinrich Woelfflin noted, we do not find "descriptions" of a specific painting, but rather poetic fantasies on a given subject.[14] What, then, does Wackenroder look for in a painting?

The answer to this question, I believe, shows, why Wackenroder found such abundant echo in the culture of Romanticism. What the spectator looks for, and indeed finds, in a painting are not the material or formal components of the painting itself; the true subject of the spectator's vision, in Wackenroder's view, is the personality of the artist. The work of art, it turns out, is only a stepping-stone on our way

to the artist, a medium through which we can meet him. An article on Albrecht Dürer, published posthumously in *Fantasies on Art for Friends of Art* (1799) (and not to be confused with the article on Dürer included in the *Confessions*), opens with a remarkable statement: "It is a delightful matter to recreate in one's mind an artist deceased long ago from the works which he left behind and, from amidst all the various lustrous beams, find the focal point to which they lead back or, rather, the heavenly star from which they emanated. Then we have before us the World Soul of all creations,—a poem of our imagination, from which the actual life of the man is completely excluded" (164): Not only are we not looking for dates, authroship, or any other kind of "external" information; in truth, we are not even looking at lines, brush strokes, or chisel marks. The best way of seeing a picture, it appears, is to look through it. Before the works of Raphael, Wackenroder says, you forget that there are colors and an art of painting (91). A Renaissance artist might have continued such an exclamation by claiming that you forget the art of painting because you believe the objects in the picture to be real objects. Not so Wackenroder. You forget that there is an art of painting, he thought, because you encounter the artist directly. Looking at a picture, we are in a semimystical way perceiving the creative artist himself. It is with him, with the rich life of his soul, that the spectator is identifying.

A central theme in Wackenroder's thought is the process—or, if you will, the mystery—of artistic creation. His fascination with Raphael, Leonardo, and Dürer is not focused on the individual products of their genius (we have just mentioned how little attention he in fact devotes to the specific work of art). But, in fact, he is also not very much concerned with the individual character of the painter as a unique human being or as a special psychological type, and he shows little interest in the events of his life. What attracts him in these great artists is their creative activity. He studies them in the hope that this will help him to understand how the mind of an artist works, how he creates his work.

The question is not new. The problem of the artist, in one way or another, has occupied the mind of many periods. Since the sixteenth century at least, the question of whether, or not, the artist is the true

origin of his work had stirred philosophers and artists. It was asked: how is it possible for the artist to produce his work, and how far, if at all, does the work bear the imprint of his personality? Notwithstanding the recurring concern, earlier periods did not provide a sufficiently articulate framework for a thorough discussion of the creative act. However one may consider the articulation of the concepts of creation in the aesthetic thought of former ages, in Wackenroder the conceptual framework, and even the terminology employed, belong to the religious traditions of German Pietism.[15] While he obviously does not use pietistic notions to analyze artists as religious individuals, he found in that tradition the conceptual tools for a discussion of creativity.

Looking back at Wackenroder's work from a distance of two centuries, it stands out for his attempt to shed light on the artist's creative act. Instead of conceiving of that act, which has puzzled so many thinkers, as of an instant, a momentous, but shapeless illumination, Wackenroder describes it as a structured process, the stages of which can be distinguished separately. Our author was of course well aware that the mystery of the creative act is one that the artist himself cannot fully penetrate. He makes Raphael say to an imaginary pupil that he, the great master himself, cannot explain how he paints his Madonnas —"not because it is a secret I would not want to disclose ... but because I myself do not know it" (93). Wackenroder nevertheless describes and analyzes, though implicitly rather than openly, what happens when a painter produces a picture.

The creative process begins with a stage of half-conscious probing. Wackenroder must have been one of the earliest authors to assume that the process of artistic creation does not begin with a bright idea or vision, but rather with a stage called "dark presentiment" *(dunkle Ahnung)*. In this stage, the artist does perceive something, some general contour, of what the work of art will eventually represent and what it will look like, but he perceives it in a blurred, confused, "dark" fashion. The notion of "dark presentiment," of a vague intuition as the beginning of the artist's labor, was not unheard of around the turn of the century. Karl Philip Moritz, the influential philosopher of aesthetics and poetics, speaks of a *dunkle Ahnung* through which the work materializes in the poet's mind.[16] Friedrich Schiller wrote to Goethe, on the 27th of

March 1801, of a dark, but powerful comprehensive idea *(Totalidee)* that precedes all technical efforts. Wackenroder belongs to the same broad school of thought. He stands out, however, by making "dark presentiment" a full-fledged stage in the creative process, and by specifically applying it to painting.

Wackenroder does not offer his views on the creative process as a systematic doctrine; they are rather implied in his descriptions. Raphael, for example, always desired to paint the Virgin, until finally he decided to do so. Since that decision,

Day and night his mind had constantly worked on her picture in abstraction; but he had not been able to perfect it at all to his satisfaction; it had always seemed to him as if his fantasy were working in the dark . . . occasionally the picture had fallen into his soul like a heavenly beam of light, so that he had seen the figure before himself with vivid features, just as he wished it to be; and yet, that had always been only a moment and he had not been able to retain the conception in his mind. (84)

In that initial stage, the artist's state of mind is one of restlessness, anxiety, and pain. Raphael prays to the Virgin in his dream (84), the musician Joseph Berglinger sheds tears. At this stage, the artist employs different techniques designed to help him overcome the "darkness" of his perception, and to make him arrive at an articulate form. Wackenroder uses Renaissance literature to picture the artist's struggles in this early stage of his work. Piero di Cosimo, so our author freely transcribes Vasari and Leonardo, "frequently fixed his eyes rigidly on old, patched, many-colored walls or on the clouds in the sky and, from such workings of Nature, his imagination seized various fantastic ideas about wild battles with horses or about huge mountain landscapes with strange villages" (122).[17] The artist longs to be redeemed from the pain and stress of that initial, "dark" stage of creation.

The second stage in the creative process, as Wackenroder saw it, can be described as that of inspiration. It is mainly now that what is called "creative imagination" comes into play. In the late eighteenth century the theory of genius could not be fully separated from the doctrine of creative imagination. The creative imagination itself was either rationalistically explained as a maturing of memories (as by Sulzer) or it was

considered a divine gift (as by the German philosopher Hamann). Wackenroder is closer to Hamann. Sulzer's explanation of genius, he says in a letter of June 12, 1792, is "so frosty and superficial, so little philosophical, as is everything of this kind in his work." In fact, Wackenroder also learned from Sulzer. However, in the matter of inspiration he was following the doctrine of a divine source.

Inspiration, in the author's view, is the moment at which the Ideal, intuitively yet darkly felt in the first stage of the creative process, appears to the artist's vision; now it can be perceived by the senses. The example adduced is, once again, Raphael. Wackenroder refers to Baldassare Castiglione's report of Raphael's relying on "a certain mental image" of feminine beauty residing in his soul in order to represent a beautiful goddess.[18] Modern students have noted that while Raphael made this reference to a mental image in connection with depicting a pagan goddess (Galatea), Wackenroder applies it to the representation of a Madonna. The substitution of a Holy Virgin for a pagan goddess, however, is not significant for our purpose. What remains in both cases is the central characteristic of this stage: the following of a mental image. Here the Romantic critic does indeed depart from his Renaissance source. Whereas Castiglione seems to consider the "certain mental image" as a stable *idea,* Wackenroder describes it as a momentary illumination, a kind of sudden revelation.

The clear vision, the sudden revelation, it is important to note, is not immediately linked to the actual painting of the picture. Raphael perceives the vision at night, in a dreamlike fashion. It "remained firmly stamped on his mind and his senses for eternity." Therefore, the artist "succeeded in portraying the Mother of God each time just as she had appeared to his soul" (84–85). The articulate vision marks a separate stage in the creative process.

The modern critical student will of course note, possibly with some scepticism, that the Virgin's articulate "appearance," which does not originate in the artist's soul or mind, closely corresponds to what he had "darkly" intuited in the first stage. Wackenroder felt this difficulty. "The most wonderful aspect of all," he says, "was that he [Raphael] felt as if this picture [the one he saw in the dreamlike appearance] were precisely the one which he had always sought, although he had only a

dim and confused conception of it" (84). The marvel of this correspondence can be understood only by assuming some outside agent, either a divine plan or a Platonic idea, inspiring the artist during his struggles in the "dark" period and "recognized" by him in the nocturnal appearance. Based on the analysis of some metaphors, mainly of light, the Platonic alternative has been suggested as the more likely one.[19]

Be that as it may, the advent of the inspiration is a breakthrough, an extraordinary experience that changes the artist's life and perhaps also his nature. Wackenroder speaks of the artist's "consecration" *(Weihe)* in the wake of this experience. Raphael, the reader is told, "had suddenly started out of his sleep, violently disturbed. . . . The divinity in the picture had so overpowered him that he had broken out into hot tears. . . . The next morning he had arisen as if newly born" (84). Experiencing the inspiring vision is linked to a state of heightened consciousness. Thus Wackenroder makes Raphael write to a supposed pupil that he executed his pictures of the Virgin as if in a "pleasant dream (93). The dreamlike character of his mental state indicates the unusual, supernatural mode of consciousness. Wackenroder's language in describing these states is deeply influenced by the language of German Pietism; the formulations often remind one of those of Jakob Boehme, the great seventeenth-century mystic.[20] Boehme was popular in the literature of German Romanticism, and Wackenroder may have been attracted to him particularly because of his descriptions of a heightened state of consciousness.

When the artist has experienced his inspiration, and after he has perceived the clear and articulate vision, the work of art is not yet shaped. This happens in the third stage of the creative process. It is the stage in which the idea is materialized in matter, the picture is actually painted. The basic requirements of this stage are skill and technique, and Wackenroder's attitude to them is ambivalent.

One is not surprised to find that he rejects rules, and that he sharply criticizes the artist who exhibits formal effects for their own sake. He praises Dürer for his "seriousness," and juxtaposes this characteristic against the fascination with formal display to which so many artists fall victim. The discussion of artistic values here becomes a criticism of society and a statement on the Romantic ideal of man. The more recent

artists, Wackenroder writes, do not "want one to participate in that which they portray for us; they work for aristocratic gentlemen, who do not want to be moved and ennobled by art but [rather] dazzled and titillated to the highest degree; they strive to make their paintings specimens of many lovely and deceiving colors; they test their cleverness in the scattering of light and shadow;—however, the human figures frequently seem to be in the picture merely for the sake of the colors and the light, I would indeed like to say, as a necessary evil" (113–114).

Manual dexterity and the mastery of artistic techniques, on the other hand, can serve the manifestation of the spirit, making the artist's vision accessible to the beholder. In the introduction to his essay on Leonardo da Vinci, Wackenroder warns the reader against those artists who, "armed with superficial and fleeting pseudo-enthusiasm, take the field against serious, well founded scholarship" (97). Our author extols Leonardo's "industrious observation" of the reality around him. Leonardo knew that "the artistic spirit ought to . . . roam about assiduously outside of itself and seek out all the forms of creation with agile dexterity and preserve their shapes and imprints in the storehouse of his mind" (99).

In spite of Wackenroder's strong leaning towards what he calls "the spiritual," he does not altogether disregard that stage in the creative process in which the painter actually paints the picture. Here, however, he points to the danger of overevaluating the specific characteristics of this stage—the virtuosity and "cleverness" of formal effects. Carefully reading Wackenroder's writings, one perceives that no such danger exists with regard to the first stages of the process—dark intuition and inspired vision. The execution of the work of art in the material medium is the only part of the creative process that, while necessary, is ambiguous in character.

Wackenroder even goes a step further. In considering the work of art itself, he applies to it the distinction between "inner" and "outer," a distinction so popular in Romantic thought. In the real work of art as we actually experience it—painted on canvas or carved in stone—he looks for an inner kernel and an outer shell.

The distinction between "inner" and "outer," as one knows, ultimately derives from the belief in the existence of a higher, "true" world

of which the world of our senses is only an insufficient, pale reflection. This distinction, a cornerstone of the Platonic tradition in European thought, was also applied to beauty. Wackenroder shared this belief. Every creature, he says, strives towards the beautiful, but it can never go beyond itself. We perceive what we can see of beauty, never absolute beauty itself. Only in moments of ecstatic intuition are we able to *name* universal, original beauty, but we are not able to reproduce it. We are always forced to content ourselves with our impressions. Therefore, a multitude and variety of impressions rules our realm; only God can perceive absolute beauty. "Just as a different image of the rainbow enters into every mortal eye, so too does the surrounding world reflect for each individual a different imprint of beauty. . . . However, universal, original beauty . . . reveals itself unto the One who created the rainbow and the eye that beholds it" (111).

These ideas, we need hardly stress, were the common property of all periods from the beginnings of Neoplatonism to Romanticism. Restating them was, then, hardly a startling innovation. But Wackenroder surprises the student by taking it for granted that the cosmic split between "inner" and "outer" also applies to the individual work of art. To be sure, it is often not easy to say in just what the "outside" of a painting (or, for that matter, of a poem) consists, as opposed to its "inner" being. Mainly, it would seem, the "outer" shell, or being, of an art work is supposed to consist in its form, and in its materialization in a specific medium. Everything that does not instantaneously emerge, but is produced with reflective consideration would seem to the Romantics as closer to the "external." In the late eighteenth century, this notion may have been linked with the theory of signs, particularly with the distinction between what were then called the natural and the artificial signs. Thus, Moses Mendelssohn believed that movements, tones, and gestures are natural signs, being linked to the "thing itself," whereas language, being derived from deliberate agreement, is a system of conventional signs.[21] Wackenroder, like other Romantics, also considers language as "external;" it is based on conventions that were deliberately set up. The understanding of language also means to go beyond the words and sentences themselves. This, in a sense, enhances the value of the visual arts. "A precious painting," so we read in his essay on how

to experience works of art, "is not a paragraph of a textbook which, when with a brief effort I have extracted the meaning of the words, I then set aside as a useless shell; rather, in superior works the enjoyment continues on and on without ceasing. We believe we are penetrating deeper and deeper into them and, nevertheless, they continuously arouse our sense anew and we foresee no boundary at which our soul would have exhausted them" (127).

Statements like this make the notion of the "external" in a painting even more problematic. If the visible appearance of a painting, its lines and colors, its shapes and tones, cannot be set aside like a useless shell, but rather continuously arouses our sense, does it mean anything to describe it as "external"? In what way, indeed, is it external? Wackenroder never provides an answer, nor do the other Romantic authors who, in one way or another, use, or allude to, this distinction with regard to painting. There is a vague, though powerful, feeling of the distinction between inner and outer in the picture, but this feeling never crystallizes into conceptual clarity.

The concept of the painting's "inner" nature is not much clearer or easier to demonstrate than that of its "external" aspect. The "inner" nature of a painting, it should be said at once, is not its contents, the subject matter or theme, as opposed to the form, which might be seen as external. The division between "inner" and "outer" does not correspond to the division between subject matter and form. It has been noted that when Wackenroder juxtaposes "inner" and "outer," his language becomes particularly vague. Nevertheless, it seems possible to claim that his views of the "inner" nature of a painting oscillate between two meanings, which, for want of better terms, may be called emotional and metaphysical.

In one sense, then, the "inner" nature of a painting consists of the emotions the picture conveys or evokes. Often Wackenroder equates "inner" with human emotions or the human mind. Particularly in speaking of works of music, he describes their "inner" nature as the preserved emotional life, whether of the composer or the listener. But for pictures, too, this interpretation is valid.

Another sense of the "inner" is less psychological and emotional; it rather points to different levels of being. The inner nature of certain

paintings, one feels in reading, is the manifestation, or perhaps the embodiment, of a superterrestrial reality. The language of art, Wackenroder believes, reveals "things celestial," or "the secrets of the skies." To be sure, it is not always clear what precisely he means by these metaphors. Are the "things celestial" the infinity of the universe, or the mysteries of a religious divinity? Though the answer is not clear-cut, it is obvious that they are not identical with our emotional life, with our subjective desires and longings. The "inner" may be elusive, it may not be possible to grasp it, yet it is conceived as an objective reality.

In the end, it may not be essential to define the precise nature of the "inner" being of the work of art. What is crucial is the feeling that there is more than can be clearly expressed, that a work of art holds more than meets the eye. What the division between "inner" and "outer" ultimately leads to is the insight that the work of art is an insufficient reflection of what it purports to represent.

It is not surprising that Romantics, so profoundly aware of the rupture between hidden meanings and visible forms, were attracted by the concept of the hieroglyph. Whenever one wished to indicate the failure to transmit completely the inner experience or inkling in the outer appearance, the image of the hieroglyph offered itself as a metaphor endowed with the authority and mystery of ancient, secret wisdom. The language of art, Wackenroder said, is "dark and mysterious," but it has a marvelous power over our mind and experience. "It speaks through pictures of human beings and, therefore, makes use of a hieroglyphic script." We understand the symbols of this script, he says, but only "in their external aspect" (119). All this reinforces the sensation of the unbridgeable gap between what is to be said and our ability to say it. As a revelation of the divine, the painting is as insufficient as the text. What it can do is to stir our emotions. Art "fuses spiritual and representational qualities" in such a "touching and admirable manner that, in response, our entire being and everything about us is stirred and affected deeply" (119). The work of art, like the hieroglyph, does not fully reveal the divine, but it affects our emotional being. If the painting is not a true revelation, it is and remains an expressive artifact.

4. SOLGER

The development of reflection on art is a complex process, and it sometimes yields surprising results. Thus it occasionally happens that the most perfect expression of an intellectual leaning or a trend of thought is found outside the mainstream and the great schools considered representative of that leaning or trend. This seems also to be true for the Romantics' idea of the artist's creative imagination.

Karl Friedrich Wilhelm Solger (1780–1819), an important figure in the history of Romantic aesthetics, strays markedly from the main current of German philosophy in the age between Kant and Hegel; he also diverges significantly from the tradition of the painters' reflections on their art, as we know them from his contemporaries, Runge and Caspar David Friedrich. But although Solger stands alone, his discussion of the artist's creative imagination is perhaps the most enthralling one bequeathed by Romanticism to succeeding generations. What he has to say on this problem also reveals, more than does any other treatment of the theme, the questions and paradoxes that remained without solution. Thus, though remaining outside the mainstream, Solger's thought is a landmark in the development of aesthetic reflection at a crucial stage in its development.

Solger's major work, *Erwin: Vier Gespräche über das Schöne und die Kunst* (Erwin: Four Dialogues on the Beautiful and on Art), appeared in 1815. His *Vorlesungen über Aesthetik* (Lectures on Aesthetics) appeared, posthumously, in 1829.[22] The *Erwin,* in many respects a strange work, refers obliquely to some contemporary discussions, but the author never tells us clearly what precisely they were. Although the book is cast in the form of a dialogue (as the subtitle announces), its style is sometimes abstract and obscure, which does not make it easy for the modern reader to make out what these discussions were. Solger is a deductive thinker who tries to derive complex results from original but very general truths; the *Erwin* is perhaps the first deductive aesthetics ever to be published. It is true that this work, like Solger's system in general, has little actually to offer by way of explaining specific paintings or sculptures, but the ideas it proposes—albeit in an abstract and philo-

sophic language—make an important contribution to our understand-
ing of Romantic, and modern, theory of the visual arts.

A central concept in Solger's system, a notion from which he tries to
derive all the others, is "imagination" *(Phantasie)*. Now, the notion of
imagination, we have had ample occasion to see, was frequently em-
ployed in aesthetic discussions of Romanticism, but several rather
different things could be meant by it. Solger, too, has more than just
one reading of the term. He distinguishes imagination *(Phantasie)* from
imaginative power *(Einbildungskraft)*. The latter is a faculty of the soul
that, "departing from the real things and our experience of their
appearances, shapes from this material specific figures according to our
needs" (100).[23] In other words, while "imaginative power" is seemingly
a productive faculty, it is wholly subordinated to our natural drives and
passions (our "nature," one might say), and it derives its material from
our individual sensual experience of nature.

Imagination proper *(Phantasie)* is given a different, rather speculative
interpretation. Possibly following some eighteenth-century leads,[24] Sol-
ger attempts to set apart a "higher" productive imagination from mere
"imaginative power." Only imagination is the organ of art. To be sure,
higher imagination encompasses more than art alone. For Solger, as for
some other Romantic thinkers, art and religion are linked to each other,
and their common bond is also reflected in the fact that imagination is
their common organ. Solger conceives imagination proper as the mirror
image of divine creativity. "The power within us that corresponds to
the divine creative power, or rather in which the divine powers come
to real existence in the world of appearances, is imagination" (199).
Imagination, so says Erwin, the primary interlocutor in the dialogue
that bears his name, is a "real [human] activity that is the revelation of
a divine one" (309).

Imagination, bridging the gap between the infinite and the finite, has
two faces, as it were, or, if you prefer, it moves in two opposite
directions. As "religious consciousness," it is oriented towards the
"innermost of the divine," it tends towards God himself; as "artistic
consciousness," it is an outpouring from the "innermost of the divine"
into the world, and it brings out a whole cosmos of fantastic figures
and shapes (307). The action of the imagination, then, is not subject to

the arbitrariness of human decision. As it encompasses the revelation of the divine, its powers go beyond those of the human artist. It is for this reason that Solger can call the religious and the artistic consciousness "the prophets and interpreters of God" (210).

The artist's task is to catch the images in the fantasy and to transform them into stable objects that we (the audience) can perceive by our senses. But the work of art, so it follows from Solger's thought, is not simply the result, or product, of imagination, a product divorced from the activity that brought it into being. Imagination as a living motion, as a process of unceasing creation, must somehow be present in the completed work. To be sure, it is difficult for us to see this unity of the cast form—the work of art—and the living motion, the creative fantasy. But this difficulty only shows how weak our perception is. That we distinguish between the idea and the work of art—this, Solger says, merely derives from the nature of our thinking (218). But in fact the work of art constantly refers to the act of creation. It is for this reason that we conceive of the work of art as of a symbol. "In this sense," Erwin says to his partner in the dialogue, "all art is symbolic." But as if to preclude any other interpretations, he adds: "but in this sense only" (218–219).

The symbol is a crucial notion in Solger's thought. A great deal of his aesthetic system rests on the distinction between what he calls symbol and allegory, a distinction not unknown at the time. The philosopher Schelling, generally considered to be Solger's master (though the relationship between them seems to have been rather complex), suggested a differentiation between schema, allegory, and symbol.[25] But while Schelling conceives of the triad as "general categories," applicable to a wide variety of phenomena (nature, science), Solger limits them to art.

Symbol and allegory, Solger believes, are universal modes of art. The difference between them is not one of value—the one is not better or worse than the other; it is a difference of nature. The symbol includes "not only the completed work, but also the life and activity of the forces [that brought it about] themselves" (223). It is, then, the unity of the thing and the motion, of the product and the production. Allegory, on the other hand, is closer to what we would today call a sign. The

dividing line between these two modes of imaging and depicting, Solger stresses, can rarely, if ever, be sharply drawn.[26] What he means by this distinction, particularly with regard to the visual arts, can best be seen in his discussion of the examples he adduces.

"In the symbol we have an object in which the activity has saturated and exhausted itself; the material, by letting us perceive the activity, gives us the feeling of calm and perfection," says Solger in the *Vorlesungen über Aesthetik* (130). Such objects were created, in purest form, by the Greeks. The Greeks did not create "pure forms [or] pure concepts," the directions into which the Idea disintegrates; they created "live persons, defined from all sides," he says in *Erwin* (227). "And what else," he continues, "is the essence of the symbol if not that intimate and inseparable blending of the general and the particular into one and the same reality?"

In the allegory the relationship between the general and the particular is different. The "intimate and inseparable blending" is gone, and instead we have here a falling apart of the two components. Solger stresses that the individual object does not necessarily stand for the general idea; a generic object can also stand for a particular idea. To use his examples: a particular nail can stand for the general idea of necessity, but a human figure—in itself, the most general image in art—can stand for a particular city (*Vorlesungen,* 133 ff.). Essential, then, is not the direction, but the fact that the two components do not overlap. This is best made manifest in Christian art. The idea, or the general meaning, goes far beyond the specific figure that represents it. The supremacy of the idea over the figure, of the general over the particular, characterizes "modern," that is, Christian, art. To be sure, a Christian allegorical figure is not just a "sign," the relationship between them is not arbitrary, but it lives in a cleavage.

Symbol and allegory, we should remember, are not only characteristic of great historical periods; they are also always courses of the imagination. The artist, in principle, can approach reality, or his subject, in a symbolic or an allegorical mode.

II. THE PAINTERS

1. THE CHARACTER OF THE ARTISTS' STATEMENTS

Romantic poets and philosophers, critics and literati, when discoursing about art, seem to have moved on an exalted plane. Yet the air around them, one cannot help feeling, was rather thin. They claimed for the ideas they pronounced an almost universal validity; the notions they employed were world-embracing. Yet often it seems that they have little to do with the work of art as a real object, or with the painter's job, as we all know it. What then, one asks, did the artists themselves have to say to this intellectual and emotional spiritualization of their craft? Romantic reflection on painting is not of a kind to yield a simple, clear-cut answer. And yet one cannot help formulating certain questions.

In studying the texts written by the artists themselves, one again encounters ambiguous attitudes and statements. On the one hand, many painters around 1800 were reflective and articulate. A sophisticated use of words, in both oral and written form, was common among them. Moreover, they obviously felt the need to account, to themselves as well as to their audiences, for their aims and strivings and to explain the principles that informed their efforts. On the other hand, they did not write systematic expositions, nor did they set forth their views in an orderly and didactic manner. Their literary legacy, as we now know it, may be voluminous at times, but it is made up primarily of personal documents, such as letters, diary entries, and confessions. It is not surprising, then, that after studying many such confessions we still feel the same, or an even greater, vagueness than the one we experienced when we read the statements of the philosophers.

Some artists, to be sure, did present their views on painting in a didactic fashion. An important example is Henry Fuseli's *Lectures on Painting,* given at the Royal Academy in London during the early years of the nineteenth century, and published posthumously in 1830.[27] Here we have a great, original Romantic painter sharing with us his views on his art. Naturally one opens this book with great expectations, and so, one assumes, many readers must have done in the early nineteenth

century. However, one's expectation of an insider's treatment of what is specific to Romantic painting is bound to be disappointed. Fuseli closely follows the patterns of Renaissance treatises on art; he discusses the topics inherited from previous centuries, and he treats them in the same order in which they had been treated in the late sixteenth century. After invoking the authority of the ancients and particularly emphasizing the significance of Quintilian, he surveys the history of ancient and "modern" art, rehearsing the Quarrel between the Ancients and the Moderns. Painting itself is treated under the traditional headings of invention, composition, and expression, chiaroscuro, design, and color, the presentation reaching a conclusion in a treatment of the human figure. Had art changed at all since the days of Lomazzo and the Venetian writers on painting? Were we to judge by what Fuseli tells us in his *Lectures,* we would hardly be able to guess the profound upheaval of which his own work is such an eloquent illustration. Fuseli's treatise is representative of the rather rare attempts made by artists of the Romantic era to provide an overall system of art. If we are looking for the painters' views on what was perceived as new and urgent, of what really concerned them at this crucial stage, we shall have to renounce the comfort of systematic presentations. It is the personal document, sometimes confused, and often employing a private language and symbolism, that holds the key to the intellectual world of the Romantic painters.

2. RUNGE

Among the most important witnesses of the artists' thought is the German painter Philipp Otto Runge (1777–1810). His *Hinterlassene Schriften* (Literary Remains) consist mainly of letters and personal notes, and contain only a few fragments of a systematic doctrine of color. In the simple sense, then, we do not have a "theory" by Runge, that is, a body of thought presented in the form he would have wished us to read. This fragmentary state of presentation should not mislead us, however. Like some other artists of his time, Runge had a profound need for reflection and intellectual understanding of art, and he strove to cast his ideas and observations into a coherent pattern of thought.

The desire for a systematic understanding of art was the Romantic artist's natural response to contemporary perceptions of historical crisis and instability. Runge was aware of how questionable, perhaps even hollow, were the models that academic wisdom was still holding up to artists for imitation. Could classical art, presented by Winckelmann and Mengs as the great model, actually perform the redemptive miracle that some critics and teachers expected of it? "We are not Greeks any more," notes Runge, "we can no longer perceive the whole when we see their perfect works of art. . . . (I,6).[28] In earlier periods, the cultural basis and the social context of art were taken for granted, but now doubt has been cast on them. Both what art should do and how it should try to do it were no longer a matter of course. What this state of affairs seemed to require of the artist was, first of all, a serious effort to firmly rebuild the intellectual basis of art and to understand its real and proper context. The painter's attempt to make out his aims as clearly as possible and to realize what he could, or could not, achieve in his art became a task that was perceived as urgent.

Let us begin with the broadest context. Runge did not consider art as a domain, or a value, in its own right. For all his Romantic flirtation with the "religion of art," he firmly believed that the painting or the piece of sculpture cannot s and alone; they must occupy their proper place in a comprehensive world picture in order to fulfill their proper function. In a note dating from 1802, he outlined, in ten points, what he called "the requirements of art." This outline brings Runge as close to an encompassing system of thought as he ever attained. Both the points themselves and their sequence are significant. Here is the role in extenso:

1) Our presentiment of God;
2) the perception of ourselves in connection with the whole, and arising from these two:
3) religion and art; that is, to express our highest emotions by words, tones, or pictures; and here the visual arts in the first place search for:
4) subject; then
5) composition,

6) drawing,
7) coloristic character,
8) posture,
9) colors.
10) tone. (I,13–14)

These ten points, one sees, are composed of three groups: first the intellectual foundations and contexts of art (1–3), then the subject matter of the work of art (4), and finally the formal components of which it consists (5–10). The intellectual, or philosophical, foundations are essential not only for an understanding of the work of art but, first of all, for its production. "In my opinion," says Runge, "no work of art can come into being if the artist did not start out from these first moments" (I,14). Nor should the work of art, even a work of religious art, be deemed to be an end in itself. "Religion is not art," he warns, perhaps even himself, "religion is the highest gift of God, art can only express it more wonderfully and more intelligibly" (II,148).

The religion of which Runge speaks, however, is not necessarily what established institutions would accept as such. To be sure, he intends the God of whom he speaks to be the Christian God, and occasionally he even quotes the Bible. But the basic feature of his religion is presentiment, *Ahnung,* man's vague, intuitive perception of the Divine. *Ahnung* is a subjective experience, and Runge's religion thus rests on a psychological foundation. It is the subjective perception of the divine, the religious experience rather than the accepted ecclesiastical dogma that is reflected in art. Moreover, every great work of art reflects our intuition of the divine. "The most perfect work of art, whatever else it may be, is the image of the most profound presentiment of God in the man who produces it. That is, in every perfect work of art we sense our intimate connection with the universe" (II, 124). Translated into modern speech, this means, first, that a painting is "religious" when it expresses the artist's religious experience, and, second, that religious experience, whatever that may mean specifically, reflects a feeling of relatedness to the universe.

Runge takes yet another step. When consistently thought through, this further notion was bound to have fateful consequences for art. In a

letter to Pauline, his future wife, in which he tells her that he intends to devote his life to art, he says however that art, too, "has value for me only insofar as it gives me a clear notion of our great connection with God" (II,174/75). In a letter to his mother, he writes that "where art is not one with, and indivisible from, the inner religion of man, there it must decline, be it in an individual person or in a whole generation" (II,122). These statements strike us as strange. Are we listening to a medieval monastic preacher who wishes to limit the sphere and autonomy of art? But Runge goes even further. In a letter to his brother Daniel, written on July 7, 1808, a letter that is an exalted panegyric on the love of Christ, we read: "I wish it were not necessary for me to pursue art, because we should go beyond art, and in eternity one will not know it" (II,223). For my part, he adds in a personal note that reminds the modern reader of Bernard of Clairvaux, "I would not need art could I live outside the world, and as a hermit." Art, then, is devoid of any autonomy, it does not carry its value within itself. It is only as a means to an end that Runge is ready to accept art.

From this point of departure, it is easy to reach the conclusion that art is primarily a language. This, of course, was an idea common in Romantic thought. What this language is to express are emotions. Runge has mainly religious emotions and experiences in mind. As with other Romantic writers, he considers religious art as not necessarily an art representing themes from Scripture, or producing pictures for the purposes of ecclesiastical institutions; religious art is an art that expresses religious emotions. Runge considered the expression of emotions a basic condition for the value of a work of art. As a young man, he was afraid "to lose emotions." One day, he shuddered, he might draw a face without emotion, "without there being something else besides eyes, mouth, and nose" (II,32). Emotions are particularly essential and complex in works of religious art. Religious emotions, in Runge's view, derive mainly from the artist's experiencing of nature. Nature is the great presence of God, and it is natural that it evokes in man the powerful stirrings and awe that presence deserves. In conclusion, there is no conflict between the religious nature and the subjective origin of the work of art. Religious art, he says, is the "language of the soul" (II,97).

The specific topic that played a central role in Runge's reflections on painting is that of light and color. It occupied his mind for many years, his views on it taking shape only gradually. In his reflections on light and color, we can observe how the painter's concern merges with the symbolic doctrines of the Middle Ages and the Renaissance. Runge was here particularly influenced by the German seventeenth-century mystic Jakob Boehme, with whose work he became acquainted through his friend the poet Ludwig Tieck.

Runge reads metaphors on light as what they are, namely, symbolic expressions in need of interpretation; but he also reads them literally. Thus light is the physical condition of brightness, but it is also the good; darkness is the privation of light rays, but it is also evil. In reading Runge, one constantly has to shift from a literal to a metaphorical sense, and back again. To give but one example, in a letter to his father-in-law, obviously written while the lamp on his desk was going out, he wishes the daylight were already there: "It is only a makeshift, this illumination by lights put up by men, till the light comes that shines in eternity among the children of man" (II,346). The oscillation between the simple object (the lamp you turn on in the evening) and the spiritual meaning ("the light that shines in eternity") is typical of Runge's thought. Probably no other painter in the early nineteenth century so clearly perceived the spiritual meaning of physical light.

Take, for instance, a statement such as the following: "Light, or white, and darkness, or black, are not colors, the light is the good, and the darkness is evil (I refer again to the [story of the] Creation); the light we cannot grasp, the darkness we should not grasp" (I,17). The historian, attempting to trace the origins of these ideas, is bewildered. The notion that light and darkness, represented by white and black, are not colors clearly derives from Renaissance workshop doctrine.[29] The equation of light and darkness with good and evil, particularly with reference to the biblical story of creation, belongs to an altogether different realm of thought, of theological and symbolic thought as it occurred in mystical movements. In Runge's mind all these are lumped together in a fashion that makes it hardly possible to separate the trends.

He describes the contest between light and darkness in terms that

remind us of an ancient mythical theogony, but here they are permeated both by moralizing metaphors and by plain pictorial experience. "The light, when it is ignited, first gives a very small glimmer, and darkness pushes it back unto itself; it is no less true, nevertheless, that it *is* a fire and a true light. Darkness cannot destroy light, but light is able to scatter untruthfulness and falseness unto the four winds. The one spark that heaven gave us can grow and thrive and become a great fire that scares away predatory beasts, and ruins the enemy in the dwellings of his own stupidity" (II,203).

Many of these metaphors seem overtly literary, and yet it may be that his very fascination with light and color reveals a painter's eye and mind. Wackenroder, we remember, showed little interest in the works and charms of light and color in art. To him, they were only "externals" *(Aussenwerke)* of art, no more deserving of greater attention than other "externals" deserve. So far as he noted coloristic effects at all, they were effects of light and atmosphere in nature, such as a sunset, not in painting. Runge, as we have seen, is in many respects quite close to Wackenroder, but he differs from him completely in his attitude to light and color.

For many years Runge made intense attempts to build up, and clearly articulate, his doctrine of color. These efforts reached a peak when he composed his *Farbenkugel* (I,112–128), preceded by a fragment on the same subject written in 1806 (I,84–112). We shall not discuss the development of his views on color, but shall instead treat them as if they were of one cast.

Color, Runge claims, is the last part of art that still strikes us as mystical, and it will forever remain so. That mystical nature follows from the unique position of color in the order of things, and from the function it has been assigned. Light itself, as we have seen, man cannot grasp, and darkness he should not. Between these two poles lies color. Runge compares color to the revelation of an invisible god. "Revelation was given to man," he says, "color came into the world" (I,17). By color he means the three basic hues, blue, red, and yellow. Light is the sun, at which we cannot gaze. But when the sun inclines "towards the earth, or to man, the sky turns red. Blue keeps us in a certain awe, that is the *father,* and red is the *mediator* between earth and heaven; when

both disappear, then comes, in the night, the fire, this is the yellow and the *consoler,* that is sent to us—the moon, too, is only yellow" (I,17).

Runge tried to work out a comprehensive and coherent color scale that would also be a symbolic system. To this end he combined the literary tradition common in German mysticism (particularly in Jakob Boehme) of reading color as an indication of meaning with the painter's intimate familiarity with chromatic tones and shades and the emotional effects they are supposed to have. Such attempts had been made before.[30] What is perhaps especially characteristic of Runge's effort is that not only does it attribute meanings to the individual hues; the very order of the specific colors within the scheme is accounted for by the structure of the symbolic system. In the history of color scales, such a full merger of sensual qualities and symbolic characteristics is very rare indeed.

Between white and black, that is, between light and darkness, there are, as we know, only three basic hues—blue, red, and yellow. Each of these has a distinct expressive character; in other words, it evokes a distinct emotional effect in the spectator. At the same time, however, each of these colors manifests a specific level, or aspect, of the "objective" structure of the divinity, a structure that does not depend on our experiences. Blue, Runge declares, indicates God the Father. The historical conventions of the iconography of colors, to say the least, do not unequivocally bear out our artist's belief. Why, then, does he make blue the color of God the Father if he cannot rely on what is generally accepted in the history of painting? What seems to follow from Runge's thought suggests that the answer also does not result from theological considerations. It is rather the expressive effect of blue that provides the solution. "Blue keeps us in certain awe, that is the *father*" (I,17). Because the emotional effect of blue is to create awe, and thus to distance the spectator from what is represented, it is the color most fitting that aspect of the divinity from which we are most removed. To be sure, Runge does not explain his intention in simple, straightforward words, but this seems the most likely interpretation.

Red, he goes on to say, "is normally the mediator between earth and heaven." Now, placing red in the center of the color scale, between white and black, has a long history. Italian sixteenth-century doctrines

of color, composed by both painters and scientists, claim this position for red.[31] Runge, however, goes beyond the Renaissance doctrines: red is not only in the middle between the ends of the color scale, it is the active "mediator" between the two poles. Red may have derived this role of active mediator from being the color of Christ. As Christ mediates between man and God, so red, his color, mediates between light and darkness. That red is the color of Christ is not only a piece of conventional iconography; it was also explicitly asserted in Runge's circle, mainly by the poet Tieck.[32]

What Runge has to say about yellow is surprising. It has always been accepted that yellow, together with red and blue, belongs to the basic colors. But views have differed widely as to what it means. Yellow was the color of gold, but it was also the color of slander, of the prostitute and the Jew. Runge grants yellow—the fire in the night, the compassionate moon—a noble character, for it must be part of the chromatic manifestation of the Trinity. Again it was Tieck who conceived of the moon as the consoler, but Runge embodies this psychological interpretation in the sphere of religious imagery. The moon, he says a little later, "is the consoler, the Holy Spirit" (I,41).

3. FRIEDRICH

The great painter of German Romanticism, Casper David Friedrich (1774–1840), is another important witness of how Romantic attitudes were perceived by the artists of the time. His notes are fragmentary, perhaps even more so than Runge's, and they consist in part of his friend's records of the conversations he had with them. This state of documentation does not, however, impair the clarity of this testimony as to the concerns and beliefs of the Romantic artist.

Friedrich accepts the split between the inner and outer vision, the being within man and the world outside him, as a matter of course. This split, in fact, forms the basis of his reflections on art. The artist, he believed, has an "innermost consciousness" *(innerstes Bewusstsein)*. Like Wackenroder and some other Romantics, he conceives of the artist's inward spiritual life as a token of the divine presence in man. "Follow unconditionally the voice of your inner self," Friedrich admonishes his

fellows, or possibly himself, "because this is the divine in us, and it does not lead us astray. Keep sacred every pure movement of your soul, keep sacred any pious presentiment" (p. 83).[33] The artist should follow this inner call of his inner self because "the only true source of art is our heart."

Caspar David Friedrich, as one knows, was a landscape painter, and we have already seen that he believed that landscape, that is, "nature," is the most worthy subject of painting.[34] Nevertheless, he stresses time and again that the work of art flows from the artist, not from the nature depicted. By making "our heart" the only origin of the work of art, Friedrich rejects, even if only implicitly, an age-old claim inherited from the Renaissance: the claim that nature, the world surrounding us, is full of forms and shapes, and that it is these shapes that stimulate the creative process. Leone Battista Alberti opened his treatise on sculpture with the bold statement that the artist, stimulated by the half-articulate forms he encounters in the nature surrounding him, notices that, with only slight changes, these shapes can be turned into artistic representations.[35] In a sense, then, he makes nature herself a partner, if not the major origin, in the creation of the work of art. This attitude changed radically around 1800. For Friedrich the Romantic landscape painter, nature is no longer "full of form." To be sure, "every manifestation of Nature, recorded with precision, with dignity, and with feeling can become the subject matter of art." But note: it is the subject matter, not the origin of art. Moreover, even in such faithful and dignified recording of nature, it is the artist's emotion that counts and that should be manifested. "It is not the faithful representation of air, water, rocks, and trees that is the task of the painter," Friedrich notes, "rather his soul and his emotions should be reflected in it [the landscape picture]."

A student in the latter half of the twentieth century cannot help noticing how frequently Friedrich speaks of the "unconscious." Clearly our artist pictured the soul as consisting of layers, one placed on top of the other. The upper layers thus cover, and hide, the lower ones. This image of the soul surely has something to do with Carus's psychology, but it may also have been derived from other sources of Romantic philosophy. Thus Schelling, in his lecture "On the relationship between

the visual arts and nature," speaks of an "unconscious force" *(bewusstlose Kraft)* in the artist's soul. In the artist's conscious production, this force acts together with his reflective thought and with his skill.[36] Friedrich makes the unconscious emotion the central motivating force in the creative process. "A feeling, darkly intuiting, and rarely fully clear to the artist himself, always underlies his pictures" (p. 89).

Friedrich extols the significance of the unconscious for the artist, of the underlying stratum that is covered by the upper, conscious layers. The unconscious emotions, he believes, are superior to analytical thinking and logical procedures. The unconscious is concerned with subjects other than those that fill our conscious thought, and the former are inherently superior to the latter. Addressing God or Nature, he exclaims: "You gave us comprehension and reason to investigate and grasp things terrestrial, but to know things celestial you gave us a heart, and put within us high presentiments."[37]

III. POSITIVISM

1. TURNING TO THE OUTSIDE WORLD

Romantic views of what makes an artist and of how he operates posited introspection as a major road to artistic creation. Both the literary men and the painters had little use for the "outside" reality of the material objects that surround us. While in their paintings the Romantic artists may have taken careful account of material realities, they disregarded them in their theories. The artist creates his work, they believed, by focusing on his inner vision, and therefore making the images of the objects around him into "raw material" to be shifted around and transformed according to his expressive needs. Thus the landscape became a field for the projection of emotions. Nature, as we have seen, had become so spiritualized in Romantic thought that its material, objective character was almost dissolved. Social and historical realities also play a minor part in Romantic thought on art. When a social reality is referred to (as in Wackenroder's description of Dürer), it becomes almost openly utopian, mythological. Is the depiction true and

correct? The question does not arise. Perhaps nothing so well illustrates the distance the theory of art has traveled since the Renaissance than the Romantics' lack of concern with objective and demonstrable truth. In Renaissance culture, as it well known, an important task of art was to present a "true" record of a given piece of the world. The theory of art was supposed to provide the rules and procedures that would ensure the correctness of the representation. On the face of it, Romantic thought continued Renaissance ideas, and even employed Renaissance terminology. Yet some of the fundamental assumptions with regard to both the artist and the spectator had radically changed. The picture, the statue, or the poem are now presumed to be revelation, either of the divine spark in the artist's soul or of his unique experiences. The theory of art adjusted to these new conditions. The suggestive, evocative description replaced the rationally argued reasoning.

Awareness of "outside," material reality and recognition of its significance for the production and understanding of art came back in force in nineteenth-century culture. Whether this return to an acknowledgment of the realities of the "world" and their relevance for art was linked with the dominant trend of Positivism, or whether it derived from other sources, it remains clear that in the mid-nineteenth century reflection on art was not primarily concerned with some "inner" life of the artist, with visions perceived in dreams, or with the experience of a supernatural beauty. Instead, aesthetic thought turns to what, at the time, were frequently called "facts." It is an altogether different intellectual climate that now sets in, and it is new approaches that come to the fore. The problems themselves do not radically change.

2. TAINE

An important representative of the new trend is Hippolyte Taine (1828–1893), a versatile and prolific author whose impact on the later nineteenth century was extensive. Characteristic of his aesthetic thought is his exclusive concern with the arts. He leaves no room for, and he has no interest in, beauty as such. "A full explanation of the fine arts,— this is what one calls aesthetics," he says in his opening remarks in the

lectures on art (I,11) delivered in 1865 at the Paris École des Beaux Arts.[38]

Taine divides the arts into two groups: one, called "the representational arts," consists of painting, sculpture, and poetry; the other, "the mathematical arts," is made up of architecture and music. He rejects, then, the common linkage of painting and sculpture with architecture, an axiom bequeathed by the Renaissance and repeated by every generation since. Our author's main interest, however, is in painting and sculpture. His criteria of judgment, it has been suggested, are in fact inapplicable to any but the representational arts.[39]

In the opening section of his lectures on art, Hippolyte Taine proclaims that his "sole duty is to offer you facts, and to show you how these facts are produced" (I,37). Now, one does not have to be a philosopher to see that the notion of "fact" is very complex and problematic. Taine himself could hardly make up his mind what precisely he was referring to in using this term. Sometimes it is the concrete, individual painting that is considered a "fact," sometimes certain types of procedure are so termed. Be that as it may, the very orientation toward facts marks the powerful reaction against the legacy of Romanticism. It is a turning away from the enclosed domain of the subjective, "inner" experience.

Taine was also opposed to any prescriptive, normative thought on art. The modern character of his own thinking seemed to him to lie in its being descriptive rather than prescriptive or dogmatic. He himself thus characterizes his theory in his opening remarks: "Ours is modern," he says, "and differs from the ancient, inasmuch as it is historic, and not dogmatic; that is to say, it imposes no precepts, but ascertains and verifies laws" (I,36). He does not wish to give instructions to the practicing artist, nor, for the benefit of the audience and its judgment, does he want to derive "good art" from such supreme values as beauty. His thought, he indicates, is opposed to metaphysical doctrines that apply their ideas as "un article de code" to admonish and direct the productions of works of art. He wants to attain knowledge that is "purified" of any external—ethical, religious, or metaphysical—consideration or coloring. It is value neutrality that seems to ensure truth.

The rejection of any prescriptive or normative orientation of art

theory is linked to the scientistic attitude that looms large in Hippolyte Taine's background. In the middle of the nineteenth century, scientism, the desire for systematic, precise, and verifiable knowledge, to be achieved by total abstention from interference with what is being studied, became an important cultural force, and helped to create an intellectual climate that affected thought in many disciplines. Taine's generation, reaching maturity in the middle of the century, was interested neither in introspection nor in rhetoric; what it wished to know was what could be learned by the observation of facts, not only in the natural sciences but also in the study of morality, religion, and the arts. The world of man was to be studied in the same way as the world of nature.

Total adherence to the reality that can be observed discloses an affinity to realism in art, and to imitation as the basic theoretical assumption. Taine indeed believes that imitating reality is a natural urge in man, and the basis of all expanding and flourishing art. Renouncing reality and precise imitation is a hallmark of decay. "Every school (I believe without exception) degenerates and falls, simply through its neglect of exact imitation, and its abandonment of the living model" (I,45).

But is exact imitation of reality the ultimate aim of art? If that were the case, Taine says, photography could be expected to produce the finest works of art. This observation must be one of the earliest references to photography in an aesthetic discussion of "mimesis." Taine, in fact, is not oblivious to the value of photography. It "is undoubtedly a useful auxiliary to painting, and is sometimes tastefully applied by cultivated and intelligent men; but after all," he adds, "no one thinks of comparing it with painting" (I,51). Slavish imitation, such as he deems photography to be, should be excluded from the realm of art. How then, one asks, is art to be imitation? The answer is that the artist should not imitate everything he sees. He should leave out some parts of what he encounters and imitate only some — select — features. "It is essential, then," Taine says, "to closely imitate something in an object; but not everything" (I,56). If you ignore this demand for selection, you make yourself guilty of an "excess of literal imitation" (I,54).

I shall not here discuss the philosophical implications of this advice

to imitate nature selectively. Such an imitation assumes that art does not follow from nature only, but also from that force that directs the artist to imitate some and to disregard other features that he experiences in reality. This belief, and the philosophical difficulties it implies, are as old as art theory.[40] Instead of dwelling on the philosophical problem, I shall ask a practical question: What is it that the artist *should* imitate?

Taine's answer is explicit and articulate, though not necessarily clear. What the artist should imitate, he claims, is "the relationship and mutual dependence of parts" (I,56). Our author is of course aware that this is an abstract definition, one that lends itself to different readings. He therefore tries to specify and explain. The artist has to "reproduce" the "relationships of magnitude," that is, the proportions he finds in nature. He is required to imitate the "relationships of position," that is, the form. "In short," he addresses the artists who made up his audience, "your object is to reproduce the aggregate of relationships by which the parts are linked together, and nothing else; it is not the simple corporeal appearance that you have to give, but the *logic* of the whole body" (I,57).

In what sense, then, is the "logic of the body" a "fact"? Surely not in the simple sense of the word. No one would claim that it is a tangible object, or that it is plainly and directly present in empirical experience, as are other material objects. It is actually in this context that Taine places the metaphysical concept of "essences." The concept of the "essence," it is well known, does not easily agree with the scientistic outlook. In the intellectual climate prevailing in mid-nineteenth-century France, *essentia* was considered the epitome of medieval metaphysics, of philosophical beliefs going beyond the limits of empirical observation. That Taine uses this concept does indeed indicate the debt he owes to metaphysics, and particularly to Hegel.[41] Be that as it may, he claims that the artist, "in modifying the relationships of parts, modifies them understandingly, purposely, in such a way as to make apparent the *essential character* of the object, and consequently its leading idea according to his conception of it" (I,64). He is aware of the metaphysical implications of what he has just pronounced. The "essential character," he explains, "is what philosophers call the *essence* of things." Our author

does not want to retain this suspicious term; it is "technical" (I,64). But he retains the idea expressed in it. It is the artist's aim "to manifest a predominant character, some salient principal quality, some important point of view, some essential condition of being in the objects" (I,64–65). In summarizing his argument, he comes back to this point, stressing the metaphysical character of the artist's function. "The end of a work of art is to manifest some essential or salient character, consequently some important idea, more clearly and more completely than is attainable from the real object" (I,76). What the artist records, it turns out, is not nature's appearance, but some deeper layer that is not available to the observing eye. The work of art, it follows by implication, amounts to a metaphysical statement.

What is it that enables the artist to make such a statement? To raise this question is, of course, tantamount to asking what makes him an artist. Taine fully accepts the traditional dictum, restated countless times since the Renaissance, that "artists are born, not trained." But he tries to define a little more closely the nature of the gift with which the artist is endowed at birth.

Taine's analysis of what makes an artist may at first seem surprising. That he does not place special emphasis on virtuosity, technical skill, and manual dexterity might have been expected at a time when the command of technique, easily acquired in established schools, was not much of a rarity. But he also does not mention imagination, that is, the faculty that conjures up, or produces in the mind almost at will, figures and scenes, shapes and objects that are not present before our eyes. Instead, he extols a condition he calls "original sensation." This is a quality the artist brings with him to the experience of physical reality. "In confronting objects," Taine says, "the artist must experience *original sensation*" (I,73). The term "sensation" was not unknown in the philosophical and aesthetic language of the eighteenth and nineteenth centuries. In its broad philosophical use, it is, in France, perhaps best known from Condillac's system of sensationalism. Condillac's theory of the origin of ideas, reducing the contents of the mind to transformed sensations, was a powerful influence, though it left little room for creativity, for the artist's spontaneous production of images.[42] The term was also used in the language of aesthetic theory and of art criticism.

"Sensation" here came to indicate the material nature portrayed in painting,[43] or the effect the painting has on the beholder.[44] Yet what Taine means by "sensation" corresponds to neither of these meanings. What he wishes to describe by this term is the unique intensity and character of the artist's experiencing of nature, the way he perceives any piece of outside reality. It is the faculty, granted to the artist, to perceive with distinction and directness the abstract structure of things. He "naturally seizes and distinguishes, with a sure and watchful tact, relationships and shades" (I,74). Nor does the power of the artist's "sensation" stop at the surface of the things perceived. Taine endows the artist with some kind of clairvoyance. Speaking of the particular "sensation" that characterizes the artist, he says: "Through this faculty he penetrates to the very heart of things, and seems to be more clearsighted than other men" (I,74). Moreover, the artist's "sensation" is not passive, waiting, like a piece of wax, to receive the imprint of the object perceived. "This sensation, moreover, so keen and so personal, is not inactive." Now, what is that "not inactive" original sensation? "We may adorn it with beautiful names;" Taine says, "we may call it genius or inspiration, which is right and proper; but if you wish to define it precisely you must always verify therein the vivid spontaneous sensation which groups together the train of accessory ideas, masters, fashions, metamorphoses and employs them in order to become manifest" (I,75).

Today Taine's name mainly evokes the composite notion of "race-milieu-moment." It was by these three factors that he tried to explain the emergence and character of the great literary and artistic creations. The formula has been severely criticized, and not much of it has survived in modern thought. The term "milieu," however, has preserved its usefulness, particularly as an indication of the new trend of thought Taine represents. "Milieu," as Wellek says, "is a catch-all for the external conditions of literature" and art.[45] In using it, Taine refers to everything that can, in one way or another, be brought into contact with art. It includes the physical environment (soil, climate), political and social conditions, and cultural and psychological forces. It has been said correctly that Taine never properly analyzed the notion, and rarely attempted to clarify what he specifically meant by it.

In stressing the significance of "milieu," Taine's chief intention is to

show that it is not the individual artist who determines the character of the work of art, but rather the broad cultural reality from which it emerges. To be sure, sometimes it would seem to follow from Taine's text that he conceives of art as only a matter of personal emotion. Discussing Michelangelo, he speaks of the artist as compulsively mimicking an inner sensation, and argues that he altered the ordinary proportions of the human body under such internal pressure (I,60 ff.). However, the major "law" governing the production of the work of art is formulated in an almost scholastic manner. "A work of art," Taine says, "is determined by an aggregate which is the general state of the mind and the surrounding circumstances" (I,87). The "aggregates" may be ill defined, they may often be confused. What the term undoubtedly shows is that the great creative powers of art are here sought beyond the artist's psyche, beyond his imagination, and his unique personal character.

To grasp Taine's theory of art, one must properly appreciate the significance of types in his thought. For all his apparent connections with realism or naturalism, it was not the individual figure, the image of the live person walking the streets, that held his attention. Almost his entire interest, Wellek correctly says, "focuses on fictional characters." For him the character is "the concrete universal,"[46] and this is the "reality" he had in mind. The concept of "type" was not new in aesthetic reflection, as one need hardly point out. In modern times it was frequently employed in German philosophical literature, particularly by August Wilhelm Schlegel and by Schelling. Hippolyte Taine formulated the concept on several occasions, not least in his lectures on art.

We have already seen that the artist's task is "to make apparent the *essential character* of the object" he portrays (64). This character is "a quality from which all others, or at least most other qualities, are derived according to definite affinities." In actual reality, the essential character "moulds real objects, but it does not mould them completely: its action is restricted, impeded by the intervention of other causes; its impression on objects bearing its stamp is not sufficiently strong to be clearly visible" (I,70). The artist's job, so Taine repeats an age-old idea, is to complete what nature could not, to show in full clarity what in

nature is partly obscured. In past ages this argument had been adduced mainly in connection with beauty. The artist, so we have heard time and again, should show the beauty that is inherent in nature but that cannot appear with sufficient clarity in the natural bodies themselves.

The individual artist and his unique character and style play almost no part in Taine's thought. This is not only a personal orientation of interests; it also jibes with his philosophical concept of man. He often conceives of the human mind in terms of mechanistic analogies. "A man's particular genius is like a clock," he could say; "It has its mechanism, and among its parts a mainspring."[47] Instead of dealing with individual artists, Taine is concerned with the character of some of the major historical formers of artistic creations, such as the Greeks, the Italians of the Renaissance period, and the Dutch between the fifteenth and seventeenth centuries. These are the great examples of collective creation, and, perhaps following Hegel, Taine declares that each of them made a distinct and lasting contribution to human culture. His comments on the individual formations are not of equal significance with regard to the theories of art he represents, and helps to construct. I shall remark briefly on what he says about the Greeks and, especially, the Dutch painters.

The primary characteristic of the Greeks was their ability to conceive comprehensive ideas and images. Note that Taine does not emphasize the "beauty" of Greek art, but rather its comprehensive, or compositional, character. Wholeness, or comprehensiveness, one could say, is a component of the traditional concepts of beauty. Yet there is a difference between a stress on beauty as such (even if it implies wholeness) and a singling out of the specific component, making it the primary subject. The ability to conceive whole, encompassing ideas and images is made at least partially explicable to Taine by the impact of the natural environment. The Greek countryside has no colossal proportions, no mountaintops lost in cloud, no features that go beyond human comprehension. This quality of the surrounding nature is also found in the social and political institutions of ancient Greece. The aesthetic character of Greek art is primarily a manifestation of that overall character. You can observe it in all the major monuments. A Greek temple, to give but one example, is "a marble monstrance enclosing a unique

statue. At a hundred paces off from the sacred precincts you can seize the direction and harmony of the principal lines. They are, moreover, so simple that a single glance suffices to comprehend the whole" (II,418).

A great many of Taine's ideas on Greek art derive from older traditions. Thus, the influence of the Greek landscape and climate on the restrained and measured forms of Greek art is found in Winckelmann [48] and his followers. But Taine's emphasis on these older ideas had a significant effect on later nineteenth-century thought on art.

While what Taine says about the Greeks indicates how much he still owes to the classicist tradition of the eighteenth century, what he says about Netherlandish painting shows how far removed in fact he is from that tradition. Dutch painting, Taine believes, stands for the northern, or "Germanic," races in general. It is of a particular character, both in its spiritual nature and in its style. What distinguishes it from the art of the "classic races," that is, the art of people on the shores of the Mediterranean, is "a preference for substance over form, of actual verity to beautiful externals" (II,220 ff.). This "instinct," as our author puts it, is also characteristic of the religion and literature of the Netherlands. As opposed to the masters of the Italian Renaissance, the Dutch artists "were incapable of simplifying nature"; they aimed at the fullness of reality (II,223). Seventeenth-century Dutch painters exalted man, but they did so "without raising him above his terrestrial condition." What they tried to do, in fact, was to "expand his appetite, his lusts, his energy, and his gaiety" (II,224). The modern reader, following Taine's argument, cannot help noticing how little our basic characterizations of Dutch versus Italian art have changed in the hundred and twenty years that have passed since these lectures were delivered to young artists in the École des beaux arts.

Hippolyte Taine, however, is not content with simply formulating the expressive character of Dutch painting. A central value of Flemish and Dutch art "is the excellence and delicacy of its coloring." What was it that brought about this sensitivity to color? The answer leads us back to the central thesis. The sensitivity to color follows from "the education of the eye, which in Flanders and Holland is peculiar" (II,225). But what precisely was it that educated the eye in Flanders and

Holland? Once again we learn something about how nature molds man and his tastes. "In the dry country [Taine obviously has Italy in mind] the line predominates . . . the mountains cut sharp against the sky." But in the Netherlands the climate is different, and so the taste that developed under its impact will prefer different values. "The low horizon is without interest, and the contours of objects are softened, blended and blurred by the imperceptible vapor with which the atmosphere is always filled; that which predominates is the spot." Such natural conditions also shape the way we perceive things. "The object emerges; it does not start suddenly out of its surroundings as if punched out; you are struck by its modelling, that is to say by the differing degrees of advancing luminousness and the diverse gradations of melting color which transform its general tint . . ." (II,226).

Here again very little room is left for the individual artist. It is the basic conditions of nature and the essential structures of society that determine the subject matter and style of the work of art. One can very well understand how a generation suspicious of Romantic introspection and longing for some kind of tangible, objective foundation was so charmed by what Taine had to say. It is obvious that this message, imbued with the scientific ideals of the time, is open to serious criticism. Succeeding generations and other trends have indeed raised questions that the Taine school could not answer. For the historian of art theory, however, it is not always the "truth" that counts; he is often more drawn by the historical power of a view than by its inner coherence. Seen in such a light, Hippolyte Taine is an important representative of the turn of thought characteristic of the mid-nineteenth century.

IV. FACETS OF REALISM

I. ORIGIN OF THE TERM

Can we take what Taine says about the visual arts as a genuine, authoritative statement of the movement known as Realism? One hesitates. Perhaps no other aesthetic concept is as multifaceted, and therefore as difficult to use, as is realism. In speaking of realism, one should

recall, we are dealing with a general tendency, not a specific doctrine. Realism, it hardly needs stressing, means different things in different contexts. In mid-nineteenth-century France, "réalisme" became the subject of a lively intellectual, perhaps ideological, debate. Jules Fleury-Husson, known by the pseudonym of Champfleury (to whom we shall return shortly), collected some of his—rather journalistic—criticisms of painting into a volume he called *Le réalisme* (1857). At the same time, his friend, the little-known Edmond Duranty, published seven monthly issues of a magazine called *Réalisme* (from November 1856 to May 1857). These and similar publications did not open up a theoretical discussion on matters of art; rather they gave a generic name to a debate that had been going on for some time. Discussions of realism, whether or not that term was employed, occupied a central place in French aesthetic thought of the period.[49]

While this debate was going on with regard to literature, what was happening to the dynamically developing theories of painting and sculpture? Here, it seems, the outlines were even more obscured than in literature, and this is particularly true for views concerning the artist's position. I shall try to present the main currents of thought that dominated the mid-nineteenth century through a few examples. While none of these amount to a systematic doctrine, taken together they may indicate the range of views held at the time.

2. PROUDHON

Let me begin with the thinkers who represent the "audience," that is, the society to which the works of art are ultimately addressed. I shall start with Pierre Joseph Proudhon (1809–1865), philosopher and social-ist, social reformer, politician, and utopian. He was not in the first place an aesthetician or critic of art, his major intellectual efforts being devoted to problems of social justice and reform. It was Proudhon who, as early as 1840, conceived the formula, destined to become famous throughout Europe, that "property is theft." Although Proudhon was mainly concerned with social matters, he formed close and lasting connections with artists, and he considered artistic creation as a signifi-cant problem in his views on man and society. He was a friend of

Gustave Courbet, and a member of the group of writers and artists who supported Courbet's radical stance. At the very end of his life, after his major works had appeared, Proudhon also published, in 1865, a book called *Du principe de l'art et de sa destination sociale* (On the Principles of Art and Its Social Function), a kind of summing up of ideas expressed in the course of thirty years.[50]

In matters of art and aesthetics, Proudhon was not one of the great minds of the nineteenth century. In acquainting oneself with his art criticism one does not experience the exhilaration of discovering a new continent, as when reading Winckelmann; nor does one have, as with Hegel, the sensation of looking down from a mountaintop at a vast landscape whose structure suddenly becomes clear. What Proudhon's often rather trivial statements offer us, on the other hand, is a familiar tone that is sometimes surprising. We are in our own world, and many of his statements could have been made yesterday. In fact, it is precisely because what Proudhon says is so close to what we are used to hearing that his phrases sound so trivial. We should read, and devote some attention to, Proudhon as the link between a past and our present, even if his intellectual level cannot be compared with that of the great figures just mentioned. Proudhon is remarkable not only because he has a general affinity for certain problems and attitudes characteristic of our own generation but because it is particularly the radical attitude, and the ideological debates it provoked, that he anticipates.

Proudhon's attitude to art may sometimes seem paradoxical. On the one hand, he posits an aesthetic faculty in man, a faculty that is a natural gift. Man cannot do without art any more than he can do without science or technique, he says in his major theoretical work. Art is also what distinguishes man from all the beasts.[51] Man, in his very nature, is an artist. He invented painting for the "pleasure of his eyes." It is for this reason that Proudhon so intimately links art with human freedom. "Art is liberty itself," he proclaims.[52] While this idea is not a new one (in a slightly different form it was formulated by Friedrich Schiller at the end of the eighteenth century), it acquires a new significance in Proudhon's doctrine.

On the other hand, Proudhon devotes a great deal of attention to the social character and significance of art. In fact, the social dimension

of the work of art is so overwhelming that it almost completely overshadows all its natural components. The concern with art's social impact is found at almost all stages of Proudhon's intellectual development, as Pierre Palix has shown (pp. 865 ff.). It also led him to far-reaching conclusions with regard to the position of the artist.

Art has an educative function, he believes, and it has the power to incite people. The Church understood this, and therefore such large parts of art were actually in the service of religion and the Church. Proudhon may be opposed to the Church in his political views, but he acknowledges the ecclesiastical insight into the power of art, with significant repercussions on his view of the artist.

Art, it follows from much of what he says, is too serious and weighty a matter to be left to the artists alone (Palix, pp. 889). Precisely because the painting or the statue has such a great power of incitement, it is society as a whole, and not the individual, even if he is the artist, that must determine the subjects and the uses of art. Proudhon, the political radical, here clearly anticipates some of the ideas we have come to know so well in our own generation. The student of history cannot help being struck by what seems to be this completely sudden emergence of the demand for a "committed art," inspired and directed by society (and whoever may be in a position to speak for society).

Proudhon stresses that the artist cannot help being "committed," to use the present-day term. To paint something without caring about what one represents is not only morally detestable; in the final analysis, it is simply impossible. The artist will always take up a position, he cannot simply remain neutral, without color, as it were. It is for this reason that Proudhon believes the artist to be the collaborator of the social reformer.

The subject matter and style of the painting follow from art's function in social reform. Proudhon defends what he calls the "critical school," that is, the school of realistic painting, against the idealizing trend that prevailed in nineteenth-century academic painting. As Proudhon projects his ideas, the representative of the idealizing trend will ask: "What can art do with such as we who are a wretched, servile, ignoble, uncouth, ugly mob?" Our author's reply to this question implies his whole view of art and of art's position in the order of things. Art, he

says, "can do something most interesting, the most glorious thing of all." Instead of saying what that "most glorious" thing is, he goes back to the basic aim of art. "Its task is to improve us, help us and save us." From this aim there follows the character of the representation. "In order to improve us it must first of all know us, and in order to know us, it must see us as we are and not in some fantastic, reflected image which is no longer us." In realistic painting, "man will become his own mirror, and he will learn how to contemplate his soul through studying his true countenance."[53]

Proudhon's statement, giving his reasons for advocating realism, deserves careful attention and analysis. He accepts as a matter of course most of the basic premises of traditional art theory, essentially seeing art as an imitation of outside reality (or "nature," as it was called in the Renaissance). Bodily appearance reflects moral character: in studying our physical countenance we contemplate our soul. All this, though perhaps in some slightly modified formulation, would have been acceptable to most artists and thinkers between the sixteenth and the nineteenth centuries. His reasons for holding views that require a realistic representation of nature, however, differ from those that made thinkers of former generations accept the same principles. For the Renaissance, and for all who accepted its legacy, the truthful rendering of nature in art—*vera imitazione,* as it was called—was an autonomous value needing no further foundation. For Proudhon, realistic representation is not an autonomous value, it is not an end in itself; rather it is only a means that makes it possible to achieve art's ultimate aim. That aim, we remember, is to improve man, even to save him. In order to achieve it, we need the shock of seeing ourselves as we are—"wretched, servile, ignoble, uncouth, ugly." In the last analysis, then, realism is an unavoidable, initial step in the treatment of mankind. One understands how the painter is the collaborator of the social reformer.

Another feature of Proudhon's concept of realism should not be overlooked, even if it is only implied. This is the associating of realism with man alone. Proudhon never explicitly states that realistic representation cannot be applied to a landscape or a still life, but all the examples he adduces clearly point to man. Thus he praises his friend Courbet, who "has seriously tried to warn us, chasten us, and improve

us through portraying us as we really are."[54] Had Proudhon never seen one of Courbet's landscapes? Given the date and their intimate relationship, he surely had. But realism, it seems, belongs to the domain of man. Another example, even more striking, is the reference to Dutch and Flemish painting, specifying "their village fairs, their wedding festivities, their gatherings, their household interiors, and even . . . their taverns. . . ."[55] There can be little doubt that Proudhon saw some of the dramatic Dutch skyscapes and peaceful pictures representing cows in meadows. Such images, however close their rendering may be to nature, do not seem to be linked to realism. Realism not only expresses society; it has social scenes and types as its subject matter.

The social essence of art extends not only over subject matter and form; it also dominates the relationship between the artist and his work. Proudhon even raises the question, though only in passing, as to whether the artist can do what he pleases with his work. Is the artist, for instance, permitted to destroy his own work? No Romantic would have been in doubt as to the reply, and some may even have glorified such a deed. Not so Proudhon. The artist, he wrote as early as 1848, "is not the owner [of the work of art he has created], he is [only its] producer." To make clear what he means, he projects the imaginary situation of "Leonardo da Vinci burning down his painting of the Last Supper, after he has produced it, [and doing so] for his own pleasure, and in order to manifest his ownership. This Leonardo," Proudhon concludes, "would be a monster."[56]

3. CHAMPFLEURY

Champfleury—the pen name of Jules François Félix Husson, dit Fleury (1821–1889)—can claim, probably with more justification than anybody else, to have coined the modern term "realism." A versatile and very prolific writer, active in various fields, he looms large on the horizon of every student who tries to follow the unfolding of modern views on art. His significance follows less from the depth and delicacy of his thought (in profundity of thought and in subtlety of perception he cannot compare with some of his contemporaries, such as Hegel or Beaudelaire) than from the fact that he was seen as a genuine and

central spokesman of a powerful trend of aesthetic thought in the modern world. His major domain was, of course, literature. He wrote novels that were much read in his time, and he wrote critical and theoretical discussions of a great range and variety. For decades, moreover, he also devoted much attention to the visual arts, primarily painting, without restricting himself to his own period. Though focusing on contemporary art, he obviously believed that the great artistic heritage of the past sheds light on the problems of the present.

Champfleury's attitude to the "art of the Louvre" is one of discrimination between different periods. Never accepting traditional art as a whole, he not only distinguished the achievement of one artist from another, but also clearly preferred certain schools, or local traditions, over others. The reasons for such preferences are always the tendencies dominating one school or another. Even his criticism, then, his judgment of individual artists or paintings, is permeated by the search for *Weltanschauung*.

In the Louvre, that is, in the great art of the past, Champfleury was mainly drawn to two groups of artists or artistic traditions.[57] Early on, mainly before 1848, he was attracted by artists who had some affinities to the spirit of the Baroque, painters of drama and tension. Rembrandt is a good example of this spirit. His dramatic power reflects the inner tension through the placing of lights and shadows: the darkness of the shadows is pierced by mysterious rays of light. Paolo Veronese, the most lively of colorists, is another prominent instance. It is not surprising that Champfleury was also attracted by the modern disciple of these artists, Eugène Delacroix.

The other school of painting that particularly interested Champfleury is of a very different expressive nature: it is the school of Dutch seventeenth-century painting. Delighted and admiring, he stands before the quiet scenes shown by Dutch painters—landscapes, still lifes, and genre scenes. It is the realism, and perhaps also the serene quiet, that speaks to Champfleury. Not only the Dutch but also French artists like Le Nain and Chardin belong to this school in his thought. Again, the criticism is based on theory. What Champfleury admires in all these artists is the faithful depiction of a reality that has not been made to look more beautiful than it really is.

The close interrelation between theoretical world view and art criticism is even more manifest in his treatment of the art of modern times, that is, of the late eighteenth and early nineteenth century. Champfleury reserves his most biting criticism for classicist painting. Why actually does he so much dislike Neoclassicism? It seems that his main objection is "falsity." "The Greeks of David are not Greeks," our author writes.[58] The Antiquity that neoclassical painters project onto their large canvases is a false Antiquity. But the critical reader is not always certain in what specific sense neoclassical Antiquity is taken to be false. Would, for instance, greater archaeological fidelity make the image of the ancient world less misleading? The answer is not always clear. More can be learned from what Champfleury has to say about the living representative of academic Neoclassicism, J. A. D. Ingres (1780–1867), for whom he reserves his harshest disapproval. Champfleury's criticism of Ingres, one need hardly specify, is not presented as a theoretical doctrine; it is primarily a criticism of individual paintings. And yet, it does make some general theoretical assumptions, even though these remain implicit. One assumption is that good painting must be based on a direct, immediate representation of reality. Champfleury criticizes Ingres's manner for "coldness," for adopting the style of official academism. The coldness of style, one cannot understand it otherwise, results from replacing nature by a system of conventions and from following artificial manneristic models rather than living reality. Ingres executes specific details precisely, and in a sophisticated manner, but it is the nature of these details and their placement in the whole image of the world depicted that Champfleury considers false. The learned composition of Ingres's *Apotheosis of Homer* is an example of "insincere mannerism."

The other assumption he makes, without stating it in so many words, is that live reality should be rendered "as it is." Champfleury, we should remember, wrote this criticism in 1848, in a period of high social tension, and it is not surprising that he makes the depiction of social reality the center of his discussion. Ingres, he claims, is the typical representative of bourgeois painting. His insincerity—a crucial component of a bourgeois painter's artistic personality—makes him cover reality, in itself ugly and deformed, with a fine gray shadow.[59] Ingres treats reality cosmetically. He makes his models leaner than they ac-

tually are, he endows them with the grace they lack in reality. Ingres's fault and that of bourgeois painting in general, we could say, is a moral one.

The criticism of classicist clichés, and even of bourgeois insincerity, sounds romantic. It would probably have been supported by all Romantic critics. But Champfleury is not a Romantic, his attitude to Romanticism is critical indeed. His disapproval of romantic art is less easily grasped than his rejection of neoclassic painting, but it is no less important. He does not use the term "romantic," he speaks of the *école fantaisiste,* but the painters he treats as its representatives (Delacroix and Géricault) show that he means what we now call Romantic painting. What the artists of the *école fantaisiste* suffer from is an excess of imagination. Once again, one wonders what precisely is meant by this lively phrase. What he intends to say seems, at bottom, to be that Romantic painters, submitting to the power of their imaginations, are carried away from actual reality. Raphael's Madonna is a *belle farce.* Of an allegorical statue called *Youth* he asks: "Does a woman exist that represents Youth? And then the young figure shown is totally naked. Is this one real?" And getting sarcastic, he continues: "One should make a gown for her; where is the gown?"[60] Based on these and some other passages, one would have to say that imagination in painting largely pertains to the realm of subject matter. All allegories, personifications, and pictorial metaphors are included in that excess of imagination. What is the difference, then, between classicism and romanticism? Champfleury does not seem to doubt the personal sincerity of the Romantic artist. He follows his own imagination, while the classicist artist accepts ready-made formulae. But both abandon reality.

Now, if we take away classicist idealization, on the one hand, and the excessive imagination of the Romantics, on the other, what are we left with? Champfleury does not hesitate: what remains is the faithful representation of reality, or what is called realism. Champfleury was indeed considered the trailblazer of Realism in literature and painting. And yet he was aware of how vague that term is. He is suspicious of all "isms," whatever they may indicate; realism, however, raises particular difficulties. It has always existed, and therefore it has naturally come to mean a great many different things. "Could I enter the policy of a

government in order to prescribe what critics have called *realism,* the pen would immediately burn my fingers, and would compel me to write: 'the cult of reality is the first of cults' "—so he said, in 1861, in the introduction to his *Grandes figures d'hier et d'aujourd'hui* (Great Figures of Yesterday and Today).[61] Almost a decade earlier, he had written that "realism is as old as the world, and there have always been realists; but the critics, in constantly employing the term, make it obligatory for us to make use of it."[62] But it is precisely the universality of realism in the art of all ages that makes it so difficult to define the concept. Once more, we learn what Champfleury actually means from the examples he discusses rather than from any theoretical definition he might offer.

These examples are taken mainly from contemporary artists. In a generation distorted and twisted by both Romantic sentimentality and neoclassical dryness, so Champfleury thought, some painters stand out by their "sincerity." Among these is Corot. Corot's virtues, as our author sees them, are primarily his sobriety and the want of "artistic effects." To put it paradoxically, Carot's "sincerity" consists mainly in what is not to be found in his work. It is, then, only by comparing him with other contemporary painters that his characteristic qualities become manifest. In the whole century discussed in the present book, ever since Winckelmann, we seem to encounter the same elusive value that is believed to be lacking in the artistic production of the near past: Winckelmann called this almost utopian value "simplicity"[63]; Champfleury's term for it is "sobriety." Though the two terms are not quite identical (Winckelmann would have disliked the "baseness" of Courbet's figures, Champfleury writes),[64] they have a great deal in common; they both express the longing for a genuine vision of the objects to be represented.

Characteristic also is Champfleury's interest in another contemporary painter, François Bonvin (1817–1887), who to us is not one of the great artists of the nineteenth century. What attracted Champfleury to him was what he perceived to be the prosaic character of his art. In Bonvin's work, so our author believes, we perceive a social tone. He describes Bonvin, "the son of a seamstress and a village policeman," as "the painter of the family."[65] The Chardinesque character of Bonvin's work is stressed, but this character has become more prosaic.

Champfleury reserves his greatest praise for Courbet, "the painter of the landscape of humanity,"[66] whose great achievement is the "rehabilitation of the modern."[67] He stresses Courbet's revolutionary role, his breaking with traditions. Nevertheless, he attempts to place Courbet in a great pictorial tradition. In France, so Champfleury reports a friend's words, three painters stand out: they are Le Nain, Chardin, and Courbet.[68] This is a realistic tradition, but it is also a tradition that, in subject matter and style of presentation, has a certain social connotation. Our author also looks for other historical connections that would be a natural context for Courbet. To be sure, Courbet did not know the Spanish masters, but, "without knowing the admirable canvases of Velasquez, he finds himself in agreement with the illustrious master."[69] All these historical relations, however, in no way detract from the main feature in the characterization of Courbet: he is the painter who "rehabilitated the modern world."

Time and again, Champfleury lauds the artist who turns to his own time. Nor was he alone in this praise. In his generation, the doctrine of accepting one's own time was frequently preached. The present-day student reading these demands, often phrased with fiery enthusiasm, naturally asks himself what they in fact meant, the concept of contemporaneity being obviously a complex one. Moreover, it is a matter of common knowledge that nobody can escape his own age, however much he may wish to do so. Artists, whoever they may be, are inevitably condemned to be the children of their time, and to reflect or express, in one way or another, the concerns and moods of their own world. And yet, it has correctly been said that the mid-nineteenth century call for artists to be "of their own time" was more than a mere truism.[70] The "present world" or "our own time," as Champfleury understood these terms, are not abstract concepts. "Our own time" is both a domain of specific subject matter and a quality, or character, of artistic representation.

Courbet, we learn, enlarged the domain of the seventeenth- and eighteenth-century "bourgeois" masters (among them such artists as Le Nain and Chardin). He did so, first and foremost, by representing figures and scenes unknown to the earlier artists. In *The Stonebreakers* he embraced modernity. Such figures do not appear in the works of the

former masters; they are documents of the modern age. But introducing new subject matter is not the only form modernity takes. Embracing "our own time" is also, and perhaps in the first place, acceptance of the central value informing and directing the artists' efforts. For centuries, the "realist" critics felt, artists were dominated in their work by the search for beauty. It was in the course of this search that certain idealizations became common, finally degenerating into "empty" academic formulae. Accepting one's age also became the acceptance of reality, even if lacking beauty, even if deformed, as worthy of representation. Interestingly enough, Champfleury's defense of this kind of modernity becomes historical. He is aware that many of the faces and figures in Courbet's *Burial in Ornans* deviate from any canon of beauty, but asks rhetorically: "The physiognomies of the people of Ornan—are they more frightening and more grotesque than those of Goya, of Hogarth, and of Daumier?"[71] Champfleury, the author of a monumental work on caricature (for which see below, pp. 380), selects his examples from the history of caricature. But he here touches on a problem—the role of the ugly in art—that became prominent in mid-nineteenth-century art. As it does not easily fit into the discussion of an individual critic, or even of a specific trend of thought, we shall deal with it separately at the end of this chapter.[72] Here one should say, however, that abandoning the search for beauty, and even accepting the ugly, is to Champfleury one of the indications of modernity.

In conclusion, we now come back to the major theme of this chapter, the nature of the artist and his role in aesthetic thought. With regard to this particular subject, the anti-Romantic leanings of realism become strikingly manifest. Romantic thought, we have seen earlier in this chapter, conceived of the artist primarily as a unique individual, a figure distinguished by the power of experience and vision; his work originates in the image appearing in his mind, beyond anybody else's reach, and it reflects his personal character and passions. In the thought of realism the emphasis shifted radically. Where Romantic thought focused on the artist's unique, personal experience, the thought of realism is concerned with the reality that is perceived as an objective configuration, both with regard to subject matter and forms. Romantics, to be sure, never denied that artists have their roots in cultural traditions. As we have

seen, Wackenroder even pictured Dürer as a kind of master craftsman working in an imaginary medieval city and guild. But they always, even in speaking of Dürer, assumed that the work of art originates in the artist's inner vision, and that the act of creation cannot be regulated by rational "laws." Seen against this background, the realists' views of the artist, and particularly Champfleury's, are of a conspicuously different character.

The first observation that strikes the student is that in realist thought the "problem of the artist" plays a much more modest role than it does in Romantic doctrines. For Romanticism, it was a central problem. Among the writers grouped as the "realistic school," the center of thought is occupied by the selection and interpretation of subject matter. The artist as such receives very little attention. Insofar as he is discussed at all, it is his role in society, the effect of his work on the audience, that is the major concern. Champfleury would agree that painting cannot be considered simply as instruction; if it tries to be instruction (many of us would today use the term "propaganda"), it will quickly lose its power.[73] And yet he suggests time and again that art brings traits of reality to our attention, and that this is an important function that the artist should never overlook. The outright rejection of art for art's sake is a characteristic feature of the realists' intellectual attitude. In 1885, at the very end of his life, Courbet remarked that it had not been his thought to "arrive at the lazy goal of art for art's sake."[74] When Courbet wrote these words, the rejection of purely aesthetic value had been a leading principle for a whole generation. To Champfleury himself, Courbet had said, precisely thirty years earlier, that his *Burial in Ornans* would be "the moral and physical history of my studio."[75]

Not less significant than what Champfleury has to say about the artist's nature and social function are the very few comments he makes about the production of a work of art. They strike us both by their content and by a certain harshness of tone. As they are marginal remarks, made in the course of discussing other subjects, some of their abruptness may be accidental rather than intended. Still, they are clearly revelatory of Champfleury's basic attitude to the problem that has fascinated so many thinkers—how a work of art comes into being.

The first statement, or rather group of statements, amounts to making realism tantamount to the negating of imagination. We have seen that Champfleury rejects allegories and personifications for the reason that they are inventions rather than depictions of a reality objectively available to every spectator. To avoid a likely misunderstanding, it should be pointed out that he does not condemn allegories and personifications because they are routine formulae that condemn the artist to a dryness of style. His only reason for discarding them is that they are inventions. For the artist's work, then, objective truth is superior to poetic invention: this is a leading principle of realist art theory, and Champfleury is its spokesman. The inventing of a new reality, a reality that did not exist before the artist shaped his work, precisely this was the cornerstone of Romantic art theory, as well as of theories in many earlier centuries. The realists' total rejection of imagination is indeed a revolutionary turn in the history of aesthetic thought.

Another of Champfleury's statements may also seem strange to a modern reader. It has to do with the actual production of a work of art. Because our author was not a painter, and was on the whole removed both from the Academy and from live workshop experience, his comments on this subject refer rather to some general characteristics of the process of creation. Though Champfleury devotes no separate discussion to the creation of a work of art, he manages to indicate that the process has no value of its own. "The powerful painter," he writes, "should be able to blot out and redo ten times in a row, and without hesitation, his best painting, [and this] in order to prove that he is neither the slave of chance nor of his nerves."[76] Champfleury does not tell us why this should be so. His statement, however, stands in clear opposition to the spirit of all earlier treatments of the subject. Ever since the Renaissance, art theory, in a more or less explicit way, conceived the creation of a work of art as a unique event. Even when in actual fact painters repeated their compositions, theoreticians did not seem to take notice of the fact. In Romantic thought, the uniqueness, the inability to repeat the process, became part of the artist's mystique. It is part of the drive to see the artist in a new light, to plant him in a new context, that he is supposed to be able to repeat the process "ten times in a row." The artist's dependence on his "nerves"—seven-

teenth-century authors or the Romantics would here use the word "inspiration"—is a failure rather than a sign of grace.

4. FROMENTIN

In France of the 1850s and 1860s, as we have had occasion to see, realism was not a well-formulated doctrine; rather it was a concern with certain problems, an interest in a group of themes, figures, and ways of depiction. In other words, it was an attitude or a mood rather than a rational system. This state of affairs often makes it difficult to say with any certainty that a given artist or writer does, or does not, belong to what is called the realistic school. Does Eugène Fromentin belong to that school? Although it may be difficult to give an unequivocal answer, he represents, better than any other theoretician, a certain facet of the thought of his time, and he is at least closely related to the realistic trend.

Eugène Fromentin (1820–1876) was indeed an unusual figure. In Meyer Schapiro's words, he was that rare man, "an accomplished artist who was also a first rate writer" (*Diderot Studies* 5, pp. 5ff.). His place in French letters of the nineteenth century is well established by his famous novel *Dominique* and by his much-read travel book, *A Summer in the Sahara*. But for decades he was also active, and well known, as a successful professional painter. It was not surprising, therefore, that in 1862 the editor of an influential periodical, the *Revue des deux mondes,* in which *Dominique* had appeared in installments, suggested to Fromentin that he make a further contribution to the journal in the field of art criticism. Another thirteen years passed before Fromentin responded to this suggestion. In July of 1875 he visited the museums and churches of Belgium and Holland, and though his journey lasted no more than three weeks, it resulted in a long series of articles, eventually collected in an imposing volume, *Les maîtres d'autrefois* (1876), which was quickly translated into English as *The Old Masters of Belgium and Holland* (1882).[77] Although Fromentin's *Maîtres d'autrefois* appeared only in the mid-1870s, its roots, both intellectually and emotionally, are to be found in the early 1860s of the nineteenth century. It belongs, then, to the time in

which the different facets of the realistic attitude were being crystallized.

A brief observation on the character of this unique text, *The Old Masters of Belgium and Holland,* may here be in order. In a short preface, Fromentin himself tells the reader what he is to expect. "The book," he says, "should be like a sort of talk about painting, where the painters would recognize their habits, where men of the world would learn to better know painters and painting" (xliii). His text does not indeed pertain to any of the established genres of art theory. Reading *The Old Masters,* one is reminded, as Meyer Schapiro has observed, of "the salon review, the travel book, the critical essay and the private journal." It is not, nor does it claim to be, a scientific or philosophical text. The paintings discussed are not grouped according to any intrinsic principle; rather they are dealt with according to the order in which Fromentin saw them while following his itinerary. His comments are written under the immediate impression of the works of art he was looking at, and he does not hesitate to openly express his emotional reactions to what he sees. In all these respects, Fromentin's text does resemble a salon review, though the paintings themselves are part of the great heritage of the past. It should perhaps be noted that this kind of writing on great historical art was not altogether isolated in his day. Twenty years before Fromentin, another well-known author, Jacob Burckhardt, traveled in Italy, noting his lively impressions on works of art in the order he saw them. These efforts formed Burckhardt's *Cicerone,* published in 1855.

Fromentin's choice of subject matter is of particular significance in our context. The whole work treats the art of the Lowlands. The core of the discussion is devoted to Rubens (pp. 18–107) and the Dutch masters of the seventeenth century (Part II), especially Rembrandt (pp. 218–313). The last, rather brief section deals with early Flemish art, or, as the author says, "Van Eyck and Memling" (pp. 317–339). In nineteenth-century France, as we have seen, a concern with the art of the Netherlands was characteristic of the taste and mood in which realism flowered. Fromentin clearly regards his investigations of the Lowland masters as a means of educating contemporary artists and of directing them in their work. In other words, he adopts the traditional aim of art

theory. Our author knows the educational value of a model. Schools, he says, still teach students how to write French prose by making them study such masters as Pascal, La Bruyère, and Bossuet (xliv). Should not the same principle be applied to painters? By analyzing the masters of Belgium and Holland, Fromentin hoped to lead contemporary painting in a specific direction, and to save it from aberrations and weaknesses. The study of Dutch painting had, in fact, already exerted its beneficial influence on modern art. Dutch landscape painting served as a model for early nineteenth-century French painters. "This time Holland found the right hearers; it taught us to see, to feel, to paint" (206–207).

What, we must now ask, justifies our inclusion of Fromentin in the broad context of realism? Because realism was not a well-defined doctrine, but rather a broad attitude, one artist's or writer's links to this trend could differ widely from that of others. Several components in Fromentin's intellectual makeup show his affinity to realism. To begin with, his desire for truthfulness to reality, the intense wish to be "close to life," while it cannot be considered a mark distinctive of realism, should be noted in the present context. To be successful as a painter of North African scenes, so he had already felt early in his life, he had to go to Africa and to observe, from close by, life among the Arabs. He was not content with the half-romantic imagery of Oriental life, as it was known in Parisian letters and paintings. He wanted to see the people in their natural environment, to observe their costumes, settings, and habits of life. The desire to directly observe one's subject, to say it once again, is not in itself a sign that one is what we would call a "realist," but it does show discontent with the other great trends of the time (Neoclassicism and Romanticism), and it discloses an attitude that is very close to that of realism.

More important, though less tangible in our present context, is a specific feature in Fromentin's mental makeup, namely, his preoccupation with permanence. It has been said that the concern with the permanent may also be discerned in his literary work: he loved the solid, unchangeable nature of the desert.[78] In his treatment of painting, we discern a similar attitude: he is interested in the stable essence of things rather than in their activity in life. In the great pictorial tradition, so Fromentin believes, the emphasis was always on man's stable nature.

The decline of painting began, he argues, when the focus of attention shifted to the story and the anecdote. At least implicitly, then, Fromentin condemns history painting. The concentration on the stable, the unchanging, the permanent leads to a direction of thought that was close to realism.

His attraction to stability is linked with his views on reality, at least insofar as that reality is the subject of artistic representation. Once again we have to stress that Fromentin's views are not clearly and systematically presented—he is no philosopher, as we have said; yet in reading his lively prose we can gain a notion of what he believed reality to be. The outside world, Fromentin believed, is full of different appearances, it displays an inexhaustible diversity of shapes. Behind that bewildering variety, however, there are simple forms. In the multitude of various shapes it is actually these simple forms that are countlessly repeated, in ever-changing combinations. The world, he says in an interesting metaphor, is a dictionary full of synonyms.[79] The original idioms, so we understand, are stable and unchanging. In Fromentin's view there is, then, a kind of a simplistic Platonism. it is not very fruitful to ask how he derived these views. Various versions of Platonism were, of course, available to him wherever he turned, and that there is indeed a Platonic influence at work in Fromentin we can perhaps see from formulations such as "Les idées sont simples, les formes multiples," a phrase he uses in speaking of reality as a dictionary. What precisely these elementary forms are in Fromentin's thought it would be difficult to say. Their function however, that of being a stable foundation for a bewilderingly changing world of appearances, is obvious.

His thoughts about the artist's task are linked with his beliefs about the nature of reality. To be sure, he speaks about the artist and his work in many ways. Thus he writes with great freshness about the different painters' use of color and of their brush strokes, and savors the marvelous texture of the canvas's surface; he perceives the mood of an artist, and his harmony with the nature that produced him ("Of all the Dutch painters, Ruysdael is the one who most nobly resembles his country"—p. 183) But he also asks how the artist relates to the reality, as he understands that concept. Now, Fromentin altogether rejects the

Romantic vision of the artist as an original creator. The painter, he believes, does not invent shapes, he does not produce something that is radically new. His distinctive characteristic is his ability to penetrate the surface of life, to discover the primary forms, and to present them to the spectator's eye. The artist thus shows us the inner structure of the world.

V. THE GREAT MASTERS

1. INTRODUCTION

The student surveying French art theory around the middle of the nineteenth century sometimes has the feeling, so he imagines, that the surveyor drawing a map of a vast plain must experience: he finds directions for orientation, he notices broad streams and surfaces, but few are the features that forcefully arrest his gaze by their individual, unique shape. In the imagined landscape of mid-nineteenth-century French art literature, there is, however, one mountain range. Seen from afar, it dominates the surveyor's field of vision. That mountain range is the work and thought of Delacroix and Baudelaire.

There are obvious difficulties in dealing, in the present context, with their theoretical legacy. Both were great and original artists, and possibly for this reason they are difficult to classify, to file under accepted labels. Can they be seen as representing their time? One hesitates to give a simple affirmative answer. In many respects they do indeed reveal, more sharply than most other thinkers, some of the central problems of their day. But they also keep alive, while transforming it, a great deal of the heritage of the past. Both carry on with some components of the Romantic vision. In this regard, their ideas are linked with strata of the past. At the same time, however, both Delacroix and Baudelaire are widely accepted and recognized as the pioneers and trailblazers of modernity.

Though they are here grouped together, it would be a mistake to overemphasize the agreement between them. Delacroix and Baudelaire, even if we consider only their views on painting, were not one person-

ality with two faces, as it were. It is true that the work and art thought of the two overlapped and intersected. Baudelaire, as one knows, wrote extensively on Delacroix, and we shall shortly come back to some of these texts. Delacroix was profoundly influenced by Baudelaire's views and criticism. But in spite of these strong interactions there were also tensions between their ideas. These tensions derive in part from their thought being rooted in different arts, painting and poetry, and in part from certain differences in how they looked at the problems they approached. While they cannot be isolated from each other, they should nevertheless be analyzed separately.

2. DELACROIX

The Character of Delacroix's Writings. Eugène Delacroix (1798–1863), one need hardly say, is one of the best-known of nineteenth-century painters. He was also—and this, too, is well known—one of the most articulate and literary-minded of artists. Delacroix's need for conceptual articulation is reflected in the considerable volume of writing, mostly devoted to painting, that is his literary legacy. None of this writing ever achieved a final and systematic form. It remained scattered in letters and journals, written under special conditions, and not composed in well-balanced form. Yet these notes, though fragmentary, are sometimes quite extensive, and they often enable the student to reconstruct the artist's views in some detail. Delacroix himself was painfully aware of the fragmentary nature of his notes. In 1857, he recorded in his diary his intention to transform them into a *Dictionnaire des beaux-arts.*[80] The *Dictionnaire,* one should remember, was at the time an accepted form for a highly systematic presentation of views on art. Viollet-le-Duc, for instance, published his *dictionnaires* in those very same years.[81] Delacroix's intention was never realized, and his literary work remained incomplete. But his desire is in itself important testimony to how he saw the theory of art.

In discussing Delacroix's theory of art, one cannot forget that the author was one of the most distinct and original painters of the century. In his writings one indeed often perceives his intimate feeling for, and first-hand acquaintance with, the craft of painting as well as his famil-

iarity with the creative process. It is precisely because of this awareness of Delacroix's own work that one is often forced to note an incongruity —at times obvious, at times only adumbrated—between his artistic and his theoretical production. I should therefore like to emphasize once again that we are here studying Delacroix's theory, not his painting. While we shall have to disregard the latter, it is important to observe that the incongruity itself is significant evidence of the fact that an artist's theory is not necessarily a mirror image of his pictorial opus. The theory of art is an intellectual pursuit with its own merits and its own character.

Delacroix's reflections on art may be fragmentary, but they are so extensive and varied that we feel we are entitled to speak of a more or less complete doctrine. It is possible, therefore, to ask what the pivotal theme of this doctrine was. In other words, what was the problem around which Delacroix's teaching revolved? Here, it seems, the answer is easily given. The subject that fascinated Delacroix and dominated his reflections on art was the creative process itself. Time and again he tries to unriddle the mystery of how a work of art comes into being, and what properties the artist must possess in order to be able to shape his work. His efforts to understand the essence of artistic imagination are set in this context. Before turning to a discussion of this central subject, however, it may be useful to briefly survey at least one other theme, though it remained marginal in the artist's thought. What I have in mind is the question of the ultimate goal of painting.

Although Delacroix did not treat this subject systematically, we are in no doubt of his major emphases. He saw a painting as a vehicle for communication between souls, the soul of the artist and the soul of the spectator. Among the notes made in preparation for the projected *Dictionnaire,* we read the entry written on January 25, 1857: "The major source of interest [in the work of art] comes from the soul [of the artist], and it goes in an irresistible manner into the soul of the spectator." The work of art serves as a bridge between the soul of the artist and that of the spectator.[82] The affinity of this view to a trend of Romantic thought does not have to be shown in detail. And yet we should note that the emphasis on reaching the spectator radically differs from a view, also found in Romanticism, that perceives the work of art

as a self-expression of the artist, conceived and produced in isolation from any audience. In Delacroix, it comes quite close to a rhetorical concept of art. The affective, emotional impact of the painting is its ultimate goal. The locus of the work of art, both in its production and its effect, is the soul. (In passing, one cannot help noticing that in this scheme of things, little room is left for the texture of the canvas or the marvels of the brush stroke. There is an obvious and wide difference between the character of Delacroix's art and the nature of his thought).

The Aim of Painting. That the central aim of a painting or statute is to move the beholder's soul, it need hardly be said, is not a new idea. The student who has followed the unfolding of art theory has seen various and repeated proclamations that the picture's or the statue's expressive effect on the spectator is the artist's ultimate goal, and art's ultimate justification. From Plato, who saw an inherent danger in the power to move the spectator, to the Counter-reformation, which saw in that power a gift of God, to be used for the right and proper purpose, almost everyone agreed that moving the spectator's mind and soul is what art attempts to do. Delacroix inherited his description of the goal of art from tradition, and there can be little doubt that he was aware of this, and saw himself as a link in a great historical chain.

While Delacroix followed tradition as regards the aim of painting, he seems to have diverged from its core in his views on how this goal is to be reached, that is, what means the artist employs and what methods he adopts in order to move the spectator. Let us recall, in broadest outline, how, between the fifteenth and the eighteenth centuries, artists and writers who preached the gospel of the affective value of the work of art thought that this value could be realized. All these generations believed that history has bequeathed to the artist a vast store-house of configurations — scenes, compositions, gestures, colors, and so forth — that are proven means of conveying experiences and evoking emotions in the beholder. To be sure, this belief was stated in a variety of ways, with a wealth of shades and nuances. The different artists and authors of course believed that the creative artist's personal experience might add to, or intensify, the expressive power of the inherited motifs. Essentially, however, they were all committed to the assumption that

the beholder is successfully stirred by means derived from this great tradition. Delacroix emphasizes other components. In his writings he never explicitly negates the expressive significance of the inherited pictorial language (in his actual work as an artist, he made extensive use of it, as we all know). However, he gives very little attention to rhetorical formulae in his theoretical reflections. Instead of the language of culture and tradition, he proposes another feature as the mainspring of creative power.

Imagination. One particular faculty distinguishes the artist: it is the faculty of imagination. In 1857, Delacroix notes in his journal: *"Imagination. It is the primary faculty of the artist."*[83] This is only one of many passages in which he stresses imagination. His friends saw Delacroix himself as the artist who was dominated by imagination. Baudelaire, in his famous essay "The Life and Work of Eugène Delacroix," describes imagination as the essence of our artist's work. "All the faculties of the human soul must be subordinated to the imagination."[84] The full subordination of all the faculties to the imagination is just what Delacroix was believed to have achieved, and this is what he himself thought leads to moving the spectator's soul. Imagination, then, as I have said, is the central theme of his thought on art.

Both in his personal notes and in his published writings Delacroix sang the praises of the artist's imagination. But it did not take him long to encounter the basic dilemma that all earlier praise of the artistic imagination had faced. Does the artist's imagination invent the image he produces out of a complete void? In other words, is the production of a work of art a "creation out of nothing," a *creatio ex nihilo,* to use the medieval term? Or does artistic imagination rather consist primarily of a certain freedom to shift and arrange the images that in themselves are not the artist's invention, but are drawn from "nature," that is, from our experience of the "outside" world? Such would be the more philosophical formulation of the unavoidable question. In art theory the question cannot remain purely philosophical or only a matter of principle; it has obvious implications for both the art critic and the practicing artist. The critic will ask whether originality (be it newness, inventiveness, or whatever else this problematic term may designate) is the major

value in an artist's work, and whether it should be ranked superior to his other achievements, such as keeping tradition alive. The language of criticism in our own day, as is well known, clearly shows how tenacious such questions still are. But the implications for the practicing artist are perhaps of greater importance. Should the painter give his fantasy free rein so that he can conjure up on his canvas whatever strikes his fancy, or should he rather limit his imagination by obeying a call for natural similitude and by adhering to rational rules?

In the middle of the nineteenth century, two significant intellectual forces combined against the view, or demand, that the artist give free rein to his imagination. One of these was the great French tradition of believing in "reason" and in the academic rules derived from it; the other was the influential thinking of a dynamically growing "realism," then at its most vigorous stage. Delacroix, as we shall immediately see, accepted the domination of "rules" and tried to make it part of his own doctrine. The claims and assumptions of "realism" he rejected out of hand. Reading his notes, particularly those written in the 1850s, it is not hard to feel that he saw the realistic attitude as an immediate danger. In his disputes with realism, Delacroix's formulations often get more pointed, and probably more extreme, than he himself would have wished them to be. The theory of realism, we remember, refused to grant the imagination any significant function in the creative process. Nature herself, so that theory held, provides the forms and motifs the artist needs. In representing reality, the artist in fact has to take care that his imagination does not interfere with the proper and truthful perception of the objects he depicts. It is mainly against this attitude that Delacroix argues. In the artist's work, he claims, the functioning and moving of the imagination never stop. When looking at nature, the artist cannot do away with his imagination. On the contrary: "In the presence of nature herself," so he notes on September 1, 1859, "it is our imagination that makes the picture."[85] And as if to strengthen his apology for the artist's imagination, he compares painting with photography. A painting and a photographic shot of the same site, he says in the note just quoted, are not the same thing. "When a photographer takes a view, all you ever see is a part cut off from a whole: the edge of the picture is as interesting as the center; all you can do is to suppose

an ensemble, of which you see only a portion, apparently chosen by chance." It is worth our while to recall that Delacroix was interested in photography and that he did not reject the new medium. Already five years earlier, he had described photography as a "tangible demonstration of the true design in nature." [86] It is also well known that he saw in photographic pictures a welcome substitute for the natural model. But both the photograph and the live model are the artist's point of departure, they are never his product. This may also explain the difference he suggests in the sentence just quoted. In the photograph, everything—objects and shapes, order and composition—is furnished by nature; the edges are just as significant as the center. In the painting, shaped by imagination even if the painter was looking at nature while working, the hierarchy of significance, the distinction between the center and the margins, is the artist's product.

With all of Delacroix's defense of the artist's imagination, he is not a radical "fantaisiste." To produce a work of art, he believes, the imagination cannot be divorced from careful observation of nature, and it cannot do without—and surely cannot replace—a system of rules. Imagination in itself, taken as something self-sufficient, is not his goal. It is even a danger. Unbridled imagination, such as he believed to have recognized in the poetry of Edgar Allan Poe, is *extraordinaire* because it is *extra-humaine.* [87] The poet's excessive flights of fancy should be tempered, and the same requirement holds good for the visual arts. Delacroix admired Rubens, but in that master's paintings he sometimes finds too much imagination.

Delacroix's theoretical position on the question of imagination can best be described as restrained, or, as George Mras puts it, "conservative" or "moderate." [88] This position implies important conclusions. Though he saw in imagination the artist's central faculty, Delacroix never believed that the creative process, the process in which the imagination materializes into a work of art, in any way resembles a *creatio ex nihilo.* Artistic imagination consists in the ordering and combining of features and forms, but the forms themselves—the "raw material," as it were, that serves the artist's imagination—are not produced by the fantasy; they are drawn from nature, from our experience, and even from our cultural heritage. That the artist take his subject matter

from nature or from literature seems to Delacroix as natural as it seemed to a Renaissance artist.

What Delacroix had to say about the role of the imagination does not consist primarily in an analysis of the conceptual terms used in treating the subject. His originality emerges most clearly in dealing with a seemingly practical device, which, however, also involves a general problem characteristic of the modern age. This theme involves both the spectator's imagination and the sketch as an art form. Nowhere does Delacroix seem to have dealt with this question in a systematic fashion, and yet one feels confident in reconstructing his views. We can approach the subject from two ends, that of imagination and that of sketch.

The Sketch. Imagination, I have frequently had to repeat in the course of this volume, is one of the oldest and most central themes of reflection on art. No wonder, then, that the notion underwent many shifts and changes, and that we encounter it in a bewildering variety of guises. One thing seems to have remained stable throughout: in discussing imagination, one always had *the artist's* imagination in mind. It was only in the modern age that the beholder's imagination began to receive more consideration, and that it was seen as part of the aesthetic problem. The spectator looking at a picture, so it was felt, was not altogether passive, and he cannot be compared to molten wax onto which a seal is impressed. On the contrary, the spectator is an active partner, as it were, in bringing about that unique encounter between man and work in which the picture or the statue acquires full life. Once the beholder was perceived in this new role, it was natural that the workings of his mind should arouse curiosity. How does the spectator exercise his imagination in the process of experiencing a painting, and how can the painter stimulate and direct the spectator's imagination? To judge from various scattered remarks, Delacroix must have been concerned with these questions over a long period.

Already in 1853, Delacroix wondered, as we learn from a note he made in his *Journal* on May 9, about the strange effect disproportion can have on the beholder. Four years later, he obviously still considered the

subject important enough to reread what he had written and to amplify his former ideas.

I said that the sketch of a picture of a monument—and the same is true of a ruin or, in a word, any work of the imagination in which parts are lacking —ought to react on the soul in just the proportion that we have to add to the work, while it is producing its impression on us. I add that perfect works, like those of a Racine or a Mozart, do not, at the first moment, produce as much effect as those of less correct or even careless geniuses, who give you salient parts standing out in all the stronger relief because others, beside them, are vague or completely bad.[89]

From Delacroix's formulation one could get the mistaken impression that he was discovering the power of the sketch. In fact, the pictorial sketch was not a new subject; Delacroix was here taking up a common theme, one that had given rise to a continuing and heated controversy. But he was taking it up from an angle that was unusual for his time.

To understand the significance and special character of Delacroix's position, we shall have to devote a few observations to its broad background. The sketch, needless to say, had been known for a very long time; it was also a formal part of academic aesthetics. Yet in spite, or perhaps because, of its age and wide diffusion, it carried a variety of meanings, and it was associated with a multitude of forms. To speak of a "sketch," therefore, was far from self-evident in meaning; nor were the reasons for appreciating, or rejecting, the sketch obvious in themselves.

The modern terms, all in French, were taken over from the language of the Italian workshops.[90] The French *esquisse,* common in the nineteenth century, is derived from the older Italian *schizzo,* while *ébauche,* equally common in Delacroix's day, is derived from the Italian *abozza.* In the Italian workshops of the seventeenth and eighteenth centuries these terms preserved their original meaning; they referred to the stages of preparing a work of art. The great codifier of Italian workshop and critical language in the late seventeenth century, Filippo Baldinucci, has left us a clear formulation of what these notions meant as technical terms. *Schizzo,* he writes, "the painters say of their lighter touches of the brush or the pencil, [touches] by which they indicate their ideas

(concetti) without bringing the [different] parts to perfection. This they call sketching."[91] And of *abbozzare* he writes that it is "said of those primary features that the painters make on canvases or panels, thus beginning to shade the figures in a gross manner *(alla grossa),* and then turning to other colors."[92]

In the course of the eighteenth and particularly in the early nineteenth century, the sketch began to be seen in a different light. Now the *esquisse* was considered not merely as a document of a preparatory stage, a stage considered significant only because the final result, the completed work of art, is of importance. Certain expressive and aesthetic qualities were now being discovered, and highly appreciated, and they were recognized as characteristic of the sketch. In the intellectual and artistic atmosphere of modern France, the new appreciation of the sketch was not an isolated phenomenon. Its full significance becomes manifest only when we realize that it is part of a larger syndrome. Just as there was a high regard for the sketch, there was a growing appreciation of drawings, *bozzetti,* and unfinished or even spoiled works by great masters. One should also recall that it was in the nineteenth century that the unfinished statue, the *non finito,* began to exert a magic power over the minds of artists, critics, and broad audiences. Delacroix himself, in the original note of May 9, 1853, that we have referred to above, records that "the effect produced by the statues of Michelangelo is due to certain disproportionate or unfinished parts which augment the importance of the parts which are complete."[93] Some years ago, H. W. Janson investigated this syndrome of appreciating the unfinished.[94] What he calls "the autonomous fragment"—the torso, the intentionally unfinished piece of statuary—is, as he says, one of the most important legacies of nineteenth-century sculpture. This "legacy" is, of course, the product of the same attitude that made people admire a sketch. That a piece of sculpture could have been composed from the outset as a fragment (as in the eighteenth century an edifice, usually in a garden, could have been planned and constructed as a "ruin")[95] is an important testimony to an attitude that is specifically "modern." In Antiquity and in the Middle Ages, unfinished works were unhesitatingly discarded if it was believed that they could not be completed. In the

nineteenth century, they came to be considered as "tokens of genius," they were bought at high prices, collected, and studied.

Precisely because we are here faced with a broad and complex attitude, we cannot avoid inquiring into its underlying motives and asking what it is that accounts for its surprising power. Several considerations—obviously interrelated, yet not identical with each other—offer themselves to the student. One circumstance is the inherent proximity of the sketch to the process of creating a work of art. It is in the nature of this process that its traces are effaced: the closer the work of art comes to completion, the fewer traces of its becoming remain visible. The great classicists, preaching the gospel of the finished and polished work, indeed explicitly required the wiping away of any residues of the stages in which it was shaped.[96] In painting, the only clear and visible vestige of the creative process is the sketch. The high regard for the creative process, therefore, necessarily leads to an appreciation of the sketch.

Another reason in support of the modern appreciation of the sketch is sometimes reflected in eighteenth- and nineteenth-century thought: it is the belief that the sketch reflects the artist's character and personality more clearly than does the finished work. Once again we must go back to Diderot, the thinker so crucial in the emergence of modern art criticism. "Sketches," he wrote, "generally possess a warmth that pictures do not. They represent a state of ardour and pure verve on the artist's part, with no admixture of the affected elaboration introduced by thought: through the sketch the painter's very soul is poured forth on the canvas."[97]

Diderot's praise of the sketch announces a distinction destined to become popular in the nineteenth and twentieth centuries. The finish of a painting, or sculpture, is seen as a matter of a broadly accepted but —for this very reason—impersonal culture. The sketch, on the other hand, is thought to precede the leveling impact of that anonymous culture; it reveals the individual, the unique personality that is the true origin of the work of art. To put it with some exaggeration, the creative process is pictured as a clash between the artist's individual personality, on the one hand, and society's impersonal culture, on the other. The

more closely a work of art approaches completion and finish, the farther removed it is from its original, personal inception. If we place this notion in a broader context, we can say that the artist is situated in opposition to society and culture. The theory of enthusiasm, of the artist's inspiration, a theory that was to become so influential in the course of the nineteenth century, seemed to further support the mutual contradiction of artist and social culture. Enthusiasm and inspiration, everybody believed, are the gifts of the individual artist only. They are, then, best expressed in the sketch, the most personal of art forms. "Passion," to quote Diderot once more, "makes only sketches." And somewhere else he asks: "How is it that a young pupil who could not even make a mediocre picture can dash off a magnificent sketch?" And his answer is: "Because the sketch is a work of fire and genius, while the picture is a product of labor, long and patient study and consummate experience of art."[98]

A third reason can be given for the new appreciation of the sketch. In its attempt to catch the evanescent, seemingly self-generated reality of the imagination, the sketch seemed to some artists and critics to manifest, more distinctly than any other art form, creative spontaneity. Already by the mid-eighteenth century, the vivacity of the sketch was seen as a definite and identifiable aesthetic value. "Why does a fine sketch give us more pleasure than a fine picture?" Diderot asked. His answer was: "Because we find in it [the sketch] more life and fewer details. In proportion as the artist introduces more detail the vivacity disappears."[99] What Diderot calls "detail" is the rational, balanced, and precise record of reality; "life," on the other hand, is that mysterious, self-generating movement that we call "spontaneity." In the revision of aesthetic concepts and judgments that began with the Enlightenment, the artist's spontaneity as such, as seen in his brush stroke and hand-writing, came to be considered a central aesthetic value. Moreover, artistic spontaneity was seen as a visible embodiment of human spontaneity and creative power in general. The sketch, then, in some mysterious fashion evoked a fundamental trait in human nature. To eighteenth-century intellectuals, it has convincingly been said, the sketch showed "what was nascent, instinctual and, therefore, fundamental to all creatures."[100]

In the early nineteenth century all the approaches to the sketch that we have outlined were vigorously alive. Delacroix, it goes without saying, absorbed all of them. Few artists of his time equalled him in perceiving the aesthetic and expressive values of the sketch, and it is not surprising that all these ideas are reflected, in one way or another, in his writings. In the great debate between the sketch and the finished painting, however, his position was not an extreme one; it was, one could say, rather "moderate." In his paintings, he never "abandoned himself to the absolute freedom of the sketch."[101] In his theoretical reflections, his position was similar. He tried to combine both attitudes.

We shall disregard all those observations in which Delacroix simply reflects the views and trends of thought on the sketch prevailing in his time. I should like to emphasize only one view, one not found as often as the others. I mean the belief that the sketch incites the imagination of the spectator. In the note of October 26, 1853, a note I have already mentioned more than once, Delacroix explicitly deplores a high degree of finish in a painting. But why is finish bad? The reason is that it suppresses the qualities that stimulate the spectator's imagination. Faced with a meticulously finished, highly polished painting, the spectator's imagination is left helpless and confined. The spectator's imagination, Delacroix writes, "enjoys uncertainty and easily spreads, and embraces vast objects on the basis of scanty suggestions."[102]

Reviewing these observations, one notes, first, the great attention devoted to the spectator and to his reactions. Second, it is specifically the spectator's imagination that is considered of primary importance. The value of the sketch consists precisely in this, that it activates the spectator's fantasy. The beholder, it follows, is not a passive receiver, more or less affected by what he sees; he is understood as acting and contributing his own fantasy in experiencing a work of art. With the advantage of hindsight, we can say that here the view of the spectator as the artist's partner begins to emerge.

Color. One additional aspect of Delacroix's elaborate and many-sided theory of art, his views on color, must still be briefly treated. Once again, the subject is not new. The position of color within the system of painting, and particularly its juxtaposition with line, is a time-

honored theme in reflections on painting. In the first volume of this book, I had, indeed, to deal repeatedly with the contest between color and line. We have seen how it appeared in the late centuries of Antiquity, how it was suggested in the later Middle Ages, how it acquired great significance in the late Renaissance, and how it dominated the passionate debates carried on in the French Academy of the seventeenth century.[103] In the first half of the nineteenth century, the controversy concerning the specific values of color and line was forcefully revived. A neoclassical trend championed the supposedly rational, spiritual, and ascetic character of line. Another group, more difficult to label under a single term, extolled the sensuous, evocative, and life-giving power of color. Delacroix, it is well known, belonged to this second group. He was, it has been said, a "propagandist for color." When we try to see his views on this subject in a broader context, it turns out that his support for color is closely related to what imagination meant in his thought, and to how he saw the spectator's role in experiencing a work of art.

The most conspicuous feature of color, Delacroix believes, is that it endows the painting with the "appearance of life." Early in 1852 he noted in his *Journal*: "Painters who are not colorists produce illumination and not painting. . . . Color gives the appearance of life."[104] This latter phrase is a figure of speech known from Antiquity to Diderot. In ancient literature it occurs in Plutarch, who in the second century A.D. claimed that "color is more stimulating than line drawing because it is life-like and creates an illusion."[105] We shall not of course attempt to trace the eventful history of these metaphors. Among modern writers I shall mention only one of Delacroix's most revered authors, Diderot. In the *Essay on Painting*, Diderot said that "It is drawing that gives form to the beings [figures], it is color that gives them life. Here is the divine breath that animates them."[106]

Now, lifelikeness, appearance of life, animating breath—are not all these descriptive phrases in fact very close to the metaphors used to characterize imagination? That our artist used the same formulae for describing the character and effect of both color and imagination probably indicates a link between the two. What color provides—this is what Delacroix seems to have thought—is one aspect of what

imagination gives on a comprehensive scale. No wonder, then, that he ascribes to color an effect similar to that characteristic of the sketch: it stimulates the beholder's fantasy. In his preparations for the *Dictionnaire* that never came to fruition, he wrote: "Color: of its superiority or of its exquisiteness, if you wish, with regard to its effect on the imagination."[107] There is a bond, then, between color and the spectator's imagination.

Here Delacroix goes beyond what was accepted in the long history of reflection on color in painting. That color appeals to the emotions, whereas line addresses itself to the rational faculties of the mind, was a belief held in many periods. What is characteristic of the new age, and particularly of Delacroix, is the explicit assumption that color stimulates specifically the spectator's imagination. Even for this connection one could find a precedent in history. At the end of the seventeenth century, Dupuy de Grez, the French writer on art, declared that "As design strikes reason, so color strikes imagination."[108] Such an isolated statement remained without further impact, however. It was only in the middle of the nineteenth century that the underlying assumptions become explicit. Delacroix, it can be said without much hesitation, opens up a new stage in modern color theory by bringing hues into connection with the spectator's imagination.

Delacroix's art theory, as also his art, has often been described as "Romantic," and there is indeed little doubt that he was influenced by various trends in Romanticism. He drew from many intellectual and aesthetic traditions, the most prominent among them being Diderot, who represented for him the Enlightenment, and the writers and artists of nineteenth-century Germany. He admired the work of Madame de Staël, the influential French writer who, around the turn of the century, had such close connections with the poets and painters of German Romanticism. Her book on Germany[109] played an important part in the development of his own ideas. But while the influence of literary Romanticism on Delacroix is certain, we must ask ourselves whether we can label him a "Romantic." Perhaps more than any other nineteenth-century painter who was closely related to Romanticism, Delacroix goes beyond the intellectual limits of that movement, and marks the transition to what we are in the habit of calling "the modern world."

3. CHARLES BAUDELAIRE (1821–1867)

His Writings on Art. "Glorifying the cult of images (my great, my unique, my primary passion)"—this is how Baudelaire described his lifelong attitude to the visual arts. Himself one of the great poets of French literature, and one of the foremost literary critics of his century, throughout his life he did indeed glorify painting and make images the objects of cult and veneration. In 1845, as a young man of twenty-four, he made his literary debut with a piece on painting, the review of the Salon of that year. He continued to write on painting and sculpture almost to the end of his life. But there is obviously more to his writings on painting and sculpture than a continued dedication and an unhesitating veneration of the arts of the eye. Baudelaire had a gospel to preach about the nature of art, and it is a message of historical significance. Every student trying to outline a history of modern reflection on art must admit that with Baudelaire a new age begins. Are we, then, entitled to treat him as part of that stage in art theory that we have tried to describe in the present volume? Should a presentation of theoretical reflection on art, as it emerged in the generation of Winckelmann, not be brought to a conclusion before the appearance of Baudelaire? While there is little doubt that Baudelaire marks the beginning of a new stage of critical thought, however, he also marks the end of a long and rich development in the theory of art. One of our aims in this final section will, indeed, be to show what he drew from the past and what are the major links that connect him with the great heritage of thought on images. Moreover, many developments in the theory of art from Winckelmann to the middle of the nineteenth century can be seen in a new light if they are looked at from the vantage point of Baudelaire.

To attempt an analysis of Baudelaire in the context of art theory is to face a familiar difficulty. Baudelaire never produced a systematic treatise on art. His writings pertinent to our subject consist of occasional pieces, either critical reviews of exhibitions (the so called "Salons") or discussions of individual artists (Guys, Delacroix, some caricaturists), and were usually composed for specific events. Some of the articles he wrote on poets and composers (such as Edgar Allan Poe and

Richard Wagner) may also contribute to our understanding of his views on painting and sculpture. On the whole, then, his reflections on painting are intimately related to special events or figures in the art life of his time, and it does not at first seem that they will be able to convey an overview of his art theory as a whole. In spite of these limitations, however, it has always been obvious that Baudelaire has a "doctrine," or a message to deliver, that can be detached from any particular occasion or figure and presented according to certain principles. Students who, in one way or another, have touched on his views, in fact, have never doubted that there is a Baudelaire "doctrine," and that it can be presented in systematic fashion. Here I shall first try to present, in brief outline, the central components of this doctrine, and afterwards attempt to shed some light on its links to past developments as well as on its ramifications for the future.

Principles: Autonomy, Imagination, "Correspondences." What is the purpose of art? This is the subject of the first principle in Baudelaire's theory of art. His central tenet is that art is autonomous. This claim, valid for both literature and the visual arts, forms the very basis of his aesthetics. Baudelaire is perhaps the most important preacher of the autonomy of art, and he is known for this belief more than for any other.

Not that he always held this view; he arrived at it after some soul searching. In his youth he wrote contemptuously of the "puerile utopia of the school of *art for art,* which by excluding morals, and often even passion, was necessarily sterile."[110] At this early stage of this thought he accepted opinions and beliefs that, as we have seen, enjoyed wide approval at the time, and were firmly rooted in a long history of the philosophy of art. Even in the early or mid-nineteenth century, as we have just noted, most trends of thought assigned to art a purpose that was not art itself. The work of art, we have heard time and again, aims at moving the passions of the audience, it strives to teach us a lesson or to improve the morals of society. But Baudelaire dissociated himself from these doctrines. He became, as we have said, the apostle of the doctrine that art has its value in itself. As early as 1846, he condemned philosophical poetry as "a false genre." He deplored the view that art should express ideas drawn from spheres as distant from art as science

or politics. "Is art useful?" he asks in another article, and answers: "Yes. Why? Because it is art."[111]

In an article called "Philosophical Art," found after his death among his papers (and most likely not yet in finished form), Baudelaire tries to define "pure art." He does so by opposing "pure" to "philosophical" art. The opening sentences should be quoted *in extenso*.

What is pure art according to the modern idea? It is the creation of an evocative magic, containing at once the object and the subject, the world external to the artist and the artist himself.

What is philosophic art according to the ideas of Chenavard and the German school? It is a plastic art which sets itself up in place of books, by which I mean as a rival to the printing press in the teaching of history, morals and philosophy.[112]

"Philosophic art," then, is art produced not for its own sake but in order to teach us something, or for some other external purpose. The plastic arts, Baudelaire sarcastically remarks on the same page, were "to paint the national archives of a people, and its religious beliefs." "Pure art," on the other hand, is the art that has no external purpose. The reference to the spectator, it is worth mentioning, is not denied in "pure" art. To speak about "evocative magic" is possible only if there is a spectator on whom this magic is to work. What is denied, or overcome, is the gap between "the art" and the purpose in a painting or a poem.

We cannot deal here with the more distant sources that may have nourished Baudelaire's concept of art as an autonomous value. Tracing the history of views concerning the purposes of art may well require a volume of its own. Here I shall only remark that the "art for art's sake" movement obviously forms part of the immediate background of Baudelaire's thought on the subject (though, being primarily a literary movement, it has a somewhat distant relation to the theory of the visual arts). Perhaps the most direct philosophical source is to be found in the Paris school of idealistic aesthetics that was active and influential in the early decades of the nineteenth century. This school is probably best represented by Victor Cousin (1796–1867), philosopher and persuasive teacher. In a lecture series delivered in 1817–1818 but published twenty

years later (in a book that achieved great fame and popularity), we find statements such as: "Art is not an instrument, it is in itself its own end" or "What is required is religion for religion's sake, morality for morality's sake, just as art for art's sake." [113] Cousin himself pointed out the theological origins of his philosophy. "We love a beautiful or good object," he said, "because it is such, without prior consideration whether this love may be useful to its object or to ourselves. All the stronger reason that, when it ascends to God, love is a pure homage rendered to his perfection; it is the natural overflow of the soul towards a being who is infinitely lovable." [114]

It is beyond our scope to explore the hidden motives that brought about the "art for art's sake" movement. To do this might well amount to attempting an analysis of a significant part of modern culture and society in general. Some scholars have seen in that movement, originally a literary one, an afterlife of Romanticism. Revolt against the rigid laws of classicism and the proclamation of a free art liberated from the fetters of traditional poetics and rhetoric are the soil in which the new attitude grew, they say. [115] Another cause that has been put forward in different forms is of a more social nature: it is the perception of the artist as thoroughly alienated from his audience. Seeing art as autonomous, that is, as detached from any social context, is the result of this alienation. [116] The tone that Baudelaire employs in speaking of large audiences would seem to support this explanation. It is a tone that, in its harshness, hostility, and contempt, is in itself vivid testimony to the alienation of progressive artists and of the critics supporting them, on the one hand, from the general audience, on the other. The broad public, in Baudelaire's words, is characterized by "the stupidity of the multitude," it suffers from the "disease of imbeciles." [117] In former periods also, the public was occasionally criticized, but it is difficult to conceive of such large-scale contempt for the "crowd."

So far we have looked at Baudelaire's views of the purpose for which a work of art is, or should be, produced. But how does it come into being? If the first topic we have outlined is concerned with the place of art in culture or society, the latter is focused on art itself.

Baudelaire wholly rejects the inherited opinion, which was almost an axiom in the art theory of most periods, that a picture comes into being

by representing nature. He in fact constantly attacked the time-honored theory that art is an imitation of nature. This total rejection of the imitation theory has two aspects. First, he questions the philosophical assumptions of the theory. In criticizing the Salon of 1859, he wrote: "In recent years we have heard it said in a thousand different ways, 'Copy nature; just copy nature.' . . . And this doctrine (the enemy of art) was alleged to apply not only to painting but to all the arts. . . ." He wants to ask these "doctrinaires" several questions. One is "whether they were quite certain of the existence of external nature." After all, we can only depict what we see and feel, the outside world as it is reflected in our minds. None of us, and most of all the artist, can go beyond our personal, subjective experience. "The artist, the true artist, the true poet, should only paint in accordance with what he sees and with what he feels."[118] We shall not here attempt to explore the philosophical aspects of Baudelaire's statement. Whatever one may think of his attitude as a philosophical argument, it is obvious that he is here questioning the very basis of what had been the credo of art theory throughout the centuries, namely, that we *can* depict nature.

The other aspect of Baudelaire's rejection of the imitation theory, perhaps even more important than the philosophical side, is the emotional connotation the "imitation of nature" acquires in his thought, and the tone in which he expresses his rejection of this theory. Thus he speaks of the "silly cult of nature." Imitating nature is equated with a loss of art's self-esteem. Looking at the painting produced in his day, he finds that "Every day art further diminishes its self-respect by bowing down before external reality; each day the painter becomes more and more given to painting not what he dreams but what he sees."[119]

The anger and contempt so clearly manifested in his rejection of realism, both in painting and in literature, vividly testify to what I here wish to point out. Realism, he says, is "a disgusting insult thrown into the face of all analysts, a vague and elastic word which means for the vulgar not a new method of creation but the minute description of inessentials." Equally telling, in this respect, is Baudelaire's open disdain for photography. The very emergence of photography seems to him to follow directly from the high regard for realism in art. In his important review of the Salon of 1859, he devoted an article to the new medium

of photography. "In matters of painting and sculpture," he wrote, "the present-day Credo of the sophisticated . . . is this: 'I believe in Nature (a timid and dissident sect would wish to exclude the more repellent objects of nature, such as skeletons and chamber-pots). . . . A revengeful God has given ear to the prayers of this multitude. Daguerre was his Messiah.'"[120]

In an original and profound insight, Baudelaire declares that the true aim of realism is the representation of a world free of, or alien to, human experience. This idea is only casually stated, but its significance is so far-reaching that we must note it. Only if we see the hidden motives and aims of realism as he saw them can we understand what true artistic creation meant to him. In his seminal reviews of the 1859 Salon, Baudelaire contrasts the realists, whom he chooses to call "positivists," with what he calls "the imaginists." The realist seems to say: " 'I want to represent things as they are, or rather as they would be, supposing that I did not exist.' In other words, the universe without man. The others however — the 'imaginatives' — say, 'I want to illuminate things with my mind, and to project their reflection upon other minds.' "[121] Here we have reached another basic principle of Baudelaire's theory of art, his doctrine of the imagination. If realism aims to depict a nonhuman world, imagination conjures up a world that is nothing but human.

The modern student asks, first of all, what is the specific place of imagination, as Baudelaire understands it, in the order of things. Does the study of the artist's imagination belong in the domain of psychology, or should it rather be approached as a kind of metaphysical reality? To Baudelaire, artistic imagination is "the queen of the faculties," and he endows it, though subtly and ambiguously, with metaphysical connotations. It thus hovers between the domain of the empirical and the metaphysical. "The imagination is an almost divine faculty," our author says, which at once perceives certain hidden relationships in the world.[122] The imagination has the power to compensate for the deficiencies of nature. "The imagination owes [this power] to its divine origin."[123] He even speaks, though vaguely (so that the reader is not sure whether he is to understand the wording as metaphoric or as literal), of a "universal imagination."[124]

The distinctive mark of the artist's imagination, as Baudelaire sees it, is its productivity, its generating power. It becomes the creative faculty par excellence. In his Salon review of 1859, he quotes approvingly (and in the original English) from Catherine Crow's *The Night Side of Nature,* which appeared in 1848. There the author distinguishes, in the vein of Coleridge and other English writers of the early nineteenth century, between "fancy" and the higher forms of imagination. The higher function of imagination, Mrs. Crow writes, "in as much as man is made in the likeness of God, bears a distant relation to that sublime power by which the Creator projects, creates, and upholds his universe." [125] The likeness to God consists in the generating, creative quality. It is, in Baudelaire's quotation from Mrs. Crow, "a *constructive* imagination."

How, in Baudelaire's view, does that creative, or "constructive," imagination work? Does the artist's fantasy conjure up images out of nothing, that is, images of objects that have never existed and have nothing to do with the impressions we receive from the outside world? Or does it rather combine in a different pattern the shapes and figures we are familiar with from our experience in this world? This is, of course, an old question, one that inevitably emerged at every stage of art theory in which the problem of the artist's imagination was posed anew or acquired renewed significance. Because the artist's imagination occupies such a central place in Baudelaire's theory, the student of his thought must repeat these old questions. Now Baudelaire, as we know, was not a systematic philosopher, and one is not surprised to find that on different occasions he gave different answers to the same questions; sometimes on the very same page we find different opinions as to how the imagination works.

One answer adumbrated in Baudelaire's writings is a modern formulation of the *creatio ex nihilo* doctrine. In original metaphorical terms he tries to suggest that the work of art is an altogether new reality, one that is not founded on any preceding concrete existence. "A good picture, which is a faithful equivalent of the dream which has begotten it, should be brought into being like a world." [126] To make sure that the concept of "dream" is correctly understood, he adds, "by this word I do not mean the riotous Bedlams of the night, but rather the vision that comes from intense meditation."

What Baudelaire understood by imagination can also be seen by examining his precise motives for rejecting realism. In the past, the unselective, naturalistic copying of "nature" had frequently been censured, the reason for these rejections being that an uncritical copying of what can be seen around us perpetuates all the deformations and imperfections of the outside world. To such naturalistic depiction, all periods have opposed an idealizing rendering of that very same reality, that is, a rendering that corrects nature's "faults." This motivation may also be found in Baudelaire's thought. His major reason for the rejection of realism, however, is a different one. A precise copy of the outside world merely duplicates what already exists. Real creation, one infers from this criticism of the realistic approach, is the projection of something that does not yet exist. "I consider it useless and tedious to represent what *exists,* because nothing that *exists* satisfies me. Nature is ugly, and I prefer the monsters of my fancy to what is positively trivial." [127] Though the imperfections of nature are also suggested, the major reason is clear: the triviality of what exists. Imagination, it follows by implication, is the creation of something that does not yet exist.

In addition to this radical interpretation of imagination, Baudelaire seems to have entertained yet another view of how the artist's fantasy works. In this view, the artist, unlike God, does not invent concrete images and visual impressions; his imagination is really nothing but a rearrangement of "raw material" that he has received from an outside source. What arises from the artist's soul is the principle of composition. Imagination, he says, "decomposes all creation, and with the raw materials accumulated and disposed in accordance with rules whose origins one cannot find save in the furthest depths of the soul, it creates a world, it produces a sensation of newness." [128]

A careful reader of Baudelaire's writings on painting is forced to conclude that he conceived of a picture completely invented by the artist as the highest aim a painter can strive for, though it may well be beyond human reach. Vaguely he foresees a painting without a subject or, at least, without a recognizable material subject. Already in his reviews of the 1846 Salon, he had said that "the right way to know if a picture is melodious is to look at it from far enough away to make it impossible to understand its subject or to distinguish its lines. If it is

melodious, it already has a meaning and has already taken its place in your store of memories."[129] He also claims, in another place, that line and color are "absolutely independent of the subject of the picture." Clearly we are here faced with a prophet of abstract art, that is, an art that is totally the product of the artist's imagination.

To create a work of art that is completely drawn from the artist's imagination may be a supreme aim, yet it is hard, or even impossible, to achieve. In practice, the artist takes most of his material from nature. This, however, does not compel us to accept the doctrine that art is an imitation of nature. Baudelaire quotes his older contemporary, Heinrich Heine, with approval. In reviewing Delacroix, Heine wrote: "In artistic matters, I am a supernaturalist. I believe that the artist cannot find all his forms in nature, but that the most remarkable are revealed to him in his soul, like an innate symbology of innate ideas, and at the same instant."[130] We can say with Wellek that "Baudelaire here seems to agree with an ultimately Neoplatonic trust in an inner model, in the vision of 'the artist who dominates the model as the Creator dominates His creation.' "[131]

The student of Baudelaire's theory of art is here faced with a contradiction. On the one hand, our author emphasizes time and again that true creation means drawing from the artist's soul, from his imagination. On the other, he does not altogether isolate the painter or the poet from the world surrounding them. On the contrary, it is the hallmark of the artist, as we remember, that he is able to discern hidden relations between the different objects in the outside world. How are we to understand this puzzle?

We come then to another central subject of Baudelaire's theory of art, his views of the "outside world." I shall touch on this subject briefly, and I shall of course do so only insofar as the "world," or whatever else that external reality may be called, is the object of, or is related to, the artist's imagination. We must keep in mind however that Baudelaire's views concerning the reality surrounding us, even as it is related to art, were not shaped by aesthetic motives alone; other concerns and beliefs played an important part in forming them. Early in his life, our author passed through a "mystic" or "occult" stage. Later on, an aspiration towards mysticism remained alive in his attitudes and

thought. He naturally combined these mystic leanings with his aesthetic concerns: art, at its highest, was to be conceived as a semimystical vision and ecstasy. Even in such a designation he may have been following traditions with which he was acquainted.[132] This background is of importance for an understanding of the central concepts he employs when he discusses "the world," namely, "correspondences" and "hieroglyphs."

These concepts have a long history in European thought and letters, particularly in the occult traditions of Western culture. We cannot of course go into the early phases of ideas about analogies, correspondences, and hieroglyphs; for our purpose it will be sufficient to recall that these notions played a significant part in eighteenth- and nineteenth-century occultism and in philosophies with affinities to the occult. The eighteenth-century Swedish scientist and mystic Emanuel Swedenborg (1688–1772) is of particular significance in our context. His large and prolix opus is dominated by a certain conceptual model that is perhaps best and most concisely stated in the title of a short treatise (not common in the work of an author whose major work extends over twelve mighty tomes), which, freely translated, would read something like "Hieroglyphic Key to the Natural and Spiritual Secrets by Way of Representations and Correspondences." It was published posthumously, in 1784, in London. The central proposition of this essay is that throughout the universe a correspondence prevails between things spiritual and natural, that thus things occupying a lower rank in the order of things reflect those belonging to a higher order.[133] This theory of correspondences, it need hardly be stressed, forms the core of the Neoplatonic doctrine of the image, a doctrine that had many versions. Swedenborg articulates the most extreme and openly mystical version of the doctrine, but even in this extreme form the theory of reflections and correspondences enjoyed a long history and a great deal of influence. Jakob Boehme, whose influence on early Romantic thought on painting has been mentioned in a previous chapter, presented it under the formulation of *signatura rerum*. Swedenborg conceived "correspondences" as a basic form of knowing the world. In every single object a secret is hidden. Had we the power to unriddle these secrets, even the stones would preach the gospel of God.

Swedenborg erected an edifice of cosmic history (a strange concoction of different sources) and in this structure he gave hieroglyphs an important place, as the visual formulation communicating the correspondences. Hieroglyphs were supposed to have originated at an early stage of world history, a stage in which mythical thought prevailed. Their essence is that they indicate the spiritual, celestial meaning hidden in material objects and their images. The Egyptians knew the correct reading of the signs; they still had the key. But in the ages following the Egyptian kingdom, that *sapientia veterum* was lost. "To the Ancients," Swedenborg confidently claims, "the foremost knowledge was that of correspondences, but today it [this knowledge] is lost" (E. Benz Swedenborg [Munich, 1948], p. 411).

Baudelaire himself mentions Swedenborg as one of his sources; other writers he adduces (such as Lavater) were also influenced by Swedenborg's thought. This does not mean, of course, that Baudelaire was a faithful follower of Swedenborg's spiritualism. We do not have to read him as an actual mystic to recognize that he used the mystical theory of correspondences and transformed it into an original part of his reflections on the art of painting. His creed was ultimately aesthetic, and the theory of correspondences is adopted not as it stands but as it suited the context of the artist and his work.

We arrive at that truth that everything is hieroglyphic, and we know that the symbols are only relatively obscure according to the purity, the good will, and the inborn clearsightedness of souls. Now what is a poet if not a translator, a decipherer? In excellent poets there is not a single metaphor, comparison, or epithet which could not be a mathematically exact adaptation to the present circumstance, because these comparisons, metaphors, and epithets are drawn from the inexhaustible fund of *universal analogy*.[134]

That Baudelaire did not have a literal reading of the doctrine of correspondences, that in his thought this theory is not a piece of Swedenborgian cosmology, but is rather seen from an aesthetic point of view, and thus has a metaphorical character, is obvious from the way he employs the term *correspondances*. His article on Théophile Gautier, poet and critic (1811–1872), provides a good example of his usage of the term. Gautier, we read here, has "an immense inborn intelligence

of universal correspondence and symbolism, the repertory of all meta-phor."[135] The artist, he says elsewhere, plays on "the immense key-board of correspondences."[136] And in still another place he says that "the entire visible universe appears as but a storehouse of images and signs to which the imagination will give a relative place and value; it is a sort of pasturage which the imagination must digest and trans-form."[137]

Now we can come back to the starting point of this section. We asked how Baudelaire could claim that the picture should follow from the imagination and still represent a landscape or a portrait, a genre scene or a still life. How can the painting be altogether human and still represent a piece of outside nature? A partial answer at least is given by making the doctrine of hidden analogies the cornerstone of a theory of art. By depicting the world as a result, at least in part, of imagination and introspection, the artist overcomes the gulf between subject and object, man and nature. This doctrine also explains human empathy with inanimate nature. The artist humanizes "not only the form of a being external to man, vegetable, or mineral, but also its physiognomy, its look, its sadness, its tenderness, its bounding joy, its repulsive hate, its enchantment, or its horror: in other words, all that is human in anything whatsoever, and also all that is divine, sacred, or diabolic."[138]

The Process of Creation. The great significance Baudelaire accords to the artist's imagination together with his belief in *correspondences* make the process in which the painter actually produces the picture a kind of testing ground, where these agents can perhaps actually be observed in action. The student therefore naturally asks how our poet-critic saw, and understood, the process of producing a work of art. Attempting to answer this question, one soon discovers how far Baudelaire deviated from old and established traditions (some of which he embraced in other respects). But one also learns that in many regards he differs from what is now commonplace wisdom. A late twentieth-century reader would often not consider him "modern."

We must begin with Baudelaire's profound distrust of inspiration as the only, or even major, source of the artist's work. In the course of years he came back to this attitude, expressing time and again his

doubts of inspiration's power. In this context, we should note the emphasis he places on the need for, and value of, skill. To young writers he insisted that "daily work serves inspiration," and he ridiculed the view that inspiration can replace other requirements. He even attacks the idol of Romanticism, the genius. "Youth concludes that it need not submit to any exercise. It does not know that a man of genius . . . must, like any apprenticed acrobat, risk his bones a thousand times in private before he walks the rope in public; that inspiration, in short, is only the reward of daily exercise." [139] Nothing could be more removed from his mind than the Romantic image of the artist, as expressed, say, by a Wackenroder, an artist who shapes his work as in a trance, fired by the appearance in a dream.

Baudelaire, it goes without saying, does not speak persuasively in favor of skill and technique in order to enhance the virtues a bourgeois society would embrace; his appreciation of disciplined, rational procedures and of well-established know-how follows from his understanding of what the creative process actually is. A famous sentence in his 1863 article on Delacroix (written immediately after the painter's death) deserves closer attention in the present context. "Delacroix," we read here, "was passionately in love with passion, and coldly determined to seek the means of expressing it in the most visible way." [140] There is, he says, summing up this polarity, "a duality of nature" in the artist. Whatever this statement may actually tell us about Delacroix, it surely reveals something essential about Baudelaire's perception of the basic conditions in which the artist has to work and in which he produces his work. It also indicates some of his views concerning the creative process itself.

The structural "duality of [the artist's] nature" is reflected in the creative process. Here it becomes a double attitude of the painter or poet to his subject. On the one hand, the artist identifies with what he represents (the part of "passion"); on the other, he maintains an emotional distance from his subject (the part of "cold determination"). Once again, Baudelaire nowhere systematically presents his views about the relations between these two poles. Yet since the matter is of obvious and crucial importance for the theory of art and the artist, we must

deal with it, though much will have to be inferred rather than directly quoted.

The careful reader cannot help feeling that Baudelaire stresses the part of "cold determination" far more than the part of "passion." Imagination, we read, is a most precious faculty, but "this faculty remained impotent and sterile if it is not served by a resourceful skill. . . ." [141] Now, the notion of skill, we should keep in mind, connotes not only the manual dexterity and technical ability necessary to translate the visions seen with one's inner eye into actual paintings that can be seen by everyone; "skill" also marks an attitude of the artist to what he renders. It is the attitude of emotional distance and restraint. Baudelaire does not picture the artist as "possessed" by his vision, to use a neo-romantic formula; on the contrary, he dominates it. The great artist, our poet seems to have believed, feels no inner compulsion to paint only one kind of theme or to depict his subjects in only one specific manner. On the contrary: Baudelaire praises Delacroix because he "loved and had the ability to paint *everything,* and knew also how to appreciate every kind of talent." [142]

Baudelaire's emphasis on what we have called the attitude of distance can be inferred from still another reflection. For centuries, or even longer, writers on art kept asking if the painter must himself experience the emotions he expresses in his work. The old Horatian maxim that haunted art theory for ages claimed that it is the artist's emotional identification with what he represents what accounts for the effect of his work on the audience: *Si vis mi flere, dolendum est primum ipsi tibi* (If you wish me to weep, you must first express suffering yourself). [143] It was this maxim that in Romanticism led to the concept of the "sincere artist."

Now, in his writings on art, it may be worth noting, Baudelaire nowhere refers to this famous Horatian statement, though he often speaks of Horace's poetics. Moreover, it would often seem that he sees the artist's ability to hide his personal feelings and completely retreat behind what he represents as a supreme achievement. "The intoxication of art hides the terror of the abyss: for genius can play comedy on the edge of the tomb." Wellek correctly sums up this attitude by saying

that "the clown condemned to death never shows a trace of his imminent fate in the superb performance of his act."[144] The creative process is one in which technique, skill, and discipline play a crucial part.

Baudelaire's analysis of the creative process may also explain his harsh criticism of a personal artistic emotionalism. He is repelled by this "egotistic" attitude of the artist. In his criticism, as often happens, his sarcastic language knows little restraint. "The apes of sentiment are, in general, bad artists": this is a typical formulation. "The cry of feeling is always absurd," is another. And speaking of the "poetry of the heart," that attitude in art that ascribes infallibility to truthful passion, he simply says that it is an aberration in aesthetics.[145] Does all this mean that he conceived the process of shaping a work of art as some kind of computation? Obviously this is not the case. He knows of the artist's intoxication, but it is an intoxication with art rather than with some particular emotion. Ultimately it is the excitement with art, not with any particular passion, that the painter and the poet should transmit to the audience.

Aesthetic of the Ugly. The new view of art as existing in its own right, and the conception of intoxication with art as such rather than with a specific passion or emotion, enlarged—or even transformed—the domain of theoretical reflection. These notions were closely linked with one of the most original departures in aesthetic thought, a departure typical of the modern age that has profoundly influenced both the theory and the practice of the visual arts. In Karl Rosenkranz's famous formulation, to be discussed in the present section, this departure may be called the "aesthetics of the ugly." In the process that brought about that new attitude Baudelaire played a crucial part.

The broad context in which Baudelaire treats the theme is significant for us; it may both indicate its historical origin and support his argument. In 1863, Baudelaire published his long essay "The Painter of Modern Life," perhaps the most programmatic statement among all his writings on painting. One of the short chapters into which this essay is divided is called "In Praise of Makeup."[146] What Baudelaire wishes to state in this essay, written late in his life, follows from the general ideas

we have so far referred to. The section he calls "In Praise of Makeup" is, in fact, a pointed, perhaps somewhat exaggerated, summary of his views on art. It is a eulogy of the artificial, and an attempt to establish the superiority of the contrived over the natural, of the products of human skill and inventiveness over the results of nature. In the eighteenth century, Baudelaire reminds his readers, "Nature was taken as ground, source and type of all possible Good and Beauty." [147] Being natural was tantamount to being good and beautiful (and looking natural, we may add, still has the same ring in the language of present-day advertising). Nature was the norm in ethics as well as in art. This view, Baudelaire is convinced, is profoundly erroneous. He lists the different kinds of violence to which nature leads us. Murder, parricide, and cannibalism are "natural." The worship of nature and the natural he calls "a blindness." The eighteenth-century negation of original sin, Baudelaire specifically points out, had no mean part in this "blindness," that is, in the adoration and idealization of nature.

It has been pointed out that Baudelaire may have been influenced here by Joseph de Maistre (1754–1821), a logician and writer who, more than a generation earlier, had attacked the Enlightenment veneration of nature on theological grounds. How, he asks rhetorically, can one blind oneself to the extent of looking in nature for causes when nature itself is only a product? [148]

Coming back to Baudelaire's 1863 essay, we can see how he maintains, and tries to carry through, the superiority of the artificial over the natural. Makeup, he declares, should not aim at making the woman who applies it look natural: "face painting should not be used with the vulgar, unavowable object of imitating fair Nature and of entering into a competition with youth." [149] Here he adds the important sentence: "Who would dare to assign to art the sterile function of imitating Nature?" The beauty of artifice is completely divorced from nature.

That divorce brings up a new question: if the beauty of art is so completely independent of nature that it can be applied to everything, would it not follow that it can also be applied to what in nature is ugly, deformed, and repulsive? We cannot, so it seems, avoid the paradoxical notion of the beauty of the ugly. The question is not altogether new. Beneath the surface, as it were, it existed, and was felt, whenever

thinkers who believed that art is an embodiment of beauty reflected on its relationship with nature. One recalls Bernard of Clairvaux's famous description of some Romanesque imagery as "deformed beauty, beautiful deformation,"[150] composed in a period that is seemingly as remote as possible from our problem. It was, however, only when art was explicitly conceived as autonomous—that is, in the mid-nineteenth century—that the notion of an "aesthetics of the ugly" could become fully manifest. It is surely not a matter of chance that Baudelaire, the advocate of an autonomous art, played such a prominent role in articulating the problem.

In literary theory, the modern concern with the ugly and its connection with the beautiful did not emerge with Baudelaire or Rosenkranz. As Hans Robert Jauss has shown in an interesting essay,[151] it originated with Victor Hugo. In 1827, the poet prefaced his play *Cromwell* with a lengthy theoretical discussion in which he presented an explanation of why the ugly should be part of the subject matter of art.[152] He also suggested a conception of the ugly that differed from those given at previous stages of reflection. The classical tradition took it as axiomatic that it is the aim of art to manifest beauty. For the ugly, then, there is no room in art. The ugly is nothing but the obverse of beauty; it is the absence of beauty that makes something ugly. Karl Rosenkranz in his *Aesthetik des Hässlichen* (Aesthetics of the Ugly) put it as succinctly as his philosophical language would allow: "The beautiful is the positive presupposition of the ugly. Were there no beautiful, no ugly would exist; it [the ugly] exists only as its [the beautiful's] negation."[153]

This concept of the ugly was clearly not sufficient for the theoretical reflections of an age that, like the nineteenth century, was often fascinated by the strange beauty residing in a pictorial representation of a deformed body or a distorted object. "Make the nature you represent beautiful": this advice, so often given to artists from the time of Alberti to that of Ingres, could here obviously not provide the answers certain artists and thinkers were looking for.

Victor Hugo defended the depiction of the ugly in art on the basis that it leads to a full cognition and rendering of nature. Greek art idealized nature, but, following Victor Hugo, we have to say that precisely for this reason it was one-sided. Victor Hugo sensed how

much the historical development of the great religions meant to art. "Christianity brought poetry to truth," he says. "Like Christianity, the modern muse sees things from a higher and larger vantage point. It senses that in creation not everything is humanly *beautiful,* that the ugly exists alongside the beautiful, the deformed next to the graceful, the grotesque behind the sublime, the evil with the good, the shadow with the light."[154] The basic reason for representing the ugly in art is that it exists in reality.

Both Hugo and Rosenkranz were aware of pictorial representations of deformed figures, but the visual arts were not at the center of their reflections. Hugo mentions them in passing, but Rosenkranz is more explicit. He has a special category called "the ugly in art."[155] It is significant, I think, that Rosenkranz, although intellectually and physically far removed from France and its avant-garde movements in art theory, suggests in his philosophical idiom a view very close to the ideas of the *l'art pour l'art* movement in France. Art, he claims early in his discussion of the ugly, is an absolute value. "The beautiful, being the appearance of the idea to the senses, is absolute in itself, and does not need support from outside of itself, a strengthening by means of contrast." But if one wishes to present the idea in its completeness, one also has to allow for "the possibility of the negative." The Greeks, to be sure, concentrated on the representation of ideal figures, but they also rendered "the hecatoncheires [giants with a hundred hands], cyclops, satyrs, graiae [gray-haired female protectresses of the gorgons], ompusae [filthy demons], harpies, chimaera." Like Victor Hugo almost a generation earlier, Karl Rosenkranz sees in religious changes a key to the unriddling of our problem. With the Christian religion, he continues the discussion from which we have just quoted, "the religion that grasped evil at its very root and taught us to overcome it, the ugly is fully introduced into the world of art."[156] The "very root" of evil is, of course, the devil. The satanic, or diabolic, is the origin of ugliness.

Although Hugo and Rosenkranz thus accept the rendering of the ugly in art, their treatment of pictorial representations remains abstract. Even the list of monsters that the Greek artists supposedly carved in stone is taken from literary sources rather than from looking at statues and paintings. Questions broader than the sources of certain monsters

also remain without clarification. In what genre of painting and sculpture does the ugly appear? A reader looking for an answer to this question would search in vain in the writings of either Hugo or Rosenkranz.

It was thus mainly Baudelaire who explored the ugly as the subject matter of concrete categories in visual art. The reader familiar with Baudelaire is not surprised that the poet-critic nowhere defines ugliness in any precise way, nor that he never offers an explanation of how the artistic rendering of an ugly object can be perceived as beautiful. Yet without encountering any systematic exposition, one feels that for many years the problem was present in his thought. He often alludes to it. In addition to some scattered references, the essay on "The Essence of Laughter" (written in 1855) and the essays on French and on foreign caricaturists (both written in 1857) offer important leads to his thought on the ugly in art.

Ugliness, we understand by following Baudelaire's trend of thought, is mainly what is opposed to harmony; it is the unresolved tension, the conflict of contradictory forces that has been left standing as it is. Contradiction and tension fascinated Baudelaire; he was under the spell of the paradox. This can be seen, first of all, in his poetry, but it also emerges from his criticism. The essay on laughter shows with particular clarity the spell that paradox held for him. "Laughter is satanic: it is thus profoundly human. . . . And since laughter is essentially human, it is, in fact, essentially contradictory; that is to say it is at once a token of an infinite grandeur and an infinite misery. . . . It is from the perpetual collision of these two infinites that laughter is struck." [157]

The strikingly nonharmonious, the unresolved tension, the screeching dissonance are manifested not only in behavior and experience (such as laughter); there is a category of objects and shapes that embody these qualities and characteristics. This is the category of the grotesque. As we have seen, by mid-nineteenth century the grotesque was casting a spell over the minds of artists and writers. Viollet-le-Duc revived (and modernized) the Gothic gargoyles of the cathedrals, and wrote beautifully about them. At about the same time, Champfleury not only composed his great work on caricature but also prefaced a book of reproductions (drawings) of Gothic grotesques. [158] For Baudelaire, the

grotesque found its most fascinating expression in caricature and in fantastic art. His essays on caricature yield rich results.[159] His treatment of Goya is particularly indicative of his views on the ugly and deformed as a component of art.

Baudelaire's response to Goya's work in general, and to *Los Caprichos* in particular, is significant far beyond the limits of mere art criticism. Some of his poems in *Les fleurs du mal* are inspired by Goya's etchings,[160] and in his critical discussion of the painter's work he brings up more questions of broad theoretical interest than in most of his writings on individual artists. "Goya," he says, "is always a great and often a terrifying artist."[161] His caricatures, Baudelaire points out, draw from the great Spanish tradition of satire, but to that tradition Goya unites "a spirit far more modern." What Baudelaire here calls "modern" has little to do with subject matter. It is the breaking through of sacrosanct borders, the questioning of established, time-honored concepts of what the art of painting can, and what it cannot, do. Goya has "a love of the ungraspable, a feeling for violent contrasts, for the blank horrors of nature and for human countenances weirdly animalized by circum-stances." Such violent transformation, bringing together features and connotations that are naturally separate, is the very opposite of what the theory of *decorum* taught was beautiful. "Goya's great merit consists in having created a credible form of the monstrous." The monstrous, of course, is the ugly whose deformations go beyond the credible. Goya makes us believe in it. "All those distortions, those bestial faces, those diabolic grimaces of his are impregnated with humanity."

The student will evidently ask what is the value of these convincing representations of the deformed. On what grounds does Baudelaire defend, or justify, the rendering of the ugly in art? Here we cannot rely on Hugo's arguments. Victor Hugo justified depicting the ugly in art on the basis that it exists in nature. Its rendering in literature and painting amounts to giving a fuller account of reality. But Baudelaire praises Goya for having conjured up in his work ugly, deformed, hideous creatures that *do not* exist in reality. His witches and monsters are creatures of the imagination, and he is specifically praised for making the unreal credible. The ultimate reason Baudelaire can give for praising Goya's distorted creatures is that they are beautiful.

His monsters are born viable, harmonious. ... Even from the special viewpoint of natural history it would be hard to condemn them, so great is the analogy and harmony between the parts of their being. In a word, the line of suture, the point of junction between the real and the fantastic is impossible to grasp; it is a vague frontier which not even the subtlest analyst could trace, such is the extent to which the transcendent and the natural concur in his art.

The general conclusion to be drawn from Baudelaire's analysis of Goya's monsters is clear. In the final analysis, the beauty of art is independent of the beauty of nature. The artist can produce a vision that is ugly in terms of natural creatures, but that has a fascinating beauty of its own. It is the ultimate triumph of the art for art's sake principle. The artist's imagination is independent even of the universal structure of beauty.

NOTES

1. William Duff, *An Essay on Original Genius* (1767). I am using the facsimile reprint, edited by John L. Mahoney (Gainesville, Fla., 1964). Page references (given in parentheses in the text) refer to this edition. And see the interesting discussion in James Engell, *The Creative Imagination: Enlightenment to Romanticism* (Cambridge, Mass., 1981), pp. 84 ff.
2. See *Theories of Art: From Plato to Winkelmann*, pp. 171 ff.
3. See George Sidney Brett, *A History of Psychology*, 3 vols. (London and New York, 1912–1932).
4. See above, Chapter 3, especially pp. 157 ff.
5. Charles Batteaux, *Les beaux arts réduits à un même principe* (Paris, 1746). Batteaux also published a five-volume work, *Principe de la littérature* (Paris, 1764).
6. Sulzer's major work is *Allgemeine Theorie der schönen Künste*, 4 vols. (Leipzig, 1771–1774).
7. See, for instance, Jan Bialostocki, "The Renaissance Concept of Nature and Antiquity," *The Renaissance and Mannerism* (Acts of the Twentieth International Congress of the History of Art), (Princeton, 1963), II, pp. 19–30.
8. The best discussion remains Erwin Panofsky's *Idea* (New York, 1968; originally published in German in 1924).
9. I refer, of course, to the famous story of Zeuxis's statue of Helen (or Venus), which was composed by imitating the most beautiful parts of the bodies of the five most beautiful maidens of Croton. For some sources, see *Theories of Art*, pp. 125 ff., and especially Panofsky, *Idea*, pp. 15 ff.

10. For Mengs's concept of the Ideal, see Monika Sutter, *Die kunsttheoretischen Begriffe des Malerphilosophen Anton Raphael Mengs* (Munich, 1968), pp. 30 ff. And see above, pp. 90 ff.

11. For Sulzer's concept of the creative imagination, which is implied rather than explicitly stated, see James Engell, *The Creative Imagination: Enlightenment to Romanticism* (Cambridge, Mass., 1981), pp. 103 ff.

12. Goethe's review of Sulzer's work on aesthetics, published in 1772, is often reprinted. See *Goethes Werke,* Hamburg edition (Munich, 1949–1962), vol. 12 (1962), pp. 17 ff.

13. I shall use the English edition of Wackenroder's work translated and annotated by Mary Hurst Schubert under the title *Confessions and Fantasies* (University Park, Pa. and London, 1971), which includes several of Wackenroder's writings. References will be given, in parentheses, in the text, the figure referring to the page number of the English translation.

14. H. Woelfflin, *Kleine Schriften* (Basle, 1944), p. 205.

15. See Mary Hurst Schubert's introduction to her translation of Wackenroder's writings *(Confessions and Fantasies),* esp. pp. 44 ff.

16. For K. P. Moritz's concepts, see Karl Borinski, *Die Antike in Poetik and Kunsttheorie,* II (Leipzig, 1924), pp. 276 ff. And see also J. Engell, *The Creative Imagination,* pp. 113 ff.

17. For Vasari's statement, see Giorgio Vasari, *The Lives of the Painters, Sculptors and Architects,* trans. A. B. Hinds (Everyman's Library) (New York, 1927), II, pp. 176 ff. For Leonardo's statement (emphasizing mainly the contemplation of old walls, but also mentioning clouds), see Leonardo da Vinci, *Treatise on Painting,* trans. A. Philip McMahon (Princeton, 1956), I, pp. 50 f. Renaissance thought on the inspiration the artist gets by looking at the clouds has been brilliantly discussed by H. W. Janson in *16 Studies* (New York, n. d.), pp. 53–69. I don't know of a similar investigation of this interesting subject in Romantic thought.

18. For this famous reference, see Panofsky, *Idea,* pp. 59 ff.

19. By Marianne Frey, in *Der Künstler und sein Werk bei W. H. Wackenroder und E. T. A. Hoffmann: Vergleichende Studien zur romantischen Kunstanschauung* (Bern, 1970), pp. 19 ff.

20. See August Langen, *Der Wortschatz des deutschen Pietismus* (Tübingen, 1954).

21. See Moses Mendelssohn, *Gesammelte Schriften* (Leipzig, 1888), II pp. 153 ff. Mendelssohn's ideas were originally expressed in his *Phaedon oder über die Unsterblichkeit der Seele in drey Gesprächen* (Berlin and Stettin, 1767).

22. For *Erwin,* I use the reprint of 1907. The *Vorlesungen,* edited from Solger's notes (there was no final manuscript by Solger himself) by K. W. L. Heyse, appeared in 1829, and was reprinted in 1929. I translate from the original edition.

23. Figures in parentheses, given in the text, refer to the 1907 edition of *Erwin.*

24. See Herbert Mainusch, *Romantische Aesthetik* (Bad Homburg, 1960) pp. 67 ff., and the study by Wolfhart Heckmann, "Symbol und Allegorie bei K. W. F. Solger," in *Romantik in Deutschland: Ein interdisziplinares Symposium,* ed. R. Brinkmann

(Sonderband der Deutschen Vierteljahrsschrift fur Literaturwissenschaft und Geistesgeschichte) (Stuttgart, 1978), pp. 639 ff., esp. p. 640.

25. See mainly Schelling's *Vorlesungen über die Methode des akademischen Studiums,* published in 1803, as well as his lectures on the philosophy of art *(Philosophie der Kunst),* given in 1802–03 and 1804–05, which had a wide circulation in manuscript form before they were published at a later date.

26. In *Erwin,* the distinction between the two modes, though present, is not fully developed or explicitly stated. In the *Vorlesungen,* Solger devoted more attention to this subject, and his formulations are more explicit. See especially pp. 132 ff. for a thorough and interesting discussion of allegory and sign.

27. Also available in reprints.

28. Philipp Otto Runge, *Hinterlassene Schriften,* 2 vols. (Hamburg, 1840). References are given in parentheses in the text, Roman numerals indicating the volume, Arabic the page number.

29. See M. Barasch, *Light and Color in Italian Renaissance Theory of Art* (New York, 1978), *passim,* esp. pp. 22 ff., 171 ff.

30. In a forthcoming study on color symbolism, I discuss in detail some of these earlier attempts. The study will be published in the acts of a Philadelphia symposium (Temple University) on color in Renaissance art.

31. See my *Light and Color,* pp. 178 ff.

32. See Heinz Lippuner, *Wackenroder, Tieck und die bildende Kunst* (Dresden, 1934), pp. 11 ff., 123 ff.

33. Quoted (and translated) from *Caspar David Friedrich in Briefen und Bekenntnissen,* ed. S. Hinz (Berlin, 1968). The page numbers of this edition are given, in parentheses, in the text after every quotation.

34. See above, pp. 259 ff.

35. See *Leone Battista Alberti on Painting and on Sculpture,* with Introduction, translation and notes by C. Grayson (London, 1972), p. 135.

36. F. W. J. Schelling, *Rede über das Verhältnis der bildenden Künste zur Natur* (Philosophische Bibliothek, Heft 60) (Leipzig, 1911).

37. For this quotation, see Caspar David Friedrich, *Bekenntnisse* (Leipzig, 1924; 1840), p. 63.

38. I quote from John Durand's translation of Taine's lectures, to be found in *Philosophy of Art,* (New York, 1888). References to this edition are given in parentheses in the text, Roman numerals referring to the volume, Arabic numerals to the page numbers.

39. This particular character of Taine's approach has often been noted. See, for example, René Wellek, *A History of Modern Criticism: 1750–1950,* IV, *The Later Nineteenth Century* (Cambridge, 1983), pp. 27–57, esp. pp. 41 ff. Wellek gives valuable references to further critical literature.

40. For brief references to some earlier versions of this problem, see *Theories of Art,* pp. 125 ff.

41. Taine's dependence on Hegel in matters of aesthetics has been stressed by René Wellek in his *A History of Modern Criticism,* IV, pp. 35 ff.

42. For a possible connection between Taine and Condillac, see Wellek, *A History,* IV, p. 35.

43. See, for instance, what Diderot says about Chardin in his review of the Salon of 1765: "If it is true, as the philosophers say, that there is nothing real but our sensations, that neither the emptiness of space nor even the solidity of bodies possesses anything in itself of what we experience from it, then let them tell me, those philosophers, what difference they can find, four feet away from your paintings, between the Creator and you." See *Diderot's Selected Writings,* trans. D. Coltman, ed. L. Crooker (New York and London, 1966), p. 154.

44. See, for instance, what Diderot says in reviewing the Salon of 1767: "Everything that astonishes the soul, everything that impresses it with a sensation of terror, leads to the sublime." *Diderot's Selected Writings,* p. 174.

45. Wellek, *A History,* IV, pp. 27, 32 ff.

46. Ibid., P. 41.

47. *Histoire de la littérature anglaise* (Paris, 1864), V, pp. 4 ff. And see Wellek, IV, p. 45.

48. See *Gedanken über die Nachahmung,* in *Winckelmann's Werke,* ed. Fernow (Dresden, 1808), I, p. 9, and especially his *History of Ancient Art,* (English translation by G. Henry Lodge (Boston, 1860), the first part of Chapter IV.

49. The literature on this subject is, of course, huge. Consult Harry Levin, *The Gates of Horn: A Study of Five French Realists* (New York, 1966), esp. pp. 64 ff., for the general contexts of realism. And see René Wellek's article "The Concept of Realism in Literary Scholarship" in Wellek's *Concepts of Criticism* (New Haven and London, 1963), pp. 222–255, for the history of the term in literary criticism. Émile Bouvier's *La bataille réaliste (1844–1857* (Paris, 1913) is also essential. An orientation on the history of the term and the movement in nineteenth-century art (primarily painting) is given by Linda Nochlin in *Realism* (Penguin Books, 1971).

50. For Proudhon as a utopian, a matter that has some relation to his views on art, see Frank Manuel and Fritzie Manuel, *Utopian Thought in the Western World* (Cambridge, Mass., 1979), pp. 740–747. A great deal of information is collected in the dissertation by Pierre Palix, *Le goût littéraire et artistique de P. J. Proudhon* (Lille and Paris, 1977). For Proudhon's views on the visual arts, see esp. pp. 815–1003.

51. See P. J. Proudhon, *Contradictions économiques ou Philosophie de la misère* (Paris, 1850), p. 326, and *Du principe de l'art et de sa destination social* (Paris, 1865), pp. 15 ff. (here quoted from Palix, *Le goût littéraire et artistique de P. J. Proudhon,* pp. 873 and 905).

52. In *De la justice dans la révolution et dans l'église* (Paris, 1930; originally published 1858), III, pp. 582 ff.; Palix, pp. 887 ff.

53. I use the English translation of Elizabeth Fraser, in *Selected Writings of Pierre-Joseph Proudhon,* ed. S. Edwards (Garden City, N. Y., 1969), pp. 214 ff. The original is in *Du principe de l'art,* p. 310.

54. *Selected Writings,* p. 216; *Du principe de l'art,* p. 316.

55. *Selected Writings,* p. 217; *Du principe de l'art,* pp. 319 ff. "Household interiors" are not precisely images of man, but they clearly are the environment shaped by man. Proudhon actually adduces this example, as the others, to indicate the expression of a social mood, namely cheerfulness.
56. See Palix, p. 876. This note seems not have been published before Palix.
57. The best survey of Champfleury's views is still Émile Bouvier, *La bataille réliste (1844–1857)* (Paris, 1913). I use the reprint of 1973. For Champfleury's attitude towards the art of the past, see especially pp. 214 ff.
58. See Champfleury's *Pamphlet* of September 24–28, quoted by Bouvier in *La bataille réaliste,* p. 230.
59. See Bouvier, pp. 218 ff.
60. Ibid., pp. 230 ff.
61. I am quoting and translating from the modern reprint: Champfleury, *Grandes figures d'hier et d'aujourd'hui: Balzac, Gérard de Nerval, Wagner, Courbet* (Geneva, 1968), p. iii.
62. Quoted in Bouvier, p. 249.
63. For the meaning of "simplicity" in Winckelmann's thought, see above, pp. 00 ff.
64. *Grandes figures,* p. 239.
65. See Bouvier, p. 221.
66. *Grandes figures,* p. 225.
67. Ibid., p. 252.
68. Ibid., p. 253.
69. Ibid., p. 257.
70. The literature on the request that artists turn to their own time is of course quite large, and little of it is devoted to the reasons for the critics' attitude. But see the concise analysis by Linda Nochlin in *Realism,* pp. 104 ff.
71. *Grandes figures,* p. 253.
72. See below, pp. 376 ff.
73. *Grandes figures,* p. 236.
74. See P. Cailler, ed., *Courbet: Raconté par lui-même et par ses amis,* (Geneva, 1950), I, p. 48. English translation in Elizabeth G. Holt, *From the Classicists to the Impressionists: A Documentary History of Art and Architecture in the Nineteenth Century* (Garden City, N. Y., 1966), p. 348.
75. Holt, *From the Classicists to the Impressionists,* p. 349.
76. Quoted in Bouvier, p. 231.
77. I use a reprint of the English translation (New York, 1963), with an introduction by Meyer Schapiro. In quoting from *Maîtres d'autrefois,* I will use this translation. Page references are given, in parentheses, in the text. Schapiro's remark quoted above is found on p. ix of the introduction. For more recent discussions (in English) of Fromentin, though mainly as a writer, see Arthur Evans, *The Literary Art of Eugène Fromentin* (Baltimore, 1964), and Emanuel Mickel, Jr., *Eugène Fromentin* (Boston, 1981).
78. See Mickel, *Fromentin,* p. 26.
79. Quoted in Mickel, *Fromentin,* p. 29.
80. See particularly the entries for January 11, 13, 23, 25 and February 4 of 1857,

in *Journal d'Eugène Delacroix,* ed. P. Paul Flat, 3 vols. (Paris, 1893–1895), Vol. 3, pp. 11 ff., 60 f.

81. See Eugène E. Viollet-le-Duc, *Dictionnaire raisonné de l'architecture Française du XIme au XVIme siècle* (Paris, 1853–1868), and his *Dictionnaire raisonné du mobilier Français de l'époque Carlovingienne à la Renaissance* (Paris, 1858–1875).

82. For this subject, see George Mras, *Eugène Delacroix's Theory of Art* (Princeton, 1966), pp. 15 ff. I shall at times follow this study. In the emphasis on the soul, Mras says, Delacroix was following Diderot. In addition to Mras, see especially the observations by Jean Seznec in *Diderot Salons,* ed. J. Seznec and J. Adhemar, I (Oxford, 1957), pp. 1 ff.

83. See *Journal d'Eugène Delacroix,* III, p. 44: entry for January 25, 1857. And see G. Mras, *Eugène Delacroix's Theory of Art,* pp. 72 ff.

84. I use here Jonathan Mayne's English translation of Baudelaire's *The Painter of Modern Life and Other Essays,* (New York, 1986), pp. 41 ff., esp. p. 48. For Baudelaire, see the section below, pp. 362 ff.

85. See *Journal,* III, p. 232. This entry is reprinted in Holt, *From the Classicists to the Impressionists,* p. 171.

86. See the letter to Constant Dutilleux of March 7, 1854, in *Correspondance générale d'Eugène Delacroix,* ed. André Joubin, 5 vols. (Paris, 1936–1938), III, p. 196. And cf. Mras, *Eugène Delacroix's Theory of Art,* pp. 53 ff.

87. *Journal,* II, p. 437: noted on April 6, 1856.

88. See his *Eugène Delacroix's Theory of Art,* esp. pp. 78 ff.

89. Both the original entry for May 9, 1853, and its amplification are given in Holt, pp. 162–163.

90. See Albert Boime, *The Academy and French Painting in the Nineteenth Century* (London, 1971), pp. 79 ff.

91. Filippo Baldinucci, *Vocabolario toscano dell' arte del disegno* (Florence, 1681), p. 148.

92. Ibid., p. 1.

93. Holt, pp. 162 ff.

94. In his Mellon Lectures, given in 1974 at the National Gallery of Art in Washington, D. C., and so far unpublished. In Janson's *19th Century Sculpture* (New York, 1985), some of the same ideas are suggested, but only in a vague and general way.

95. For "ruins" and follies, see the still unsurpassed work by M. L. Gothein, *A History of Garden Art,* trans. Archer-Hind (London and Toronto, n.d.; originally published in German in Jena, 1926), II, pp. 5ff.

96. Nicolas Boileau, the leading French critic of the Neoclassical age, in his *L'art poétique* offers this advice to the poet composing a poem:

Polissez-le sans cesse et le repolissez;
Ajoutez quelquefois, et souvent effacez.

See *Oeuvres complètes de Boileau-Despréaux* (Paris, 1835), I, p. 244.

97. See Diderot, *Salons,* ed. J. Seznec and J. Adhemar, II (Oxford, 1960), p. 153. I use the translation given by Boime in *The Academy and French Painting,* p. 84.

98. Diderot, *Salons,* III (Oxford, 1963), p. 241.

99. Ibid., p. 242.
100. See Boime, p. 83.
101. See Mras, *Delacroix's Theory of Art,* pp. 86 ff.
102. Delacroix, *Journal,* II, pp. 102 ff.
103. See *Theories of Art,* pp. 355 ff. with references to further literature.
104. *Journal,* I, p. 459: note of February 23, 1852. For a discussion of Delacroix's theoretical views on color, see Mras, *Delacroix's Theory of Art,* pp. 119 ff.
105. Plutarch, *Moralia,* translated by F. C. Babbitt, (London, 1927), I, p. 83. This sentence is found in the essay called "How the young man should study poetry."
106. See Diderot, *Oeuvres ésthetiques,* ed. P. Vernière (Paris, 1968), p. 674. This is the opening sentence of the second chapter of the *Essai sur la peinture.*
107. *Journal,* III, p. 56: noted on January 25, 1857.
108. Dupuy de Grez, *Traité sur la peinture pour en apprendre la théorie et se perfectionner dans la pratique* (Toulouse, 1699), p. 208.
109. Madame de Staël, *De l'Allemagne,* 3 vols. (Paris, 1818).
110. Baudelaire wrote this in his introduction to Pierre Dupont, *Chants et chansons* (Paris, 1851); reprinted in Baudelaire, *L'art romantique,* ed. J. Crepet (Paris, 1925). For the applications of the principle to literature, see the clear exposition in René Wellek, *A History of Modern Criticism,* IV (Cambridge, 1983), pp. 434–452.
111. *L'art romantique,* pp. 320, 284.
112. See Charles Baudelaire, *The Painter of Modern Life and Other Essays,* trans. Jonathan Mayne (New York, 1986), p. 204.
113. Victor Cousin, *Du vrai, du beau et du bien,* ed. A. Garnier (Paris, 1917), pp. 223 ff. (This was the thirtieth edition of Cousin's work, a good indication of its popularity.) For the problem in general, consult the still valuable presentation by Albert Cassagne, *La théorie de l'art pour l'art en France* (Paris, 1906; reprinted Geneva, 1979). For a more comprehensive view of the origins of *l'art pour l'art,* see the article by M. H. Abrams, "Kant and the Theology of Art," *Notre Dame English Journal* 13 (1981): 75–106.
114. Cousin, *Du vrai, du beau et du bien,* p. 224. Here I use the English translation in the Abrams article, p. 97.
115. See Cassagne, *La théorie de l'art pour l'art en France,* pp. 142 ff.
116. This thesis has assumed many variations. The most sophisticated is probably Walter Benjamin's, best seen in his *Charles Baudelaire: Ein Lyriker im Zeitalter des Hochkapitalismus* (Frankfurt am Main, 1969), esp. pp. 72 ff. In a more simplistic form, this explanation is put forward by Arnold Hauser in *The Social History of Art* (New York, 1958), III, pp. 147, 193, 211.
117. These terms are used in the review of the Salon of 1859. See Charles Baudelaire, *Art in Paris 1845–1862,* trans. Jonathan Mayne (Oxford, 1965), p. 1954.
118. *Art in Paris,* p. 155.
119. See the review of the Salon of 1859 in *Art in Paris,* p. 154; also *Curiosités esthétiques; L'art romantique,* ed. H. Lemaître (Paris, 1962), p. 319.
120. *Art in Paris,* p. 152; *Curiosités esthétiques,* p. 317.
121. *Art in Paris,* p. 162; *Curiosités esthétiques,* p. 329.

122. *The Painter of Modern Life,* pp. 102 f.; *Curiosités esthétiques,* p. 630.
123. *Art in Paris,* p. 157; *Curiosités esthétiques,* p. 322.
124. *Art in Paris,* p. 162; *Curiosités esthétiques,* p. 329.
125. *Art in Paris,* p. 159; *Curiosités esthétiques,* p. 325. For the problem of imagination in English aesthetics of the early nineteenth century, I should like to refer again to James Engell, *The Creative Imagination: Enlightenment to Romanticism* (Cambridge, Mass., 1981). See especially pp. 172–183, for the distinction between "fancy" and "imagination." In English aesthetic thought, however, it is literary production that occupies the attention of the writers. Questions of the specifically *visual* imagination are less prominent than in Baudelaire.
126. *The Painter of Modern Life,* p. 47; *Curiosités esthétiques,* p. 429.
127. *Art in Paris,* p. 155; *Curiosités esthétiques,* p. 320.
128. *Art in Paris,* p. 156; *Curiosités esthétiques,* p. 321.
129. *Art in Paris,* p. 50; *Curiosités esthétiques,* p. 108.
130. *Art in Paris,* p. 57; *Curiosités esthétiques,* p. 118. Heine wrote his piece as a review of the Salon of 1831, and it was published in a French translation.
131. René Wellek, *A History of Modern Criticism,* IV, p. 439.
132. Ibid., p. 438.
133. The literature on Swedenborg and his influence on eighteenth-and nineteenth-century thought is large. A clear and detailed representation of his doctrine is found in Ernst Benz, *Emanuel Swedenborg: Naturforscher und Seher* (Munich, 1948), esp. pp. 387–576. For his impact on Coleridge (who has many parallels with Baudelaire), see Thomas McFarland, *Coleridge and the Pantheist Tradition* (Oxford, 1969), esp. pp. 283 ff.
134. Quoted in Wellek, p. 438.
135. *Curiosités esthétiques,* p. 676. The article is not included in the English translations of Baudelaire's criticism I have used in this section. The English wording is taken from Wellek, p. 438.
136. See *Curiosités esthétiques,* p. 213. The quotation is taken from the review of the 1855 world exhibition, which, so far as I know, has not been translated into English.
137. Quoted in Wellek, p. 439.
138. *Curiosités esthétiques,* p. 734. The translation is Wellek's, p. 441. This passage is found in Baudelaire's discussion of Victor Hugo, but obviously it is also valid for the painter.
139. Quoted after Wellek, p. 436.
140. *The Painter of Modern Life,* p. 45; *Curiosités esthétiques,* p. 426.
141. *The Painter of Modern Life,* p. 45; *Curiosités esthétiques,* p. 426.
142. *The Painter of Modern Life,* p. 44; *Curiosités esthétiques,* p. 425.
143. Though this famous maxim has been used very frequently, there seems to be no comprehensive study of its history in the theory of the visual arts. For some of the uses made of it in modern criticism and theoretical thought, see above, pp. 17 ff., 130 ff.
144. Wellek, p. 443.

145. Quotations after Wellek, p. 450.
146. See *The Painter of Modern Life*, pp. 1–40; *Curiosités esthétiques*, pp. 453–502 (the whole essay). The title of Chapter XI of the essay (in English) is translated as "In Praise of Cosmetics." The French *maquillage*, the word Baudelaire uses, is more correctly translated as "make-up," and this term, I believe, also better expresses the author's intention.
147. *The Painter of Modern Life*, p. 31; *Curiosités esthétiques*, p. 490.
148. See J. de Maistre, *Les soirées de Saint-Petersbourg* (Paris, n. d.), I, p. 235. Baudelaire himself said elsewhere that Joseph de Maistre, together with Edgar Allan Poe, "taught [him] to think." See note 1 (by the editor) in *Curiosités esthétiques*, p. 490.
149. *The Painter of Modern Life*, p. 34; *Curiosités esthétiques*, p. 493.
150. See *Theories of Art*, pp. 95 ff., with references to further discussions.
151. See "Die klassische und die christliche Rechtfertigung des Hässlichen in mittelalterlicher Literatur," in Hans Robert Jauss, *Alterität und Modernität der mittelalterlichen Literatur* (Munich, 1977), pp. 143–168.
152. Victor Hugo, *Cromwell* (Paris, n. d.; editions ne varietur), pp. 1–47.
153. Karl Rosenkranz, *Aesthetik des Hässlichen* (Königsberg, 1853), p. 7.
154. *Cromwell*, p. 8.
155. *Aesthetik des Hässlichen*, pp. 35 ff.
156. *Ibid.*, pp. 38–39.
157. *The Painter of Modern Life*, pp. 153–154; *Curiosités sethétiques*, p. 253.
158. For Viollet-le-Duc, see above, pp. 213 ff.; for Champfleury's work on caricature, see above, pp. 340; and see also Jules Adeline, *Les sculptures grotesques et symboliques (Rouen et environs), preface par Champfleury* (Paris, 1878).
159. The essays are: "On the Essence of Laughter and, in general, on the comic in the plastic arts," "On Some French Caricaturists," and "On Some Foreign Caricaturists," published in that order, in *The Painter of Modern Life*, pp. 147–165, 166–186, and 187–196; and, in the same order, in *Curiosités esthétiques*, pp. 241–263, 265–289, and 291–304.
160. See Marcel A. Ruff, *L'esprit du mal et l'esthétique Baudelairienne* (Paris, 1955; reprinted Geneva, 1972), pp. 306–307.
161. For his discussion of Goya's caricatures, from which all the quotations in this paragraph are taken, see *The Painter of Modern Life*, pp. 191–193; *Curiosités esthétiques*, pp. 295–299.

Bibliographical Essay

I have designed this bibliographical essay to serve a threefold purpose: while it is primarily meant to assist the reader who wishes to follow up discussions of the problems raised in this volume, I would also like to record here some of my major intellectual debts and to indicate (so far as this is possible in the limited space available) the reasons for my positions. It goes without saying that in the following remarks I shall not attempt to list fully even all the most important studies on a given subject. On the contrary, I shall be selective, and choose only such contributions as meet my triple definition. It should be kept in mind that the progress of research into the different themes and areas discussed here has been uneven, a state of affairs necessarily reflected in this bibliographical essay.

I: THE EARLY EIGHTEENTH CENTURY

The literature on the Enlightenment, even if we limit ourselves to the problems of aesthetics, is of course enormous, and thus makes it especially difficult to make a selection. Ernst Cassirer, *The Philosophy of the Enlightenment* (original German edition, 1932; English translation, Princeton, 1951), remains a classic contribution, though the author's views

have not gone uncriticized. For our purpose, Cassirer's chapter on aesthetics is particularly significant. Basil Willey, *The Eighteenth Century Background: Studies on the Idea of Nature in the Thought of the Period* (London, 1940), while it does not discuss painting or sculpture, is helpful because the concept of Nature is of such crucial importance in the theories of art. In the same context, we should also remember Johan Huizinga's persuasive essay "Naturbild und Gechichtsbild im achtzehnten Jahrhundert," available in a collection of his articles entitled *Parerga* (Basel, 1945). Arthur O. Lovejoy's celebrated essays in the history of ideas, including some chapters of *The Great Chain of Being: A Study in the History of an Idea* (Cambridge, Mass., 1936) as well as several of the articles collected in *Essays in the History of Ideas* (Baltimore, 1948), also do not deal directly with the theory of art, but are illuminating for an understanding of the contexts in Enlightenment thought. The religious aspect of the Enlightenment is studied in Frank Manuel, *The Eighteenth Century Confronts the Gods* (Cambridge, Mass., 1959). For specific developments of Enlightenment thought in Germany, particularly in the early part of the eighteenth century, Hans M. Wolff, *Die Weltanschauung der deutschen Aufklärung* (Bern, 1949) provides stimulating instruction.

For an informative and useful survey of aesthetic thought during the Enlightenment, see the appropriate chapters (especially chapters VIII–XI) in Katharine E. Gilbert and Helmut Kuhn, *A History of Esthetics* (New York, 1939; reprinted New York, 1972). The classic work by Karl Borinski, *Die Antike in Poetik und Kunsttheorie* (I, Leipzig, 1914; II, Leipzig, 1924), while not precisely limited to our period, is an enlightening and thought-provoking discussion of reflections on art, especially on classical art, focusing largely on the eighteenth century. Francis Coleman, *The Aesthetic Thought of the French Enlightenment* (Pittsburgh, 1971) surveys the most important developments of aesthetic reflection in France. An article by George Boas, "The Arts in the *Encyclopédie,*" *Journal of Aesthetics and Art Criticism* 23 (1964): 97–107, discusses views on the arts in the pivotal work of the period, the *Encyclopédie*.

Studies dealing specifically with Enlightenment theories of painting and sculpture are not numerous. For France, we have the still classic treatment by André Fontaine, *Les doctrines d'art en France* (Paris, 1909; reprinted Geneva, 1970), Chapters VI–IX. Art criticism, particularly by

Diderot, has received close attention in recent years (see below). Useful on a broader scale is the rich collection of lengthy passages, culled from eighteenth-century French authors, arranged according to individual topics in the theory of painting, with comments by Peter-Eckhard Knabe, *Schlüsselbegriffe des kunsttheoretischen Denkens in Frankreich von der Spätklassik bis zum Ende der Aufklärung* (Düsseldorf, 1972).

I shall now turn to the individual authors.

Vico's writings are available in a good English translation, and in somewhat abbreviated form also in a paperback edition. See *The New Science of Giambattista Vico,* translated by Thomas G. Bergin and M. H. Fisch (Garden City, N. Y., 1961). The modern "discovery" of Vico, and the subsequent flourishing of Vico studies (which are still thriving), has so far not produced a treatment of Vico's views on the visual arts. The classic works on Vico, by Benedetto Croce (Bari, 1911) and Robin G. Collingwood (London, 1913), concentrate on different problems. We hope that Meyer Schapiro will soon publish his long-awaited study on that subject. In the meantime, some discussions bring us closer to it, though they do not deal with it directly. Isaiah Berlin's *Vico & Herder: Two Studies in the History of Ideas* (New York, 1976), esp. pp. 1–142, is useful to the student of art theory in outlining Vico's intellectual personality and his major sources of inspiration. Closer to our subject is R. R. Caponigri, *Time and Idea: The Theory of History in Giambattista Vico* (London, 1953), but this also does not deal with the arts specifically. Erich Auerbach's celebrated studies of Vico's attitude to literature are illuminating to the student of visual images as well.

Dubos's great work on the arts has not been translated, but is available in a recent reprint. See Du Bos, *Réflexions critiques sur la poésie et sur la peinture* (Geneva, 1967). A. Lombard, *L'Abbé Du Bos: un initiateur de la pensée moderne* (Paris, 1913; reprinted Geneva, 1969) gives a balanced account of Dubos's life and work. Unfortunately for our purpose, he does not concentrate on the visual arts.

Shaftesbury's writings are best studied in the early editions of *Characteristicks of Men, Manners, Opinions, Times.* I used the edition published in London, 1732. In spite of his considerable influence on eighteenth-century aesthetic thought, particularly in Germany, there seems to be no comprehensive and systematic presentation of his views on the visual

arts. An old German dissertation, Grete Sternberg's *Shaftesburys Aesthetik* (Breslau, 1915), attempts to do this, but is only a beginning. Interesting observations are found, inter alia, in Samuel H. Monk, *The Sublime: A Study of Critical Theories in XVIII-Century England* (New York, 1935; Ernst Cassirer's *The Platonic Renaissance in England* (Austin, Tex. 1953; original German edition, Leipzig and Berlin, 1932) deals with the influence of the "Cambridge School" on Shaftesbury, and, though not focused on problems of art, has much to say on Shaftesbury's understanding of artistic creation.

Modern study of Gerard de Lairesse attaches less importance to him than did his contemporaries. In his time, Gerard was famous and influential. The original Dutch version of his great book *(Groot schilderboek . . .)* was soon translated into French as *Le grand livre des peintres ou l'art de la peinture consideré dans toutes ses parties, & demonstré par principes . . .* (Paris, 1787; reprinted Geneva, 1972). An English translation soon followed and went through several editions. In modern research, he is frequently mentioned, but usually rather casually. A thorough presentation of Gerard's "system" is given by Georg Kauffmann in his "Studien zum grossen Malerbuch des Gerard de Lairesse," *Jahrbuch für Ästhetik und allgemeine Kunstwissenschaft* 3 (1955–57): 153–196.

English eighteenth-century reflections on art, concentrating on the sublime, have been better studied, though primarily from the literary side. For a synoptic view, one does best to turn to Samuel Monk's book on *The Sublime* already mentioned, especially Chapter IX, "The Sublime in Painting," and to Walter J. Whipple, *The Beautiful, the Sublime and the Picturesque in Eighteenth-Century British Aesthetic Theory* (Carbondale, Ill., 1957). Marjorie H. Nicolson, *Mountain Gloom and Mountain Glory* (Ithaca, N.Y., 1959) concentrates mainly on the sublime in nature. So also does her entry, "The Sublime in External Nature," in *Dictionary of the History of Ideas,* ed. Philip Wiener (New York, 1973), pp. 333–337. There are good modern editions of a number of eighteenth-century writings. See particularly the edition of *The Spectator* by Joseph Addison (now Oxford, 1965); and of Edmund Burke's *A Philosophical Enquiry into the Origin of our Ideas of the Sublime and the Beautiful* (now London, 1958). Jonathan Richardson's *An Essay on the Theory of Painting:* the Second Edition, "Enlarged and Corrected" (London, 1725) is the primary text for our purpose. It

was translated into French and published as Jonathan Richardson, Père et Fils, *Traité de la peinture et de la sculpture* (Amsterdam, 1728; reprinted Geneva, 1972).

II: BEGINNINGS OF THE NEW AGE

The writers and artists discussed together here are, as a rule, treated in different disciplines, and the points of contact between them are therefore seen as marginal. This explains why Diderot is only occasionally mentioned in modern discussions of Winckelmann, while many important studies of Diderot's attitude to the visual arts manage to disregard Winckelmann altogether. This state of affairs will necessarily be reflected in our bibliographical comments.

Because there is no modern edition or translation of Mengs's texts, the best and fullest edition of his writings is still *A. R. Mengs' sämtliche hinterlassene Schriften, gesammelt, nach Orginaltexten neu übersetzt und mit mehreren Beilagen und Anmerkungen vermehrt herausgegeben von Dr. G. Schilling,* 2 vols. (Bonn 1843–1844). In the original Italian, these texts appeared as *Opere di Antonio Raffaele Mengs, primo pittore del re cattolico Carlo III, publicate dal cavaliere D. Giuseppe Niccolla d'Azara e in questa edizione Corrette e aumentate dell'avocato Carlo Fea,* 2 vols. (Rome, 1787).

The most extensive discussion of the principles informing Mengs's thought is found in Monika Sutter's dissertation, *Die kunsttheoretischen Begriffe des Malerphilosophen Anton Raphael Mengs: Versuch einer Begriffserläuterung im Zusammenhang mit der geistesgeschichtlichen Situation Europas bis hin zu Kant* (Munich, 1968). The title of this useful study should not mislead us into expecting to find a philosophical system in Mengs's writings. Karl Borinski's brief remarks on Mengs (*Die Antike in Poetik und Kunsttheorie,* II, pp. 211–215) are illuminating, as is almost everything he wrote. On Mengs's beginnings as a painter (which may also shed some light on his theories), one learns from K. Gerstenberg, "Die künstlerischen Anfänge des Anton Raphael Mengs," *Zeitschrift für Kunstgeschichte* 3 (1933): 77–88. The relationship between Mengs and Winckelmann was already seen by Goethe as a subject of significance, worthy of careful investigation. Monika Sutter gives a good survey of the problem in pp. 216–240

of her dissertation, but one derives additional instruction from Gerstenberg's *Johann Joachim Winckelmann und Anton Raphael Mengs* (27. Hallisches Winckelmannprogramm) (Halle a. S., 1929).

Winckelmann's work is available in several editions (in the original German, and in part in Italian). I have used *Winckelmann's Werke,* ed. C. L. Fernow (Dresden, 1808–1817), But for *The History of Ancient Art,* I use a modern edition: J. Winckelmann, *Geschichte der Kunst des Altertums* (Vienna, 1934). Of this masterpiece there is an old, but adequate, English translation: *The History of Ancient Art,* 2 vols. (Boston, 1860). Of the short but important *Thoughts on the Imitation of Greek Works of Art* there was no full and satisfactory English translation.

The literature on Winckelmann is sizable, the various authors approaching their subject from different points of view and with different interests in mind. The broad social and biographical context is given in the still unsurpassed classic, Carl Justi's *Winckelmann und seine Zeitgenossen,* 3 vols. (Leipzig, 1866; 5th ed., Cologne, 1956). Though it appeared more than a century ago, it is still indispensable for all Winckelmann studies.

On Winckelmann's position in the history of German and European letters, a subject that has occupied the minds of scholars ever since Herder and Goethe, one learns from many and very different works, of which I shall mention only a few examples. On Winckelmann's position in the tradition of modern humanism, Horst Rüdiger, *Wesen und Wandlung des Humanismus* (Hamburg, 1937) is enlightening. On his position in the history of German literature, the reader may profit from Walther Rehm, *Götterstille und Göttertrauer* (Bern, 1951), pp. 101–182, though a certain romantic leaning on the author's part may inspire caution. Henry Hatfield, *Winckelmann and his German Critics* (New York, 1943) gives an analytic survey of the discussions inspired by Winckelmann's work. Karl Borinski's observations (*Die Antike in Poetik und Kunsttheorie,* II, pp. 203–225) are again illuminating. An enlightening analysis of Winckelmann's German style and of the significance of his language for broader issues is found in Max Blackall's *The Emergence of German as a Literary Language 1700–1775,* 2nd ed. (Ithaca, N.Y., 1978), pp. 371 ff. Winckelmann's style of writing in general is analyzed by Hanna Koch, *Johann Joachim Winckelmann: Sprache und Kunstwerk* (Berlin, 1957). Winckelmann's

role as the founder of the specifically Greek ideal in European, and particularly German, thought and letters has deservedly attracted great attention. The revival of Greek paganism in his thought receives a lively discussion from Eliza M. Butler in the Winckelmann chapter of her book *The Tyranny of Greece over Germany* (Cambridge, 1935). Henry Hatfield's chapter "Winckelmann and the Myth of Greece" in his *Aesthetic Paganism in German Literature* (Cambridge, Mass., 1964) is devoted mainly to the "cult of beauty" and what is called Winckelmann's "paganism." In this context, Winckelmann's conversion to Catholicism may become a subject of interest also for the student of art theories. About the broader implications of this subject one can learn from W. Schultze's concise study "Winckelmann und die Religion," *Archiv für Kulturgeschichte* 34 (1952): 247–260.

The Neoplatonic background of Winckelmann's thought has frequently been stressed. From a more philosophical point of view, it has been convincingly argued by Ernst Cassirer in his book *Freiheit und Form: Studien zur deutschen Geistesgeschichte* (Berlin, 1916), pp. 200–218. In the context of art, this aspect has been treated by Rudolf Zeitler, *Klassizismus und Utopia* (Figura, 5) (Stockholm, 1954), pp. 191 ff. The chapter on Winckelmann in Ernst Heidrich, *Beiträge zur Geschichte und Methode der Kunstgeschichte* (Basel, 1917), pp. 28 ff., and Wilhelm Waetzoldt, *Deutsche Kunsthistoriker,* I (Leipzig, 1921), pp 51–73, remain instructive and useful.

While the student of the theory of art is concerned with the whole of Winckelmann's work, he can deal fully with only a rather limited part of Diderot's oeuvre. Most of the writings pertaining to our subject are conveniently collected in a volume of the Diderot edition by Paul Vernière, *Oeuvres esthétiques* (Paris, 1968). Also useful is the English translation, by Derek Coltman, *Diderot's Selected Writings* (New York and London, 1966). Diderot's reviews of the great exhibitions, the "Salons," are now available in an exemplary edition: *Salons,* texte établi et présenté par Jean Seznec et Jean Adhemar, 4 vols. (Oxford, 1957–1967).

Diderot's attitude to the arts and his activity as aesthetician and critic of art have been analyzed from different points of view. The volumes of *Diderot Studies* naturally contain many investigations that belong to our subject matter. The background of his activity as a critic is well presented in the classic work, already mentioned above, by

André Fontaine, *Les doctrines d'art en France,* especially in the last chapter
(Chapter IX), which deals with the new medium of the newspapers and
their role in the development of art and the study of art. The develop-
ment of Diderot's thought on the arts has been carefully traced by
Jacques Chouillet in his dissertation, *La formation des idées esthétiques de
Diderot 1745–1763* (Lille, 1973). Yvon Belaval's work *L'esthétique sans
paradoxe de Diderot* (Paris, 1950) is an important contribution elucidating
the rather obscure and hidden outlines of Diderot's aesthetic system,
but it focuses on the theater and on literature, almost completely
disregarding the visual arts. See also the interesting discussion by
H. R. Jauss, "Diderots Paradox über das Schauspiel (Entretiens sur le
'Fils naturel')," *Germanisch-Romanische Monatsschrift* N. F. 2 (1961): 380–
413.

Diderot's activity as a critic of contemporary painting is of course of
central importance for our subject. On the background and broad
contexts of this activity, one learns a great deal from A. Dresdner, *Die
Entstehung der Kunstkritik im Zusammenhang der Geschichte des Europäischen
Kunstlebens* (Munich, 1915; reprinted Munich, 1968), a pioneering work
that, together with Fontaine's classic, established the modern treatment
of the subject. Michael Fried's *Absorption and Theatricality: Painting and
Beholder in the Age of Diderot* (Berkeley, Los Angeles, London, 1980) has
made substantial contributions to the study of Diderot's criticism.
Meyer Schapiro's article, "Diderot on the Artist and Society," in *Diderot
Studies* 5 (1964): 5 ff., focuses on social aspects of Diderot's criticism.
The various studies by Herbert Dieckmann, mainly his *Cinq leçons sur
Diderot* (Geneva, 1959), have helped to enlarge and deepen our under-
standing of Diderot's criticism. Important for Diderot's views on what
optical experience, the basis of pictorial imitation, can achieve, and on
its limits, is M. J. Morgan, *Molyneux's Question: Vision, Touch and the
Philosophy of Perception* (New York, 1977). Though this book does not deal
with "criticism" in the narrow sense of the term, the philosophical
discussion of the differences between the individual senses has a direct
bearing on criticism of the visual arts.

Of particular interest is Diderot's attitude to the art of his time, both
with regard to the genres of painting and to the work of individual
painters. Relevant to the former is the article by Jean Seznec, "Diderot

and Historical Painting," in E. Wasserman, ed., *Aspects of the Eighteenth Century* (Baltimore, 1965). For the latter, see the interesting symposium *Diderot et Greuze*, Actes du Colloque de Clermont-Ferrand 16 novembre 1984 (Clermont-Ferrand, n. d.).

Sir Joshua Reynolds's *Discourses* have been frequently reprinted. I have used the edition in Everyman's Library: Sir Joshua Reynolds, *Fifteen Discourses Delivered In The Royal Academy* (London and New York, n. d.). About his theories, mainly in the context of Italian and French traditions, one learns from Rensselaer Lee, *Ut pictura poesis: The Humanistic Theory of Painting* (New York, 1967), pp. 19 ff., 62 ff. (originally an article in the *Art Bulletin*).

III: UNITY AND DIVERSITY OF THE VISUAL ARTS

The system of the arts in philosophical reflection up to Kant has been studied and clearly surveyed. Here, Paul O. Kristeller's article "The Modern System of the Arts" is the best-known presentation; frequently reprinted, it is most readily available in P. O. Kristeller, *Renaissance Thought* (New York, 1965), II, pp. 163–227. For the period from Kant onwards, however, the subject has lost its attraction. We do not have a classic presentation of the theme in modern thought. There are, however, a great many studies about individual thinkers that are pertinent to our theme.

Lessing's writings are available in many editions and in various translations. The analytical and critical literature dealing with Lessing's attitude to the arts is of course also rather large, though some of the subjects of particular interest for our purpose have not been sufficiently studied; students analyzing Lessing's aesthetics have naturally been concerned mainly with literature. For the background and origins of Lessing's comparison of the arts, one still learns a great deal from Hugo Blümner's *Lessings Laokoon* (Berlin, 1880). A recent interpretation from a modern point of view of the *Laocoön,* and of the German philosophical tradition immediately preceding Lessing, is both instructive and stimulating: David E. Wellbery, *Lessing's Laocoön: Semiotics and Aesthetics in the*

Age of Reason (Cambridge, 1984). Henry Hatfield, in the Lessing chapter of his *Aesthetic Paganism in German Literature* (pp. 14–32), focuses on Lessing's essay "How the Ancients Represented Death," but is more concerned with general cultural trends than with any reflection concerning the variety and unity of the arts. Karl Borinski's brief remarks on Lessing's theory of illusion and expression (*Die Antike in Poetik un Kunsttheorie*, II, pp. 225–230) raise broad problems. E. H. Gombrich's "Lessing," *Proceedings of the British Academy* 42 (1957): 133–156 (now reprinted in Gombrich's *Tributes* [Oxford, 1984]) is a lively discussion of Lessing's attitude to the visual arts.

Herder's thought and impact have of course been studied. Of works in English, we learn much from the second part of Isaiah Berlin's work mentioned above *(Vico and Herder)* as well as from the more recent study by H. B. Nisbet, *Herder and the Philosophy and History of Science* (Cambridge, 1970). Few students of Herder have devoted their efforts to his theory of the visual arts. His *Plastik* is of course included in all major editions of his works, but only one serious study of what it says about the foundations of sculpture, and by implication of painting, is available: see Bernard Schweitzer, "Herders 'Plastik' und die Entstehung der neueren Kunstwissenschaft," reprinted in Schweitzer's *Zur Kunst der Antike: Ausgewählte Schriften* (Tübingen, 1963), I, pp. 198–252.

Hegel's *Vorlesungen über die Aesthetik* are now available in a good English translation: see Hegel, *Aesthetics: Lectures on Fine Art*, translated by T. M. Knox (Oxford, 1975). A considerable literature, often of a rather complex character, has grown up around this influential work. Lukacs's various Marxist interpretations of Hegel's thought on art are famous. They are perhaps best summarized in his comprehensive essay "Hegels Aesthetik," reprinted in Georg Lukacs, *Beiträge zur Aesthetik* (Berlin, 1954), pp. 97–134. Here Lukacs is concerned mainly with general philosophical and historical themes, and deals only marginally with the arts. In another essay, "Hegels Lösungsversuch," in the context of Lukacs's discussion of "specificity" *(Besonderheit)* as the particular category of aesthetics, he attempts an explanation of the concept in the development of German idealistic philosophy. Here, too, the arts are hardly discussed. See Georg Lukacs, *Über die Besonderheit als Kategorie der Aesthetik* (Neuwied and Berlin, 1967), pp. 47–92. An altogether different

approach informs the interesting presentation by Peter Szondi in his "Hegels Lehre von der Dichtung." See his *Poetik und Geschichtsphilosophie* I (Frankfurt am Main, 1974), pp. 269–511. Though Szondi is mainly concerned with poetry, as his title indicates, he also makes interesting observations on the visual arts. Jack Kaminsky, *Hegel on Art: An Interpretation of Hegel's Aesthetics* (New York, 1962) is a balanced presentation of Hegel's views. For our purpose, Chapters IV and VI are of particular importance, but in Hegel's thought, as we know, it is very difficult to consider any one subject in isolation from others.

Scholarly investigation of thought on synaesthesia, especially in the visual arts, is both limited and lacking in systematic approach. Leo Spitzer, *Classical and Christian Ideas of World Harmony* (Baltimore, 1963) is a brilliant discussion of a complex of ideas that is naturally linked with our subject, but stops long before our period and does not deal with artistic application of synaesthesia. For ideas current in the Renaissance and Baroque, one learns a great deal from Albert Wellek, "Renaissance- und Barock-Synaesthesie: Geschichte des Doppelempfindens im 16. und 17. Jahrhundert," *Deutsche Vierteljahrsschrift für Literaturwissenschaft und Geistesgeschichte* 9 (1931): 534–584. For the subject in Romantic literature, see E. von Erhardt-Siebold, "Harmony of the Senses in English, German and French Romanticism," *Publications of the Modern Language Association* 47 (1932): 577–592. A recent study by Edward Lockspeiser, *Music and Painting: A Study in Comparative Ideas from Turner to Schoenberg* (New York, 1973), focuses mainly on later stages of reflections on synaesthesia than those discussed in the present volume.

I shall deal with the ideas of Delacroix and Baudelaire in the last section of this essay.

IV: THE SYMBOL

The literature concerning symbol and symbolism is enormous. However, with regard to certain specific and well-defined areas, one still awaits a critical discussion.

The late eighteenth and early nineteenth centuries inherited Renaissance visual symbolism, treated in such classics as Erwin Panofsky's

Studies in Iconology (New York, 1939; reprinted 1962). Jean Seznec, *The Survival of the Pagan Gods* (New York, 1953) gives a broad and fascinating panorama of mythological symbolism; E. H. Gombrich, *Symbolic Images: Studies in the Art of the Renaissance* (London, 1972) attempts a psychological interpretation of Renaissance approaches to mythologies (see especially "Icones symbolicae").

Of particular value for the period discussed here is S. A. Sorensen, *Symbol und Symbolismus in den ästhetischen Theorien des 18. Jahrhunderts und der deutschen Romantik* (Copenhagen, 1963). The clear and balanced presentation of Tzvetan Todorov, *Theories of the Symbol* (Ithaca, N.Y., 1982), especially Chapter 6 ("The Romantic Crisis"), deals with literature, but is helpful also for our purpose.

The authors discussed in this chapter have been treated very unevenly by modern scholarship. In the rather large literature on Winckelmann, there is little discussion of his *Versuch über die Allegorie,* nor is there a translation of the text into English. Creuzer's contribution to the study of symbolism, on the other hand, has received a significant amount of scholarly attention. Arnaldo Momigliano's article "Friedrich Creuzer and Greek Historiography," *Journal of the Warburg and Courtauld Institutes* 9 (1946): 152–163, though focusing on historiography, is a good introduction to our author. A recent study of Creuzer's basic concepts, as they emerge from his monumental work, is by Marc-Matthieu Munch, *La 'Symbolique' de Friedrich Creuzer* (Association des publications près des universités de Strasbourg, fasc. 155) (Paris, n. d.). About the impact of Creuzer's *Symbolik,* one learns from Ernst Howald's interesting collection of documents, *Der Streit um Creuzers Symbolik* (Tübingen, 1926). See also Todorov's *Theories of the Symbol,* pp. 216 ff. A study of Creuzer's writing from the point of view of the visual arts (for which the four volumes of the *Symbolik* would provide interesting material) is still missing. I quote Creuzer from the first edition (*Symbolik und Mythologie der alten Völker,* 1810–1812). The work was so successful that a second edition was soon necessary. A decade after the fourth volume appeared in print, an abridged edition, containing only some nine hundred pages, was published in Leipzig (1822).

Bachofen aroused much curiosity and also attracted scholarly attention. A complete edition of his works (in the German original) is now

available. The selection in English, *Myth, Religion, and Mother Right: Selected Writings of J. J. Bachofen,* translated by R. Mannheim (Princeton, 1967), gives a balanced picture of his ideas. An introductory survey of Bachofen's thought can be found in the introduction to this work. C. A. Bernoulli's *Johann Jakob Bachofen als Religionsforscher* (Leipzig, 1924) is a traditional assessment of Bachofen's work. For a modern approach, one may turn to Hans Kippenberg's interesting introduction to his recent selection from Bachofen's works, *Mutterrecht und Urreligion* (Stuttgart, 1984), pp. ix–lv. Lionell Gossman, *Orpheus philologus: Bachofen versus Mommsen on the Study of Antiquity* (Transactions of the American Philosophical Society, Vol. 73, Part 5) (Philadelphia, 1983) deals with a specific subject not directly pertaining to ours; nevertheless, Gossman's study is helpful also to the student of Bachofen's views concerning symbolic imagery.

Reflections on landscape as a symbolic form, mainly by painters in the last years of the eighteenth and early years of the nineteenth centuries, remained fragmentary, although when seen together, they amount to a significant statement. A recent collection of studies edited by M. Smuda, *Landschaft* (Frankfurt am Main, 1986), though not precisely focused on the years discussed here, may be helpful for our investigation. Herbert von Einem's thoughtful study "Die Symbollandschaft der deutschen Romantik," best available in the author's *Stil und Überlieferung: Aufsätze zur Kunstgeschichte des Abendlandes* (Düsseldorf, 1971), pp. 210–226, though dealing with the paintings themselves, introduces the reader to the thoughts and reflections of the artists. Von Einem's *Deutsche Malerei des Klassizismus und der Romantik: 1760 bis 1840* (Munich, 1978) is also stimulating and helpful in elucidating the Romantics' attitudes to landscape as a kingdom of symbols.

C. G. Carus, one of the most versatile figures in the intellectual and artistic life of his time, was also a major figure for the subject here considered. While Carus has not suffered from neglect by modern scholars, his view of landscape painting as a form of symbolic expression has not received the attention it deserves. Some of the monographs devoted to Carus's thought touch on the subject of the landscape in art as a symbol, though they do so mainly for what these views may disclose about Carus's contribution to literature. See Erwin Wasche, *Carl Gustav Carus und die romantische Weltanschauung* (Düsseldorf, 1933), pp.

101–127, and Berna Kirchner, *Carl Gustav Carus: seine 'poetische' Wissenschaft und seine Kunsttheorie, sein Verhältnis zu Goethe und seine Bedeutung für die Literaturwissenschaft* (Bonn, 1962), pp. 36–43. Carus's own work, *Die Symbolik der menschlichen Gestalt* (Leipzig, 1953), though not mentioning landscape, helps one to understand his views of how real forms in nature, and in their representation by artists, can be symbolic.

Caspar David Friedrich's significance as an artist, and more particularly his role in the history of landscape painting, has not gone unnoticed in modern scholarship. His written notes, modest to be sure, were used only to help explain his paintings. They also contribute, however, to the Romantic theory of the symbolic expression of nature.

The symbolism of color is a time-honored subject; it has evoked interest in various fields of study, most of them far removed from art or even from aesthetics. Yet in spite of the age-old interest in the subject, we still do not have an authoritative survey of this theme. Individual publications at least indicate something of the subject's broad scope. See, for example, *Eranos Yearbook 1972* (Vol. 41 of the series), titled *The Realms of Colour* (Leiden, 1974), with contributions ranging from a discussion of color symbolism in Shi'ite cosmology or color symbolism in Black Africa to an analysis of Orphism and optical art.

Philipp Otto Runge's extensive observations on color in general, and on color symbolism in particular, are scattered throughout the two-volume edition of *Hinterlassene Schriften* (Hamburg, 1840–1841; reprinted Göttingen, 1965). For a discussion of Runge's color symbolism, see Rudolf M. Bisanz, *German Romanticism and Philipp Otto Runge: A Study in Nineteenth Century Art Theory and Iconography* (De Kalb, Ill., 1970), pp. 86–96.

Goethe's *Farbenlehre* [Color Theory], in the original German, is available in several editions. See also the well-known English translation, *Goethe's Theory of Colour, translated from the German with notes by Charles Lock Eastlake* (London, 1840). Most modern discussions of Goethe's color theory concentrate on his dispute with Newton and on the scientific validity (or lack of validity) of the poet's theory; the interesting sector on color symbolism is not given sufficient attention.

V: THE ARTIST

Modern scholarship has been fascinated by the concept of the artist (especially as "genius"), particularly as that concept emerged in the eighteenth and early nineteenth centuries. From the large volume of literature I shall mention only a few general works. A concise introduction is Rudolf Wittkower's entry "Genius: Individualism in Art and Artists," *Dictionary of the History of Ideas,* II (New York, 1973), pp. 297–312, esp. section iv. M. H. Abrams, *The Mirror and the Lamp: Romantic Theory and the Critical Tradition* (Oxford, 1953) approaches the problem mainly from the point of view of the literary critic. Edgar Zilsel, *Die Geniereligion: Ein kritischer Versuch über das moderne Persönlichkeitsideal* (Vienna, 1918) draws mainly social perspectives. (Zilsel's later work, *Die Entstehung des Geniebegriffs* [Tübingen, 1926], is still a classic, but scarcely goes beyond the Renaissance.) Recently, James Engell has ably surveyed the views concerning the creative imagination as they developed among literary men, with an emphasis on English culture. See his *The Creative Imagination: Enlightenment to Romanticism* (Cambridge, Mass., 1981).

For William Duff, whose *Essay* was reprinted in 1964, see mainly Engell, pp. 64 ff. M. H. Abrams, *The Mirror and the Lamp,* pp. 88 ff., throws light on an interesting aspect of Sulzer's reflection on art. Wackenroder has elicited a considerable amount of comment and investigation. Mary H. Schubert's introduction to the English edition of Wackenroder's *Confessions and Fantasies* (University Park, Pa., 1971) is informative and balanced. Marianne Frey's study *Der Künstler und sein Werk bei W. H. Wackenroder und E. T. A. Hoffmann: Vergleichende Studien zur romantischen Kunstanschauung* (Bern, 1970) attempts a general outline of what Romanticism thought about the artist's nature and the process of creation. Heinz Lippuner, *Wackenroder, Tieck und die bildende Kunst* (Dresden, 1934) attempts to focus on the visual arts. For Solger, see the brief but clear summary by Tsvetan Todorov, *Theories of the Symbol,* pp. 218–221. See also H. Mainusch, *Romantische Ästhetik* (Zurich, 1960), pp. 67 ff. On a specific subject, but central for Solger, one can learn from a paper by Wolfgang Heckmann, "Symbol und Allegorie by K. W. F. Solger,"

Romantik in Deutschland: Ein interdisziplinäres Symposium, ed. R. Brinkmann (Stuttgart, 1978).

The student of art theory concerned with Runge will, in the present context (in addition to what was mentioned in the note to Chapter 4), derive instruction from J. B. C. Grundy, *Tieck and Runge: A Study in the Relationship of Literature and Art in the Romantic Period* (Strasbourg, 1930), and W. Roch, *Philipp Otto Runges Kunstanschauung* (Strasbourg, 1909). A concise presentation of Runge's color theory can be found in the recent work by Lorenz Dittmann, *Farbgestaltung und Farbtheorie in der abendländischen Malerei* (Darmstadt, 1987), pp. 330 ff.

Hyppolite Taine's work on the visual arts is now available in a reprint of the 1889 English translation: *Philosophy of Art* (New York, 1971). Students of art theory and of the history of art have paid only scant attention to his work, but we can learn much about Taine's approach and the problems that concerned him from the chapter in René Wellek's *A History of Modern Criticism: 1750–1950,* IV, *The Later Nineteenth Century* (Cambridge, 1983), pp. 27–57.

The concept of realism is one of the most complex notions in the critical vocabulary. Uses of "The Concept of Realism in Literary Scholarship" have been traced by René Wellek in his *Concepts of Criticism* (New Haven and London, 1963), pp. 222–255. Essential for any study of the debate over realism in mid-nineteenth-century art and literature, especially in France, is Émile Bouvier, *La bataille réaliste* (Paris, 1913; reprinted Geneva, 1973). Linda Nochlin's *Realism* (Penguin Books, 1971) deals with painting rather than with theoretical reflection, but it also lays out the ground for a study of the latter.

A small but good selection of Proudhon's writings on art is available in *Selected Writings of Pierre-Joseph Proudhon,* ed. Stewart Edwards, translated by Elizabeth Frazer (Garden City, N. Y., 1969), pp. 214 ff. Eugène Fromentin's classic work, the *Maîtres d'autrefois,* is available in an English translation, with an introduction by Meyer Schapiro. See *The Old Masters of Belgium and Holland,* translated by M. C. Robbins (New York, 1963). On Fromentin, see also Arthur Evans, *The Literary Art of Eugène Fromentin* (Baltimore, 1964), and Emanuel Mickel, Jr., *Eugène Fromentin* (Boston, 1981).

Delacroix's writings are easily accessible. Of particular importance is

Correspondance générale d'Eugène Delacroix, ed. André Joubin, 5 vols. (Paris, 1936–1938). For an English translation of considerable, and well-selected, parts, see *Delacroix: Selected Letters, 1813–1863,* selected and translated by Jean Stewart (London, 1971), and *The Journal of Eugène Delacroix,* translated by Walter Pach (New York, 1972). Delacroix's views on painting and on the artist's task have been ably presented in a systematic fashion, and with references to the traditional Italian theory of art, by George Mras, *Eugène Delacroix's Theory of Art* (Princeton, 1966).

Baudelaire's writings on painting have been published frequently. A good edition is Baudelaire, *Curiosités esthétiques, L'art romantique,* ed. Henri Lemaître (Paris, 1962). In English translation, they are available in two good selections: Charles Baudelaire, *The Painter of Modern Life and Other Essays,* translated by Jonathan Mayne (London, 1964); and *Art in Paris 1845–1862: Salons and other Exhibitions,* translated by Jonathan Mayne (Oxford, 1965). In modern critical literature, Baudelaire's work as a critic of art has been assessed several times. Margaret Gilman, *Baudelaire the Critic* (New York, 1943) is an important contribution to our subject. Gita May's *Diderot et Baudelaire: Critiques d'art* (Geneva, 1957) attempts to place Baudelaire in the historical context of the critical tradition in France. Walter Benjamin's study of Baudelaire, *Charles Baudelaire: Ein Lyriker im Zeitalter des Hochkapitalismus* (Frankfurt am Main, 1969), though not primarily concerned with criticism, makes an interesting contribution to the understanding of his work as a modern critic. The chapter on Baudelaire in the fourth volume of Wellek's *A History of Modern Criticism 1750–1950,* the volume on *The Later Nineteenth Century,* pp. 434–452, is a clear and erudite presentation of a complex but fascinating subject.

Name Index

Abrams, M. H., 9, 405
Addison, Joseph, 46, 77 ff.
Alberti, Leone Battista, 21, 39, 58, 62, 94, 318
Alciati, Andrea, 224 ff.
Auerbach, Erich, 393
Augustine, Saint, "creature cannot create," 130

Bachofen, Johann Jakob, 238–245
 on meaning of rope plaiting, 242
Baldinucci, Filippo, 44, 355 ff.
 quoted by Winckelmann, 100
Batteaux, C., 290
Baudelaire, Charles
 "art for art," 363 ff.
 on artist's productivity, 368
 audience of sculpture, 216
 color, 211 ff.
 on "correspondences," 371 ff.
 on Delacroix, 351
 on Goya's monsters, 382
 on imagination, 367 ff.
 on inspiration, 373 ff.
 on laughter, 380

on music, 212
music and painting, 213 ff.
"philosophic art," 364
on photography, 367
principles of his art theory, 363–373
on process of creation, 373–376
"pure art," 364
rejects realism, 366 ff.
on sculpture, 214 ff.
on skill and technique, 374
theory of imitation, 366
on the ugly in painting, 380
on Wagner, 211
writings on art, 362–363
Baumgarten, Alexander Gottlieb, 2, 8 f., 90, 179
Bayle, Pierre, 35, 36
Bellori, Giovanni Pietro, 123
Berenson, Bernard, 208
Berlin, Isaiah, 9 f.
Bernard of Clairvaux, 313, 378
Bernini, Gian Lorenzo, 96, 111
 artist of subjectivism (Winckelmann), 100
 criticized by Winckelmann, 99

Name Index

Janson, H. W., 356
Jauss, Hans Robert, 378
Justi, Karl, 90, 396

Kant, Immanuel, 24, 43, 157
 influenced by Shaftesbury, 37
Kippenberg, Hans, 403
Kircher, Athanasius, 12
Kleist, Heinrich, 260
Kristeller, P. O., 399

Lactance, 11
Lairesse, Gérard de, 55 ff., 57–73, 122, 274
 on genres of painting, 60 ff.
 Grand livre, 57 ff.
 hierarchy of genres, 65
 individual genres, 67 ff.
 on "kinds of painting," 63 ff.
 landscape painting, 64 ff.
 and mythographic tradition, 64
 on ruins, 68
 on still life, 65
 types of still life, 71
Lebrun, Charles, 22
Le Nain, Antoine, 335
Leonardo da Vinci, 203, 291
 color observations, 268
 comparison of the arts, 168 ff.
 on painting and sculpture, 169 ff.
Lessing, Gotthold Ephraim, 28, 149–164
 on aesthetic experience, 156
 the beholder, 156
 "material confines" of arts, 161
 painting and poetry, 157
 on signs, 153 ff.
 on space, 157
 on time, 157
 on work of art, 155
Lomazzo, Giovanni Paolo, 67, 149
Longinus, 76, 128, 140
Lovejoy, Arthur O., 392
Lukacs, Georg, 400

Maistre, Joseph, 377
Manuel, Frank, 392
Mendelssohn, Moses, 302
Mengs, Anton Raphael, 90–96, 292
 on primeval styles, 91 ff.
Michelangelo, 93
 Diderot on, 130
 Flaxman on, 265
 Piles, Roger de, on, 138
 Reynolds on, 138
 Taine on, 326
Momigliano, Arnaldo, 44, 402
Monk, Samuel, 77, 394
Montfaucon, Bernard de, 12 ff.
Morelli, Giovanni, 49
Moritz, Karl Philip, 297
Mozart, Delacroix on, 207
Mras, George, 353

Newton, Isaac, 270
Nicolson, Marjorie, 42, 82, 394

Panofsky, Erwin, 78, 401 ff.
Pascal, B., 124
Pevsner, Nicolas, 54
Piles, Roger de, 47 ff., 129, 153 ff.
 on Michelangelo, 138
 on schools of painting, 49 f.
 on the sublime, 76
Piranesi, Giovanni Battista, 101 ff.
Plotinus
 influenced Creuzer, 237
Plutarch, quoted by Bachofen, 244
Poe, Edgar Allan
 Baudelaire on, 362
 Delacroix on, 353
Poussin, Nicolas, 63, 201
 on "aim" of painting, 23
 letter on modes, 61
 on novelty in painting, 39 f.
Proudhon, Pierre Joseph, 330–334
 advocates realism, 333
 and Courbet, 331 ff.

Name Index

Quintilian, 25, 45
 on power of the eye, 32

Raphael Santi, 92 f., 296, 298 ff., 299 ff.
 Champfleury on, 337
 Dubos on, 27 ff.
 Reynolds on, 137
Rehm, Walter, 104
Rembrandt, H., 335
 Richardson on, 81
 Hundred Guilder Print, 81
 St. Peter's Prayer before the Raising of Tabitha, 81
Reni, Guido, 93, 231
 Hegel on, 198
Reynolds, Sir Joshua, 132–140, 150
 on "borrowing," 134
 copying, 134
 on "greatness," 139
 imagination, 134
 "originality," 138 ff.
 on poetry, 136
 theater, 136
Richardson, Jonathan, 50 ff., 55 ff., 73–83
 on brushstrokes, 80
 on connoisseurship, 50
 on Rembrandt, 81
 on Zuccari's *Annunciation,* 81
Richter, A. L., 274–278
Riegl, Alois, 208
Ripa, Cesare, 224, 228, 230, 257
Rosenkranz, Karl, 376 ff., 379 ff.
Rubens, P. P., discussed by Fromentin, 344
Runge, Philipp Otto, 267–269, 310–317
 on ancient Greeks, 311
 light and color, 314
Ruysdael, discussed by Fromentin, 346

Schapiro, Meyer, 23, 69, 128, 343 ff.
Schelling, F. W. J., 253, 318 ff., 326 f.

on landscape painting, 247
on symbolism, 307
Schiller, Friedrich, 297 ff.
Schlegel, August Wilhelm, 173–178, 246 ff., 326
 on form, 175 ff.
 painting and sculpture, 175
Schlegel, Friedrich, 183
Seznec, Jean, 63, 398 f.
Shaftesbury, Anton Ashley Cooper, 16 f., 36–43, 78
 artist's freedom, 39
 on creative artist, 38
 on enthusiasm, 42
 on genius, 38
 harmony, 37
 on originality, 38 f.
 on Prometheus, 40
Solger, K. F. W., 305–308
 on imagination, 306
 symbol, 307
Sorensen, Bengt Algot, 227, 402
Spanheim, Ezechiel, 45
Spence, Joseph, 164
Spitzer, Leo, 38, 401
Spon, Jacques, 45
Sulzer, J. G., 248 ff., 289–293, 298 ff.
Sutter, Monika, 395
Swedenborg, Emanuel, 211, 371 ff.
 Baudelaire's source, 372
Szondi, Peter, 401

Taine, Hippolyte, 320–329
 against prescriptive thought, 321 ff.
 on artist, 324 ff.
 Dutch painting, 328
 education of the eye, 328
 Greeks, 327 ff.
 "milieu," 325 ff.
Tertullian, 21
Testelin, Henry, 61 f.

Valeriano, Pierio, 13, 228
Vasari, Giorgio, 177

413

Subject Index